YVES

SAINT

THIS EXHIBITION IS MADE POSSIBLE THROUGH THE PATRONAGE OF
MADAME CARLA BRUNI-SARKOZY

LAURENT

The Yves Saint Laurent exhibition was held at the Petit Palais/Musée des Beaux-Arts de la Ville de Paris, March 11–August 29, 2010.

Under the supervision of Mr. Pierre Bergé, the show was curated by:

Florence Müller
Senior curator

Farid Chenoune
Associate curator

Gilles Chazal
Senior Curator of National Heritage Director, Petit Palais/Musée des Beaux-Arts de la Ville de Paris

Charles Villeneuve de Janti
Curator of National Heritage, Petit Palais/ Musée des Beaux-Arts de la Ville de Paris

Nathalie Crinière
assisted by Mathilde Le Coutour
Exhibition designer

Philippe Apeloig
assisted by Yannick James and Matthias Neuer
with valuable help from Tino Grass
Graphic design

Alexandre Guirkinger
Photographer

Mr. Pierre Bergé and the Board of Directors of the Fondation Pierre Bergé–Yves Saint Laurent would like to thank:

Madame Carla Bruni-Sarkozy

Mr. Bertrand Delanoë
Mayor of Paris

The Cultural Affairs Department of the City of Paris, notably:
Laurence Engel, Catherine Hubault, Catherine Grangeon, Bénédicte Dussert, Christel Bortoli, and Bénédicte Breton

The Petit Palais/Musée des Beaux-Arts de la Ville de Paris, notably:
Gilles Chazal, Déborah Zéboulon, Anne Le Floch, Sophie Adelle, Hubert Cavaniol, Charles Villeneuve de Janti, Fabienne Cousin, Caroline Delga, Françoise Camuset, and Joëlle Raineau

Paris Musées, notably:
Édouard de Ribes, Aimée Fontaine, Leslie Grumberg, Denis Caget, Éléonore Maisonabe, Cécile Gindre, Marie Jacquier, Samuel Taieb, Cécilie Poulet, Blandine Cottet, Camille Borgetto, Gilles Beaujard, and Sophie Durst

The lenders, notably:
Charlotte Aillaud (CAT. 75), Comtesse Jacqueline de Ribes (CAT. 65 and 261), Michèle and Olivier Chatenet (CAT. 59 and 63)

The Fondation's conservation department:
Gaël Mamine, Sophie Couret, Laurence Neveu, Mireille Prulhière, Sandrine Tinturier, Samy Jelil, and Julie Périnet

The Fondation's public relations department:
Robin Fournier-Bergmann, Pauline Cintrat, and Olivier Flaviano

The authors:
Jéromine Savignon and Bernard Blistène

The press agency:
Patricia Goldman Communication

Les Films de Pierre:
Pierre Thoretton and Hugues Charbonneau

Researchers:
Pauline Vidal and Chloé Lefebvre

External consultant:
Sophie Aurand

As well as:
Annie Boulat, Betty Catroux, Catherine Deneuve, Loulou de la Falaise, Barbara Sieff, and Connie Uzzo

And, at the Fondation Pierre Bergé–Yves Saint Laurent:
Philippe Mugnier, Olivier Ségot, Pascal Sittler, Valérie Mulattieri, Kamel Khemissi, and Joséphine Théry

At Éditions de La Martinière
Isabelle Jendron, Laurence Basset, Brigitte Govignon, Isabelle Dartois, Cécile Vandenbroucque, Florent Roger, Ombeline Canaud, and Marion Lacroix

Florence Müller, Farid Chenoune, Jéromine Savignon, and Bernard Blistène would like to thank the following people for their contribution to the catalog:

Claude Berthod, Claude Brouet, Gilles de Bure, Gabrielle Busschaert, Amina Chenounne, Jean-Pierre Derbord, Dominique Deroche, Pierre Dinand, Jean-Luce Huré, Peter Knapp, Marie-José Lepicard, Baroness de Ludinghausen, Franka de Mailly, Maison Anouschka, Guy Marineau, Christine Martin, Anne-Marie Muñoz, Jutta Niemann, Jean-Jacques Picart, Mariella Righini, Clara Saint, David Teboul, Susan Train, and Goran Vejvoda

There are many great artists, but few are truly exceptional in the way that Yves Saint Laurent was. I had the enormous privilege of wearing his designs and the great honor of modeling for him. Yves Saint Laurent revolutionized fashion. He created an inspired, vivid universe that overturned conventions and conformity. With Saint Laurent, art became fashion—and fashion an art. Women's beauty, freedom, and strength were the sources of his vision of style and appeal, shaped by a demanding, passionate approach to his work. The name Yves Saint Laurent will be associated with haute couture forever, in France and abroad, because he was a creative mentor to everyone, everywhere. This magnificent retrospective in the wonderful setting of the Petit Palais is an elegant tribute to Yves Saint Laurent, revealing the heart and soul of his designs.

Carla Bruni-Sarkozy

The art of Yves Saint Laurent and his immense creativity are among the most magnificent modern-day expressions of French genius. Through his dazzling talent and visionary work, Yves Saint Laurent helped establish Paris as the capital of fashion while disseminating the city's freedom and elegance throughout the world.

He invented radically new fashions, proclaiming the liberation and beauty of women and overturning old codes of a world that had turned too long without them. In a particularly rigorous aesthetic quest, in which he challenged the notions of feminine and masculine, he revolutionized haute couture, created a new perception of the body, and contributed to the emancipation of Western European society.

Our city is proud to host the first complete retrospective of this major artist's brilliant oeuvre, produced over a forty-year period. From March 11 to August 29, one and all will have the opportunity of discovering or rediscovering it, thanks to the partnership of the Petit Palais, Musée des Beaux-Arts de la Ville de Paris; and the Fondation Pierre Bergé–Yves Saint Laurent. Our thanks go to these two indispensable institutions that were so naturally associated in this project.

I wish each visitor a marvelous journey through this exceptional exhibition, dedicated, as was the life of Yves Saint Laurent, to the celebration of women and their freedom.

Bertrand Delanoë
Mayor of Paris

The Fondation Pierre Bergé–Yves Saint Laurent is pleased to present this retrospective exhibition of Yves Saint Laurent's oeuvre in collaboration with the Petit Palais. The foundation, set up in 2002 as a nonprofit organization during Saint Laurent's lifetime, now boasts more than 5,000 haute couture garments, over 150,000 drawings, sketches, accessories, and sundry objects, plus over 1,000 examples of Saint Laurent Rive Gauche designs. All are conserved in scientifically controlled conditions that are the envy of costume museums throughout the world.

Because one of the foundation's aims is to promote the oeuvre of Yves Saint Laurent, we have recently contributed to exhibitions in Montreal, San Francisco, and Rio de Janeiro. Furthermore, the foundation's headquarters on avenue Marceau in Paris have hosted five Yves Saint Laurent shows titled, respectively, *Dialogue avec l'Art; Smoking Forever; Voyages Extraordinaires; Nan Kempner, Une Américaine à Paris;* and *Théâtre, Cinéma, Music-Hall, Ballet.* But the foundation is not devoted solely to Yves Saint Laurent's work. Open to various fields, it has presented exhibitions on Robert Wilson's *Fables de La Fontaine,* Russian folk dress, Moroccan photographs by David Seidner and André Ostier, India of the maharajahs, and the work of Jean-Michel Frank. The foundation also supports other cultural initiatives. We notably focus on two Paris institutions, the Festival d'Automne (a seasonal performing arts festival) and the Palais de Tokyo (a contemporary art venue). Indeed, Yves Saint Laurent was nothing if not an artist of his times, and we think patronage of contemporary creativity is the best way to remain faithful to his memory. This exhibition would not have been possible without the precious help of many people. I would like to thank the mayor of Paris, Bertrand Delanoë, who suggested organizing it, and Carla Bruni-Sarkozy, who agreed to preside over it. I am also grateful to Gilles Chazal, curator and director of the Petit Palais, to exhibition curators Florence Müller and Farid Chenoune, and to exhibition designer Nathalie Crinière.

I hope this retrospective will enable a wide audience to discover—or to rediscover—the work of Yves Saint Laurent, the better to appreciate a major creative realm of the twentieth and twenty-first centuries, the world of fashion.

Pierre Bergé
President of the Fondation Pierre Bergé–Yves Saint Laurent

Why Yves Saint Laurent at the Petit Palais? The Musée des Beaux-Arts de la Ville de Paris does not have its own haute couture collection, and it has never, until now, held an exhibition of this art form. Other specialized establishments in Paris may well appear more legitimate candidates for organizing such an event.

So why Yves Saint Laurent at the Petit Palais? Simply because it's Yves Saint Laurent! Because, beyond being a fashion designer, Yves Saint Laurent is an exceptional artist, whose work easily joins the long succession of prestigious monographic exhibitions mounted by the museum.

Yves Saint Laurent! An artist who sought inspiration in the masterworks of other artists—and who collected them; the auction held at the Grand Palais in 2008 was a sumptuous demonstration of that. An artist whose keen sensibility captured the vibes of society and whose ability to influence it grew with his convictions and talent. "With him, everything changed" is how Pierre Bergé neatly summed it up. The Western woman began to adopt classic men's clothing—pullover, shorts, trouser suits, tuxedo, leather jacket—as well as traditional garments such as the pea jacket, in haute couture style.

The workshop of this artist of female elegance was a silent, white, sparsely furnished studio bathed in light, with a mirror wall as a creative tool and a small monastic desk. His easel was a woman offering him her movement and gesture. "All my dresses stem from a gesture. A dress that does not reflect or conjure up a gesture is no good." His palettes were his scrupulously selected fabrics: Vibrant in his hands, when draped on the body of a living model they generated life, comfort, ease of movement—an exaltation of woman that said it all.

In a final, dazzling flourish, each new season's designs posed as a collection of "paintings"; and through his work, this lover of Velázquez, Delacroix, Monet, van Gogh, Mondrian, Braque, and Picasso gave full expression to Yves Saint Laurent himself.

From season to season the master's "paintings" were renewed and varied, necessarily. But Yves Saint Laurent's major concern was not novelty for novelty's sake or for the infinitely multifarious game of fashion. His true quest, beyond the requisite diversity, was to achieve a deeper style, to attain those essential structures that offer women full freedom and elegance.

The principal themes and subtle variations of forty years of haute couture creation is what the Petit Palais wishes to show in this exhibition, mounted thanks to the support of Pierre Bergé, the scholarly work of Florence Müller and Farid Chenoune, and the exhibition design of Nathalie Crinière. To these four we extend our warm thanks. May our visitors derive much enjoyment from this festival of beauty and freedom.

Gilles Chazal
Chief Curator
Director of the Petit Palais, Musée des Beaux-Arts de la Ville de Paris

Yves Saint Laurent did not like to explain his work. He preferred to "let the mystery be."[1] Yet few fashion designers have left such an extensive exegesis of their work. The impressive number of interviews he gave, even though he refused them in his last years, not to mention his portraits, publications, and appearances, give the impression that everything has been said, everything showed. But, despite it all, the mystery remains. Who is Saint Laurent? Was he a designer for every woman or the last of the great couturiers? Did he prefer the ready-to-wear fashion of today or the haute couture of the past? Was he a lover of the classical, seeking rigor and simplicity, or of the baroque, inspired by refinement, poetry, and his own luxuriant fantasies? Did he design for democratic times or for an elite? Was his work an expression of the revolutions of his generation or a nostalgic defense of vanishing splendors? Did he want to make women strong by giving them a masculine armor or did he see them as idols on a pedestal? Was he a lover of his kindred human beings—so keenly observed behind his bespectacled shyness—or did take refuge behind a wall of pride? The magazine *Marie France* was asking in September 1969, "Has Saint Laurent Brought Haute Couture into the Street or, Verging on Genius, Has He Raised the Street to Haute Couture?"

As we gather the keys to understanding his work, for the first posthumous retrospective of his career, the gray areas fade, opinions are formed. Yves Saint Laurent wanted to make his mark on his time, and he achieved that ambitious goal. He designed the wardrobe of modern times, embellishing it with vintage and exotic influences. He placed the notion of appeal above that of elegance. He created fashion desires that had little to do with the laws of fashion. But the dresses, drawings, photographs, and essential objects of his life's work do not suffice to elucidate the Yves Saint Laurent mystery. "I want to become a legend," he once declared.[2] That is what he became. A legend that fascinates and raises many a question. This exhibition tackles a number of them, issues that emerge when we encounter the worlds in which the designer moved and his experiences: his Dior years, his aesthetic phantoms, his revolutions, his women, his imaginary voyages, his nights . . .

Yves Saint Laurent was born the same year as the French Popular Front. Did this predestine him to become the first so-called social couturier? Edmonde Charles Roux saw him as a liberator: "Chanel liberated women, Yves liberated fashion, took away its sacred aura. You didn't laugh at Balenciaga; it was like being at Mass. Yves introduced a spirit of fun. There weren't just the grand formal dresses but a boiler suit too; younger, freer, that had seen more of life."[3] After creating his revolution, Saint Laurent lived his life as one might read a never-finished Proust book, taking up the great work from year to year: inventing a style. The end of his career was marked by the profound changes that altered the identity of fashion. Saint Laurent deplored the world's uniformity of appearance governed by the luxury multinationals and mass retail. He saw the street come under the influence of an international carelessness; he was disgusted to see a world that had become "sloppy" (*avachi*),[4] whose ambition in clothing was limited to a concern for comfort, synonymous, to his mind, with mediocrity. He preferred to stop there. Yet he remained, tormented as he was by the quest for perfection, eternally unsatisfied with the fabulous heritage he left behind him.

Florence Müller and Farid Chenoune

NOTES

1. *Dutch*, Winter 1997.

2. Laure de Hesselle and Julie Huon, "Le dictateur de velours," *Victor*, December 22, 2000.

3. Conversation with David Teboul, 2001.

4. *Dutch*, Winter 1997.

SAINT LAURENT AND I

PIERRE BERGÉ

INTERVIEWED BY FLORENCE MÜLLER
AND FARID CHENOUNE,
OCTOBER 9, 15, AND 26, 2009

I met Yves Saint Laurent as soon as he took over from Christian Dior, who was a personal friend of mine. As chance would have it, I had dinner with him the night before he left for Montecatini in October 1957. I was one of the last people in France to see him alive because it was his final Paris social engagement. I had known Dior for a long time. Bernard Buffet, with whom I was living, had painted his portrait, which still hangs in the boardroom of the Dior firm. We were close friends. Dior had a house in the Gard [southern France], and I was living in the Bouches-du-Rhône [also southern France]. We met regularly. That's why we were invited to attend the first collection presented by his successor, Yves Saint Laurent, in January 1958.

FASHION IS NOT AN ART. — At the end of that first show, I went up to Yves and said, "Hello, Mr. Saint Laurent. It was wonderful!" Not that I didn't think it; I just didn't know anything about it! I didn't know a thing about fashion, which I didn't hold in very high esteem. I felt that fashion was a question of arranging, of matching colors. I'd never even attended a fashion show. Back then, fashion didn't play the same role it does today. Cocteau, Bérard, Poulenc, and Sauguet only attended Dior shows because they'd been a group of friends for a long time. I wasn't interested. For me, haute couture was just a way of dressing rich ladies. I never suspected that someday I'd run a fashion house—the biggest of its time—and that I would rank certain fashion designers—if not fashion itself—as the equals of other artists. Because although I don't think that fashion is an art, it takes an artist to create it.

BORING UPPER-CLASS COUTURE. — Yves Saint Laurent and I felt the same way about haute couture. We wanted to bring a touch of social relevance to it. Throughout his life Yves really liked only three designers: Chanel, Madeleine Vionnet, and Schiaparelli. Chanel because she pioneered an incontrovertible path that Yves followed, going much further than she did. Vionnet he liked for her fashion inventiveness and social commitment. And he borrowed many things from Schiaparelli. There are Saint Laurent smock tops that are very similar to Schiaparelli's. There was a fourth designer who was important, but with whom he was only more or less comfortable—Christian Dior. On one hand, he knew that Dior was a great fashion designer as well as his own mentor, but on the other hand, as soon as he took over the house of Dior he killed the Dior technique. In a single season he made Christian Dior look old-fashioned. One of the designers he didn't like was Balenciaga. When Balenciaga died, Yves said he was a great technician but that he produced only upper-class couture. He said it would be boring if fashion did nothing more than dress rich women.

History moved swiftly for Yves. Since he had the good luck to succeed Christian Dior, his media success was based on Dior's death. If he hadn't been Dior's successor, the international spotlight would never have been turned on him in that way. Naturally, the collection was wonderful. Naturally, he achieved fame that very day. But if he hadn't been Dior's successor, maybe he wouldn't have become famous so quickly.

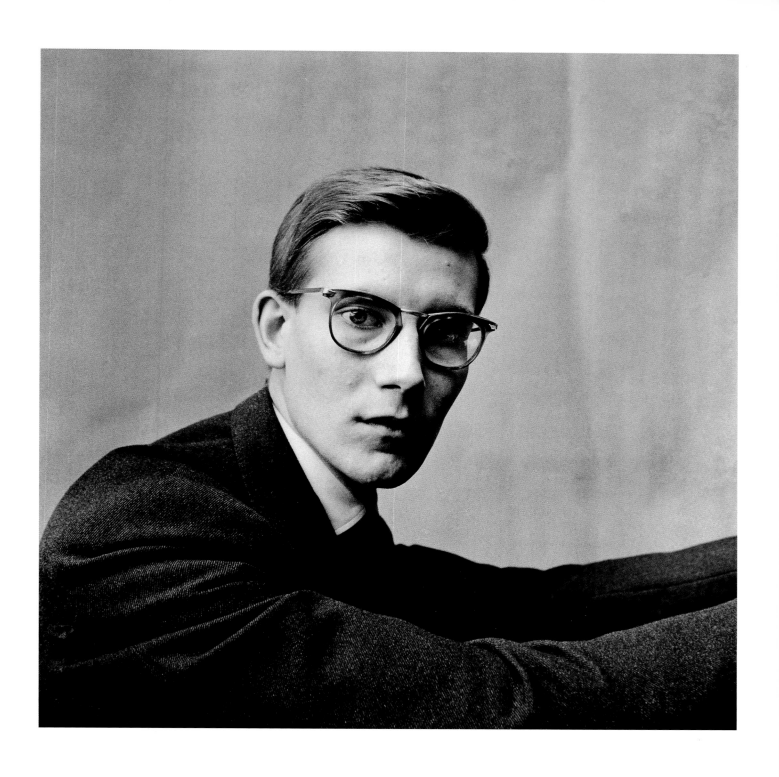

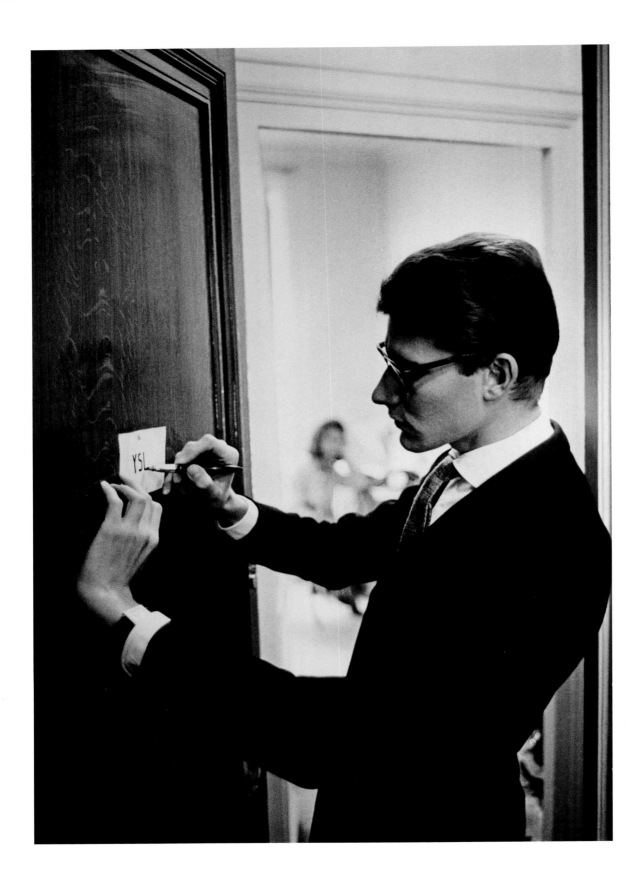

Page 21 — Yves Saint Laurent,
1957. Photograph by Irving Penn.

Opposite — Yves Saint Laurent,
rue Jean-Goujon, 1961.

YVES'S TEMPERAMENT: AUTHORITY AND ABSOLUTE CERTAINTY. — **Three days** after that first show, Marie-Louise Bousquet—who at that time was the correspondent for *Harper's Bazaar*—invited us to dine at a restaurant called La Cloche d'Or. There were five of us at dinner: Raymonde Zehnacker, Bernard Buffet, Yves Saint Laurent, Marie-Louise, and I. Yves made a strong impression on me. I saw a nearsighted young man who seemed shy and fragile. But I immediately realized that this young man had some surprises in store for us. He didn't say much. But in the little he said you sensed an extraordinary tenacity, extraordinary conviction, extraordinary determination. Some of Yves's qualities, like authority and gaiety, are never emphasized. His authority was scarcely noticeable because he was so kind and polite. People were not very aware of his iron will: You could never get Yves to give an inch. Despite his kindness, on the eve of a show I once saw him take apart an entire dress for the sake of 3 millimeters. Had anyone said, "Oh, but Mr. Saint Laurent, you know, the seamstress will have to spend all night on it—it's not that important," he would have learned that, indeed, things were never that important: They were absolutely crucial! So the seamstress spent the night redoing the dress. But she never resented him. Everyone knew that his demands weren't capricious. He had a bent for accuracy and an absolute certainty about things. Yves was like a racecar driver who wants the most amazing Formula One car ever, turning to the best manufacturers to invent a special gasoline or produce special tires. His entire life was driven by it. He was very unhappy when we founded the house in 1961 because our workforce was mediocre. He was so unhappy that he lost his appetite. We had to reassure him, saying, "Look, you'll see, everything will go fine." Meanwhile, he spent his time trying to equip himself with the best machine, and he ultimately pulled it off! This absolute mastery of the craft was something he maintained to the end. The chiffon dresses in his last collection— the retrospective show in 2002—are extraordinary.

YVES'S TEMPERAMENT: GAIETY AND SELF-DESTRUCTIVENESS. — **Alongside this** authority, there was his gaiety. A short film made by Jeanloup Sieff reveals Yves's happy, funny side—he sang and had fun at Sieff's place. People thought he was kind but sad. True, he went from depression to depression; equally true, he lived through the hell of drugs and the prison of alcohol. Yet it was during his alcoholic periods that Yves produced his finest collections, in an authentic creative madness, absolutely wonderful work like the Russian collection.

INTERSECTING AMBITIONS. — **Our bond was like the one between Patrocles and** Achilles. My own ambitions had orbited around culture. I wanted to be a writer because I couldn't be an artist or musician. When I was teenager, age fourteen or fifteen, I started a film club and a newspaper in my high school. I wrote to Jean Giono, and he answered. Later he answered me again. In *Liberté, j'écris ton nom,* I published the letter in which he advised me against becoming a conscientious objector. I also got involved in politics—not electoral politics but political philosophy. I studied Max Stirner, the Hegelian left, and anarchism. I handed in a blank sheet. I was about seventeen and a half when I headed up to Paris. That's when I met Garry Davis and his "citizens of the world." At eighteen, I started a newspaper. Then, at nineteen, I found myself with Bernard

Buffet in Provence. So I'd often go to see Giono [who lived nearby]. In Oran, Saint Laurent had the same ambitions as I did. He knew that culture was to be found in Paris, and he wanted to get there just like I wanted to get out of La Rochelle. Except that he was driven by real talent.

A FASHION HOUSE TOGETHER. — I finally wound up understanding what "fashion" was all about. The so-called Beat collection, shown in July 1960, was panned by the press. Boussac was highly critical and demanded that Saint Laurent go. Boussac wanted him to make way for somebody else. He suggested that Saint Laurent become a worldwide representative for Dior, that he play some sort of salesman's role. Yves turned it down. At which point he was drafted into the army and subsequently sent to the Val-de-Grâce military hospital. While he was in there, Jacques Rouet, who was running Dior, phoned me and said, "The House of Dior will make an important announcement tomorrow, and I wanted to let you know beforehand." I liked Rouet—he came over to my place and read the press release: Yves was being replaced by Marc Bohan. When I told Yves, he said to me, "Then we'll start a fashion house ourselves, and you'll run it." I'll never forget that statement. I replied, "That's just what we're going to do." And that's what we did. Rouet was great. He tried to convince Boussac to finance a fashion house for Yves and even drew up a business plan. That's the business plan I used to open our own house. The number of seamstresses, number of managers—it was all detailed. Rouet knew exactly what needed to be done. I owe him a lot. He was a really great guy who understood the language of true creative artists, a language Boussac didn't grasp. Rouet appreciated the considerable value of the notoriety that Saint Laurent had earned in three years at Dior. In the end, we had to go for it without Boussac's help. We started up in a mezzanine on rue La Boétie in early December 1961, just a month and a half before the show. Through a relative of Suzanne Luling, who managed Dior's salons, we met J. Mack Robinson, an American seeking to invest money in Europe. It was Robinson who financed the fashion house, which was bought by Charles of the Ritz in 1965.

RIVE GAUCHE. — Saint Laurent was only more or less comfortable in the role of couture designer. He wanted to create his own ready-to-wear line. He wanted women who didn't have the means to buy haute couture to be able to wear a Saint Laurent. But because he also insisted on the best fabrics and best factories, which upped the cost of a garment, he failed to reach his desired target of young women without much money. There were thus two kinds of Rive Gauche women. First there were rich women who opportunistically thought it was wonderful to be able to dress themselves for a lot less than haute couture cost. We were more interested, though, in the others: the career women between thirty-five and forty-five, the editors, lawyers, and professional women. They were the core Rive Gauche clientele. Saint Laurent wanted to give women access to the basic, simple garments of a modern wardrobe, except that his clothing was the product of meticulous fittings, wonderful proportions, and perfect fabrics. A woman wearing Yves Saint Laurent could feel confident, self-assured. That was also his ultimate goal in haute couture. He didn't want a woman arriving at a party to wonder if she looked silly! A woman

Pierre Bergé and Yves Saint Laurent, 1961. Photograph by Pierre Boulat.

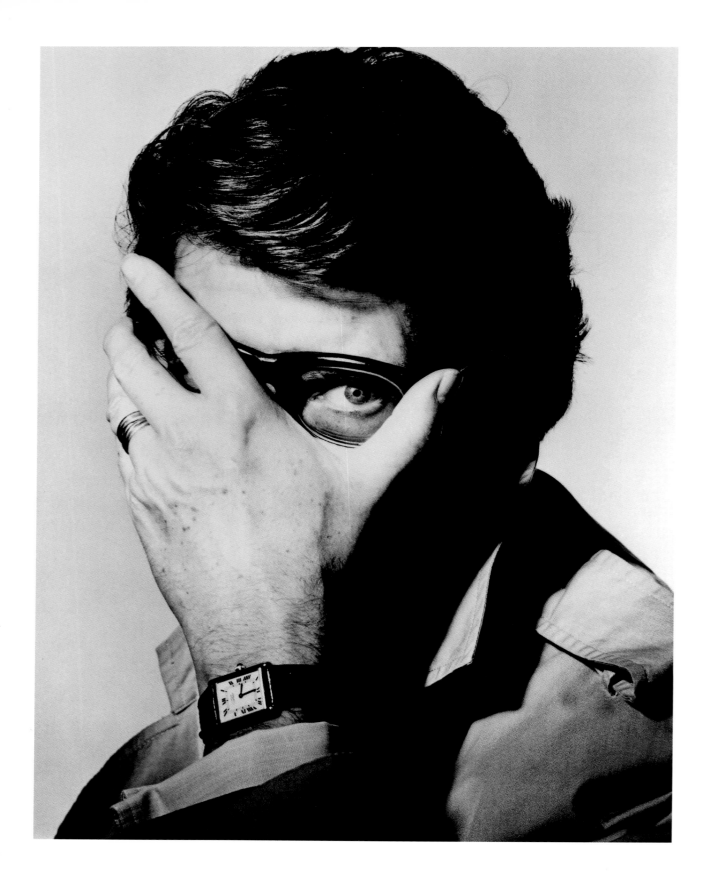

wearing Saint Laurent is always just right. With Rive Gauche, Saint Laurent extended his commitment to all aspects of the firm's business, from design and manufacture to presentation, advertising, distribution, and retail outlets. It represented a total commitment on his part.

WOMEN. — Girlish and childish women were not his style. He loved sensual women like Victoire, Danielle, and Violetta, women with distinct characteristics—the pirate types and dark-skinned types like Mounia, Khadija, Katoucha, Iman, Kirat, Amalia—and he liked blacks, preferably American, because he said they have their own special way of moving. The firm was launched, for that matter, with a black model named Fidélia. Saint Laurent liked two types of women: dream women and real women. The dream women were heroines like Marella Agnelli and Jacqueline de Ribes; the real women were dynamic ones like Loulou de la Falaise and Françoise Giroud. Giroud was his perfect example. When she died, he cut out a photo of her and pinned it to the wall. For Yves, a modern woman was a woman in a Rive Gauche suit who drove her own car to her office, her desk at the newspaper, or her business. He hated the rich bourgeoisie; he hated women who spend their time at the hairdresser getting a blow-dry. Things like that didn't interest him.

STYLE VERSUS FASHION. — To survey forty years of creative design, I believe in the criterion of "emergent phenomena." The pantsuit was one emergent phenomenon. The tuxedo for women was another. The "Mondrian" dress was a third. Like almost all artists, Yves Saint Laurent did it all in ten years. By 1972 all his essential work had been done. Another emergent phenomenon was Rive Gauche. And then another phenomenon, although not an emergent one, occurred when he decided to get on to Chanel's wheel, as they say in cycling. Back in 1958, down near Aix-en-Provence, between his two shows, I'd asked him what he thought of Chanel. "Oh yeah," he'd said, "it's all very good, but it's not fashion!" Because the doxa of fashion was that it had to be revamped every season—not only at Christian Dior but everywhere. I admire Saint Laurent for having realized this was a mistake. He came from a very bad school represented by Dior that subjected fashion to artificial changes.

And yet, without being prodded by anyone, Saint Laurent came to grasp Chanel's true significance and thus moved into her slipstream. From that point on, he hated fashion, as he himself wrote. He believed only in style. He became passionate about style. Style was behind the emergence of Saint Laurent's own major contribution.

Obviously, from the 1990s on, he no longer played on the register of inspiration. He stuck firmly to his style. And since he was a master, he managed to maintain his style to the end. Even though it's true that the youthful effervescence and daring he had displayed for so many years were no longer there because he was henceforth banking on reliable values, those values were still his own making!

YVES'S CHARISMA: TURNING YVES SAINT LAURENT INTO AN ICON. — **His charisma came from his total sincerity. One day, Maria Callas asked me to describe her greatest quality. I can't remember what I answered, but she replied, "You're wrong! My greatest quality is honesty. If I can't sing a score, I don't sing it."**

We're living in a period of overexposure. I've always thought, and Yves soon agreed with me, that we couldn't hide from anything. Hiding from things meant opening the door to conjecture, rumors, problems. Saint Laurent's life resembled his oeuvre: There was no time for dissembling. From the moment I bound my fate to Yves Saint Laurent's, I never had second thoughts. I knew who he was, and I knew what he'd do. Nothing that happened ever surprised me. What surprised me was what didn't happen! He never raised a single question about my running of the firm. As for me, I had blind faith in him. I knew he was steadily building an oeuvre. And I know what role I played.

I always wanted to turn Yves into an icon, right from the start. The famous portrait by Irving Penn started out as a snapshot. Penn was attending a fashion show, and he came in and snapped that brilliant photo. It's my favorite portrait of Yves: the gesture, the dual personality, the eye, the beauty of the garment. Jeanloup Sieff's nude photo of Yves was Yves's idea. It was designed to promote a male fragrance. Although it wasn't used very widely, we knew instantly that it was an iconic photo. In the first Rive Gauche boutique on rue de Tournon, there were not just clothes; there was also a portrait of Yves by Eduardo Arroyo. Yet even though I exploited marketing techniques, we never had a marketing policy. We did everything ad hoc, without being either modest or naive.

THE PHYSIQUE OF FAME. — **Saint Laurent was an artistic genius. If he hadn't met me, his career wouldn't have been the same, for countless reasons. But he would have done something else. I can't be credited with Yves Saint Laurent's talent. For that matter, he was already famous by the time I met him. I just looked after him and his oeuvre. I ran the firm with an iron fist. I quarreled with the press when necessary so they'd know who they were dealing with. Yves felt I behaved like a tyrant. I started the fashion shows promptly on time. I wasn't going to wait for Madame Wintour to take her seat, and I had the American fashion reporter Eugenia Sheppard thrown out. I always protected Yves. But his iconic status was also due to something else: to his taste for privacy, his tendency to remain silent, not to speak or exhibit himself, his reluctancy to grant interviews. It increased the mystery. But it wasn't my idea. On the contrary, sometimes I tried to get him to agree to interviews, unsuccessfully. He built himself up as an icon.**

Marilyn Monroe was a celebrity who displayed herself; Saint Laurent was a celebrity who hid himself. When you're famous at twenty, it's not the same as becoming famous at forty-two, like Christian Dior. Saint Laurent looked like a rock singer. Saint Laurent owed his true celebrity to his physique, which suited the times. He was a real figure. One day Matthieu Galey said to me, "Whatever you do, don't seat me next to Yves. It always gives me the impression of sitting next to a royal highness."

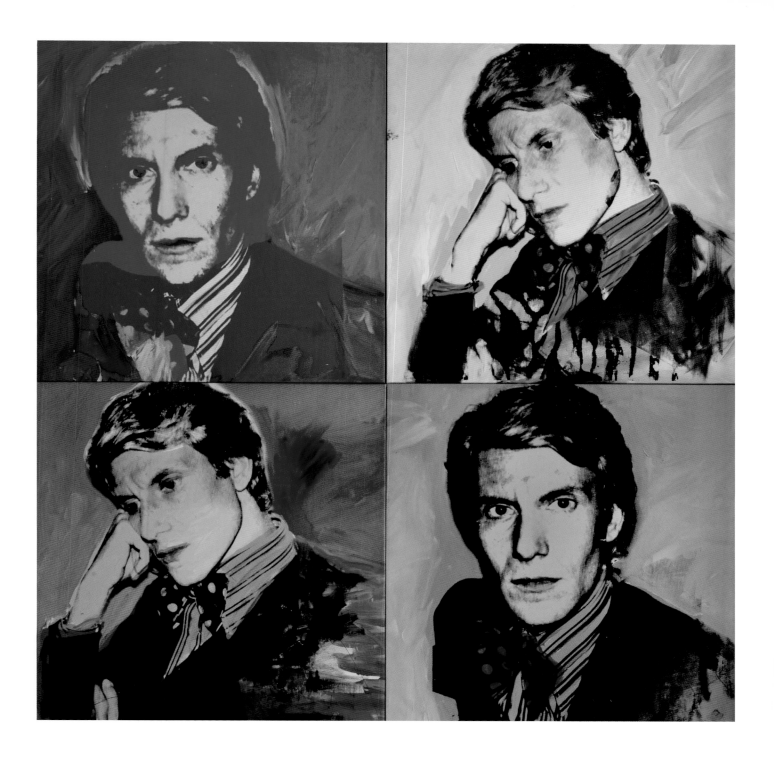

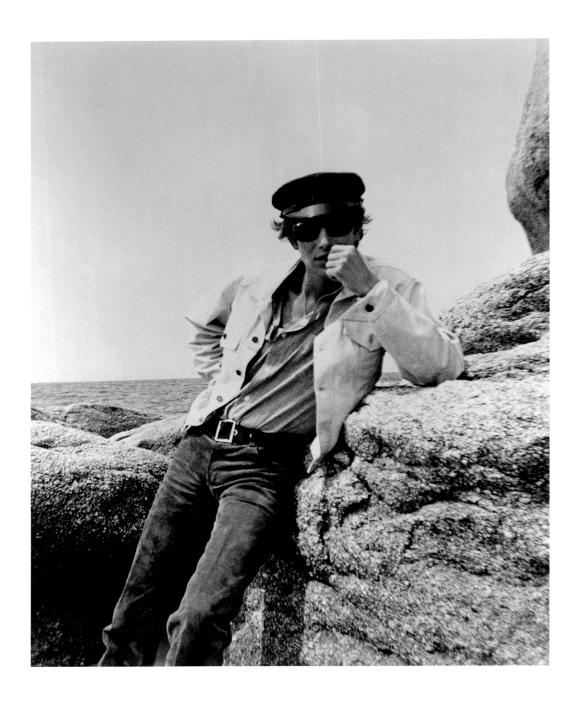

IN TUNE WITH HIS TIMES. — Saint Laurent embodied more than a conflict between the classical and the baroque. True, he was an out-and-out Cartesian, a man with a measuring tape, a man of moderation. Yet, like all Cartesians, he had moments of immoderate extravagance—he managed to draw moderation from extravagance. That contrast provided a new viewpoint, but it didn't alter the status of things, whereas the Yves Saint Laurent slogan "Down with the Ritz, up with the street!" embodied another, more fundamental, conflict: haute couture versus street fashion. Major developments in art are often due to major political events or revolutions. It's a mistake to think that art evolves in an abstract way. The Renaissance resulted from the Turkish invasion of Constantinople in 1453. The cultural crucible of Constantinople swept across the Mediterranean. And the period when France was at its best, under Louis IV, was also the period when it was most powerful in the artistic sphere. With Saint Laurent, we're dealing with a period when the postwar situation had only just been digested—in an ambivalent way, for that matter, when it came to fashion. The war encouraged resistance, leading to Frenchwomen's right to vote and social progress. In 1958, the year I met Yves, we were entering a new era, one that would rid itself of the dross of the past, one that would cast male-female relationships—and women's relationship to civic society—in an entirely new light. Women were no longer just objects but were on the threshold of equality. A fashion designer arriving on the scene in 1960 could not view women—or the street—as people had who went before him. Dior and Balenciaga totally missed this point. But not Saint Laurent. He had a lightning-quick grasp of his times. As for Chanel, strangely enough she was the product of another war, the First World War, whereas Saint Laurent came right after the Second World War. He served as a conduit between nineteenth-century tradition and twentieth-century modernity. The time spent at Dior was therefore significant. It was like a pianist who studied under Franz Liszt. Even today, if you listen to a student of a student of a student of Liszt, you detect a touch and a tone immediately distinguishable from all others.

A FRUSTRATED CALLING. — Yves Saint Laurent built his oeuvre on dresses. Proust—whom Saint Laurent didn't read all that much, by the way—said that when you're a genius you can't be interested in anything other than your work. That's what happened to Saint Laurent. Flaubert's motto, "Madame Bovary, that's me," is a good model for how the ladies' tuxedo defined Saint Laurent: "Le smoking, that's him." But he immediately realized he was doing something that wasn't an art, namely, fashion. In a way, Saint Laurent was too talented for that profession. And the profession wasn't worthy of Saint Laurent. The cards just weren't dealt very well—there's no point in blaming anyone. Like Marguerite Duras, I've always thought that if you never became a writer it's because you weren't made for it. But you can easily imagine a Saint Laurent who, exposed at a young age to a major art scene, to painting, might have taken another path. He soon grasped the limitations of fashion. Therein lies one of the reasons for his depressions and dissoluteness. There was a frustrated calling in him.

THE NOAILLES LIFESTYLE. — We often used the "Noailles lifestyle" as our guide. Their house was exactly what we would have liked to do ourselves. If you asked me who we'd dream of being if we weren't Yves Saint Laurent and Pierre Bergé, I'd answer, "the Noailles." It's obvious on every level: the way they supported the artists of their day—Luis Buñuel, Jean Cocteau, Jean-Michel Frank, Mallet-Stevens, and others; the way they forged a couple; the way they built a house at Hyères on the Riviera; the way they gave wonderful parties. In a brief text on Marie-Laure de Noailles, I wrote that she "considered virtue to be an impediment, eccentricity to be a virtue." Both of the Noailles—she with greater flair, he with greater restraint—blazoned eccentricity across their chests like a banner. They were antiestablishment, and he was even excluded from the Jockey Club. They were part of "society," as it's called, and they were fully aware that people thought they were outrageous, but they found it funny. They had a strange relationship. They were people who lived an unusual life, who lived apart, he in Fontainebleau and Grasse and she in Paris and the Camargue where she bought a little farmhouse. Yet those two people wrote to each other every day, which just reveals their true character: Behind the social facade and the extravagance, there were profound feelings and respect that survived throughout their lifetimes.

AFTER YVES. — So what is Saint Laurent's heritage? Well, school teaches you to how to speak and spell, but does that mean people speak and spell French properly? No. It's the same with fashion. Saint Laurent always said that he gave women the tools, but it was up to them to use them. Street fashion has unknowingly taken a lot of its cues from Saint Laurent, but it hasn't always understood what he taught. It wasn't for nothing that I founded the Institut Français de la Mode [French Fashion Institute]. I don't believe in shutting designers up in ivory towers. Those days are long gone. The people with the best approach are now found in places run by no one particularly famous. Because a T-shirt, after all, is a T-shirt! Putting a label on it doesn't mean it should be expensive! The big problem with today's fashion is that couturiers and designers think they're creating artworks. Since that's what they think, they feel free to do anything and everything. They think they're following Duchamp's lead: You only need to put a garment in a gallery or museum to turn it into an artwork, like Duchamp with his urinal and bottle rack. They forget that a garment, whatever you may think, is not made for being photographed, for being merely looked at, but is made to be worn.

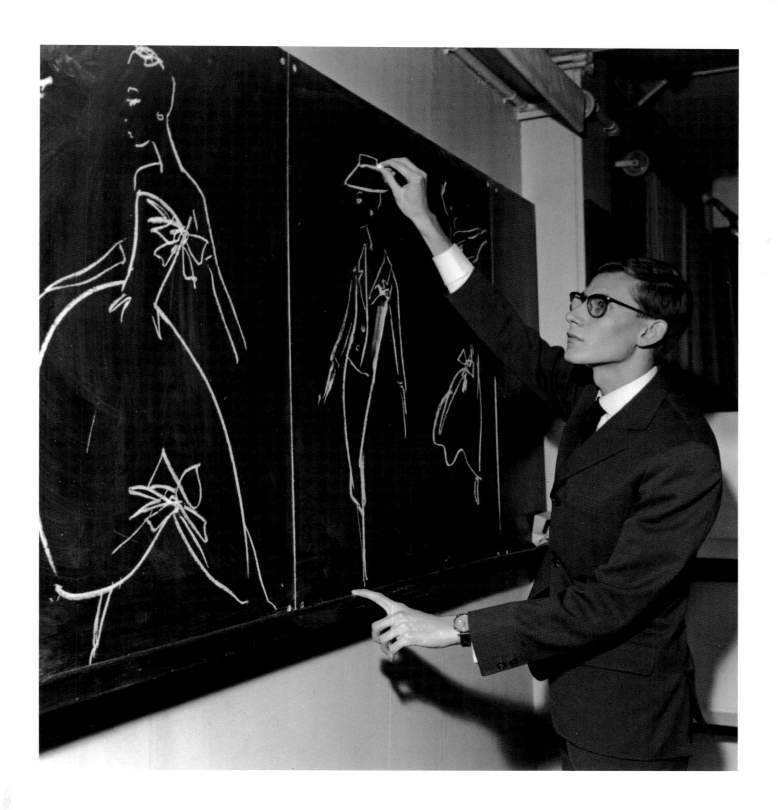

NOTES

1 — On Christian Bérard, see the year 1950 in Farid Chenoune's essay in this volume, "Yves Saint Laurent, A Life." Along with composers Henri Sauguet and Francis Poulenc, Bérard was one of the group of faithful friends that Dior forged between the ages of eighteen and twenty-five during the Roaring Twenties.

2 — Raymonde Zehnacker was Dior's "closest and most personal colleague." When Dior died, she became head of production at the firm alongside Marguerite Carré, the lynchpin of the "Dior technique" (see the press release dated November 14, 1957, Dior Heritage Archives). Bousquet, who had been a key figure on the Paris social scene since the 1930s, was the Paris correspondent for *Harper's Bazaar*.

3 — Jeanloup Sieff (1933–2000) was a photographer, notably of fashion, who was close to the Bergé–Saint Laurent couple and their friends. He produced numerous photo spreads on the house of Yves Saint Laurent that were published in the leading European and American magazines.

4 — Well-known French novelist Jean Giono (1895–1970) was a notorious pacifist at the start of World War II [translator's note].

5 — German philosopher Max Stirner (1806–1856) is best known for *The Ego and Its Own*. Bergé read Stirner as a teenager in La Rochelle and often mentions the influence of Stirner's individualistic, indeed anarchistic, philosophy on his own life and commitments. "It was probably Stirner who transformed my whole life when he wrote, 'There is no freedom, only free men.' After that, it was like the sky was the limit." Interview with Pierre Bergé, October 26, 2009.

6 — Marcel Boussac (1889–1980) was a powerful textile industrialist who financed the founding of the house of Dior in 1947 and remained its owner until 1978.

7 — Victoire, Danielle, Violetta, Mounia, Khadija, Katoucha, Iman, Kirat, and Amalia were all models particularly appreciated by Yves Saint Laurent at various points in his career because they influenced his vision of women and his way of constructing a dress based on the overall effect of bodies, comportment, and personality.

8 — Agnelli, Ribes, and Giroud were all major clients of Yves Saint Laurent couture. Marella Agnelli was the wife of Italian industrialist Gianni Agnelli. For more information on Jacqueline de Ribes, Françoise Giroud, and Loulou de la Falaise, see "Portraits of Women" in this volume.

9 — *Doxa*, meaning an unquestioned truism or belief, is a term made fashionable in recent years by social philosopher Pierre Bourdieu [translator's note].

10 — The British journalist Anna Wintour (born 1949) has been editor in chief of the influential American magazine *Vogue* since 1988. Eugenia Sheppard (1900–1984) was an American fashion reporter who wrote notably for the *New York Herald Tribune* and the *New York Post*.

11 — Matthieu Galey (1934–1986) was a famous literary and theater critic as well as a novelist and diarist who left an incisive account of Parisian life at the time.

12 — Charles, vicomte de Noailles (1891–1981), and his wife, Marie-Laure (1902–1970), were legendary twentieth-century French socialites known for their supreme sense of taste and their enthusiastic patronage of modern artists in the 1920s.

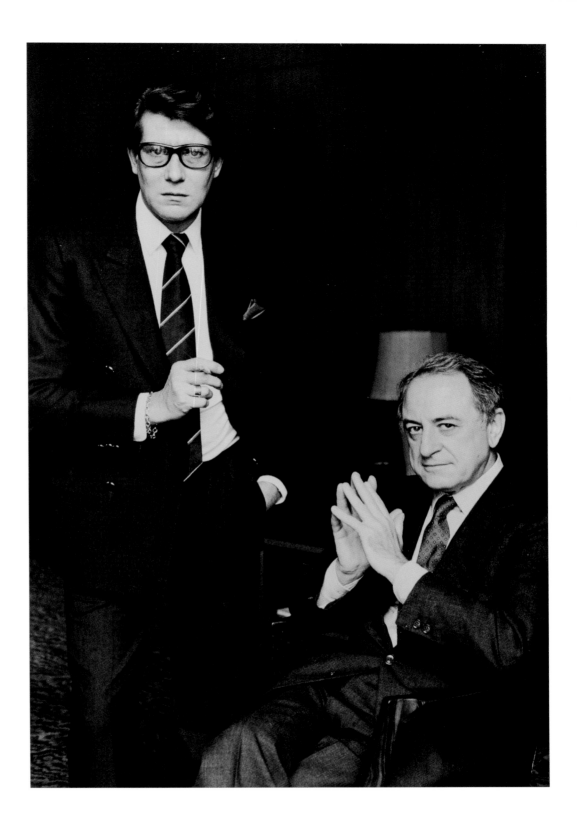

Yves Saint Laurent and
Pierre Bergé, 1983.
Photograph by Alice Springs.

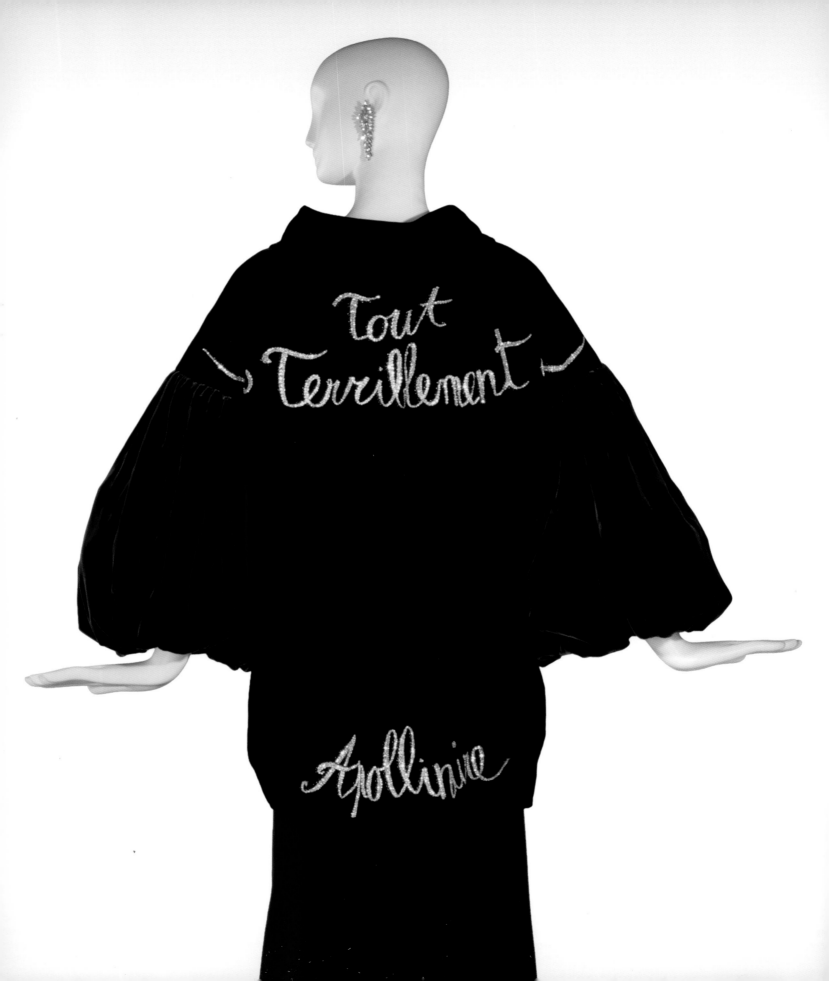

YVES SAINT LAURENT, A LIFE— "ENTIRELY INTENSELY"

CHRONOLOGY ESTABLISHED BY FARID CHENOUNE

1936–1955. ALGERIA. CHILDHOOD. TEENAGE YEARS. PARIS.

ORAN 1936

AUGUST 1 — Yves Henri Donat Matthieu-Saint-Laurent was born in Oran, Algeria, to Lucienne and Charles Matthieu-Saint-Laurent. His father was a corporate insurer and administrator who also ran a chain of movie theaters. He would grow up with two younger sisters, Michèle (born in 1942) and Brigitte (born in 1945). The family lived in a large three-story house at 11 rue Stora. During the summer vacation from June to September, they moved to a villa in nearby Trouville, Oran's bourgeois beach resort.

1942

Saint Laurent attended Catholic primary school.

1944

He then went to the Collège du Sacré Coeur, where he remained until he was sixteen. "Our world was Oran, not Paris. Nor Algiers, that metaphysical city depicted by Camus, nor Marrakech with its pink magic. Oran was a cosmopolitan city with people from everywhere and elsewhere, a dazzling town, a patchwork of colors beneath the North African sun. It was a place for feeling good, and we did. My summers flew by like scudding clouds, in a seaside town where my parents and friends lived in a clan.... Summers ended too soon. September meant a return to school and reawakened anxieties. I was shy and sensitive, different from my schoolmates."
Yves Saint Laurent, manuscript, 1983

1945

AUGUST 1 — On Saint Laurent's ninth birthday, as he blew out the candles on his cake in front of his gathered family, he announced, "Someday, my name will be written in lights on the Champs-Elysées."

1947

His father returned from Paris with production stills of the movie L'Aigle à Deux Têtes, adapted from Jean Cocteau's play. Saint Laurent compiled a photo album from them.

1948–49

EARLY POEMS.
Every Saturday, he went with his mother to a large bookstore on boulevard Seguin. There they bought French magazines such as Paris Match, Le Jardin des Modes, and, above all, Vogue, which Saint Laurent devoured. He reproduced models of the dresses and soon invented a fashion house (Yves Matthieu-Saint-Laurent Haute Couture, place Vendôme) with an imaginary clientele.

1950

MAY 6 — He attended a performance in Oran of Molière's Ecole des Femmes [School for Women] directed by Louis Jouvet. The set and costumes were by Christian Bérard (1902–1949), an artist friend of Jean Cocteau and Christian Dior, who was a gifted jack-of-all-trades. Bérard's nostalgic and refined Romantic revival taste influenced the performing arts, fashion, and the decorative tastes of the cream of Paris society in the 1930s and 1940s. "I realized immediately that I had just witnessed a work of genius, and despite everything I have seen since, nothing has equaled it." Saint Laurent's love of theater would never wane.
Yves Saint Laurent: Théâtre, Cinéma, Music-Hall, Ballet, exhibition catalog (Paris: Fondation Pierre Bergé–Yves Saint Laurent, October 4, 2007–January 27, 2008).

1951

Saint Laurent copied Gustave Flaubert's novel Madame Bovary by hand, in red ink, illustrating several scenes from it in watercolor. He first read Marcel Proust's A la recherche du temps perdu [Remembrance of Things Past].

SUMMER — He decorated the garage of the family's Trouville villa like a "jazz dive."

1952

JUNE — An article in L'Echo d'Oran covering a children's gala at the municipal opera house mentioned "the wonderful costumes designed by a fifteen-year-old youth, Yves Matthieu-Saint-Laurent."

SEPTEMBER — Saint Laurent entered secondary school (Lycée Lamorière) to study for his baccalauréat diploma.
Throughout this period, he silently endured bullying from classmates who suspected him of being homosexual.
"I hung out with this girl—I could go out with her in the company of other friends, boys and girls. This group of friends didn't try to find out if I was homosexual, out of respect. But here again, I had two sides: I would go out with anonymous guys. Arabs. Everything was secretive. I was ashamed. Everything was done in fear and anxiety. This intense fear stayed with me for a long time. Being homosexual in Oran was like

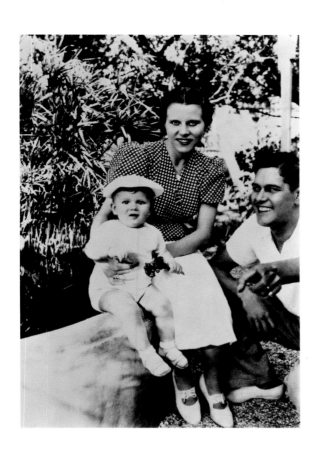

Page 36 — Fall–Winter 1980 haute couture collection, a tribute to Guillaume Apollinaire (CAT. 179).

Left — Yves Saint Laurent and his parents, Oran, 1938.

Below — Yves Saint Laurent with dress designs for his imaginary fashion house, November 1953. Photograph by François Pagès.

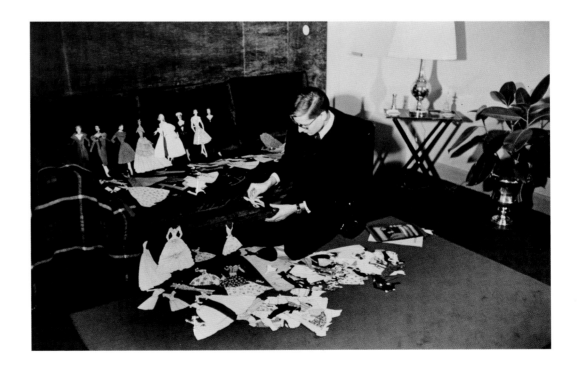

being a murderer. I never told my parents a thing. In the end, I knew they realized what I was, my mother before my father.... The day I was awarded the Légion d'Honneur, my father was incredibly moved. I had this wonderful red-ribboned medal, and for some reason I found myself alone with him—I started to cry, and I said to him, 'Papa, you must know what I am. I guess you wanted a real son who would carry on your name.' And he replied, 'None of that matters, son.' That was in '85. It was the first time we'd mentioned it."

Laurence Benaïm, *Yves Saint Laurent* (Paris: Editions Grasset, 1993)

So you grew up among women?
Yes there was my mother, of course, and also my two younger sisters, my grandmother, and my aunt.... Once I started secondary school, I began leading a double life: On the one hand, in the house there was all this gaiety, the world I invented with my drawings, sets, costumes, and theater; on the other hand, in parochial school there were trials and a world that excluded someone dreamy, pensive, and shy like me, where kids mocked me, bullied me, hit me. During recreation period I'd hide in the church, and when school got out I'd wait until all the other students had left, in order to avoid the torture. Those are the years that gave birth to my unshakable determination to conquer Paris and reach the top. I'd address my classmates in my mind, saying to them, "I'll get the better of you some day: You'll wind up with nothing, and I'll have everything."

Yvonne Baby, "Yves Saint Laurent au Metropolitan Museum de New York, Portrait de l'Artiste," *Le Monde*, December 8, 1983

1953
Saint Laurent turned seventeen. He read in *Paris Match* about the first annual competition for fashion drawings, organized by the International Wool Secretariat. Drawings had to be submitted prior to October 31. Jury members included Christian Dior, Jacques Fath, and Hubert de Givenchy. Saint Laurent sent three sketches: a dress, a woman's suit, a cloak, and won third prize in the "dress" category.

DECEMBER 20 — Having traveled to Paris from Oran with his mother, he received his prize at the Théâtre des Ambassadeurs from actress Jacqueline Delubac. He met Michel de Brunhoff, editor in chief of *Vogue Paris*

since 1929, thanks to an introduction by the Ducrots, friends of his parents; de Brunhoff advised him to get his *baccalauréat* diploma before envisaging any career.

He failed his philosophy course and had to repeat it.

1954
Saint Laurent maintained a correspondence with de Brunhoff, sending him drawings from Oran, asking for advice about which path to follow—theatrical costumes and set design versus fashion and haute couture.

JUNE — He passed his *baccalauréat* exam. He wrote to de Brunhoff again:
"Dear Mr. de Brunhoff,
"I apologize for not having replied earlier, but I wanted to wait for my exam results. As I had hoped, they are fully satisfactory, and I am planning to move to Paris in the early autumn. My plans are perhaps too vast—like Bérard, I'd like to turn my hand to several things that are, in fact, all one: theatrical sets and costumes, interior decoration, illustration. At the same time, I'm extremely drawn to fashion. My career choice will certainly be determined by an opportunity in one or the other of these possibilities. Whatever the case, do you still think that I should begin with the course at the Chambre Syndicale de la Haute Couture [Fashion Industry Association]? Please tell me if you think otherwise.
"As you advised, I have been painting a good deal but I have also continued to design stage sets, costumes, and dresses, which I will send to you shortly."

SEPTEMBER — Saint Laurent moved into a room at 209 boulevard Pereire in the seventeenth arrondissement of Paris, renting from a general's widow, Madame Buisson. He began vocational training at the school of the Chambre Syndicale de la Haute Couture, where his father had registered him, but he only lasted a few months.

NOVEMBER 25 — He once again entered the anonymous competition organized by the wool industry, and he won first prize (300,000 francs) and third prize (50,000 francs) in the "dress" category. The dress for the first prize, a symmetrically draped cocktail gown in black wool (by Rodier) with jet buttons, was executed by Hubert de Givenchy's studio.

1955
JANUARY — Saint Laurent returned to vocational school but was bored.

JANUARY 14 — His father wrote a letter to Michel de Brunhoff:
"Dear Mr. de Brunhoff,
"I apologize for writing to you before we have even had the pleasure of meeting, but I have been encouraged to do so by the friendship you have displayed toward my wife and the interest you have shown in my eldest son, Yves.
"We have just received his first two letters on his return to Paris after the Christmas vacation spent in Oran. They reveal a bitterness not apparent through the euphoria of the first term, especially in the enthusiasm that followed his success in the wool-industry competition.
"During the vacation, for that matter, this enthusiasm was still apparent, and Yves was full of plans.
"I realize that the transition from family home to student lodgings, plus the memory of two weeks of vacation spent with his old friends. has led to a natural bout of the 'blues.' Yet it seems that, as Yves himself says, the course at the school does not demand all his time. He is looking for various activities in order to fill the gaps in his day, which only increase his 'blues.' You have surely noticed his terrible shyness and fear of bothering people, which is why, given the enormous trust that we know he places in you, I would like to ask you, when you next see him, to give him some advice and, if necessary, give him a push.
"I feel that his youthfulness requires the discipline that comes with work, and only you can guide him in the career he has chosen.
"My apologies again for such a long letter, which I would ask you not to mention to him. I would particularly like to thank you for everything you have already done, and will do in the future, for Yves.
 "Yours sincerely,
 "Ch. Matthieu-Saint-Laurent"

Above, left — Christian Bérard (1902–1949), French painter and designer, an influential figure in Parisian life in the 1930s and 1940s.

Above, right — Louis Jouvet (1887–1951). His production of *L'Ecole des Femmes*, staged in Oran on May 6, 1950, with set design and costumes by Christian Bérard, was decisive in Yves Saint Laurent's choice of artistic vocation.

Right — Letter from Yves Saint Laurent to Michel de Brunhoff, head of *Vogue Paris*, June 1954.

Cher Monsieur

Je m'excuse de ne pas vous avoir répondu plus tôt, mais j'ai préféré attendre les résultats de mon examen pour le faire. Comme je l'espérais, ils ont été pleinement satisfaisants, et je dois m'installer à Paris au début de l'automne.

Mes projets sont peut-être trop vastes : Ainsi que Bérard, je voudrais m'intéresser à plusieurs choses qui en réalité, n'en font qu'une : Décor et costumes de théâtre, décoration, illustrations. D'autre part, je me sens extrêmement attiré par la mode. Le choix de ma carrière naîtra certainement d'une occasion dans l'une ou l'autre de mes possibilités. Quoiqu'il en soit, pensez-vous toujours que je doive commencer par la chambre syndicale de la Couture? Si vous pensiez autrement je serais heureux que vous me le disiez.

Comme vous me l'aviez recommandé, je peins énormément mais je continue aussi à dessiner des maquettes de décors, de costumes ainsi que des modèles de robes que je vous enverrai bientôt.

Veuillez, cher Monsieur, croire à l'assurance de mes sentiments les meilleurs et présenter mes hommages à madame de Brunhoff.

Mathieu Laurent

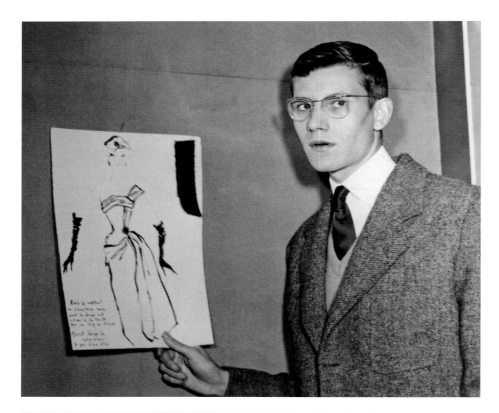

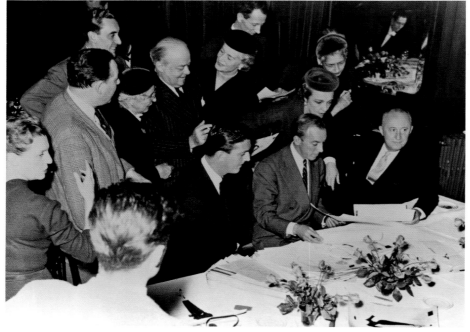

Opposite, above — Yves Saint Laurent holding a sketch, December 11, 1954.

Opposite, below — Jury of the Secrétariat International de la Laine Prize, November 25, 1954. In the foreground, left to right: Hubert de Givenchy, Jacques Fath, and Christian Dior.

Right — Yves Saint Laurent and his design at the awarding of first prize (in the "dress" category) by the Secrétariat International de la Laine, November 25, 1954.

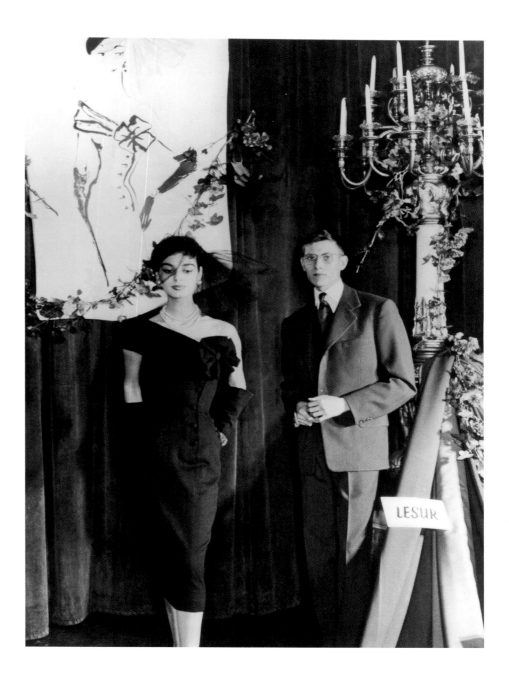

1955–1962.
DIOR.
GROOMING
THE PRINCE.

1955

JUNE — Michel de Brunhoff wrote a letter to Edmonde Charles-Roux, who would succeed him as editor in chief of *Vogue Paris*: "The Saint-Laurent kid arrived yesterday. To my amazement, of the fifty drawings he brought me, at least twenty could have been by Dior himself. Never in my life have I met anyone so talented. I have requested a meeting for him on the spot, telling Dior that my insistence was designed to prove that it couldn't be a question of leaks, since the lad has only just arrived and [Dior's] collection is only two days old.... I am taking him by the hand myself in a little while.... If only you were here! Remember me if, some day, this kid becomes a giant."
Laurence Benaïm, *Yves Saint Laurent* (Paris: Editions Grasset, 1993)

Saint Laurent was introduced to Christian Dior, who immediately hired him at his side in his workshop.

JUNE 20 — This was his first day of work at Dior, 30 Avenue Montaigne in the eighth arrondissement of Paris.

AUGUST — His first dress was photographed by Richard Avedon. The model Dovima posed among the prancing elephants at the Cirque d'Hiver in Paris, where this now famous fashion shoot was held. At Dior, Saint Laurent met Anne-Marie Muñoz, who would work with him when he set up his own fashion house.

1956

At a ball hosted by Baron Alexis de Redé in the Lambert mansion in the third arrondissement of Paris, Saint Laurent met Zizi Jeanmaire and Roland Petit, for whose ballets and shows he would subsequently design many sets and costumes.

1957

OCTOBER 24 — Dior died of a heart attack in Italy at age fifty-two.

NOVEMBER 15 — Respecting the wishes expressed by Christian Dior shortly before his death, Yves Matthieu-Saint-Laurent was appointed art director of the most famous fashion house in the world, owned by the textile magnate Marcel Broussac.

Tribute to Christian Dior
"I remember everything, its entire atmosphere, its pearl gray walls and white moldings, the Kentia palms set all along the grand staircase, the scent of large bouquets on show days.

"I remember *him* above all. The man I could never bring myself to call Christian, but always Monsieur Dior. Because through this strange and wonderful collaboration that united us right from my arrival in his house until his death, our two terribly complex personalities erected an unbreachable barrier between us, due, on my part, to my immense respect for him, and on his, to the great propriety that all fathers probably display in front of their sons. Yet an amazing closeness grew up between us. His eyes glistened with affection, mine with admiration for an idol who showed some feeling for me. I remember moments of relaxation and wild laughter; I recall his profound goodness and the peerless quality of his esteem, affection, and protection.

"He taught me the essentials. Then came other influences that because he had taught me the essentials merged with those essentials and provided the marvelous terrain that would allow me to assert myself, to grow stronger, to spread my wings, to finally create my own universe.... Whatever has subsequently happened to me in my career, I must say it was with Dior that I was happiest. I was not yet twenty years old. As Proust wrote, 'The only true paradise is paradise lost.'"
Yves Saint Laurent, May 1986

Saint Laurent moved into a large studio at 7 square Pétrarque in the sixteenth arrondissement of Paris.

1958 The "Trapeze" Line. Pierre Bergé.
10 A.M., THURSDAY, JANUARY 30 — This was the presentation of Saint Laurent's first collection, Spring–Summer 1958, described in the press file as the "Trapeze" line.

"In his buttonhole he pinned a sprig of lily-of-the-valley, which had been Christian Dior's lucky charm. Then he shut himself away in the models' changing room. Over the next three hours, every time a model opened the door, he could hear the applause in the super-packed Dior salons, which greeted the 180 dresses of his first collection."
Jours de France, February 8, 1958

After the ten-year reign of the cinch-waisted "new look" launched by Christian Dior in 1947, the "Trapeze" line triumphantly freed the waist. "I never saw a better Dior collection."
Eugenia Sheppard, *New York Herald Tribune*, January 31, 1958

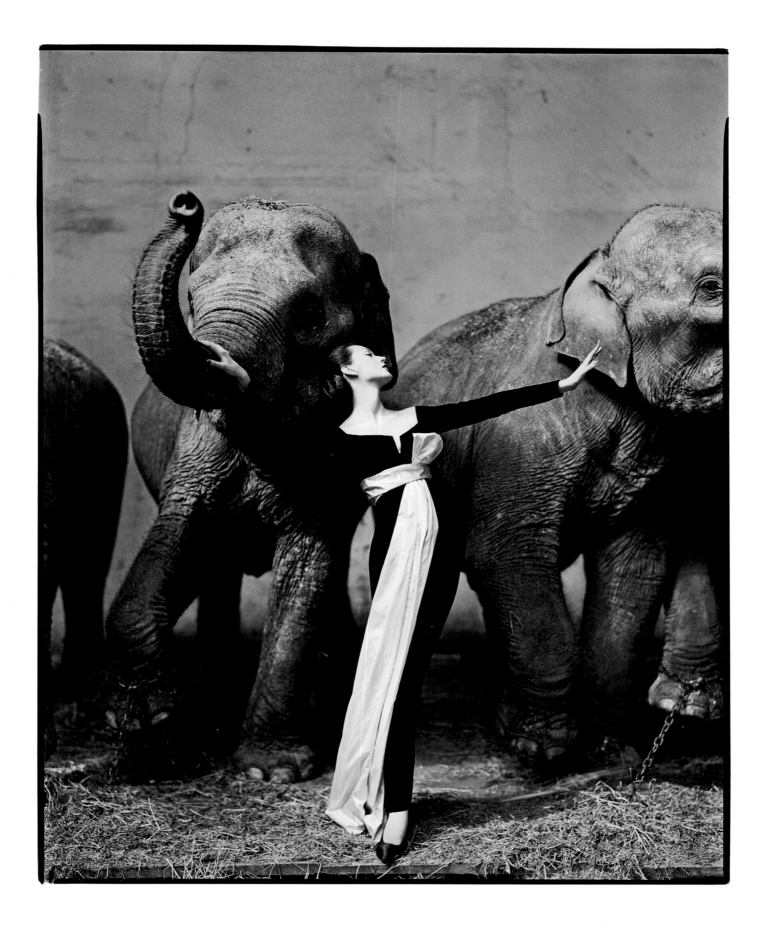

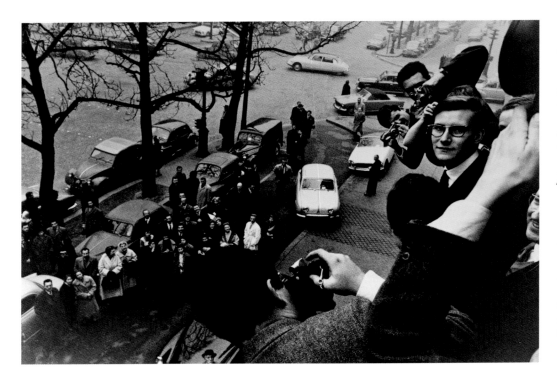

Page 45 — *Dovima et les éléphants*, evening dress by Christian Dior, Cirque d'Hiver, Paris, August 1955. Photograph by Richard Avedon. Design by Yves Saint Laurent at Dior. It was his first to get a lot of media attention.

Above, left — Yves Saint Laurent on the balcony at Dior, 30 avenue Montaigne, on January 30, 1958, after the presentation of the "Trapeze" collection. Photograph by Philippe Dalmas.

Below, left — Yves Saint Laurent and his senior colleagues at Dior: left to right, Raymonde Zehnacker, Marguerite Carré, and Mitzah Bricard, 1957.

Opposite — Yves Saint Laurent and the "Trapeze" collection, at Christian Dior on January 30, 1958. Photograph by Sabine Weiss.

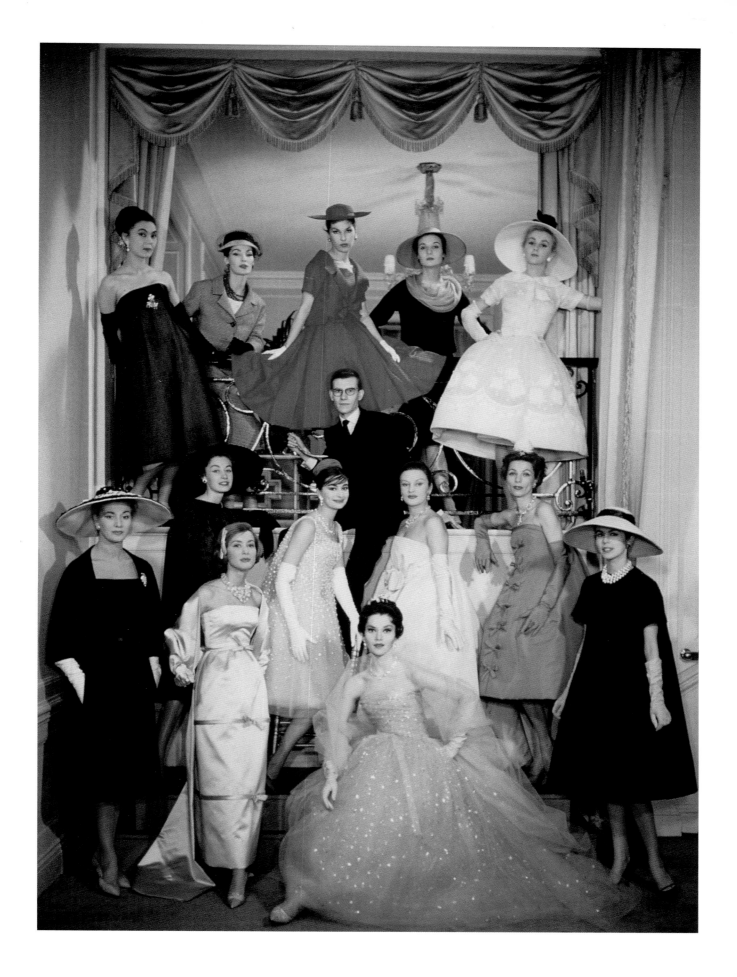

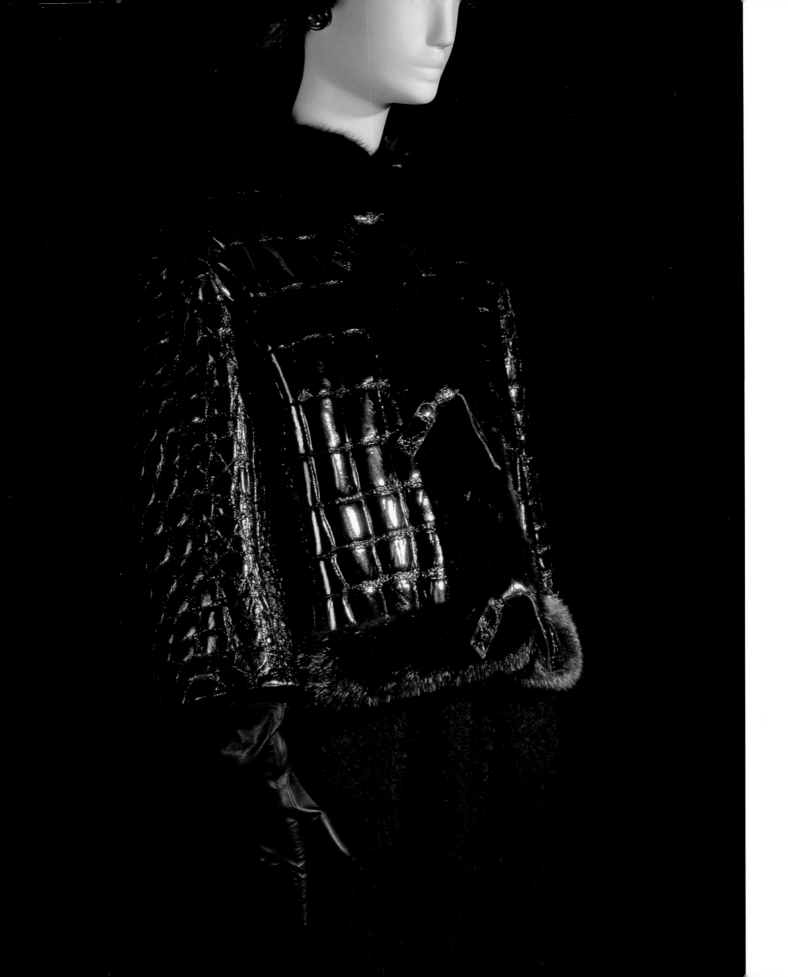

FEBRUARY 3 — Yves Saint Laurent and Pierre Bergé had both attended Dior's funeral, and the latter congratulated the former after the Trapeze show. But the two men only truly met during a dinner organized three days later at the Cloche d'Or by Marie-Louise Bousquet, the *Harper's Bazaar* correspondent in France and a mainstay of the Paris social scene since the 1930s.

Pierre Vital Georges Bergé was born in November 14, 1930, on the Ile d'Oléron off La Rochelle, France. His mother was a schoolteacher, his father a tax inspector. Both were left-wing activists. At secondary school in La Rochelle, Bergé lived for books and politics. A few months before he was due to take his *baccalauréat* exam, he decided to "head up" to Paris to become a writer or reporter. The seventeen-year-old Bergé made a living as a door-to-door bookseller, joined the peace movement founded by Garry Davis ("the citizen of the world"), and founded a short-lived political magazine, *La Patrie Mondiale*. He made friends with the likes of Jean Giono and Jean Cocteau, and he became the lover of artist Bernard Buffet, whose career he actively promoted. "[Bernard] was twenty years old, I was eighteen, and like every instance of love at first sight, it struck us like lightning.... Our saga lasted for eight years.... During those eight years, we were together every single day. Life revolved around Bernard's work. That's where I did my apprenticeship."
Pierre Bergé, *Les jours s'en vont, je demeure* (Paris: Editions Gallimard, 2003)

Once Bergé met Saint Laurent, a new saga would begin.

Saint Laurent received the Neiman Marcus Award, which the famous upscale American department store awarded annually to a fashion designer.

As he acquired fame, Yves Matthieu-Saint-Laurent lost a little of his name. The press henceforth referred to "Yves Saint-Laurent" or just "Saint-Laurent," sometimes dropping the old-fashioned hyphen (as did the designer himself when he founded his own house).

FEBRUARY 6 — "The newest idea certainly comes from Yves Saint Laurent, with the dress he calls a 'blouse-dress' [*robe-blouse*]." Hanging from the shoulders, it falls softly. The body is henceforth set in a bell jar rather than a gem case."
L'Express, February 6, 1958

JULY — Fall-Winter collection, described in the press file as "Curving Line, Curved Figure"
"This collection will mark a turning point in Yves Saint Laurent's development insofar as this pupil of Dior has moved away from Dior. He uses dazzling effects to generate elegance.... We must be careful here, for this is a new and whimsical way of conceiving elegance. I pity and envy the craftspeople who have to put body into these dreams with their strong, accurate, brilliant hands. But I do not envy certain socialites and busybodies who will never understand that the wary little world of Paris fashion has now been infiltrated—to devastating effect—by a poet."
Lucien François, *Combat*, August 17, 1958

1959
JANUARY — Spring-Summer collection, dubbed "Long Line, Natural Figure"
"A threshold has now been crossed: *line has been sacrificed to the benefit of style*. This style is deliberately young and gay, typically 1959."
Collection press release (a press file that read almost like a manifesto)

"Saint-Laurent, having completely freed himself from Christian Dior's influence, presented an excellent collection, much superior to his previous one.... What he is showing will shock no one. Twenty designs in his collection could be immediately worn by any woman, without fear of appearing too bold.
"His suits with straight jacket and tipped-back collar in crisp fabrics—a personal, and highly developed, version of the Chanel suit—are interspersed with a some belted jackets and a few bolero tops worn with wide pleated skirts....
"He is launching a sailor's smock [*marinière*] of navy jersey over a white front piece, or chiffon-handled flat. It will be an instant hit.
"Saint-Laurent will be very successful. He deserves it, and we need it."
L'Express, February 5, 1959

JULY — Winter-Fall collection
"The thrust of modern life has created a new woman.... Super-short jackets ... layered, flowing, loose skirts ... straight dresses gathered at the waist by a wide belt.... Lightness of short evening wear in a taffeta dress with embroidered tulle. Return of lace flounces and ruffles in a caressing style [*chouterie*]."
Collection press file

Saint Laurent creates his first costume designs for Roland Petit's ballet, *Cyrano de Bergerac*, at the Alhambra Theater.

1960
JANUARY — Spring-Summer collection
"On leaving Dior's last Wednesday, the women there felt vaguely old-fashioned and wondered how any poor, normally constituted creature—which many of them were—would manage to make the traditional attributes of her sex vanish. If it is to succeed, this fashion will have to do without male approval—flat chest, bare arms, barely a hint of a waist—such is the woman that Yves Saint Laurent is offering to men's eyes. What will they intuit of a body barely brushed, from shoulder to thigh, by light, capricious silks that take the form of a sailor's, artist's or butcher's smock? ... Never has fashion been so openly unsexy ... and never will it require so much grace of a cryptic kind. This year, the dress won't make the woman—the woman will make the dress."
L'Express, February 4, 1960

JULY — Fall-Winter collection
Saint Laurent's sixth and final collection for Dior. Inspired by the nonconformist beatnik youth of the day, his knitted dresses with turtleneck collar and his "Chicago" outfit with its leather jacket did not sit well with the world of haute couture (even if the jacket was crocodile leather trimmed with black mink). From one collection to another, the very names of Saint Laurent's designs set a new tone for the times: "Rebelle," "Jazz," "Surboum" [Party], "Avant-Garde," "Dragueuse" [On the Prowl], "Greenwich Village," "Lolita," "Marilyn," "Motard" [Biker], "Quatre-Cents Coups" [Wild Oats], "Tricheuse" [Cheatin' Woman], "Zazie," "Blouson Noir" [Black Leather Jacket], "Jazz Quartet," "A Bout de Souffle" [Breathless], "Blouson d'Or" [Gold Leather Jacket], "Dolce Vita," and even "Tramway Nommé Désir."

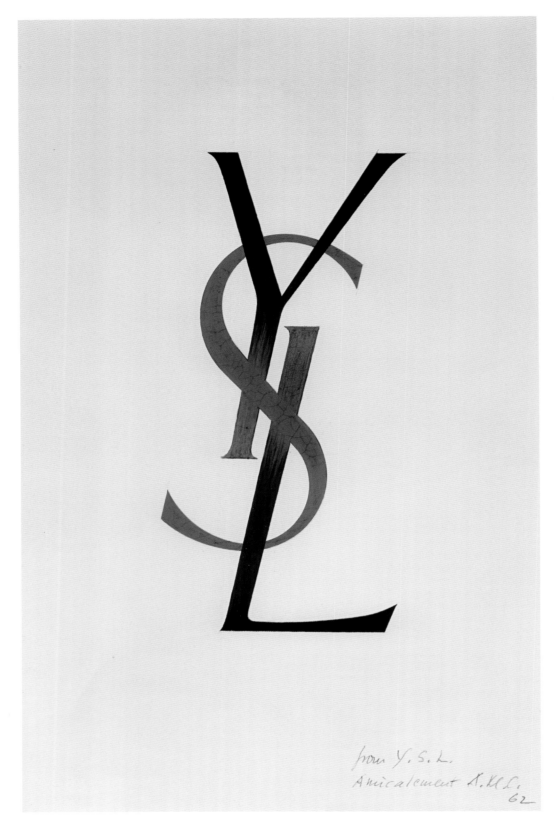

Page 48 — Fall–Winter 1960 haute couture collection (CAT. 8).

Left — Adolphe-Jean-Marie Mouron, known as Cassandre (1901–1968), initials of the Yves Saint Laurent haute couture house, 1961.

"My final collection at Dior profoundly shocked the couture [world], though it was the first important definition of my style.... Those street inspirations all seemed very inelegant to a lot of people sitting on the gilt chairs of a couture salon.... Social structures were breaking up. The street had a new pride, its own chic, and I found the street inspiring—as I would often again."
Yves Saint Laurent, *Yves Saint Laurent* (New York: The Metropolitan Museum of Art, 1983)

SEPTEMBER 2 — Drafted as part of the 1956 induction group after having managed to defer it several times, Saint Laurent had to join the army just when France was mired in the Algerian war of independence (1954–1962).

NOVEMBER 9 — He was declared "permanently unfit" for military service.

Depression. He was transferred to the Val-de-Grâce military hospital in Paris. At Dior, he was replaced by Marc Bohan, who had signed a two-year contract with the firm. "I remember very clearly that, when I told him he was no longer the head of Christian Dior, he said, 'Then we'll start a fashion house ourselves, and you'll run it.'"
Pierre Bergé, interview, October 12, 2009

1961
JANUARY — Saint Laurent took the Christian Dior company to the labor tribunal for illegal rupture of contract. He moved to 3 place Vaubon in the third arrondissement of Paris, where he lived with Pierre Bergé.

JULY — Saint Laurent opened the first office of the future fashion house, a two-room mezzanine space at 66 rue La Boétie in the eighth arrondissement. He was joined by three former Dior employees: star model Victoire Doutreleau, press officer Gabrielle Busschaert, and studio chief Claude Licard (replaced a few months later by Anne-Marie Muñoz).

DECEMBER 4 — The Yves Saint Laurent fashion house officially opened, with financial backing from an Atlanta businessman, J. Mack Robinson, who later declared, "I admired his being so young and so talented" (*Bravo Yves*, 1982). Robinson sold his stake in 1966.

Saint Laurent made costume designs for Jean Anouilh's play *Le Cirque* and Roland Petit's ballet *Les Forains*.

To prepare the first collection, temporary premises were rented at 11 rue Jean Goujon in the eighth arrondissement. Meanwhile, work was being done on a large townhouse at 30b rue Spontini in the sixteenth arrondissement, formerly owned by the designer Forain, into which the fashion house would move.

The first dress from the house of Yves Saint Laurent, labeled 00001, was made for Patricia Lopez-Willshaw, a postwar socialite.

The graphic designer Cassandre (1901–1968) created the YSL logo of intertwined letters. "Cassandre was the best and greatest graphic designer of his day. The first thing we did, even before putting together the financing or looking for staff, was to meet him. He had designed the Christian Dior logo but had fallen into oblivion. That was 1961. He came up with just one proposal: the intertwined letters. The meeting took place at a Paris restaurant, Le Débarcadère."
Pierre Bergé, interview, October 9, 2009

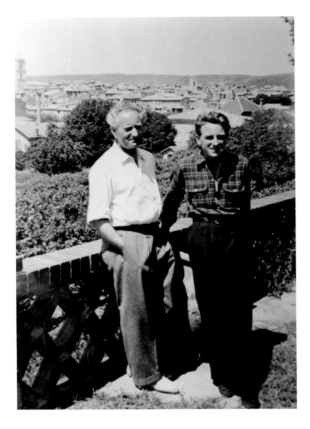

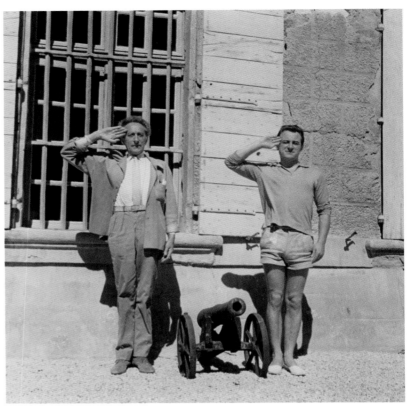

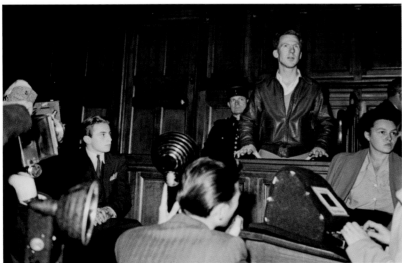

Above, left — Jean Giono and Pierre Bergé, 1950.

Above, right — Jean Cocteau and Pierre Bergé.

Left — Trial of Garry Davis, "world citizen" and peace movement activist. At the left: Pierre Bergé, who was involved in this movement at the time, October 4, 1949.

Opposite — Yves Saint Laurent in the Christian Dior studio, 1960. Photograph by Mark Shaw.

1962–1965.
YSL, THE
EARLY YEARS.

1962

JANUARY 29 — Spring–Summer collection
First pea jacket [caban] with pants; first tunic;
first navy wool smock [vareuse].

The first collection of the house of Yves Saint Laurent was presented in the freshly painted salons of 30b rue Spontini. There were a hundred and one designs. In Paris that year fashion shows were held by forty-six haute couture houses, six of which were new.

"His suits won him praise as the best suit-maker since Chanel."
Life, April 9, 1962

"Yves Saint Laurent's great talent lies in giving the tics of his day an aristocratic allure."
Lucien François, *Combat*, February 23, 1962

"*Meeting a Young Man as Sleek as an Antelope*
This young, shy prince of haute couture, a former pupil of Christian Dior, has just opened his own fashion house, and this morning he submitted his first designs to the judgment of industry insiders. 'Things are going just the way the Americans predicted,' said one female expert. "This year they wagered on the young generation, and they've won.' Concluding the fashion show was a wedding gown of white goffered piqué fabric that sparked wild applause from the audience. The young designer's pale face then briefly appeared in the wings—but only briefly because a flock of admirers surrounded, embraced, and gobbled him up. . . .

"I had met him six days earlier in his studio, when he was just moving into his new premises. A woman friend had managed to get me an interview, overcoming the barriers that protected him during the feverish run-up to the show. I was delighted even though, to tell the truth, I never expected this interview to produce sensational revelations about the future trend of fashion, nor to disclose developments in the Dior case, nor even to provide Saint Laurent's view on rival designers or developments in the fashion market. Yet I confess that I was highly curious to meet this 'phenomenon,' already surrounded by a mythical aura despite his youthful age.

"The meeting was scheduled for 11 A.M. on rue Jean Goujon, but the entrance was hard to find. Number 11 rue Jean Goujon is one of those town mansions that perpetuate the memory of a glorious past—the Belle Epoque—with roofs that recall those old chateaux. The main entrance led to a big art gallery, and I couldn't find another entrance.

Finally I noticed a small side door, easy to overlook—it had a simple label thumbtacked to it, with the letters Y.S.L. Old Paris mansions have a special feature, namely small, mysterious spiral staircases, oval in shape, that seem to be made for secret amorous trysts. But never had I seen one so narrow, steep, and creaky. I climbed up to the top floor, where I discovered a narrow hallway with a door that was just opening. Out came Yves Saint Laurent himself, nearly knocking me over. He was wearing a blue work smock and seemed lost in thought. I explained who I was and he apologetically handed me over to Pierre Bergé, the head of the firm, who was also very young but shorter and with the hard facial features of a man who knows where he is headed. It is said that Bergé is a genius at publicity, and that the artist Buffet owes part of his extraordinary fame to Bergé's help and support. Now it's Yves Saint Laurent's turn. After a brief wait, a young woman led me into the 'sanctuary,' a large room located in one of the mansion's round towers. It was magnificently chaotic in a way that even a set designer could not have managed with so much wit and whimsy: white netting over the windows, samples of fabrics, embroidery, buttons, and trimmings heaped into fantastic piles; the walls, meanwhile, were covered with drawings for costumes for ballets by Roland Petit, with two abstract gouaches by César, and various photos of designs and models. A portrait of Christian Dior dominated the wall behind the desk of the young man with the sleekness of an antelope.

"He was wearing a gray suit in the American cut, with cuffless pants, a blue shirt and a gray and beige tie. His appearance in no way suggested a wonder child, nor was there anything mysterious or deadly about it. On the contrary, the pale softness and thoughtfulness of his face lent him a terribly Romantic air. Above all, however, he seemed serious and well-bred—a perfect aristocrat.

"It may seem dumb, but famous people always make me nervous, even if they're only twenty-one and don't take themselves at all seriously. What's more, in this case I found myself in a totally unfamiliar world. Adding my shyness to his own didn't bode well for the interview—his slender, elegant hands toyed nervously with a silver paperweight. . . .

"In a natural way he said that recent days had been exhausting because he often worked late into the night; that sometimes his ideas for new designs came in a flash of inspiration, but that in general they were

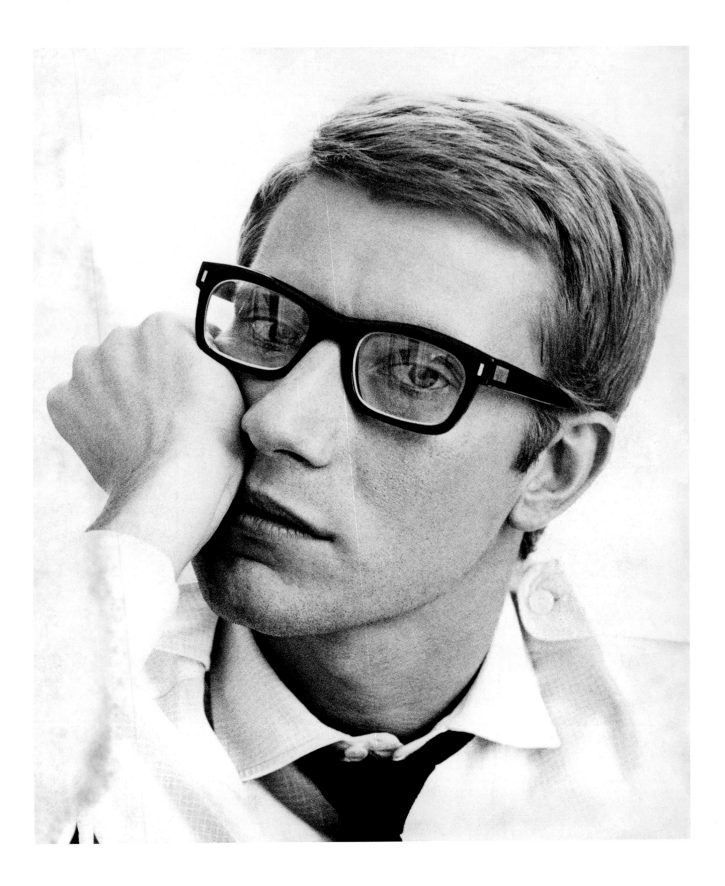

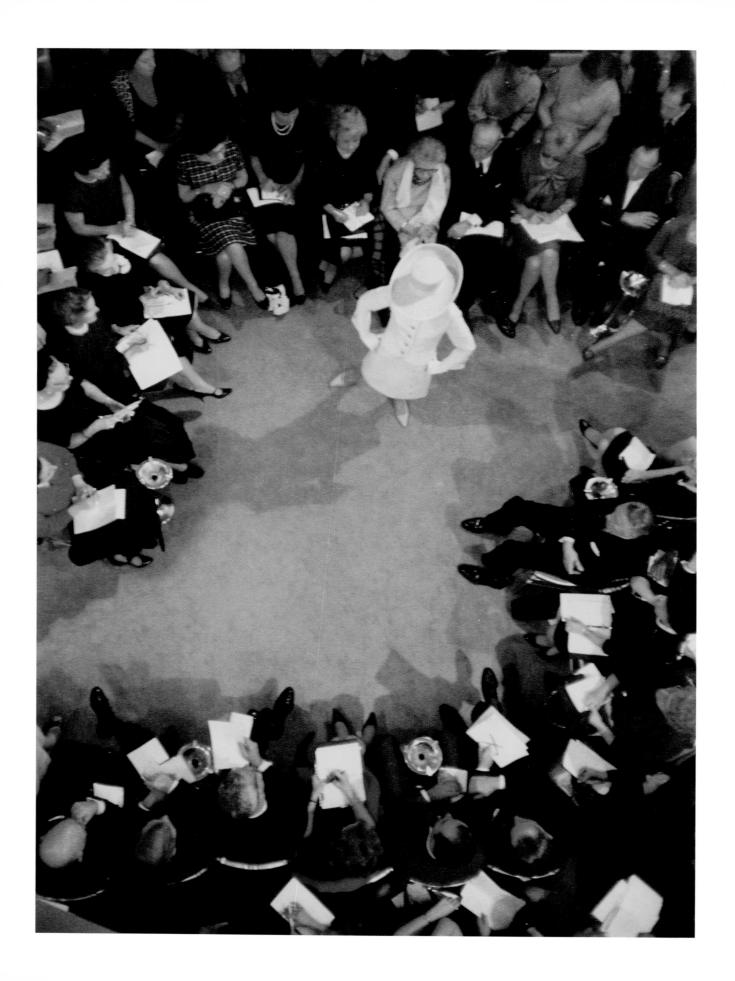

Page 55 — Yves Saint Laurent, 1964. Photograph by Maurice Hogenboom.

Opposite — First Yves Saint Laurent show, January 29, 1962, 30 bis rue Spontini, Paris. Photograph by Pierre Boulat.

Right — Yves Saint Laurent, in the wings of his first haute couture show, 1962. Photograph by Pierre Boulat.

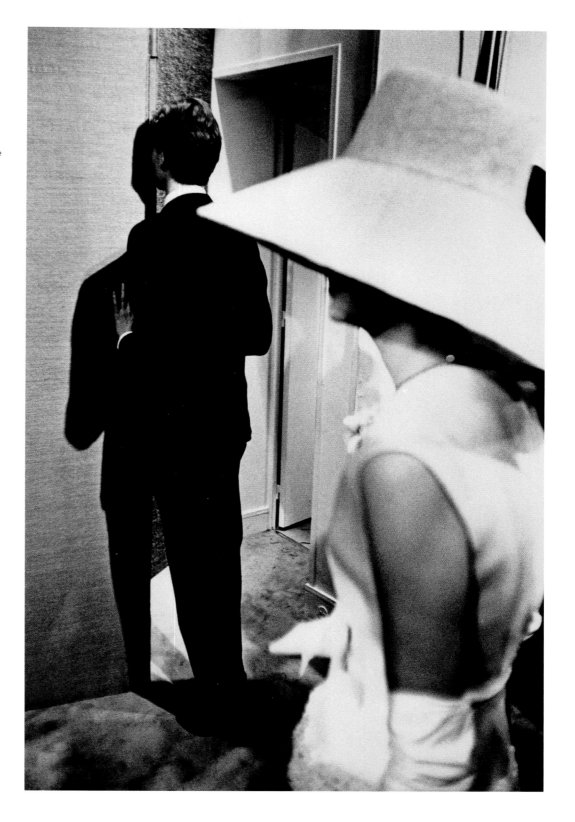

Seating at the first Yves Saint
Laurent haute couture show,
Spring–Summer 1962.

A seating chart / table plan.

G	68 Lady Presnell	67 Mrs Miller	66 Mrs Casey	65 Henry Clarke	64 Consaint Lee	63 Miss Train	62 Mrs Peek	61 Mrs Simpson	60 H.A Breiter	59 H.A Payne	58 Hotel Shelly Riggs	57		
I		F	26 Dokadue	25 R Cynnin gham	24 Mme de Marcus Morris	23 de Mme de Langlade	22 Miss J. Daves	E. 21 Charles Prous	Princess Garratt	20 Mme Saad	19 Mme Mme Saad	Hawly van Thiel	56 Heke Morses	Mrs Prow row
69 Mrs Harwood		H Heymger									18 H.E Petrasymi	55 Mrs Hornby		
70 Mme Ghali		27 Jane Stark								17 Sheppard	54 Mrs Dickson			
71 Mme Gauthier		28 Mrs Peterson								16 M.L Prousquest	53 Mrs Easton			
72 Mr Colcurte		29 Mrs Delano Forbes								15 Nancy White	52 Mr Israel			
73 Mr M Melvan		30 Francoise Giraud								14 Mrs Hamilton	51 Mme Petit Gerard			
74 Mr Lucien Francois		31 Pierre Louchel							S	13 Liber L. Scannell	50 Calmel			
75 Mme Anna Gret										12 Mme Castaman	49 E. Valeri			
										11 Mme Jalou	48 Lise elina			
											47 Shelley			
											46 Cancalon			
										D	45 Mme Harden			
	2 Mme da Elle medret	Ernest Jane Carter	3 Mrs Ashley	4 Mme Fewer Fewre	5 Ph de Croiset	Jean Fayan	7 E. Raymond	8 Simone Marion	9 Lajouff	10 Alice Chavanel	James A Brady	John Painchief	44 Barbara Gregor	
												B	E	
2 Gauthier	33 Calda Gries	34 Kampf	35 Demachy	36 Jackson	37 Caron	38 Prouet	39 Live male	40 Chevalier	41 Austin Brugh	42 Flanders real	43 Mme Schwartz			
6	77 H. Widmer	78 Loudean	79 Mrs Brezpole	80 Peter Knapb	81 Rene Zoun	82 Rooh Anderson	83 Ginette Hallot	84 Befue	85	86 Messin	87 Mr Book	88	89	C

Above — From left to right: Victoire Doutreleau, Françoise Sagan, Yves Saint Laurent, Bob Westhoff, Pierre Bergé, and Suzanne Deforrey in the apartment on place Vauban, January 1962. Photograph by Pierre Boulat.

Below — Yves Saint Laurent, during the setting up of the couture house at rue Spontini, 1962. Photograph by Pierre Boulat.

the product of patient research, of an almost architectural labor, which didn't leave him much time for sports or a hobby; that he loved working for the theater and ballet, designing sets and costumes, but that he couldn't devote himself to it as much as he would like. He had never done painting in the strict sense, nor written stories nor kept a diary. When it came to fashion, he disapproved of extremely mannered designs that won audience approval at the shows but that no one ever ordered. He did not work just to get his name in the papers; what interested him was designing clothing that could be worn by all women.

"From time to time an embarrassed silence weighed upon us. Clearly, Yves Saint Laurent felt no need to confide in me, and I couldn't think of anything else to ask him. So I wound up going away with the painful certainty of appearing to be a total idiot."
Dino Buzzati, *Corriere della Serra*, January 30, 1962

JULY — Fall–Winter collection
First Norman smock [*blouse normande*]; first evening trench coat of black satin ciré.

"It's the tunic line triumph!"
Daily Herald, July 31, 1962

Saint Laurent designed the sets and costumes for two Roland Petit ballets, *Maldoror* and *Rhapsodie Espagnole*. Algeria gained independence. His parents and sisters moved to Paris.

1963
JANUARY — Spring–Summer collection
White-collared smock dresses [*marinières*].

"When you design a collection, do you think of your private customers, of the professional buyers, of the press or of a combination of these?"
"I think of all of them but basically I think of a woman...."
"There are said to be three great fashion schools today: Balenciaga, Chanel, and you. Do you agree?"
"Oh I couldn't say anything on that."
Women's Wear Daily, April 3, 1963

APRIL — Saint Laurent made his first trip to Japan, where his collection was shown.

JULY — Fall–Winter collection
Chasuble dresses; first boots.

"His show opener was a black Robin Hood outfit, with long boots reaching the hem of a black mink polo, topped by a sporty felt hat. This set the theme of a relaxed collection, in which St. Laurent gave up his usual austere elegance. Others had tried to replace the old gussied-up couture with an easy boyish look. But it was St. Laurent who carried the boyish look through everything he showed— from daytime wear to evening clothes. The shirt, the jerkin, the sailor's jacket, the farmer boy's smock, the fisherman's oilskins appeared first in tweeds, then reappeared in satins, all transformed by St. Laurent's genius into clothes designed to catch what St. Laurent calls the elusive mood of 1963.... Perhaps the most dominant influence on St. Laurent's whole style is his conviction that a woman's life has become less self-consciously feminine, more active, and less cloistered."
Newsweek, August 12, 1963

Saint Laurent designed the costumes for Claudia Cardinale and Capucine in Blake Edwards's film, *The Pink Panther*, and costumes for Roland Petit's revue, *Zizi Jeanmaire le Champagne Rosé*.

1964
JANUARY — Spring–Summer collection
First peasant skirt.

JULY — Fall–Winter collection
Tunic coats; lace dresses.

A failed collection: "I've never been able to work on a wood mannequin; I playfully unroll the fabric around the model—I need models who inspire me—turning around her, making her move until the moment when I'm lightning-struck by the dress or suit.... The only collection of mine that failed—a total fiasco, the same year that Courrèges arrived and made a hit [1964]—was when I didn't have good models and wasn't inspired."
Paris Match, December 4, 1981

Saint Laurent designed the costumes for Beaumarchais's play *Le Mariage de Figaro* and for François Billetdoux's play *Il Faut Passer par les Nuages* for the Renaud-Barrault theater company.

His first perfume, Y, came out.

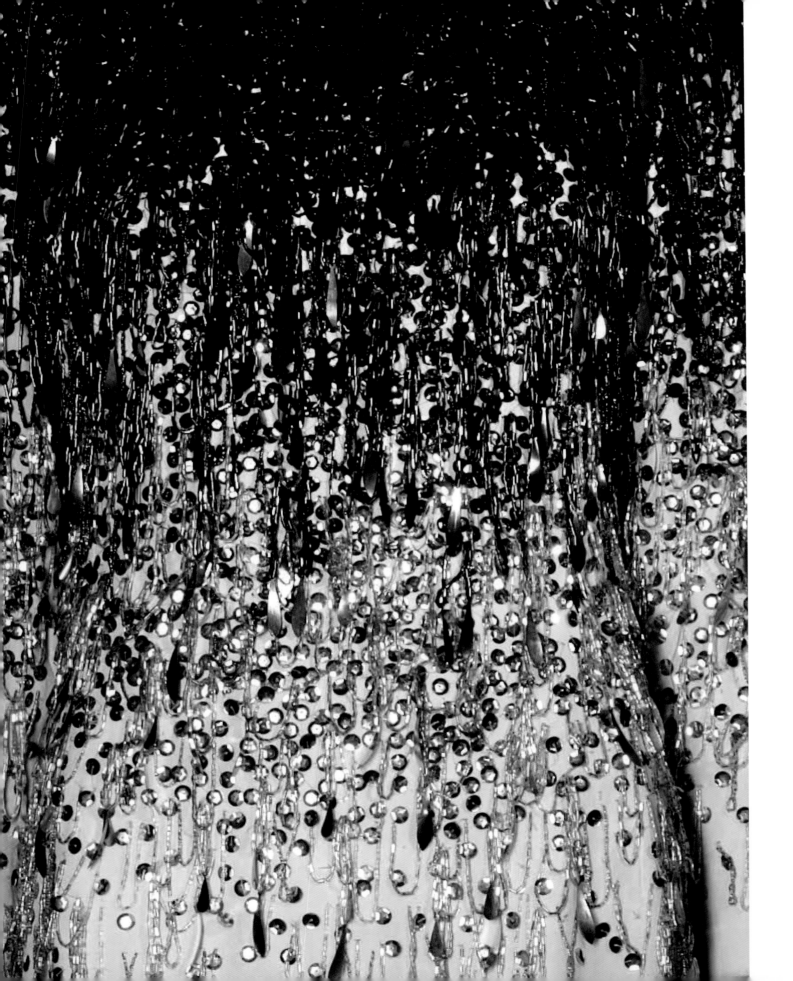

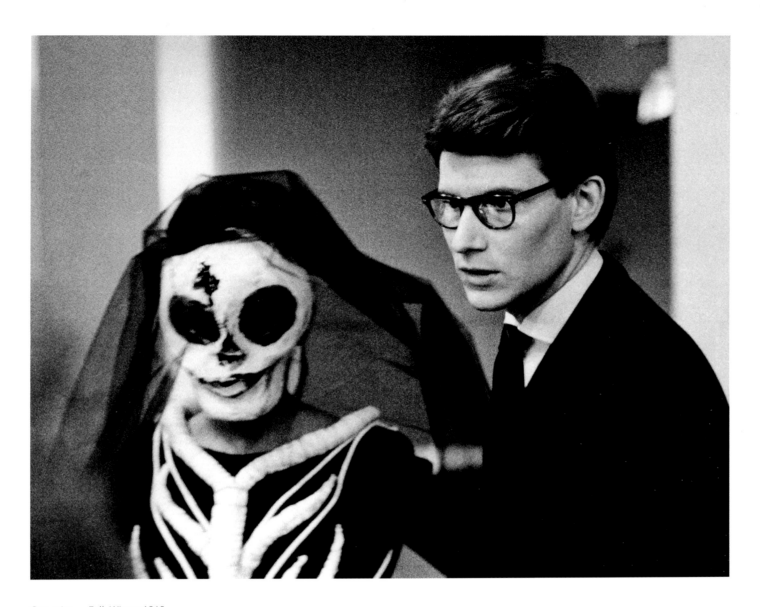

Opposite — Fall–Winter 1962
haute couture collection (detail of
CAT. 194).

Above — Yves Saint Laurent
and one of his designs for *Les
Chants de Maldoror*, a ballet by
Roland Petit. Théâtre de Chaillot,
Paris, 1962. Photograph by
Giancarlo Botti.

The studio, rue Jean-Goujon, winter 1961; left to right: Gabrielle Busschaert, Victoire Doutreleau, Claude Licard, Esther, Yves Saint Laurent, Pierre Bergé, Gérard, and the model Heather. Photograph by Pierre Boulat.

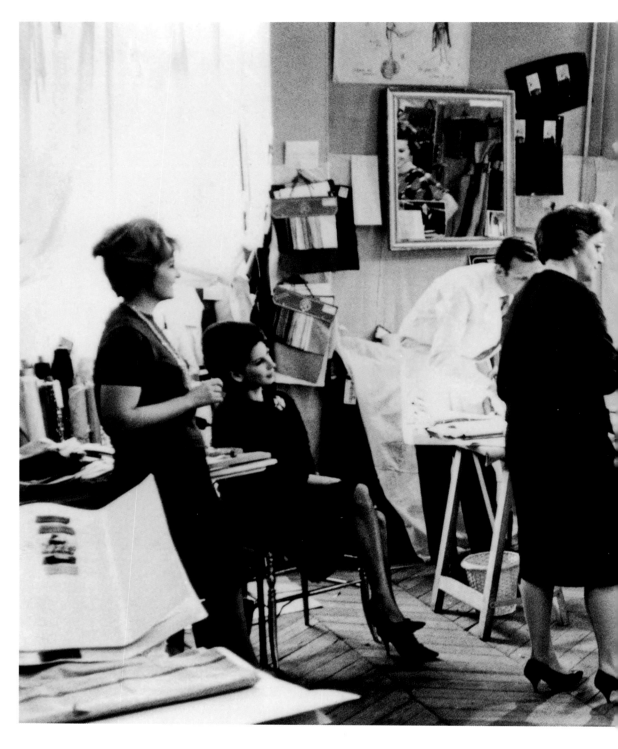

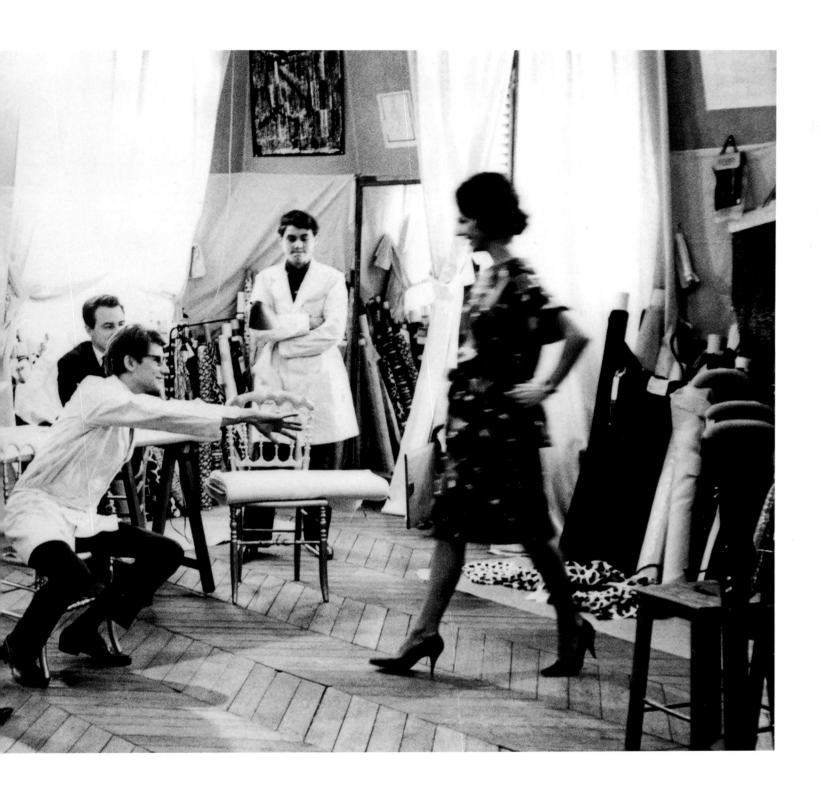

1965–1971. LAUREN BACALL: "WHEN IT'S YVES, IT'S PANTS."

1965

JANUARY — Spring–Summer collection
Tweed suits, capes, and dresses; printed silk dresses.

JULY — Fall–Winter collection
Mondrian and Poliakoff dresses; knitted bridal gown.

"I was fed up with making dresses for blasé millionaires."
Le Journal du Dimanche, August 15, 1965

"The *Mariner IV* probe has proven that Mars is uninhabited, so there's no point in figuring out how to dress Martians. Courrèges having temporarily withdrawn from the contest, fashion has come back to women and women are coming back into fashion. In the month of August 1965, people are no longer talking about astronauts, but about a fashion designer. With Ringo's hair, John's wit, George's appeal and Paul's popularity, this twenty-eight-year-old 'Beatle of Rue Spontini' has pulled off a revolution by showing dresses rather than 'outfits.' . . . Saint Laurent nevertheless acknowledges a debt to Courrèges: 'I was getting bogged down in traditional elegance, and Courrèges yanked me out of it. His collection stimulated me. I said to myself, "I can come up with something better."'
"One night, his mother gave him a book on Mondrian, and when leafing through he glimpsed what 1965 fashion might be, and what he would do. 'I suddenly realized that dresses should no longer be composed of lines, but of colors. I realized that we had to stop conceiving of a garment as sculpture and that, on the contrary, we had to view it as a mobile. I realized that fashion had been rigid up till then, and that we now have to make it move. . . .' Methodically, without fury or regret, he tore up his drawings laden with furbelows, ribbon and embroidery, and went back to work with the idea of superseding all the current conceptions of elegance, including his own just two days earlier. . . . Yves Saint Laurent does not believe for an instant that this movement will stall— 'I'm convinced that we're on the eve of an upheaval in our lifestyle as important as the one introduced by the Art Deco exhibition [in 1925]. Down with the Ritz, down with the moon, up with the street!'"
Patrick Thévenon, "Le couturier qui a pensé aux femmes d'aujourd'hui," *Candide*, August 15, 1965

Saint Laurent met Rudolf Nureyev.

Saint Laurent designed the costumes for Roland Petit's ballet *Notre Dame de Paris*, for Marguerite Duras's play *Des Journées Entières dans les Arbres* (starring Madeleine Renaud), for Leslie Caron in Michael Gordon's film *A Very Special Favor*, and for Jean Seberg in Mervyn LeRoy's film *Moment to Moment*.

The fashion house was bought by the American cosmetic and perfume firm Charles of the Ritz.

1966

JANUARY — Spring–Summer collection
First pants and sailor's smock [*marinière*] ensembles in wool or navy duck; sailor's cap; navy-and-white sequined pullovers; safari outfit.

JULY — Fall–Winter collection
Three- and four-color jersey dresses dubbed "Pop Art" (heart, sun, moon, face, body); first tuxedo (*le smoking*); first cocktail pantsuit of black velvet; the "nude" look, early see-throughs.

"'The buyers talk about a lot of curves at Balenciaga. What do you think?'
'I don't think that the round woman is the modern woman. The woman today, August 5, 1996, has bones—she is nervous. The woman of the *dix-neuvième* [nineteenth] century was round. *C'est fini*, the round. It is for Renoir.'"
Women's Wear Daily, August 5, 1966

"How do you wear this tuxedo? It's such a new uniform that there aren't any rules on the art of wearing one. . . . If you don't yet dare to been seen in a tuxedo at a social event, make a start at a ski resort—in the chalet, or for dining, there where pants are really *de rigueur:* don a tuxedo."
Vogue Paris, December 1966

SEPTEMBER 19 — The first ready-to-wear boutique, Saint Laurent Rive Gauche, opened at number 21 on quiet rue de Tournon in the sixth arrondissement, halfway between the Latin Quarter and Saint-Germain-des-Prés. Catherine Deneuve presided over the launch.

Saint Laurent met Andy Warhol. "He had a sharp eye, that is to say ruthless; nothing escaped him, he spared neither friends nor admirers. . . . With Paul Morrissey he

made some half-scandalous, half avant-garde movies. He loved pornographic films and took me to see *Deep Throat* as soon as it came out. In Europe, he discovered an unknown world of which he had dreamed. As a pure product of America, he believed in a certain idea of culture. Did he realize that our own was coming to an end? That everything that fascinated him—haute couture, Art Deco, the bar of the Ritz, Café Florian—would soon no longer mean anything? I'm not so sure."
Pierre Bergé, *Les jours s'en vont, je demeure* (Paris : Editions Gallimard, 2003)

He designed the costumes for Arletty in Jean Cocteau's play *Les Monstres Sacrés* at the Théâtre des Ambassadeurs and for Sophia Loren in Stanley Donen's film *Arabesque.*

Saint Laurent won *Harper's Bazaar*'s "Oscar" award.

He traveled to Marrakech; in the medina he and Bergé bought Dar el Hanch (the "House of the Serpent").

1967
JANUARY — Spring–Summer collection
First chalk-stripe pantsuits with vest; African dresses inspired by Bambara art; safari dress; first short tuxedo dress; first beige safari jacket [*saharienne*].

"American women are going to want to burn all the clothes they have when they see this.... Saint Laurent's new Vestsuits in men's wear fabrics are the sensation of the Paris season.... What a show—it could have come right off Broadway."
Women's Wear Daily, January 31, 1967

JULY — Fall–Winter collection
Long leather coats; suede tunic dresses with fringe; tuxedos with knickerbockers.

Saint Laurent met Talitha Getty, wife of young billionaire Paul Getty and one of the hippie movement's "beautiful people." She would be found dead of a heroin overdose in Saint Laurent's Rome apartment on July 11, 1971.

Encouraged by Françoise Sagan, Saint Laurent published a graphic novel, *La Vilaine Lulu* (Paris: Editions Tchou), based on a Dior character who obeyed only her own desires.

He designed the costumes for Edward Albee's play *Delicate Balance* by the Renaud-Barrault company and for Catherine Deneuve in Luis Buñuel's film *Belle de Jour*, based on the novel by Joseph Kessel.

1968
JANUARY — Spring–Summer collection
First "see-through blouse" of cigaline to be worn with tux and shorts; first short jumpsuit for evening wear; bloomers.

"Included in the show was a white silk scarf emblazoned with Yves Saint Laurent's initials in black. It sold by the thousands. Other people still do it on bags, sweaters, and fabrics. For me, it's part of the past and I would never be either so vain or naive to repeat a gesture of that sort. It's typical 'designer' stuff.'"
Elle, June 9, 1971

FEBRUARY 11 — On a popular Sunday prime-time television show (*Dim Dam Dom*), Coco Chanel named Yves Saint Laurent as her spiritual heir: "Because one day or another, someone will have to carry on my work."

MARCH — Saint Laurent was interviewed by Claude Berthod on a subsequent broadcast of *Dim Dam Dom*.
Is your idea of a woman an elegant woman?
I don't like the word "elegant." I think it's as outdated as the term "haute couture." I think that a woman who dresses to please men is an appealing one. The word "appeal," you see, has replaced the word "elegance." Everything has changed. It's more a certain way of living than certain way of dressing.
And what do you think of the others?
The other designers?
Yes, your colleagues, your fellow designers.
That's a very difficult question. I think there are three kinds of fashion designer. The truly great ones known how to go straight to a woman's heart just by making a very simple dress or very simple suit.
And how many of them are there?
Oh, I think there have only been two, so far. There was Balenciaga and there was Chanel, who left their marks on their times and their profession. I don't think I've made it that far yet, and I don't think that any current designers have made it, at least not for the moment.
And the rest are all in the same category?
No, there are those I call the "dressmak-ers" [*couturières*] who do good, honest

work—very boring, very bourgeois. And then there are the "messmakers" [*couturasses*], I mean the kind of people who do everything for show, who need music, who put Mickey Mouse ears in the hair, who deck out women with iron and leather ... things I don't understand, that totally escape me.
. . .
I believe Proust is your favorite writer. Would you like to answer Proust's famous question-naire [based on the "Confessions" quiz]?
Sure.
What is your main character trait?
Determination.
Your greatest drawback?
Shyness.
Your favorite quality in a man?
Indulgence.
In a woman?
Same thing.
Your favorite historical character?
Mademoiselle Chanel.
Your favorite real-life heroes?
The people I admire.
Who would you like to have been?
A beatnik.
What is your ideal of earthly bliss?
Sleeping with the people I love.
What is the height of misery?
Loneliness.
Where would you like to live?
In sunny climes, by the sea.
What talent would you like to have?
Physical strength.
What fault are you most tolerant of?
Betrayal.
Who is your favorite painter?
Picasso.
Favorite musician?
Bach. And nineteenth-century composers of opera.
What writers, apart from Proust?
I love Proust so much that it's hard for me to share him with other authors. But I adore Céline and also Aragon.
What is your favorite color?
Black.
What do you hate most of all?
The snobbery of wealth.
Do you have a motto?
I'll borrow the motto of the Noailles family: *More Honor*—in the singular rather than "honors" in the plural.

JULY — Fall–Winter collection
First long jumpsuits, of wool jersey for daytime or black-flecked silk jersey for evening, worn with a black chenille duffle coat; dress of chiffon and ostrich features with see-through front.

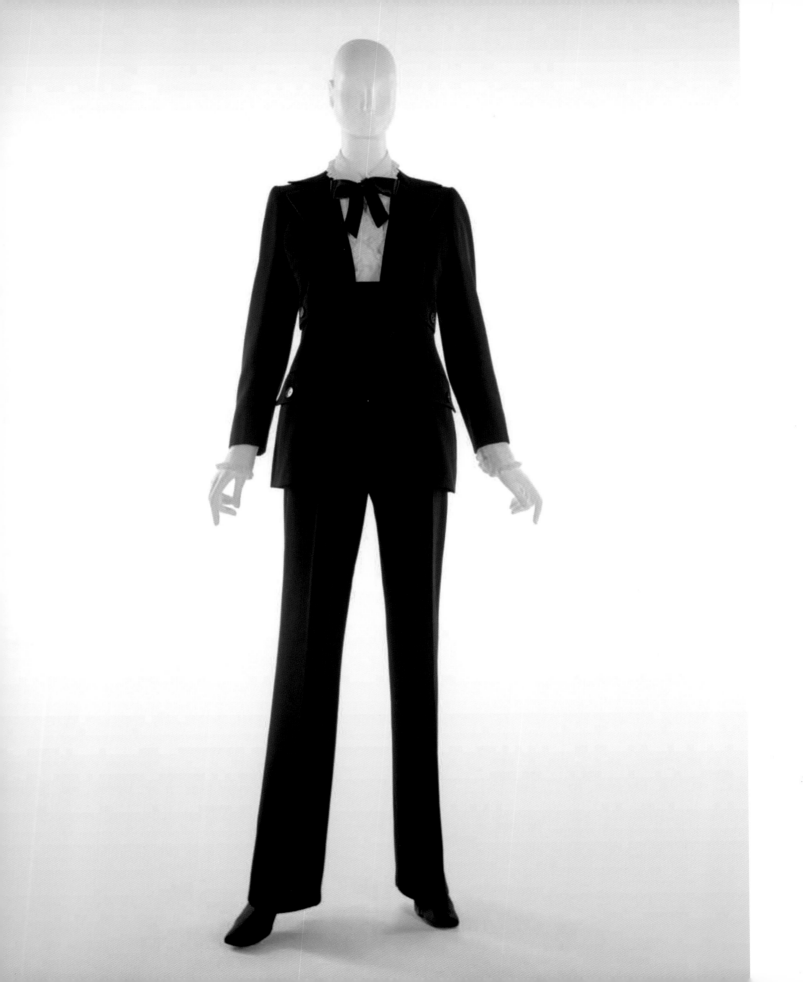

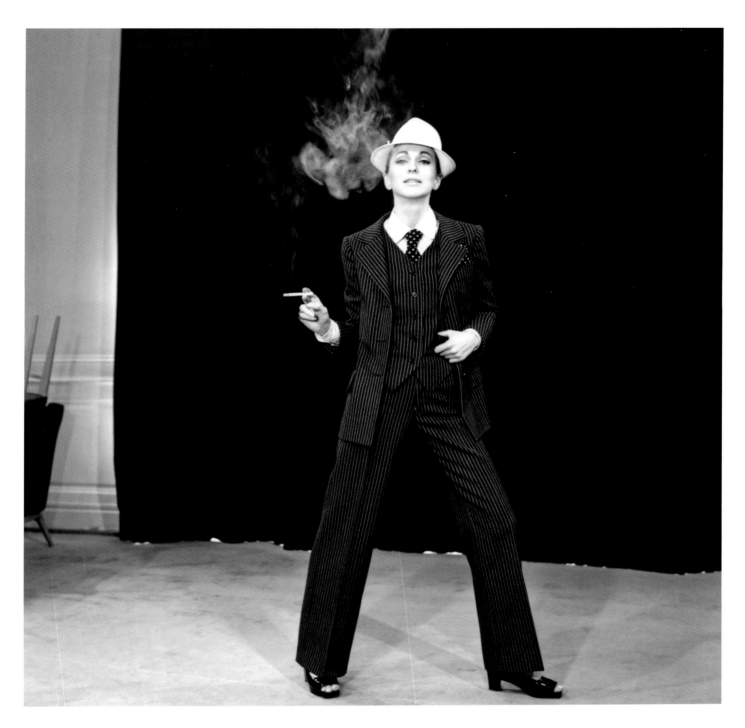

Opposite — Fall–Winter 1966
haute couture collection: first
tuxedo (CAT. 262).

Above — Spring–Summer 1967
haute couture collection: first
pantsuit (CAT. 26).

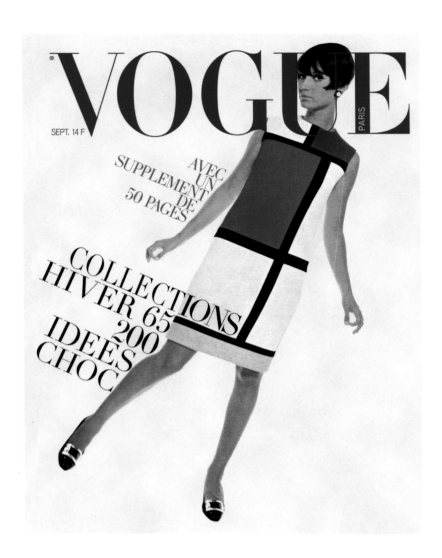

Left— Cover of *Vogue Paris*, September 1965. Dress in multicolored wool jersey, Fall–Winter 1965 haute couture collection, tribute to Piet Mondrian. Photograph by David Bailey.

Opposite — Fall–Winter 1965 haute couture collection, tribute to Piet Mondrian (detail of CAT. 192).

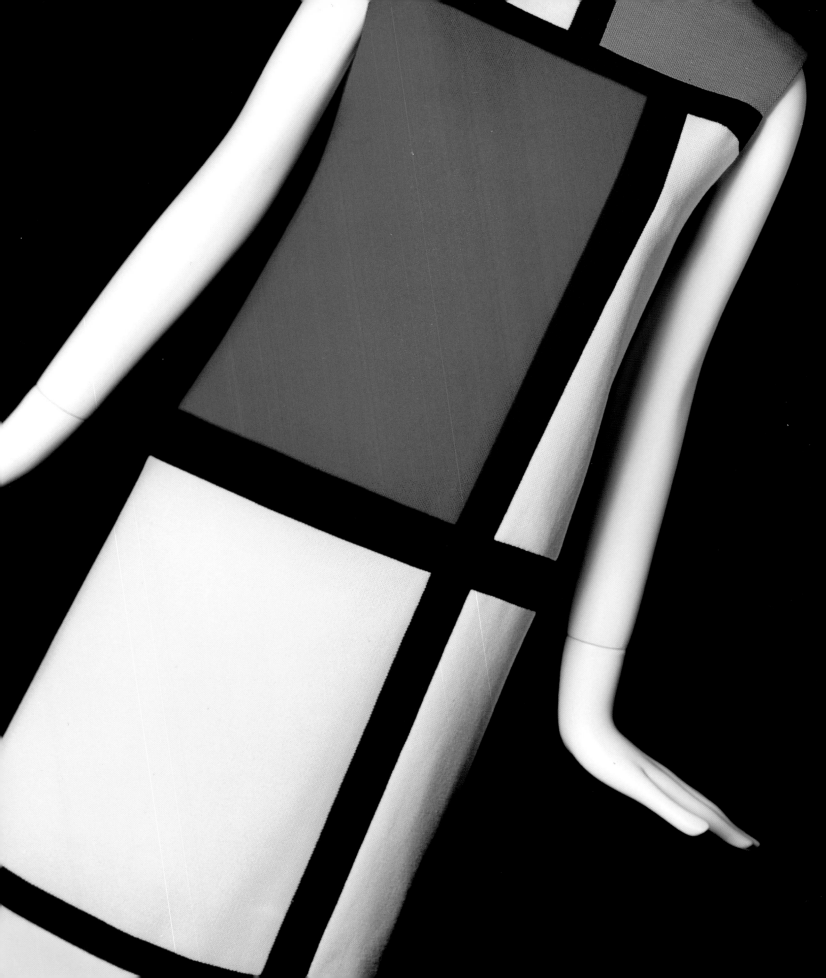

Above — Yves Saint Laurent and his original drawings for *La Vilaine Lulu*, 1967. Photograph by Robert Doisneau.

Below — *La Vilaine Lulu*, a character created in 1956 by Yves Saint Laurent and published in 1967.

PATRIOTE

LULU CARMEN

VILAINE LULU CLASSIQUE
DE FACE

SEPTEMBER 1 — A unique safari jacket [*saharienne*] made not for a collection but for a safari-theme photo spread by Franco Rubartelli was published in *Vogue Paris*.

SEPTEMBER — The first Saint Laurent Rive Gauche boutique opened in New York.

Saint Laurent met Betty Catroux in Chez Régine, a Paris nightclub—the start of a long friendship. "We were both very skinny and very pale, two platinum blonds with an androgynous side. We both liked things a little shady. I was her twin."
Saint Laurent, interviewed by David Teboul, 2001

Saint Laurent met Louise "Loulou" de la Falaise, daughter of Comte Alain de la Falaise and Maxime Birley. "It was after the [revolutionary] events of 'May 68,' in the Paris home of Fernando Sanchez, a mutual friend. Coming straight from London, Paris still seemed very 'square' and 'straight' to me. I instantly took a liking to his childish humor and jokey side."
Loulou de la Falaise, interview, October 9, 2009

He designed the costumes for Madeleine Renaud in Marguerite Duras's play *L'Amante Anglaise*, directed by Claude Régy at the Théâtre National de Paris; and for Catherine Deneuve in Alain Cavalier's film *La Chamade* [*Heartbeat*], based on the novel by Françoise Sagan.

Saint Laurent's theatrical drawings were exhibited in New York and London.

1969
JANUARY — Spring–Summer collection
Safari pantsuits; "1920s" dresses; chiffon dress with hood.

JULY — Fall–Winter collection
Jersey jumpsuit; bird-of-paradise dresses; patchwork dresses; dress of Georgette crêpe with galvanized bronze "bust" sculpted by Claude Lalanne.

Saint Laurent designed the costumes for Catherine Deneuve in François Truffaut's film *La Sirène du Mississippi* [*Mississippi Mermaid*].

The first Saint Laurent Rive Gauche boutique opened in London, as well as a Saint Laurent Rive Gauche for Men at 17 rue de Tournon in the sixth arrondissement of Paris, where the *Il* [*His*] style is born.

1970
JANUARY — Spring–Summer collection
Maxi coats; long skirts, and pyjamas of printed silk; wide-trousered suits.

"Contrary to what has been shown in the other couture houses [...], Saint Laurent's pants are so wide as to be veritable Oxford bags. Often they have turn-ups. And in contrast to the low hipster line to which we have become accustomed, Saint Laurent's trousers are built right over the diaphragm, with a narrow leather belt.... The collection ended conventionally with a bride—but a most unconventional one in a severely tailored white flannel trouser suit. This seemed not so much haute couture as high camp."
The *Guardian*, February 2, 1970

JULY — Fall–Winter collection
"Hippie"-inspired coats of studded suede, patchwork, crushed velvet; embroidered Chinese tunic; "Love" dress and dress with transparent lace back, both worn with a "Forties" turban.

"Hippie is more than a way of dressing. It's a spirit which fills young people. I don't know any young people who are not hippies in their spirit. When the revolution comes, it will come from the young people.... It's an irreversible conflict of generations.... It's always like this in fashion and you can see it in the young people of today. Every twenty-five years the body changes ... the gestures change. There is a new body emerging—slim and long. Girls who are now fourteen will grow old in a different way than the woman who is now thirty-five or even twenty-five.... Look at all that advertising—you must buy these shoes to go with this bag to go with that belt. Such advertising takes people for imbeciles. The result? The young people don't shop in the big stores anymore."
Women's Wear Daily, June 15, 1970

He designed the costumes for Sylvie Vartan for her concert at the Olympia theater, and for Zizi Jeanmaire's revue at the Casino de Paris, composed of thirty-three tableaus and seventeen ballets, including one titled *H*—"Saint Laurent devised a hashish den. Fabulously exotic. Raw silks, sequins, decorated with scaly serpents beneath a mirrored ceiling."
Elle, February 16, 1970

The "Love" cards were launched. These greeting cards, in the form of a poster designed by Saint Laurent (usually in Morocco), were sent to the "happy few," becoming an annual end-of-the-year ritual. The most striking examples were the ones with a heart and snake motif, Saint Laurent's fetish symbols. The tradition was broken only twice, in 1978 and 1993, called "years without Love" by enamored collectors.

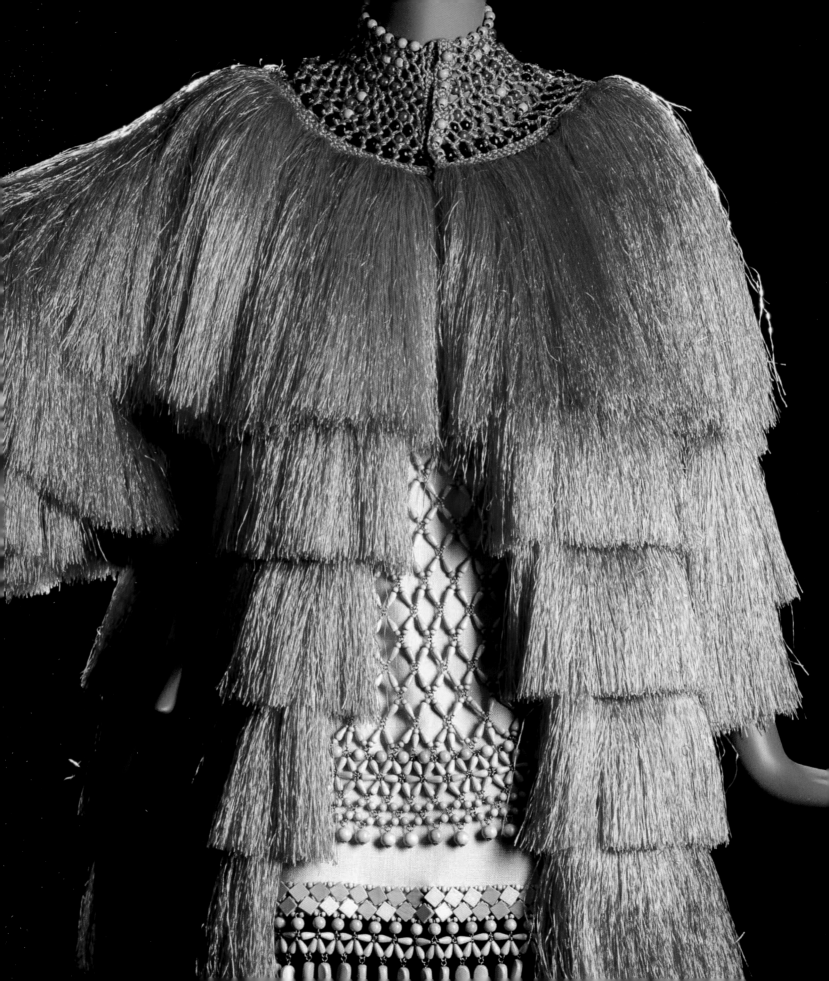

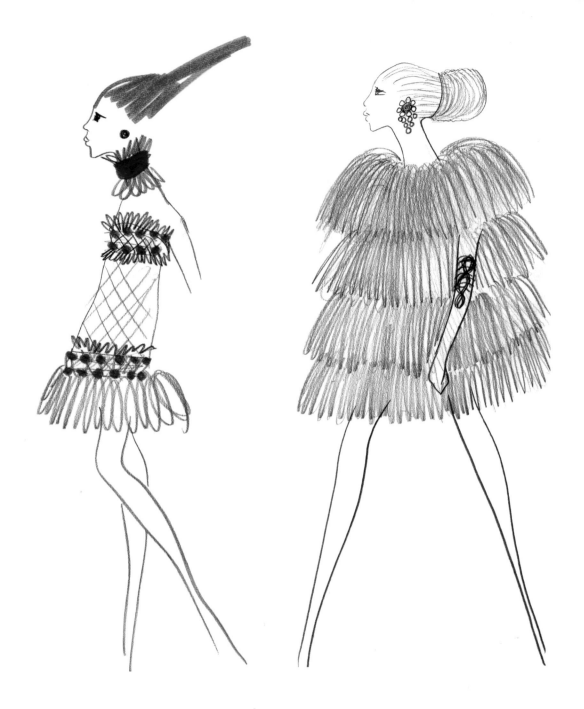

Opposite — Spring–Summer 1967 haute couture collection, the first African collection (detail of CAT. 165).

Above — Bambara-inspired sketches, Spring–Summer 1967 haute couture collection.

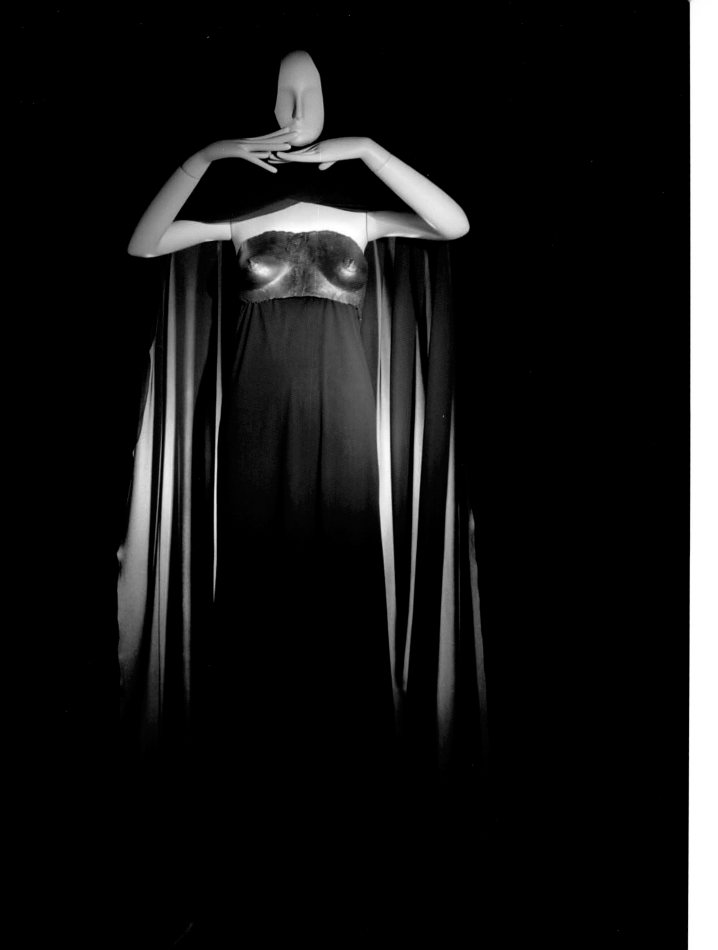

Opposite — Fall–Winter 1969 haute couture collection (detail of CAT. 174).

Above, right — Claude Lalanne and Yves Saint Laurent in Ury, during fittings of the "Lalanne" dresses, bust and waist sculptures in galvanized copper, Fall–Winter 1969 haute couture collection. Photograph by Jean-Philippe Lalanne.

Below, right — These same designs, published in *Paris Match*, August 23, 1969. Photograph by Manuel Litran.

Pages 78–79 — *Love*, 1970.

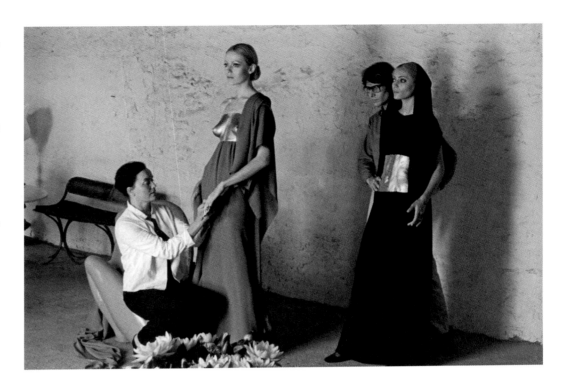

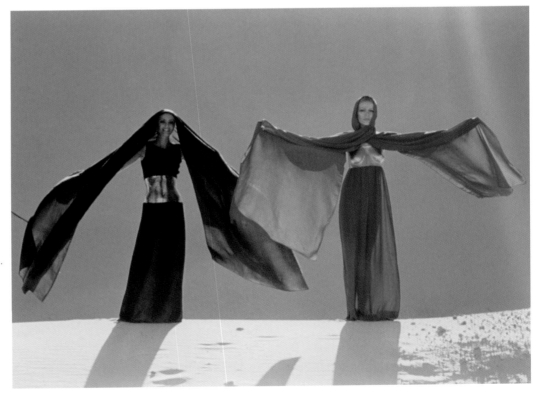

1971–1978. A DECADE OF SCANDAL.

1971

JANUARY 10 — Gabrielle "Coco" Chanel died, age seventy-eight.

Spring–Summer collection, dubbed "The Forties" or "Liberation" collection. This collection brought a whiff of scandal to the emerging "vintage" trend. Square shoulders, bouffant sleeves, platform shoes, shortened dresses, seductive makeup: Such allusions to "the women of easy virtue" in Paris during the German occupation shocked people. "The ugliest show in town," wrote Eugenia Sheppard in the *New York Post* (February 1, 1971).

"This collection, which everyone is calling kitsch, was a reaction to the absurd direction fashion was taking … with 'gypsies' covered in bracelets and dragging long skirts. So I conceived my collection as a kind of humorous protest, which everyone took seriously."
Yves Saint Laurent, 1972

JULY — Fall–Winter collection, later called the "Proust Ball" collection in reference to a ball given by Guy and Marie-Hélène de Rothschild at the Château de Ferrières on December 2, 1971.

Rive Gauche perfume was launched—a scent "*not* for unassuming women," according to its French advertising slogan that accompanied a photograph by Jeanloup Sieff.

Saint Laurent designed the costumes for Johnny Hallyday's concert at the Palais des Sports.

Saint Laurent posed nude for photographer Jeanloup Sieff as part of the advertising campaign for his first eau de toilette for men. "It was just provocation on the part of Yves Saint Laurent. The picture didn't specifically target the gay population, even though it resonated strongly among them. In any case the photo was hardly published at the time. Just barely in the French press. It was only much later on that it became an almost mythical icon."
Pierre Bergé, *Dutch*, Winter 1997

Saint Laurent announced his intention to abandon haute couture.
Why?
Because I'm unhappy and I don't want to go on this way, constantly torn between what I want to do and what I have to do. When I do things I *like* in haute couture—my first

tuxedos, the 1945 dresses, and so on—they are resounding failures, financially…. I don't want to impose traumatizing garments on unwilling women, most of whom are of a respectable age. My real public is young women, working women.
Is it also because you want to refashion both garments and women?
As a designer, I've never promoted "cosmic" clothes and dresses with holes. And I don't see the point of changing garments from one season to the next if they're right, whether it's a pea jacket or blue jeans, a tuxedo or a trench coat. This was so true that I wound up making the same things for couture and for ready-to-wear. The more perfect a garment, the simpler it is. I wasn't going to add buttons and pleats just to make something look expensive!
Elle, June 9, 1971

1972

JANUARY — Spring–Summer collection
Safari suits; printed white blouses; pleated skirts

Limited to fifty designs, this private show of haute couture was reserved, with a few exceptions, to the fashion house's clientele, estimated at the time to be three hundred women.

"This collection is discretion, simplicity and refinement…. I don't have to think of what's new, of style, of design, of a 'look,' of press opinion. My worry now—and it's mostly pleasant—is to make beautiful forms with beautiful materials, thinking of women I like."
Women's Wear Daily, January 18, 1972

JULY — Fall–Winter collection
Mottled knit cardigans; flannel pants; Jacquard-print wool dresses; printed silk gown.

Saint Laurent designed the costumes for Roland Petit's revue *Zizi Je T'aime* at the Casino de Paris. When Edmonde Charles-Roux asked Saint Laurent what he could learn from musical revues, he replied, "Rapidity. In variety shows, everything's right there. You can create a whole world with three props. With a packet of black feathers you make a large hat; put it on a tall, completely naked, completely black woman, so that when she walks on stage it steals the show, is the *only* show…. And you have to maintain a sense of the grandiose with, simultaneously, the picture postcard effect. Furthermore, in music hall even more

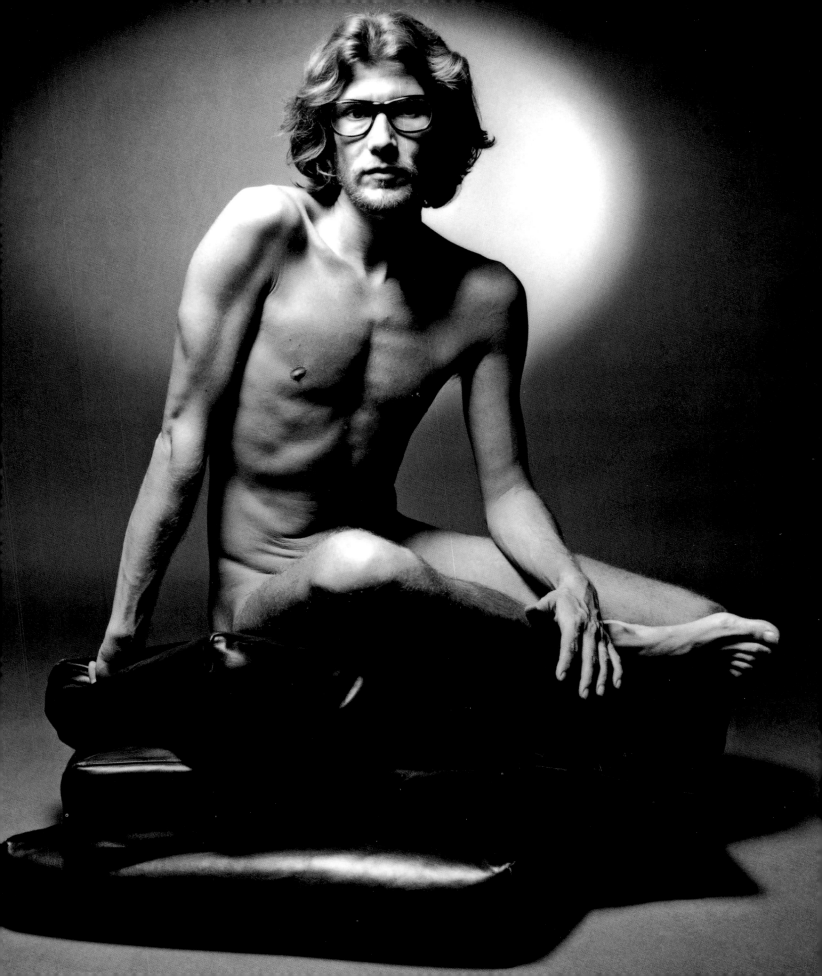

than in legitimate theater, life is turned upside down: Impoverished materials look rich, and vice versa. Forget the usual rules . . . which is not so easy."
Les Lettres Françaises, March 8, 1972

Loulou de la Falaise joined Saint Laurent in his studio to work alongside Anne-Marie Muñoz. "Yves didn't tell anyone. I thought it was supposed to last a month or two. I was a little frightened. I dressed myself in gray, like a schoolgirl's uniform. I had no idea of what I was going to do—I worked on jewelry, fabrics, knitwear."
Loulou de la Falaise, interview, October 9, 2009

Bergé and Saint Laurent bought back the fashion house from Charles of the Ritz. Licensing deals were developed.

Andy Warhol produced portraits of Yves Saint Laurent from Polaroid snapshots.

Saint Laurent and Bergé moved into a duplex apartment above a garden at 55 rue de Babylone in the seventh arrondissement of Paris. There they would set up much of their collection of art and furniture.

1973
JANUARY — Spring–Summer collection
Belted shirt-jackets of leather and suede; embroidered cardigans; printed crêpe pajamas.

JULY — Fall–Winter collection
Fur-lined leather jackets trimmed with fox at neck and wrist; cardigans with herringbone embroidery of white gold or silver; pleated see-through blouses; two-color chiffon dresses.

NOVEMBER 13 — Elsa Schiaparelli died, aged eighty-three.

Saint Laurent designed the costumes for Maya Plisetskaya in Roland Petit's ballet *La Rose Malade;* for Collin Higgins's play *Harold and Maude*, produced by the Renaud-Barrault company; for Jeanne Moreau, Delphine Seyrig, and Gérard Depardieu in Peter Handke's play *La Chevauchée sur le Lac de Constance* [*The Ride Across Lake Constance*]; finally, for Anny Duperey in Alain Renais's film *Stavisky.*

He exhibited his theatrical set models and costume designs at Galerie Proscenium, 35 Rue de Seine in the sixth arrondissement.

1974
JANUARY — Spring–Summer collection
Glen-plaid pantsuit; print dresses with tie-collar [*col cravate*].

JULY — Fall–Winter collection
Artist smock coats of broadcloth; Liberty-print woolen chemise dresses.

This show was the first to be held in new premises at 5 avenue Marceau in the sixteenth arrondissement, a Second Empire mansion revamped by Victor Grandpierre (who decorated the mansion at 30 avenue Montaigne where Christian Dior opened his couture house in 1947).

"Yves Saint Laurent's Naive Chemise is the only real fashion message out of this season. . . . 'For me the chemise is an expression of freedom,' said Yves just after the show. 'I wanted to make the fabric float over and just caress the body in a sensual way.'"
Women's Wear Daily, July 25, 1974

He designed the costumes for Roland Petit's ballet *Shéhérazade* at the Opéra de Paris.

1975
JANUARY — Spring–Summer collection
Striped silk jersey dresses; first tuxedo jumpsuit of black gabardine; chiffon jellabas.

JULY — Fall–Winter collection
Tweed suits; printed silk blouses; panne velvet dresses.

He designed the costumes for Helmut Berger in Joseph Losey's film *The Romantic Englishwoman.*

Saint Laurent and Bergé bought a house called Dar el Saada in Marrakech.

1976
JANUARY — Spring–Summer collection
Chalk-stripe pantsuits; Chinese tunic; sunburst-pleated skirt.

MARCH 3 — Bergé moved out of 55 rue de Babylone; he and Saint Laurent would no longer live together. "There was the alcohol, then cocaine, then the heavy tranquilizers. Yves never came back to life. . . . I didn't leave Yves for someone else. But for myself, to save myself. . . . Yves had begun to live a self-destructive life, which I didn't want to witness. It was the period when he adored

nightclubs like Le Sept. That was his life."
Pierre Bergé, quoted in Laurence Benaïm, *Yves Saint Laurent* (Paris: Editions Grasset, 1993)

JULY — Fall–Winter collection, dubbed "Opera and Ballets Russes," presented at the Hôtel Intercontinental on rue Scribe in the ninth arrondissement, where the couture house's shows would henceforth be hosted. Preceded in April by the Saint Laurent Rive Gauche Fall–Winter collection, called "The Russian Look," this show made the front page of the July 29 issue of the *New York Times*, which hailed it as a revolutionary collection that would "change the course of fashion around the world." The quilted jackets were very popular.

"It is a painters' collection, inspired by Delacroix's odalisques, Ingres's women, van Eyck's *Woman with a Pearl*,[1] and by La Tour, Rembrandt, Degas's black-corseted ballerinas, and also by the Visconti of *Senso*, the Civil War, and von Sternberg's Dietrich. It is extremely selfish because rather than dresses I was really showing what I like in painting. For daywear, everything came from traditional cuts found in Russia, Czechoslovakia, Austria, and Morocco. That was the source of the naiveness of the cutting that, along with color, makes it youthful."
Vogue Paris, September 1976

OCTOBER 17 — Rive Gauche Spring–Summer 1977 collection
"There is a Saint Laurent mystery: the fashion world has been buzzing with the strangest whisperings in recent weeks, indeed months. . . . He is no longer seen or heard. And then on October 17 a double event turned this mystery into astonishment. First of all, his collection: . . . a marathon of a summer 1977 collection presented in a frantic whirlwind, a two-and-a-half-hour fashion show featuring 281 designs, a gigantic review and sudden gathering of every folk tradition in the world, from Spanish cigar-rollers to Tyrolean damsels via the Balkans, North Africa, and the Orient. A crazy collection that stirs passions, from the enthusiasm of the American press to the reservations of the French press, which is wondering what has happened to Yves Saint Laurent. This question became all the more pressing when the second event occurred: the designer came out to acknowledge the applause literally carried by his models, his face ravaged and haggard.

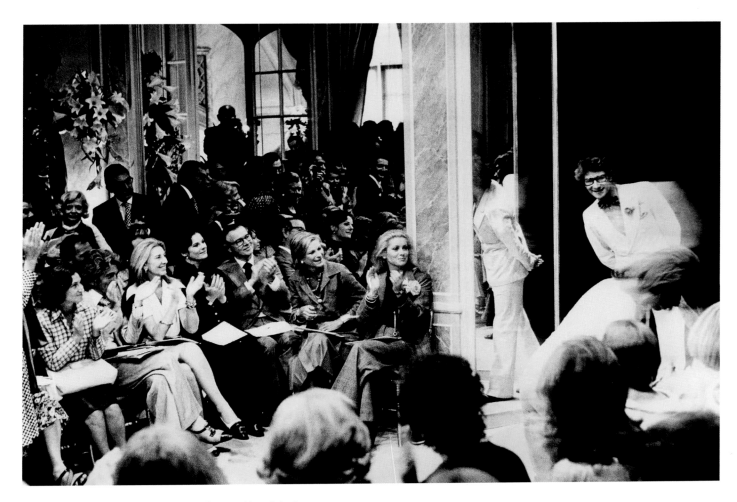

Page 81 — *Yves Saint Laurent Nu*, 1971. Yves Saint Laurent posing for the advertising of his first eau de toilette, Pour Homme. Photograph by Jeanloup Sieff.

Page 82 — Spring–Summer 1971 haute couture collection (CAT. 95).

Opposite — Fall–Winter 1976 haute couture collection, "Opéras and Ballets Russes" (detail of CAT. 121).

Above — Yves Saint Laurent at the end of the Fall–Winter 1974 haute couture show, at 5 avenue Marceau. In the first row, Nan Kempner and Catherine Deneuve. Photograph by Pierre Boulat.

Yves Saint Laurent: 'Ideas have been bursting in my head for the past several months. I'm bombarded by them. This show, which people call so long, could well have had another hundred pieces.... And yet I'm unwell, very unwell. I was already sick before the haute couture show in July, but nobody noticed. Yet I was on a drip because I was so depressed. This collection was almost entirely done in the hospital. I was only allowed out in the very last days. Afternoons. Fortunately, I knew exactly what I wanted—to the extent that the studios could work from my sketches, without having to alter a button or ribbon.... I have the feeling that the sicker I was the gayer I needed to make things. I'm not rejecting what I've done—a woman in a pantsuit is not old-fashioned next to the Spanish lady. But I wanted to demonstrate that there's more than just one way to feel good about yourself, and above all I had the feeling that the masculine aspect incarnated by the avant-garde—emancipation and freedom—was entering a bourgeois phase. I had to escape that.'
Barbara Schwarm, "Yves Saint Laurent: Je n'en peux plus," *Le Point*, December 6, 1976

Saint Laurent had interior designer Jacques Granges decorate his new apartment on avenue de Breteuil in the seventh arrondissement to create an "Antonioni-like atmosphere."
Does this new apartment—in tones of beige and brown, crisp and clean and almost impersonal—represent part of your need for change?
I need it as a haven. To be alone. I need more freedom, I can no longer go on being constantly assailed, harassed.... And I also come here to write, which has become a necessity for me, a kind of therapy. I'm writing a book that will be published in the spring, a book about myself and my deepest aspirations—I'll hardly even mention fashion. That's what's most important to me at the moment.
Barbara Schwarm, "Yves Saint Laurent: Je n'en peux plus," *Le Point*, December 6, 1976

1977
JANUARY — Spring–Summer collection, known as the "Spanish and Romantic" collection
Hussar jackets of wool, gabardine, and silk; collarette blouses; gypsy skirts of striped silk, lace, taffeta; moiré bodices.

JULY — Fall–Winter collection, known as "China and Opium"
Capes; short overcoats [*paletots*] of oilskin, damask, and embroidered velvet; taffeta pants; mink-trimmed suede boots; kimono dresses, empress dresses.

JULY — Saint Laurent's Opium scent was launched in France. A red vial, an intense, indolent, sensual perfume, and an ad campaign featuring Jerry Hall with a deadly slogan ("Opium, for women who give themselves to Yves Saint Laurent"), all devised by Maimé Arnodin and Denise Fayolle's Mafia ad agency. The American launch occurred one year later, on September 20, at a party for a thousand guests on board the *Peking* docked in New York. "[Opium] was the only name I wanted.... It's a fragrance which evokes all the things I love—the refined Orient, Imperial China, exoticism.... In Europe, Opium is not considered a negative concept in relation to the development of Orientalism as a school of thought.... Nineteenth-century aesthetes, poets, and writers knew and understood the very release of imagination, dreams and mystery it evokes.... Byron, Delacroix, Baudelaire, Rimbaud, they all understood the exotic beauty of the Orient without having traveled there. If you don't have the power of imagination, you don't have anything."
Women's Wear Daily, September 18, 1978

In the United States, Opium was as scandalous as it was popular. It triggered picket lines on Seventh Avenue, protest buttons, threats to boycott the Squibb laboratories, and a campaign to rename the scent by the American Coalition Against Opium and Drugs. Only the slogan was changed: "Women who give themselves to Yves Saint Laurent" became "Women who adore Yves Saint Laurent." Sales attained $3 million between September 1978 and June 1979.

Bergé bought the Athénée-Louis Jouvet theater in the ninth arrondissement (which he resold in 1982). "Because it was [the theater of] Bérard and Jouvet."
Pierre Bergé, interview, October 26, 2009

Opposite — Advertisement for the perfume Opium, with Jerry Hall, 1977. Photograph by Helmut Newton.

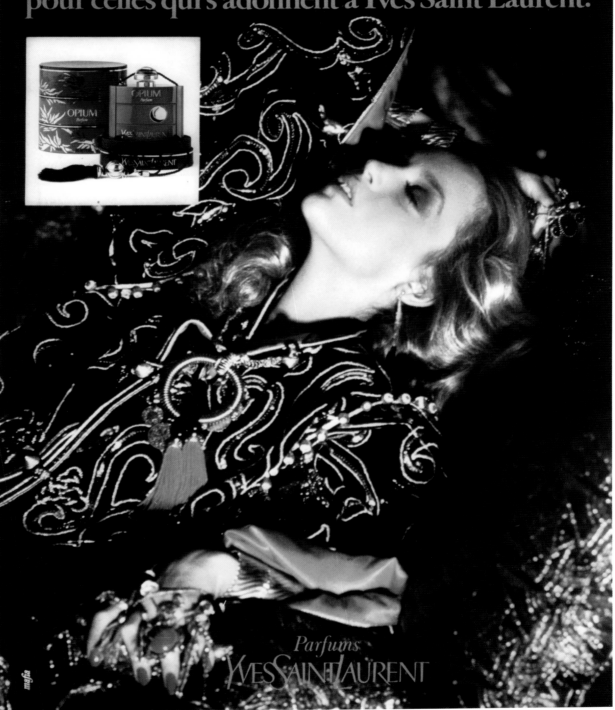

1978–1984.
ELEGANCE.
REFLECTING
THE MASTERS.

JANUARY — Spring–Summer collection, dubbed "Broadway Suit"
First spencer tuxedo of black barathea, over lacy black top.

"I was inspired by the American spirit of 'Porgy and Bess,' the attitude of the blacks in the deep South of America."
Yves Saint Laurent, *Women's Wear Daily*, January 26, 1978

"Mounia, YSL's 'Porgy and Bess' mannequin, got ovations every time she sauntered out on the runway in another version of the spencer jacket. When she finally strolled out in long black satin gloves, bowler hat with tulle veil and diamante stars, and a knee-length, black embroidered chiffon dance dress, it was like an opening night.... YSL wants the woman to decide if she's going to wear her spencer over a long or short black tuxedo skirt, tuxedo pants, or a long crepe satin or mousseline flounced skirt."
Women's Wear Daily, January 26, 1978

MARCH — Fabrice Emaer, who had run Le Sept, the nightclub on rue Sainte Anne where Saint Laurent liked to go, opened the Palace in a former music-hall theater on rue du Faubourg Montmartre in the ninth arrondissement. The club would remain the shrine of Paris night life until it closed in 1983.

MAY — Saint Laurent designed the costumes and sets for Jean Cocteau's play *L'Aigle à Deux Têtes* at the Athénée-Louis Jouvet Theater and the dress for vocalist Ingrid Caven for her concert at Pigall's in Paris.
"This is the dress that Yves Saint Laurent cut directly onto her body, in a salon of his fashion house, 5 avenue Marceau: she was waiting.... There is a man there, half in shadow, very still—small, unremark-able clothes, steady on his feet, solid calves, tight hams, back of one hand on his hips, the other hand holding spectacles. Who is he? The boss, the director, the chief doctor or the eminence grise, security or the lover, the superintendent, the Lord High Chamberlain? He observes, he watches everything, even if there is nothing to see, but there is always something to see! A trace of dust on the carpet, a cushion lying out of place on the sofa, a drape not ready, the low-born Prince now licensed to grumble: that's

him. The man settles into the shadows. Yves Saint Laurent enters, walking with his hips, dragging one leg and throwing it forward, the style Marlene Dietrich had fifty years back. He has a certain Prussian elegance, *todchic,*[2] a white shirt, followed by three assistants: three ladies, elegantly dressed, two of them holding a heavy roll of black satin. Like a surgeon in his operating theater, unblinking, he shows her the two sides of the fabric. 'Which side to you want to wear?' His voice was soft, with the charm of a tiny defect, a sort of lisp. She chose one side for its shine: it was the reverse, the wrong side. She did not do it on purpose but the truth is, she always loved the wrong side of things, the forgotten part, she was trying to show what was hidden, the wings of a stage, the sewing rooms of the world, she left the back-drop open on the pipes or the fire escape.
"Her breasts are bare, she's quite still. With a tape measure, he marks points all over her body, dozens of points, many more than the usual fitting session, almost as many as on some acupuncturist's dummy. Each part of her body seems suddenly precious to her. He rattles off numbers: distance between shoul-der blade, knees, other mysteries in figures. One of the three women silently writes the figures down in a notebook. She thinks for a moment of the picture Andy Warhol made of Yves's bulldog. He made four versions: nose, mouth, eyes, ears underlined and high-lighted with four different colors, green blue, red, yellow. She couldn't remember where she saw the beast of many colors; in *Stern* or maybe in *Vogue?* Or maybe in *Ici Paris* — she loved to read that kind of trash.
"Two of the women step forward with the heavy bale of cloth: Yves unrolls some meters of satin and throws them over Ingrid's shoulder. The three ladies' maids advance, retreat, sometimes on the diago-nal, likes chess pieces move one, two, three squares. He has taken a double thickness. And now: he starts to cut. The three maids, from a distance, have their eyes fixed on the silver scissors. He hacks the satin briskly, there is something iconoclastic, even brutal, but also sensual. The noise of metal is echoed by a silky whisper. She looks straight ahead, naked in front, her back covered in black fabric that he holds bunched together in his left hand....
"He cut in silence, an inch from the breasts of his impassive model, like some micro-surgeon making brilliant cuts in skin. Was something not working? He was suddenly

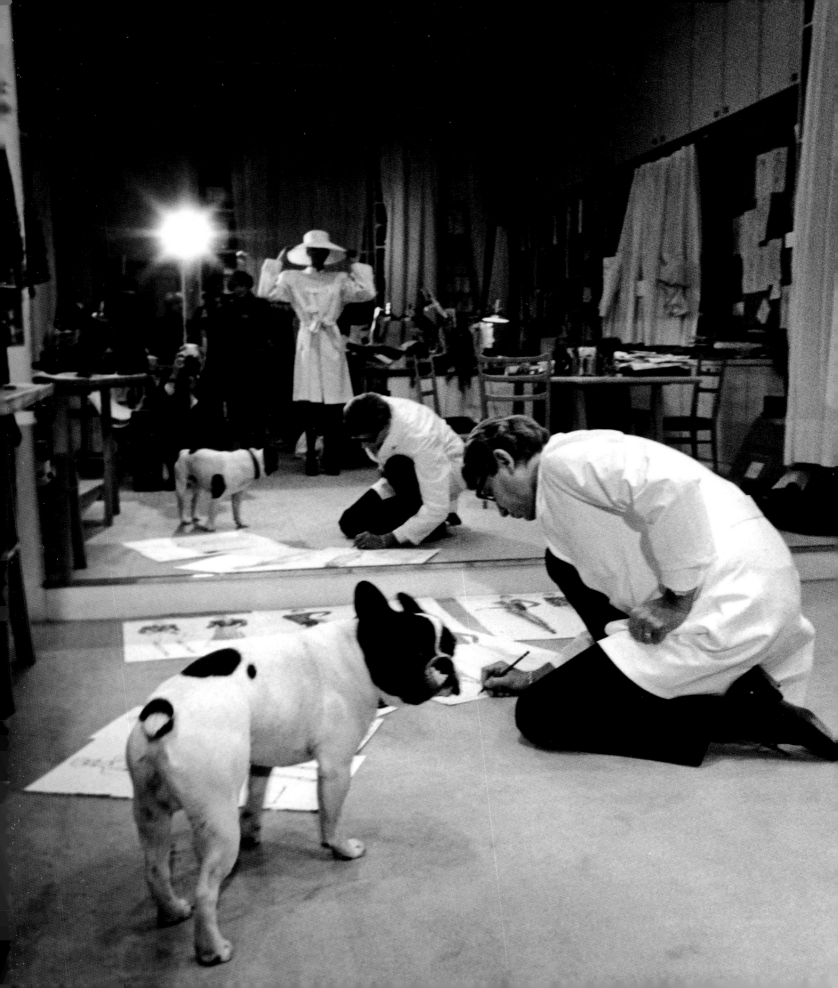

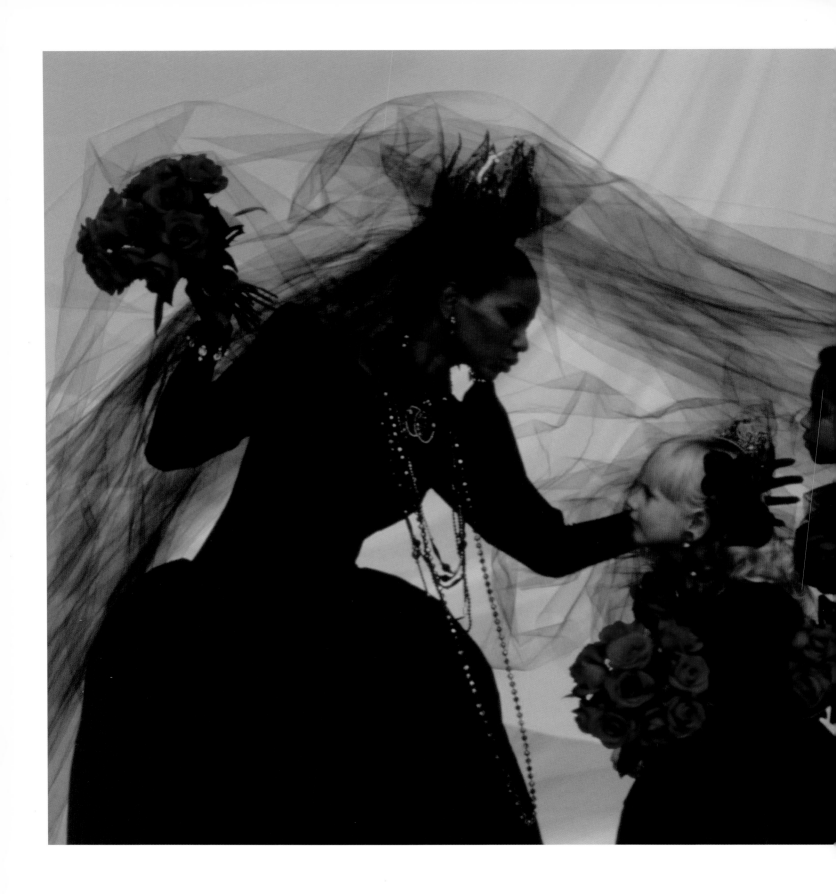

Page 89 — Yves Saint Laurent
before his collection sketches,
with his dog Moujik, in the studio
at 5 avenue Marceau, 1982.
Photograph by Pierre Boulat.

Left — Wedding dress from the
Fall–Winter 1981 haute couture
collection, American *Vogue*,
September 1981. Photograph
by Arthur Elgort.

frowning, mouth pursed, either disgusted or afraid, just like a furiously concentrated surgeon, wrinkles around his mouth: like the bulldog.... Then it passed ... sometimes something alien does pass over our faces, we're occupied for a moment by a dog, an enemy, or death itself. As he cuts, the two ladies' maids come forward with their load of satin so he can pull on the cloth, he has his nose in it, friction from the ends of his hooked fingers.... It was soon finished and all the women were around him. They formed a tight group, the four of them, some esoteric bunch of avant-garde *artistes:* a singer, one-third naked, the three ladies' maids in their frocks, with the frockmaker surgeon prince in the very middle of the empty and enormous room. Abruptly, Yves the magician began to open and organize the cloth on the body, like some paper-cutting game for children, or the origami of the Japanese: a paper flower that opens and unfolds in water. The women, arms empty now, stood back to judge the effect: from the front, a kind of melted, ruffled armor, with long cuffs that were tight and then flared out around the wrist, a kind of doublet above that was molded to her, which made her seem entirely invulnerable. From behind, it hardly held together at all—'A successful dress,' he told the magazine *Elle,* 'has to look like it might fall off at any minute'—with the *décolleté* split down to the hips an inch too far—he knew just where he could go too far. A fine thread, stretched above the shoulder blades, closed the dress with a tiny hook. On both sides of the spinal column there were great flourishes of cloth that went down to the ground—like the winged crests of the huge Jurassic lizards, the dorsal plates of a stegosaurus: an almost affected kind of mannerly dress, contradicted by exact, sharp cuts. The result of a struggle. You could see all this at once, just as the dress was made all at once. The dress was like the fabric of his mind, which is what 'style' means. You find this mix of death and fashion also, oddly enough, in the rough districts of Marseilles. *Sapé à mort,* you hear, a southern take on Prussian *todchic,* which is how with the help of a phrase Erich von Stroheim and Marlene Dietrich come to resonate just a little with the show-off hooligan charmers of the *Belle de Mai, la Joliette, la Rose: 'Hey! Bitch! Slut! The gear's to die for!'* a sudden guest appearance on the Canebière by the Blue Angel and the Man You Love to Hate."
Jean-Jacques Schuhl, *Ingrid Caven,* trans. Michael Pye (San Francisco: City Lights, 2004).

JULY — Fall–Winter collection
Velvet jackets embroidered with dots or stars; lamé damask dresses with flame or shell patterns; velvet cloaks and dresses embroidered with flowers.

"High Chic has hit Paris. The French couturiers have come up with a new shape and a new attitude to go along with it—a glamorous approach to fall dressing which means wider shoulders, body-conscious lines, and shorter lengths."
Women's Wear Daily, July 25, 1978

"This collection is highly elegant, provocative, and at the same time incredibly modern, which may seem contradictory. I was seeking purity, but added unexpected accessories such as pointed collars, little hats, and tassel shoes. They were intended as humorous little nods to haute couture—adapting street irony in a more appropriate spirit, giving it the same sense of freedom you sense in the street, that same provocative, arrogant side you get from punk fashion, for example. All with dignity, style, and lavishness, of course."
Yves Saint Laurent par Yves Saint Laurent (Paris: Herscher/Musée des Arts de la Mode, 1986)

1979
JANUARY — Spring–Summer collection
White gabardine pants suits; white chiffon blouses; tunics; black silk jersey pants; spencer jackets; satin sheath dresses.

"In a season where SHAPE has become the most important trend coming out of Paris, YSL goes against the current. Privately, Yves St. Laurent says, 'It's time for me to be quiet and rework my own classics. After all these years, the pause is essential and this moment is right for quiet fashion. Why should there be a new idea every minute?'"
Women's Wear Daily, February 2, 1979

JULY — Fall–Winter collection, "A Tribute to Picasso & Diaghilev"
Suede patchwork harlequin jackets; moiré Picasso jacket; ballerina's dresses; velvets, taffetas, tulle.

1980
JANUARY — Spring–Summer collection
Printed silk crêpe dresses; gabardine suits; coral-embroidered satin dresses.

JULY — Fall–Winter collection, "A Tribute to Apollinaire, Cocteau, & Aragon"
Evening ensemble embroidered with the words *Tout terriblement* ("Entirely intensely"), inspired by a poem by Guillaume Apollinaire.

Saint Laurent designed the sets and costumes for Jérôme Kilty's play *Cher Menteur,* adapted by Jean Cocteau for the Athénée-Louis Jouvet Theater, starring Edwige Feuillère and Jean Marais.

Saint Laurent and Bergé bought Villa Oasis and the large Majorelle garden, which once belonged to artist Jacques Majorelle.

1981
JANUARY — Spring–Summer collection
Chalk-striped woolen suits; printed silk blouses; boater hats; printed gold lamé dresses.

JULY — Fall–Winter collection, "Inspired by Matisse & Fernand Léger"

He designed the uniform for Marguerite Yourcenar's induction as the first female member of the Académie Française.

"Hôtel Ritz
13 Place Vendôme
Paris
April 5, 1982

Dear Mr. Saint Laurent,
I have only met you once or twice, relative to a wonderful present that I have not forgotten, but on returning from Morocco I wanted to express my thanks for the Majorelle garden and for your perhaps excessive generosity in opening it to the public, at least when you're not there. I myself have strolled there many a time, and it is one of the best memories, by far, of my latest stay in Marrakech. Gardens have their own style, as do books, clothing and jewelry. This one creates a unique harmony.

Yours sincerely,
Marguerite Yourcenar"

Saint Laurent designed the Kouros fragrance for men.

1982
JANUARY — Spring–Summer collection
Gabardine and baratahea spencers; draped belts; lamé turbans and suits; Indian-style embroidered boleros.

"After this 'recapitulative' show (which nevertheless had a '1982' twist, namely a Chanelizing, jaunty bourgeois trend) ... there finally surfaced a sense of one individual's pleasure, of someone behind these limpid, smashing dresses molded in black or

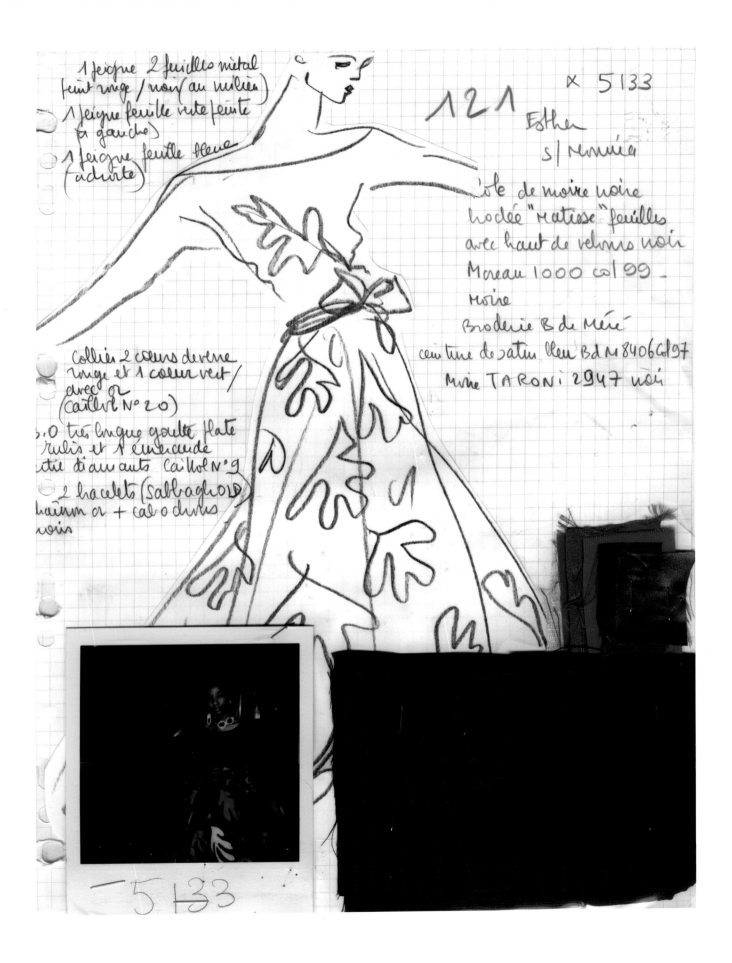

1 seigne 2 feuilles métal
feint rouge / noir (au milieu)
1 seigne feuille verte peinte
(a gauche)
1 seigne feuille bleue
(a droite)

Collier 2 coeurs devene
rouge et 1 coeur vert /
avec or
(Cartier N° 20)

.0 très longue goutte plate
rubis et 1 émeraude
etie diamants Cartier N° 9

2 bracelets (Sabbagh or)
chaine or + cabochons
noir

121 X 5133
Esther
S/ mémoire

'ôle de moire noire
hodée "matisse" feuilles
avec haut de velours noir
Moreau 1000 col 99
Moire
Broderie B de Méré
ceinture de satin bleu Bd M 84064197
Mme TARONI 2947 noir

5133

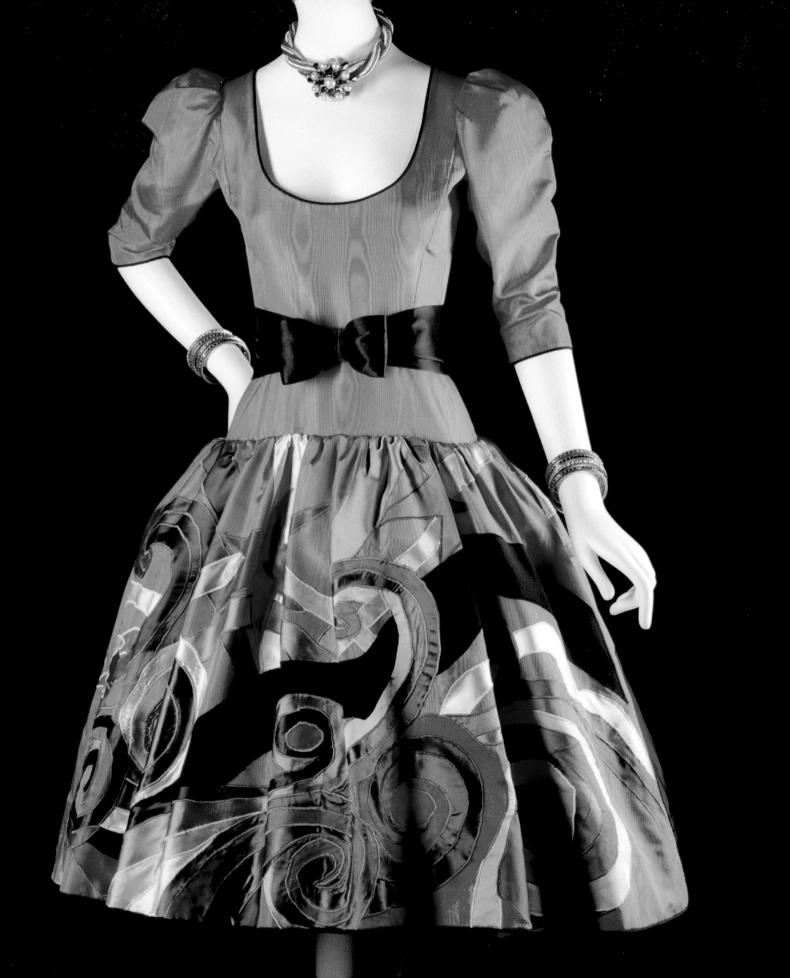

navy satin with a fluid drape and movement that is triggered with every sway of the hips by an evil diamond brooch clutching the bolt of cloth tossed—still alive—over the model."
Michel Cressole, *Libération*, January 28, 1982

JANUARY 29 — The fashion house celebrated its twentieth anniversary at the Lido nightclub in Paris. Saint Laurent received the International Fashion Award of the Council of Fashion Designers of America from the hands of Diana Vreeland. "Most famous women wore black Saint Laurent outfits. Film star Catherine Deneuve wore a spencer tuxedo suit, and jewelry designer Paloma Picasso dressed up with red jeweled shoulders and crown."
Associated Press, February 3, 1982

JULY — Fall–Winter collection
Long hussar cloak; leather suits; barathea jackets with trimming; pillbox and other hats.

1983
JANUARY — Spring–Summer collection
Wide-shouldered, nip-waisted jackets; scale-embroidery dress; short overcoat [*paletot*] of gold leather.

JULY — Fall–Winter collection, titled "Paris"
Silk poplin raincoats; hound's-tooth suit; yellow *domino* cloak; Japanese dress.

DECEMBER 4 — The scent called Paris was launched.
"Your fragrance riveted me there, next to a tree. I'll never forget it. Maybe we'll meet again someday. There are countless places in Paris where I might see you again, where I could clutch your roses to my breast. Our roses. The most beautiful roses. Or maybe you were just an excuse for me to achieve my dream of giving Paris its own perfume. Glamorous, dazzling Paris—your glitter and your fireworks continue to set the world alight. For this new scent, I chose your name. Because nothing is more beautiful, because I love you so completely. My *Paris*."
Yves Saint Laurent, 1983

DECEMBER 14, 1982–SEPTEMBER 2, 1984 — The Costume Institute of the Metropolitan Museum of Art in New York, headed by Diana Vreeland, hosted the museum's first retrospective devoted to a living designer: *Yves Saint Laurent, Twenty-Five Years of Design*.
"I like to think that the Maid of France, Jeanne d'Arc, is his real inspiration—young and charming, defiant and brave. Yves has done special things for certain clients—actresses, beauties of great name—but the Maid of France is his real ideal—the young French girl, Jeanne d'Arc or a *midinette* walking to work in the rain or the spring sunshine in Paris, wearing a shirt and pants. A girl in America, in Japan, in Germany would rather look like the girls in the streets of Paris than anyone else. The French girls just happen to look wonderful: they are built differently, and in blue jeans, for instance, they look sharp and chic. Yves Saint Laurent has a 50-50 deal with the street. Half of the time he is inspired by the street, and half of the time the street gets its style from Yves Saint Laurent."
Diana Vreeland, *Yves Saint Laurent*, 1983

"The Yves Saint Laurent retrospective … shows that a designer can also be—*must* also be—a geometer, a vehement soul with an inexhaustible capacity to love, an illusionist, a child, an astronomer, a genius and a fool, a Sunday (or nocturnal) author, a copycat, an animal tamer, a fairground barker, a clairvoyant. And that women don't want to resign themselves to being just a woman, but want to be saints and harpies, huntresses and lionesses, virgins and courtesans, indeed men, or else countesses and wenches, clowns and spies, or even a quiet young woman beneath a wide-brimmed hat or gray fedora, or a great, immobile traveler."
Hervé Guibert, *Le Monde*, December 8, 1983

He designed the costumes for Marguerite Duras's play *Savannah Bay* at the Théâtre du Rond Point in Paris.

Saint Laurent and Bergé bought Château Gabriel at Benerville-sur-Mer on the Normandy coast of France, where the designer henceforth spent every August. Each bedroom was named after a character from *Remembrance of Things Past* by Marcel Proust, who allegedly met his publisher, Gaston Gallimard, there. Saint Laurent occupied the Swann bedroom, Bergé the Baron de Charlus's room.

There was a new entry in Larousse's encyclopedic dictionary: "Saint Laurent, Yves. French fashion designer born in Oran, 1936. Famous for his original interpretations of everyday garments (pea jacket, pantsuit, etc.), his stylistic rigor, and his talent as a colorist."

Page 93 — Sketch for a dress in the Fall–Winter 1980 haute couture collection, tribute to Henri Matisse.

Opposite — Fall–Winter 1979 haute couture collection, tribute to Pablo Picasso (CAT. 187).

1984–1994
MADAME DE STAËL: "FAME IS A GLITTERY BEREAVEMENT FOR HAPPINESS."

1984
JANUARY — Spring–Summer collection
Pantsuits of colored gabardine; printed silk blouses and belts; white organdy blouse; chiffon dresses. Bridal outfit with pants. A new look at the classics.

JULY — Fall–Winter collection
Fox coats; jersey jumpsuit; tuxedo with colored lapels and cuffs; cameo-embroidered boleros; blue faille *domino* cloak.

1985
JANUARY — Spring–Summer collection
Trench coat; snake-print dresses; lamé chiffon dresses.

MARCH 12 — Saint Laurent was made a knight of the Légion d'Honneur by French president François Mitterrand.

MAY 6 — He went to the opening of a retrospective hosted by the Palace of Fine Arts in Beijing, *Yves Saint Laurent 1958–1985.*

JULY — Fall–Winter collection
Broadcloth and satin-leather coats; wool jersey tunics; Mao-collar jackets; pants tuxedo.

OCTOBER 23 — Saint Laurent was awarded a Fashion Oscar at the Paris Opera House [Palais Garnier].

He designed the costumes for Isabelle Adjani in Luc Besson's film *Subway.*

1986
JANUARY — Spring–Summer collection
Jackets in black-and-white shepherd's check; large boaters; snake and crocodile embroidered jackets; asymmetrical and draped satin dresses.

JULY — Fall–Winter collection
Silver-fox-lined suede coat; silk faille trench coat; panther-print silk lamé dresses; panne silk-lamé sari dresses.

Bergé and Saint Laurent joined with Carlo de Benedetti to buy Charles of the Ritz, owner of Parfums Yves Saint Laurent.

An exhibition titled *Yves Saint Laurent: 28 Ans de Création* was hosted first by the Musée des Arts de la Mode in Paris (May 30–October 26), followed by the Tretyakov Gallery in Moscow (December 1986–January 1987; 240,000 visitors), and then the Hermitage in Leningrad (now Saint Petersburg; February–March 1987).

1987
JANUARY — Spring–Summer collection
Wide-shouldered whipcord suits; miniskirts and minidresses.

"Wednesday, late morning, at Saint Laurent's Hôtel Intercontinental show—today's rumor is that Yves Saint Laurent is tiring of haute couture and is ready to shift his talents to a single, upscale ready-to-wear line. Perhaps in anticipation of this shift … instead of the two-hundred-some designs usually presented, here we saw 'only' ninety-seven.... What hasn't changed, though, is Saint Laurent's overwhelming superiority. Which we will never stop asserting."
Gérard Lefort, *Libération,* January 31/February 1, 1987

FEBRUARY 22 — Andy Warhol died.

MAY–JUNE — An Yves Saint Laurent retrospective was held at the Art Gallery of New South Wales in Sydney, Australia.

JULY — Fall–Winter collection
Fur-lined, fox-trimmed suede coats; satin leather suits; feather dresses, felt fez.

OCTOBER — Saint Laurent Rive Gauche Spring–Summer 1987 collection, "A Tribute to David Hockney"

1988
JANUARY — Spring–Summer collection, "Cubist Collection: A Tribute to Braque"
Van Gogh jacket.

JULY — Fall–Winter collection
Silk faille raincoats; pants tuxedos; tuxedo dresses; long-skirted tuxedos; grape-embroidered jackets and capes "in tribute to Bonnard."

AUGUST 31 — French president François Mitterand appointed Bergé to head the Paris Opera Houses.

SEPTEMBER 9 — Saint Laurent was the first designer to participate in the French Communist Party's annual *Humanité* festival by showing 180 designs.

NOVEMBER 8 — The designer's father, Charles Matthieu-Saint-Laurent, died at age seventy-nine.

Yves Saint-Laurent et la Photographie
(Paris: Albin Michel, 1988) was published
with an introduction by Marguerite Duras.

"*The Sound and the Silence*

He is childlike. He is tall. Alto. A man
from Oran with white skin. One day they
came into the great hall of the Rond-Point
[Theater] during a Savannah Bay rehearsal,
Pierre Bergé and he. We heard nothing—
neither the door nor the footsteps. Suddenly
they were there, two meters away from us.
They were silent, discreet, but their presence
was of kings.

"I know him only slightly. We've spoken two
or three times, of theater dresses, colors,
fabrics, of the deep red velvet of a certain
gown. Once he talked of my books.

"He's an intimidating man, more so, surely,
than most—more so than any doctor
or actor you will meet. Yet he's shy and
vulnerable, too.

"He looms up, putting his face with its
naked, inscrutable smile close to yours—and
nothing in that look suggests the power of
the man. There is no hint of pretense or
play-acting. One is simply overwhelmed. It
is too much all at once, this bodily presence.

"The look on Yves Saint Laurent's face cannot
be described. It is unbearably sweet and sad,
yet in its quality of infinite solitude it can
make itself masterful.

"He sees in you what you cannot see: your
own mortality. This is the point where all
begins for the man from Oran.

"That look! He looks at what he sees, and
(like all the world) sees with eyes open, just
as he sees with eyes closed—around him,
near him, far and beyond. Only observe the
result.

"I cannot but believe that for Yves Saint
Laurent the act of creation is a sort of sleep—
blinding, deathly, dark; it is the night of the
body. Call it a void—the soul of inspiration.
When in photographs or on television I see
Yves Saint Laurent smile, talk to famous
people, I tell myself: 'Voilà! They've woken
him again!'

"I will always see him as a writer. His work
is not of words, yet I think of it as of the
written word; for where the intellect is
finest-tuned, silent, it sets itself to writing.
He finds in each one of us a whole world to
embrace.

"The whole of life, or life's detail—it's all one
to Yves Saint Laurent: a crowd, a man, a
throng, a desert, a person before him, an
empty set. Like a writer, each day is as the
first. Like the text which owes its meaning to

a single comma, his world hangs by a comma
also; undone, to be re-begun.

"Let me explain again: he sees each of us as
part of an 'everyone'—the lost one, drowned
by the man. 'But,' you will tell me, 'we all see
ourselves and others thus. . . .' Yes, that's it.

"He sees in you what you don't know you
have. What you thought you had he doesn't
look at, because you don't have it. You never
had it. He takes you apart. He reaffirms your
mortality. You feel nothing, you let it happen,
because in his relationship with you, in the
course of this exchange that he is orchestrat-
ing between you and yourself, you are going
through a sacrificial process. He and you.
He distorts your bodily self. You thought
you were not beautiful, yet from your very
longing to be so, he draws a new beauty. This
is your transformation for eternity.

"There is a woman, he is here. He draws, and
there is a the woman—dressed.

"I tend to believe that the fabulous univer-
sality of Yves Saint Laurent comes from
a religious disposition toward garnering
the real, be it man-made—the temples of
the Nile—or not man-made—the forest of
Telemark, the floor of the ocean, or apple
trees in bloom. Yves Saint Laurent invents
a reality and adds it to the other, the one he
has not made. And he fuses all of this in a
paradoxical harmony—often revolutionary,
always dazzling. Yes, this is it: he makes daz-
zling explosions of stuff.

"He makes a dress. He puts a woman in that
dress in the middle of desert sands, and it
is as though the desert had been waiting for
that dress. The dress was what the desert
demanded—it speaks volumes.

"When a dress of Yves Saint Laurent's
appears in a salon, or on television, we
cry with joy. For the dress we had never
dreamed of is there, and it is just the one
we were waiting for, and just that year. We
are the desert that was waiting for the dress,
and thus each day we wait for the moment
of truth.

"To put it another way, it's incredible to
be recognized to this degree by the entire
world, including those who will never have
access to Yves Saint Laurent's clothes. Year
after year he creates what we knew (though
we didn't know we knew it) we wanted.
Imagine that!

"The price of a dress has nothing to do with
the dress itself (nor has the price of a paint-
ing to do with the painting—remember
how the theft of Monet's *Sunrise* cut to the
quick?) With prêt-à-porter, elitism in high

fashion is no longer an issue. Yves Saint
Laurent women are made in the harm, the
château, on the edges of cities . . . they are in
the streets, the Métro, Prisunic, the Bourse.

"As for Yves Saint Laurent himself, it would
seem that the adoration of which he is the
object is of no importance to him—it is, after
all, nothing to do with him (I hear him say).
What is hardest of all to put into words is his
attitude of self-disregard. He's one of those
people who are attracted by the sublima-
tion of the self, drawn to the annihilation
of that certain part of the self which they
themselves do not name, but others call life.
More than that I will not say—it cannot be
expressed.

"The look again: it's his—uniquely, absolutely
his (and that's not lightly said). He sees a
woman, a man, a garden, a prison, the ocean,
a photograph of Auschwitz, the laughter of
a child: no analysis, no reflection on these
things that touch his life so closely. He does
not speak of good and bad. The particular
and the general—it's all one to him; he
embraces the whole with its good and its
bad, or he leaves the whole aside. And I
think that he's right (though he may not
know he is right) to gather it all up or leave
it all behind. Humanity must take upon
itself every crime, every smile. All must be
assumed. Without this—no writer. No Yves
Saint Laurent.

"It is like a road. From the night of the intel-
lect comes forth a road, and to start the
journey down that road one word is needed,
or two: 'hips,' let us say, and 'strut.' Then
the hips sway into motion along the road
and the rest comes after: legs, arms, the top
of the body—they rise out of those sinuous
hips swathed in pink, the rest black or a wild
blue or a secret red they call amaranth, from
Cayenne, like the flowers of the same name,
like people, like Rimbaud, like Mozart.

"Sometimes I call Yves Saint Laurent by the
name of another man. It happens in winter,
at night, there is snow, and from behind a
wall, and across time, someone who is not
sleeping composes music to be sung.

Marguerite Duras, "Summer 1987," published in
an anonymous English translation in *Yves Saint
Laurent and Fashion Photography* (New York: Te
Neues, 1999)

1989

JANUARY — Spring–Summer collection
Barathea pantsuits; shantung blouses; sailor's
smocks [*marinières*]; brocade dresses and skirts.

Shares in the Yves Saint Laurent Group were offered on the over-the-counter market at the Paris Bourse.

SEPTEMBER — A show of Saint Laurent theatrical costumes was held in Leningrad.

A dacha was built on the grounds of Château Gabriel.

1990
JANUARY — Spring–Summer collection
White cotton duffle coat; pea jackets [cabans]; pantsuits; hooded silk dresses; printed damask dresses; dresses of satin, tulle, and sequins; tributes to—among others—Marilyn Monroe, Catherine Deneuve, Zizi Jeanmaire, Marcel Proust, and Bernard Buffet.

JULY — Fall–Winter collection
Woolen and suede coats; panther-embroidered dresses; feather cloak; tiger-print chiffon dresses.

NOVEMBER–DECEMBER — The Sezon Museum of Art in Tokyo presented *Yves Saint Laurent 1958–1990.*

1991
JANUARY 24 — Bergé, in *Le Nouvel Observateur,* wrote, "Haute couture is terminally ill."

JANUARY 30 — Spring–Summer collection
Barathea suits; bermuda suits; coats; raincoats; hooded dresses.

"Saint Laurent is the same as usual, which means being new while remaining constant, modern without rejecting classicism: in short, everything we like when Saint Laurent moves comfortably from pea jacket to duffle coat, from raincoat to cape, from safari jacket to pleated skirt. Even if you have to get used to the idea that evening wear means going out nearly naked (though veiled by lace-embroidered mousseline), there is not an ounce of bluff or showoff, not a line that doesn't fall exactly where you least expected it, not a color that is not a perfect red or faultless cobalt. In short, it's cool, controlled, imperial. You can take it or leave it. We'll take it."
Marie Colmant and Gérard Lefort, *Libération,* January 31, 1991

JULY — Fall–Winter collection
Suede coats, pants, and chasubles; wool jersey jogging outfit; corset dresses [guêpières].

JULY 11 AND 15 — An interview with Saint Laurent published in *Le Figaro* newspaper was titled, "The great designer tells all, for the first time." Never before had he mentioned his homosexuality in the media.

1992
JANUARY 3 — The thirtieth anniversary of the Yves Saint Laurent fashion house was celebrated at the Paris Opera House [Bastille]. At this time, employees of the fashion house numbered three thousand worldwide.

JANUARY — Spring–Summer collection
Cotton sateen dress embroidered with flowers or fruit; sequin-embroidered jackets and dresses; silk oriental-dancer dresses [bayadères]; tribute to Matisse in Morocco.

JULY — Fall–Winter collection, "Brassiere and *Redingote* Suit"
Fitted coats [redingotes] of corduroy or lamé brocade; *redingote* tuxedo pantsuit; lacy and sequined bras; bare-backed tuxedo dress; multicolor satin dresses.

1993
JANUARY — Spring–Summer collection
Spencer pantsuits; rose-printed chiffon dresses; satin dresses.

MAY 17 — The sale of the Yves Saint Laurent Group to Elf-Sanofi was approved by shareholders of both firms during their annual general meetings. Saint Laurent and Bergé retained ownership of the haute couture house.

JUNE 7 — Champagne perfume was launched, aimed at "happy, lively women who sparkle." In France, a lawsuit by the champagne winegrowers' association resulted in the renaming of the scent, which became simply Yves Saint Laurent and later Yvresse. In the United States, the Champagne name was retained.

JULY 2 — Bergé was named a "goodwill ambassador" by UNESCO.

JULY — Fall–Winter collection
Velvet jackets; knickerbocker suits with vest, "in tribute to Oscar Wilde"; dresses with "see-through breasts."

The first biography of Yves Saint Laurent, written by Laurence Benaïm, a journalist at *Le Monde,* was published in France.

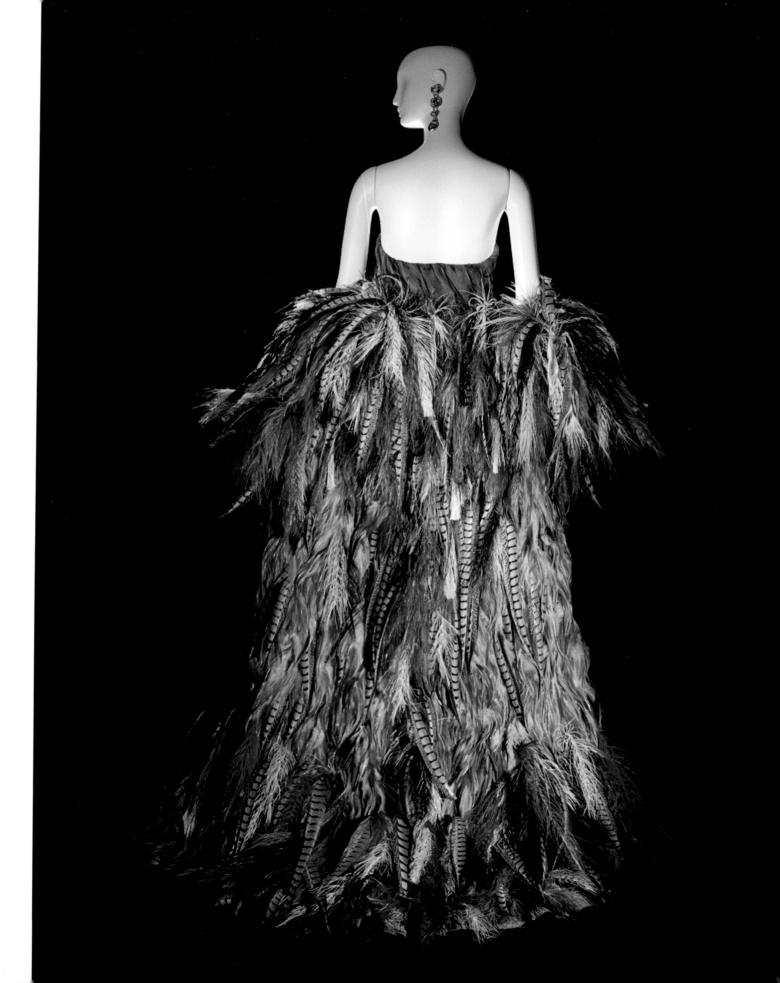

ELLE

N° 2230

POURQUOI CRAQUE-T-ON POUR LES HOMMES FAIBLES?

CATHERINE DENEUVE : UN RÔLE EN OR DANS SON NOUVEAU FILM

M 1648 - 2230 - 10.00 F

SOMMAIRE PAGE 3 HEBDOMADAIRE. 3 OCTOBRE 1988.

BEL 71 FB. NL 5,75 FL. GB £ 1,50. SUI 3,70 FS. ALL 6 DM. CAN $ 3,50. ITA 5 300 L. ESP 350 PTS. PORT 220 ESC. GRE 350 DR. MAR 10 DH. TUN 1700 MIL. ANT REU 16 F. GAB 1200 F CFA. CÔTE D'IV 995 F CFA. USA : N.Y. $ 2,95 OTHER $ 3,25.

Opposite — Catherine Deneuve in a gold leather trench coat from the Fall–Winter 1980 haute couture collection, cover of *Elle* (France), October 3, 1988. Photograph by Bettina Rheims.

Right — Yves Saint Laurent before his haute couture production boards.

1994–2002.
A COLLECTION
IS FOREVER.

1994

JANUARY — Spring–Summer collection
Pantsuits; white piqué and navy dress; fringed, pearl-embroidered dresses.

JULY — Fall–Winter collection
Short overcoat [*paletot*] of crocodile leather with hip-high boots; plaid wool suits; miniskirt tuxedo; mandarin coats; printed chiffon dresses. **This was a collection "whose structured look, classic tailoring and opulent Saint Laurent color palette seemed the apotheosis of the current obsession with glamour."**
Women's Wear Daily, September 12, 1994

1995

JANUARY 1 — Saint Laurent was promoted to the rank of officer of the Légion d'Honneur.

JANUARY — Spring–Summer collection
Cinch-waisted pantsuits; Salomé shoes; trompe-l'oeil tuxedo dresses; gazar jackets; organza and lamé dresses with butterfly patterns; butterfly prints.

JULY — Fall–Winter collection
Pea jackets [*cabans*]; safari jacket; panther-print chiffon dresses; black lace dresses; Infanta dresses.

The "Yves Saint Laurent *Smoking* [Tuxedo]" was listed as a "holiday guest" in the Winter 1995–96 catalog of the large mail-order clothier La Redoute. It was priced at 1,400 francs for the jacket and 500 francs for the pants, as compared to roughly 15,000 francs in the Rive Gauche boutiques.

1996

JANUARY — Spring–Summer collection
Linen jackets; printed silk dresses; short suit; draped silk jersey dresses; short fox-lined overcoats in pink or blue, or with ostrich feathers; a return to the "Forties" look of the Spring–Summer 1971 collection; first safari tuxedo.

"The hair, the wide shoulders, the silken legs—all in a double tribute to Hollywood stars and to his famous 'Liberation' collection, revisited for one endless season. . . . To the strains of Glenn Miller and the Andrew Sisters, [Saint Laurent] managed to convey the spirit of an era through his dresses, which here embody what they have always inspired in him. 'Never were women more attractive in films and photos. Because they seemed free, determined, happy. And maybe because they were expecting a rosy future, which lit up their eyes and made their high heels drum gaily—[after war-time shortages] they were thrilled to rediscover silks, colors, the joy of dressing up and the pleasure of pleasing. Like me, they couldn't give a damn about fashion with a capital F.'"
Laurence Benaïm, *Le Monde,* January 28, 1996

JULY — Fall–Winter collection
Jersey or wool crêpe chemise dresses; printed silk blouses; pant tuxedos; dresses in velvet and satin; embroidered lace dress; short, rooster-feather coat; sable and velvet cloaks.

1997

JANUARY — The Association pour le Rayonnement de l'Oeuvre d'Yves Saint Laurent (Society for the Promotion of Yves Saint Laurent's Oeuvre) was founded.

Spring–Summer collection
Pantsuits; draped belts; printed chiffon dresses; tuxedos; asymmetrical, draped satin gowns.

"At the age of sixty, Yves Saint Laurent is old enough to be the father of Alexander McQueen and John Galliano, the two Britons who have transformed French *haute couture* this week. But he still knows how to keep his loyal clientele happy. . . . Saint Laurent's sixty-two-piece collection was paraded to the soundtrack of the new Woody Allen comedy, *Everyone Says I Love You,* the opening scenes of which were filmed in the YSL New York boutique. The designer paid tribute to the 'party town' with a Monroe-style halter-neck gown in gossamer-light silk mousseline, and a fringed and sequined disco dress that was pure Studio 54."
Hillary Alexander, *Daily Telegraph,* January 23, 1997

JULY — Fall–Winter collection
Sable and mink coats; fox fur hats; wool crêpe dresses; lamé tunics and pants in tiger or panther prints; velvet gowns embroidered with gems, evoking the court of France's Valois kings and its portraitist, François Clouet.

SEPTEMBER 26 — Yves Saint Laurent opened his first boutique in Moscow.

1998

JANUARY — Spring–Summer collection
Gabardine and barathea pantsuits; shantung tunic and skirt; short, satin coat; shantung coat; white spencer with black pants; satin dresses.

Detail of the cork board behind
Yves Saint Laurent's table in the
studio at 5 avenue Marceau, 2002.
Photograph by Alexandra Boulat.

MARCH — The International Fashion Photography Festival featured a show of designs by Yves Saint Laurent as viewed by twenty-four photographers.

Saint Laurent stopped designing the ready-to-wear collections for Yves Saint Laurent Rive Gauche.

JUNE — Albert Elbaz was named artistic director of the ready-to-wear line.

JULY 12 — In a prelude to the final soccer game of the World Cup, three hundred designs were paraded through France's national sports stadium as two billion television viewers looked on.
"It isn't really like a fashion show. The dresses were designed for this particular event.... We selected the most spectacular—but not necessarily the most important—designs from Saint Laurent's entire career. There were no pantsuits, or pea jackets.... It reflected forty years of successful achievement by Yves Saint Laurent—we were associating ourselves with victory and fame.... There could be only one winner in the World Cup Final, held in the Stade de France, but that winner was preceded by another winner—Saint Laurent. That was the story, straight out of ancient history: the three hundred most beautiful women in the world, drenched in gold, silk, and light, dressed by Saint Laurent, accompanied the gods of the stadium, just like ancient warriors."
Pierre Bergé, *Paris Match*, July 16, 1998

JULY 22 — Fall–Winter collection
Cashmere coats; tuxedos; spencer pantsuits; dresses of velvet, lace, and chiffon; fox and ostrich overcoats [*paletots*]; black velvet and satin dresses; white mink coat.

"The first item was a study in gray flannel trousers. Over fifteen others followed among the next seventy pieces, including a racy jumpsuit in silver lace. Saint Laurent is the master, among other things, of pants for women, taking Dietrich's silver-screen tuxedo and letting it run the streets as a feminine garment. Opening his show with trousers also constituted a manifesto: the perfect chromosome for Yves Saint

Laurent's fashions is no longer really an X or a Y, but something more like an XYSL chromosome."
Olivier Séguret, *Libération*, July 24, 1998

1999
JANUARY — Spring–Summer collection
Chiffon blouses to accompany whipcord pantsuits, wool crêpe short suits, and tuxedos; lace and chiffon dresses, a new paean to the female body via transparency and nudity with a bridal gown stripped down to garlands of roses worn by Laetitia Casta (evoking the garlands of white camellias worn in the Spring–Summer 1967 collection, as photographed on Twiggy in the June 1967 issue of *Vogue Paris*).

JULY — Fall–Winter collection
Crocodile jackets; tuxedo cape; chiffon tuxedo dress; Romanian-style embroidered blouses of wool etamine.

Elf-Sanofi sold the Yves Saint Laurent Group to Gucci.

2000
JANUARY — Spring–Summer collection
Pea jackets [*vestes-cabans*]; pants; tank tops; safari suits; low-waisted fringed skirts with lace tops; gypsy dresses.

JULY — Fall–Winter collection, dubbed "Tout Terriblement Apollinaire" (Entirely Intensely Apollinaire)
A classic collection, perhaps explaining the title "Tout Terriblement," a phrase that first appeared on a cape dress from the Fall–Winter 1980 collection, taken from a poem of shaped verse by avant-garde poet Guillaume Apollinaire.

JULY 14 — Saint Laurent was promoted by French president Jacques Chirac to the rank of commander of the Légion d'Honneur.

2001
JANUARY — Spring–Summer collection
Blouses of shantung and organdy, embroidered with fruit; tuxedos; tulle dresses embroidered with sequins.

MARCH 24 — Sculptor Eduardo Chilida chose Yves Saint Laurent to receive the Rosa d'Oro, an award bestowed on a leading

figure in the world of culture by one of his peers. The winner then choses the next year's recipient; in May 2004 Saint Laurent awarded it to David Hockney.
"I always placed great importance on color, and you could say that David Hockney is one of the greatest colorists of the century, notably alongside Matisse and Rothko."
Pour Saluer David Hockney, Rosa d'Oro Award, Palermo, May 2004

JULY — Fall–Winter collection
Tweed jackets; velvet skirts; blouses; fitted coats [*redingotes*] of broadcloth and moiré fabric; fur-lined leather coats; tuxedo dresses; embroidered harlequin jackets; faille dresses.

2002
JANUARY 7 — Yves Saint Laurent held a press conference at 5 avenue Marceau, announcing his retirement. He was sixty-five.

"The morning of January 7, 2002, was gray and heavy. A phone call indicated that the appointment was important, without giving details. It was an invitation to the house at 5 avenue Marceau, for over forty years the laboratory and headquarters of the most sensational adventure in twentieth-century fashion design. A luxury building whose façade was stamped in relief with three initials, a logo that had become an instantly recognized password throughout the world, becoming one of the synonyms for France with its chic and its lifestyle, its irrepressible (and, to many people, incomprehensible) frivolity, its simultaneously charming, brilliant, risqué and often melancholic attitude, a kind of typically French ardor, either frosty or tropical but never temperate.... Once inside the house we were guided by friendly faces ... toward a gray salon where an improvised set for the press conference awaited us—a few gilt chairs, a little table covered with a green cloth, a curtain masking the back of the room. We sat wherever we wanted.... Behind the curtain, invisible movement made the fabric shudder, signaling feverish agitation and imminent action—just like the start of a fashion show. But, contrary to tradition, it wasn't at the end of the show that the designer made an appearance. Suddenly there was Yves Saint Laurent in a

dark suit, a large, bent carcass of a man, as usual more intimidated than his admirers. He had come to say he was leaving us. Four pages—a sober, dignified statement, in which phrases read with a slight hint of emotion resounded in our ears like the death knell of a world collapsing before our eyes, yet which also rang out like a stirring anthem of liberation."
Gérard Lefort, *Têtu*, July–August 2008

"Everyone needs artistic phantoms in order to live. I pursued them, sought them out, hunted them down. I experienced much anguish and torment, terrible solitude and fear. I met those false friends, sedatives and drugs. I knew the prison of depression and the jail of health clinics. One day I managed to escape it all, squinting in the light but sobered. Marcel Proust taught me that 'the splendid and pitiable family [of neurotics] is the salt of the earth.' Without realizing it, I was a member of that family. My family. I didn't choose that fatal lineage, and yet thanks to it I was able to raise myself to the heights of creativity, able to frequent the people Rimbaud called the fire-bringers, able to find myself, finally able to realize that the most important encounter in life is with oneself. The most beautiful paradise is paradise lost."
Farewell press conference, January 7, 2002, published in *Libération*, January 8, 2002

JANUARY 23 — Spring–Summer collection THE LAST COLLECTION — a retrospective of the forty years of the house of Saint Laurent. Over three hundred pieces were presented at the Pompidou Center in Paris.

OCTOBER 1 — The couture house closed its doors.

DECEMBER 5 — The Fondation Pierre Bergé–Yves Saint Laurent was officially established as a nonprofit foundation.

DECEMBER 31 — The mansion at 4 avenue Marceau was purchased to serve as the foundation's headquarters, where the legacy of couture firm since 1962 was to be preserved—approximately five thousand garments, fifteen thousand accessories, and thousands of sketches.

2007
JULY 14 — French president Nicolas Sarkozy elevated Yves Saint Laurent to the distinguished rank of grand officer of the Légion d'Honneur.

2008
JUNE 1 — Yves Saint Laurent died in his Paris home at the age of seventy-two. His funeral was held on June 5 in the church of Saint Roch in the first arrondissement of Paris.
"Yves, how fresh and beautiful was that Paris morning when we first met! . . . On the marble plaque awaiting you, above your name I want them to engrave, 'French fashion designer.' What a fashion designer you were! You composed a work whose echoes will resound for a long, long time. And you were thoroughly French because you could hardly be anything else—as French as a poem by Ronsard, a garden by Le Nôtre, a score by Ravel, a painting by Matisse."
Excerpt from Pierre Bergé's funeral oration to Yves Saint Laurent in the church of Saint Roch, Paris, June 5, 2008

JUNE 11 — Yves Saint Laurent's ashes were scattered in the garden of Villa Oasis, his Marrakech home.
A column erected in the Majorelle garden today commemorates the French fashion designer.

NOTES

1 — In fact, Vermeer's *Girl with a Pearl Earring.*

2 — *Todchic*, a German word, synthesis of "dead" and "chic." Prussian neatness, rather military, not the exhausted chic of the duke of Windsor, is meant here.

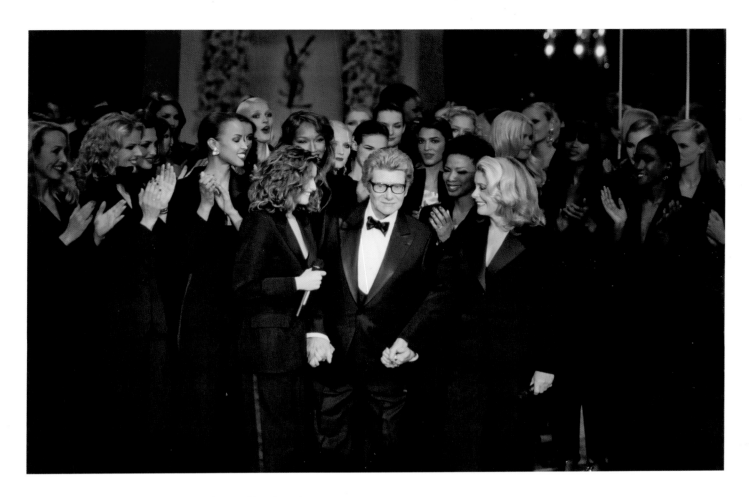

Pages 108 and 109 — Yves Saint Laurent and Pierre Bergé, in the wings of the show at the Hotel Intercontinental, Paris, 1998. Photograph by Derek Hudson.

Opposite — Spring–Summer 2002 haute couture collection (CAT. 304).

Above — Yves Saint Laurent flanked by Laetitia Casta, Catherine Deneuve, and the models of the retrospective show of January 22, 2002, Centre Georges Pompidou, Paris. Photograph by Guy Marineau.

Page 112 — Love, 2003.

LOVE

2003

yves Saint Laurent

GOLD, BECAUSE IT
OFFERS THE PURITY
AND THE FLOW
OF SPRINGWATER,
SHAPING THE BODY
UNTIL IT IS NOTHING
MORE THAN A LINE.

YVES SAINT LAURENT,
MANUSCRIPT, ARCHIVE OF THE FONDATION PIERRE BERGÉ–YVES SAINT LAURENT

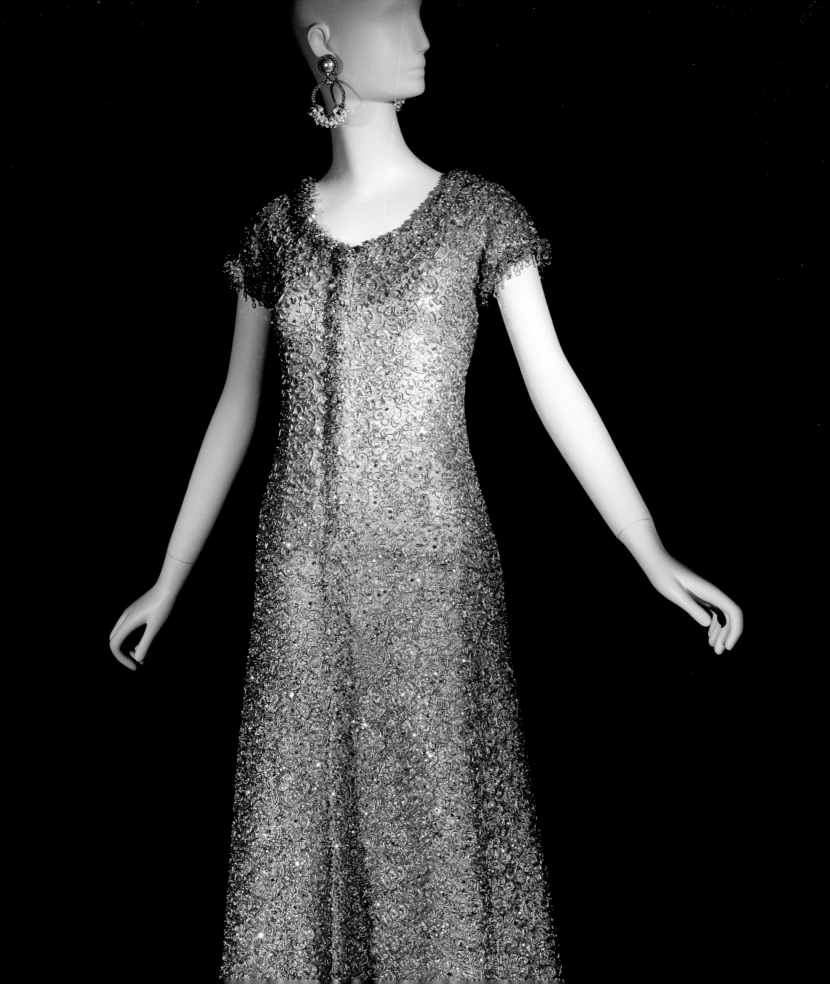

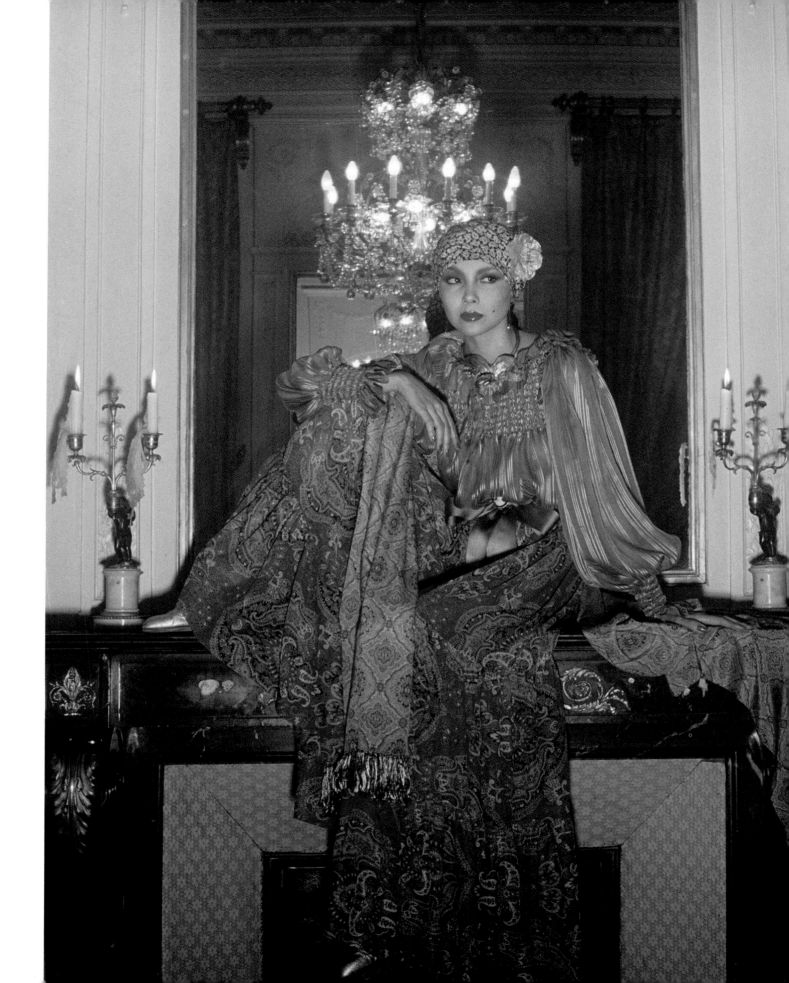

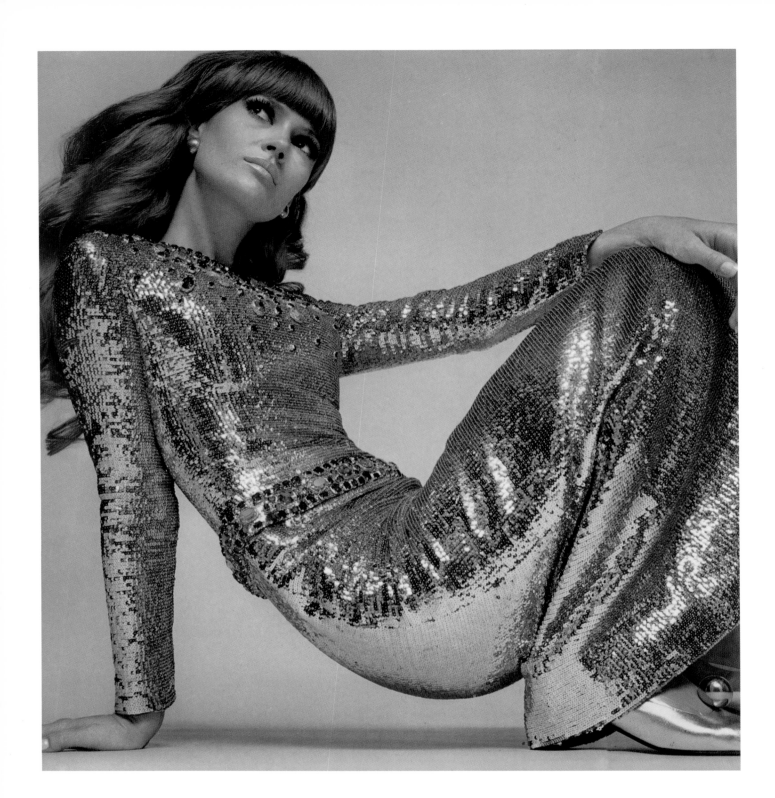

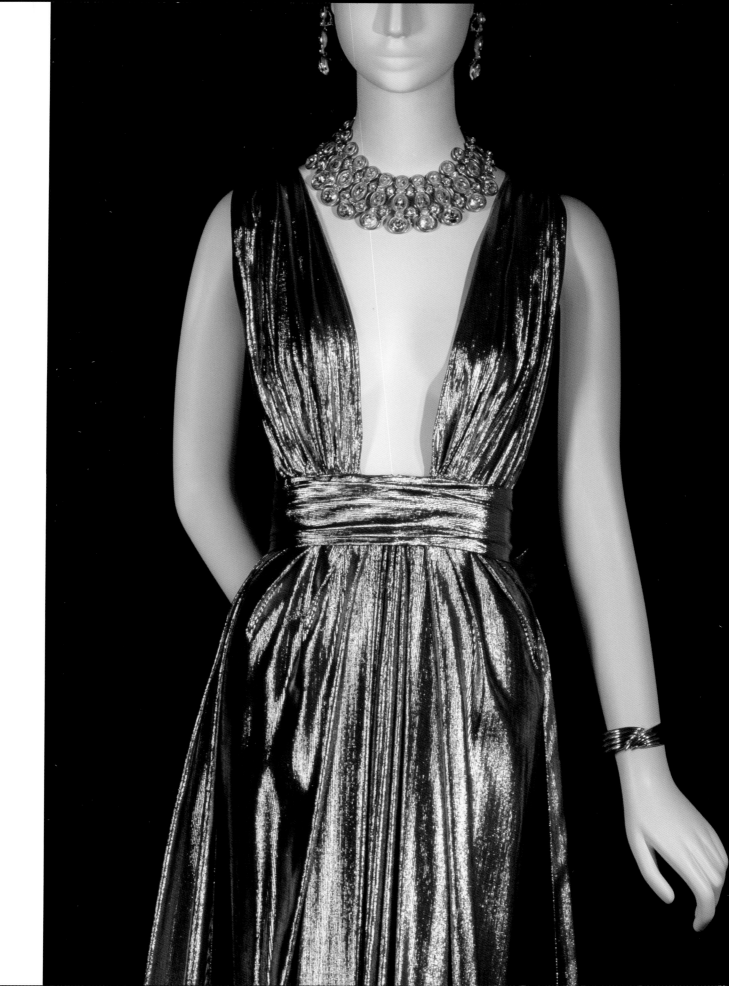

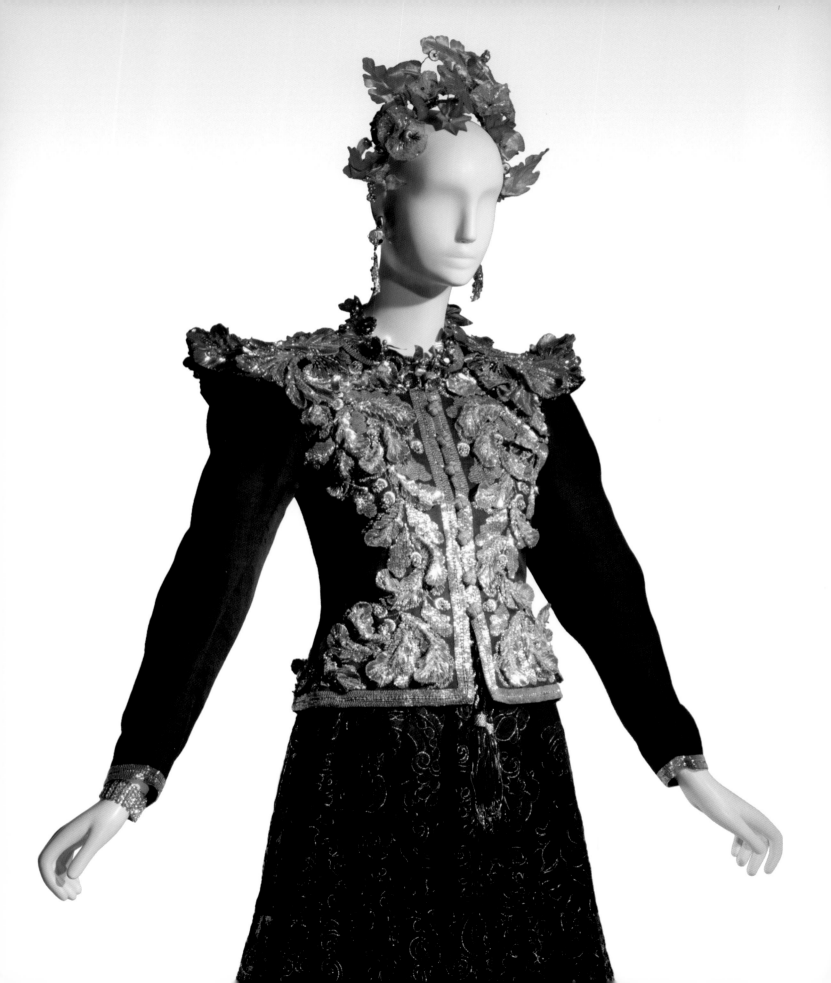

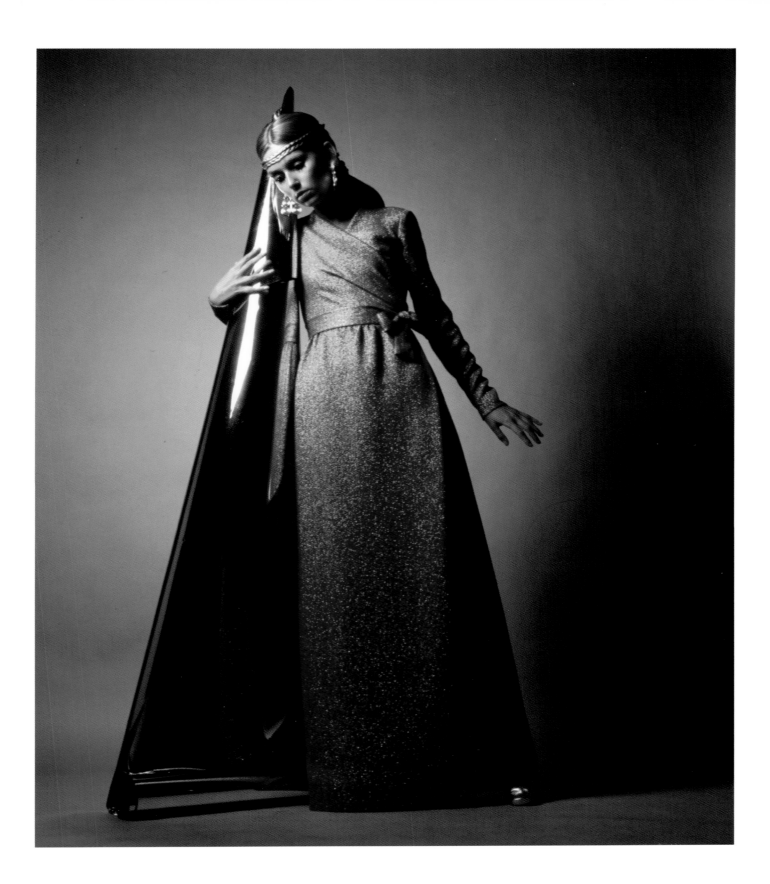

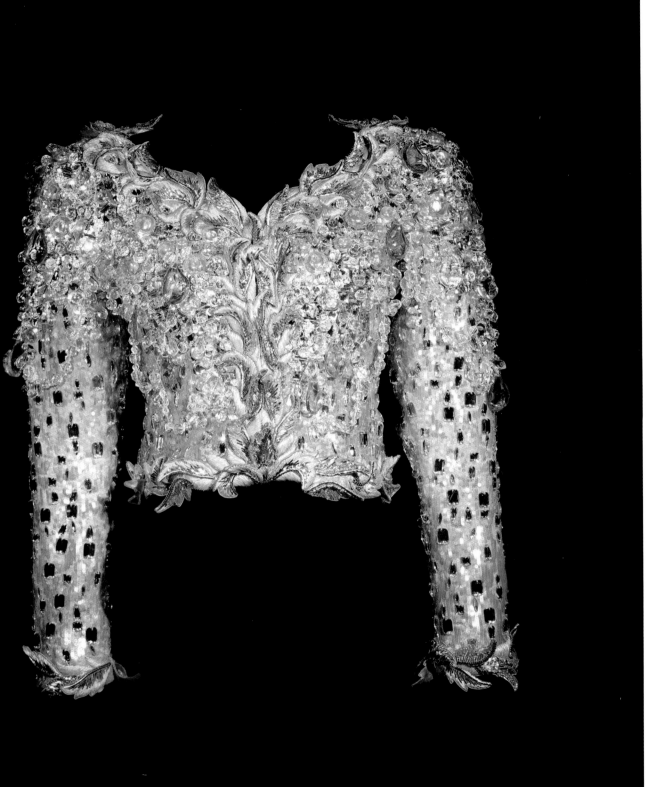

Page 115 — Card with yellow and gold samples from one of the color files assembled over the years by the Yves Saint Laurent studio.

Page 116 — Spring–Summer 1967 haute couture collection (detail of CAT. 71).

Page 117 — Chiffon blouse and skirt, British *Vogue*, March 1977. Photograph by David Bailey.

Page 118 — Sequined dress with incrustations of Tyrolean cut stones, *Vogue Paris*, Fall–Winter 1966 haute couture collection. Photograph by David Bailey.

Page 119 — Spring–Summer 1981 haute couture collection (CAT. 230).

Page 120 — Spring–Summer 1980 haute couture collection (CAT. 76).

Page 121 — Crossover lamé dress, *Vogue Paris*, September 1968. Photograph by Jeanloup Sieff.

Opposite — Spring–Summer 1990 haute couture collection, tribute to my House (detail of CAT. 259).

DRESSING FOR MODERN TIMES: YVES SAINT LAURENT'S "ESSENTIALS"

FLORENCE MÜLLER

NOTES

1 — Barbara Schwarm, "Yves Saint Laurent: 30 ans déjà et la gaieté retrouvée," *L'Officiel France*, 1991.

2 — John Helpern, "Yves Saint Laurent on Yves Saint Laurent," Hong Kong: *Fémina*, 1978 p. 94.

3 — Yves Saint Laurent, "Quand Yves Saint Laurent parle," *20 Ans,* January 4, 1973.

Yves Saint Laurent made the style of the modern woman, which he defined by stating, "I invented its past, I gave it a future and it will endure well after my death."[1] He borrowed from traditional work clothes and created his own stylized take on them, propelling them into the spheres of haute couture and ready-to-wear. A series of these so-called clothing revolutions forged the social dimension of Saint Laurent's work. The principles at play in this wardrobe evolved constantly, lending themselves to numerous interpretations. These "essential" garments became classics, not because of their eternal, permanent nature but because their fundamental concept was infinitely variable. Behind any definition of this concept lies the designer's unwavering desire to escape the laws of fashion. In 1978, he laid out the idea to the journalist John Helpern: "What I try to do is make *un type parfait*—a perfect type of garment, whether it's a simple blouse or a pair of pants, and encourage women to build around them. From season to season, I always vary my designs around the same basic prototypes. So a woman needn't change her wardrobe constantly."[2] With these *types parfaits* emerged the apparent paradox of a creative talent that was—and asserted itself as—both classical and revolutionary. In 1973, Saint Laurent said provocatively, "For me, the avant-garde is classicism."[3]

PEA JACKET

IN BRIEF — The pea jacket [*caban*] was the first "essential" garment presented by Yves Saint Laurent in his first collection, Summer 1962. It had the look of a sailor's work jacket, with an urban and feminine twist. It was among what Saint Laurent called the "permanent forms."

DISTINGUISHING FEATURES — Given star billing at the first collection, the pea jacket constitutes the manifesto design of his entire work. In it Saint Laurent achieved a perfect symbiosis between a functional garment and an urban fashion design. Its blend of realism and prestige pushed back the conventional boundaries of haute couture, opening it up to modern times. Saint Laurent retained the garment's robust, warm, and comfortable look. He widened the cut a little, preserving its functional qualities. But he feminized it with the addition of gilt buttons. This first Winter 1962 design (CAT. 13) was described in the collection program as a "boating ensemble in white shantung. Navy jacket [*vareuse marine*]."

SUCCESS — The "sailor's theme" was recurrent in the work of Yves Saint Laurent. In the summer of 1966, he devoted part of his collection to it. The pea jacket was presented in several different versions: close fitting, worn with a gilt anchor brooch and a cap, or sometimes adapted into an afternoon dress in navy wool. In the same collection were striped smocks [*marinières*] sparkling with red, white, and blue sequins.

 The pea jacket shown in Summer 2001 featured even more differences in contrast to the original version of 1962: It was shorter and closer fitting but was still made of navy wool. It was worn with white pants and a white cotton sweater.

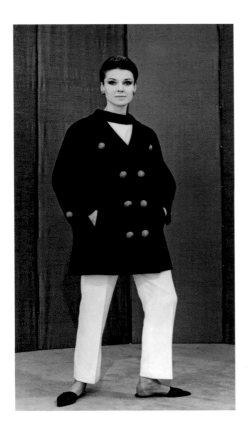

Opposite — The first pea jacket, first design of the Spring–Summer 1962 haute couture show.

Right — Black wool three-quarter-length pea jacket, Spring–Summer 1963 haute couture collection, American *Vogue*, September 1966. Photograph by Irving Penn.

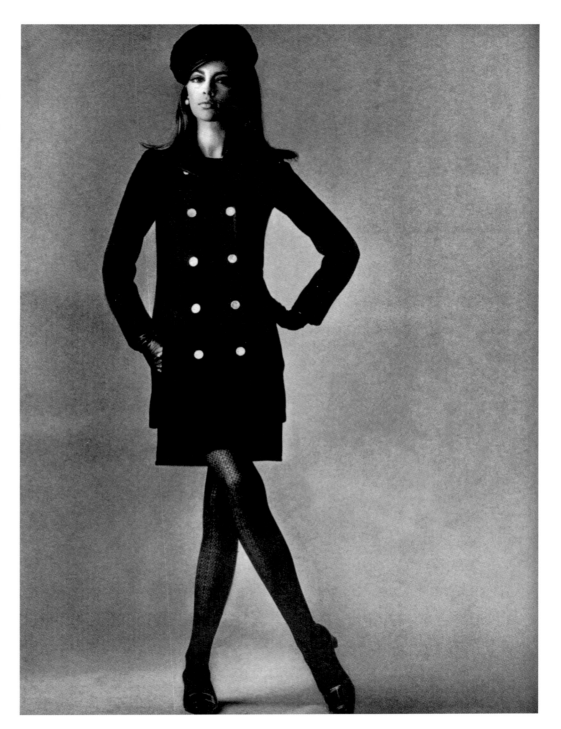

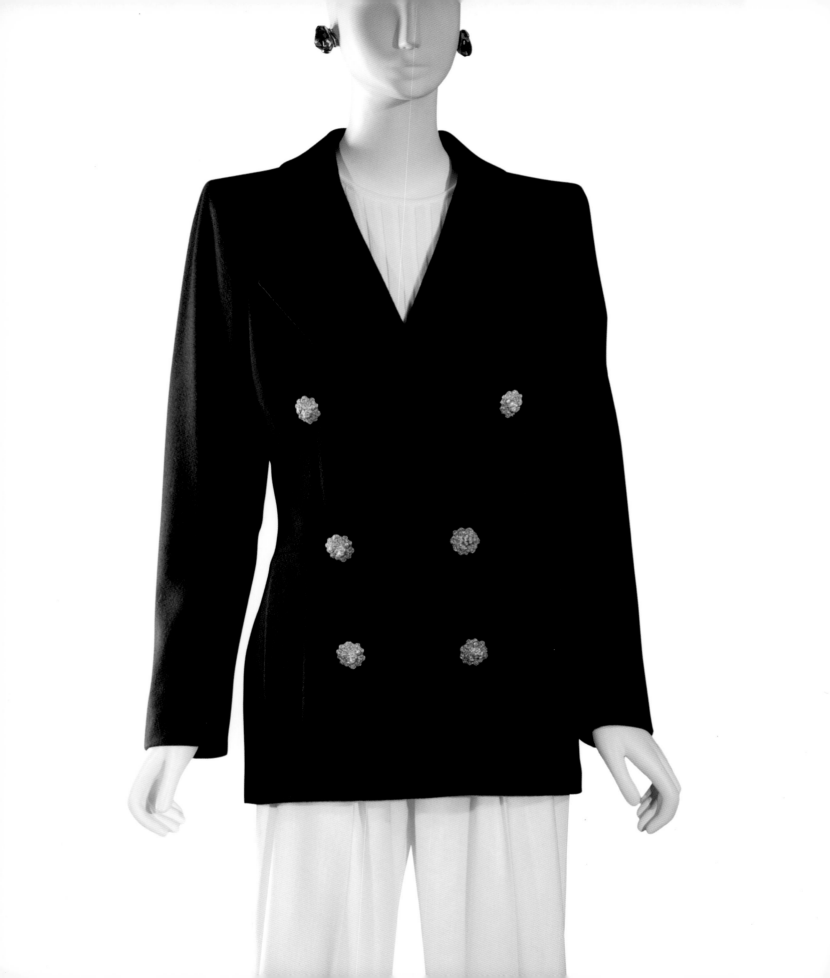

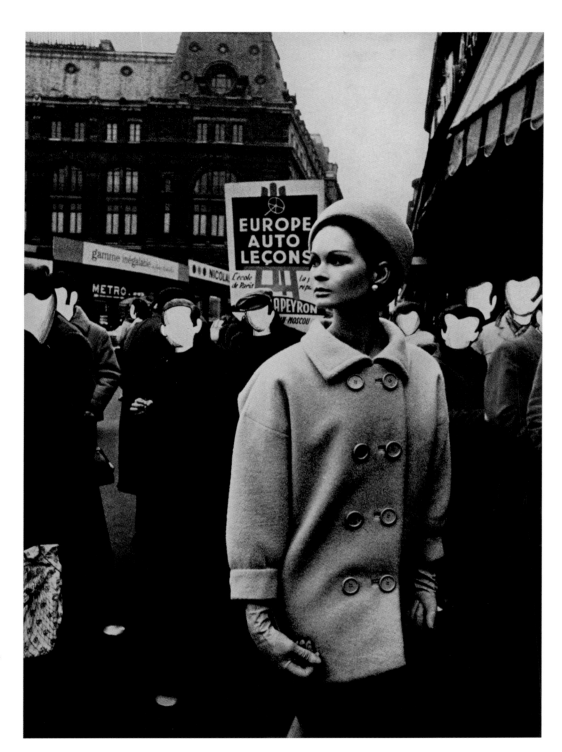

Opposite — Spring–Summer 2001
haute couture collection (CAT. 18).

Right — Beige wool pea jacket,
Spring–Summer 1963 haute
couture collection, American
Vogue, March 15, 1963.
Photograph by William Klein.

TUNIC

DATE OF BIRTH — **Summer 1962**

IN BRIEF — The tunic [*tunique*] was part of a family of clothing that lengthened the figure and concealed the hips. The *marinière* smocks and *vareuses*, sweater tunics, which also hid the hips, were part of this group of garments dear to Yves Saint Laurent. The tunic would be adopted by all the women who sought to attenuate the body-hugging effect of these first pants.

DISTINGUISHING FEATURES — In the program for the Summer 1962 collection, the *marinière* smock was described as a "navy wool *vareuse*" (CAT. 36), the term used by the French navy. When the second collection of Winter 1962 was shown, Jean Graham of the *Daily Herald* enthusiastically titled her article of July 31, 1962, "It's the tunic line triumph!" Identified as the follow-up to the previous season's *marinière* smock, the design offered possibilities of variation within a whole collection, and even beyond. The tunic would constitute one of the basic principles of the Saint Laurent style, with its cut that would fit all sorts of figures. The "Robin des Bois" look, a striking ensemble with hood, woolen tights, thigh-high boots, and a glossy black raincoat, appeared in the Winter 1963 collection.

SUCCESS — In 1963, *News Chicago* analyzed the Saint Laurent designs: "His tunics, jerkins or jackets—whatever you like to call them—instead of molding the form and lifting the bosom were supple and loose."[4] Eugenia Sheppard, editor in chief of the *New York Herald Tribune*, went further: "Saint Laurent holds Paris in the palm of his hand today."[5]

In its August 1, 1967, issue, *Women's Wear Daily* proclaimed, "Saint Laurent's sweater tunic is the most important fashion news in Paris. Suddenly the sweater tunic looks right and young." The American magazine had correctly identified the key to its success. This sleeveless jersey tunic, worn over a sweater and over pants or tights, created a youthful look. Millions of women would copy this style in Europe and the United States.

NOTES

4 — "Saint Laurent Simply a Genius," *News Chicago*, July 31, 1963.

5 — "The Rites of Fashion," *Newsweek*, August 12, 1963.

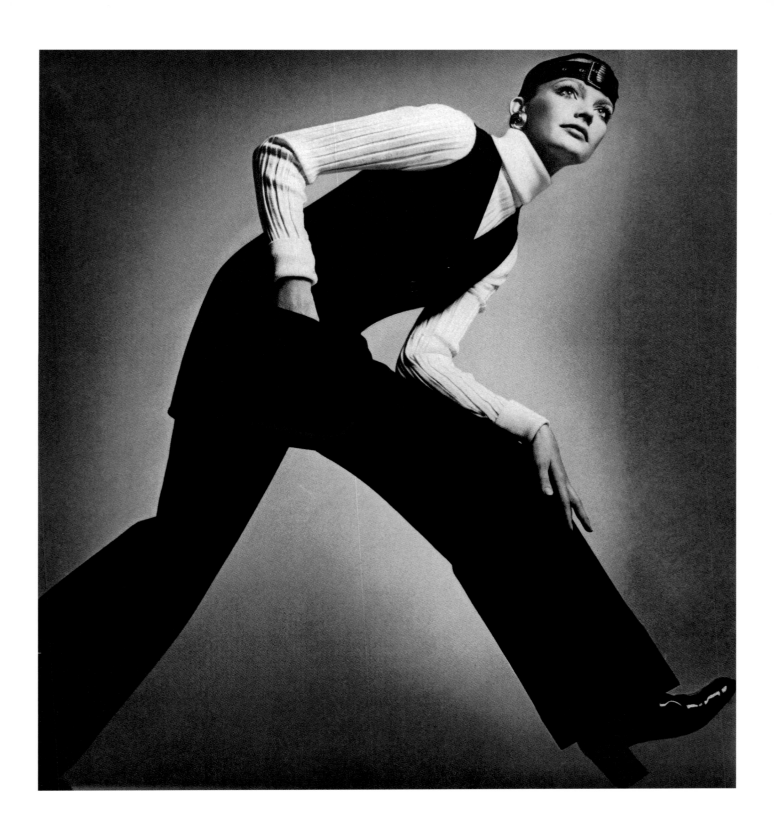

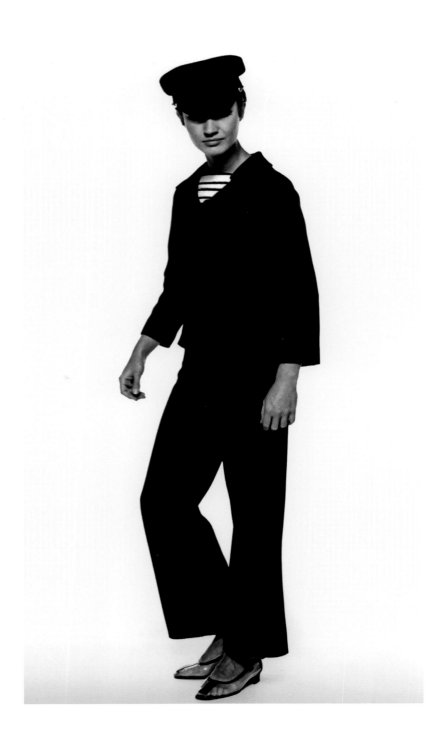

Page 131 — Chasuble tunic and pants in jersey wool, *Vogue Paris*, September 1968. Photograph by Guy Bourdin.

Left — Navy wool smock tunic and pants, Spring–Summer 1966 haute couture collection, French *Marie Claire*, March 1966. Photograph by Marc Hispard.

Opposite — Baroness Philippine de Rothschild in tunic and suede thigh-high boots, Fall–Winter 1963 haute couture collection, American *Vogue*, December 1963. Photograph by Henry Clark.

TRENCH COAT

DATE OF BIRTH — **Autumn–Winter 1962**

IN BRIEF — **This garment was worn by officers in the trenches of World War I. Throughout his work, Yves Saint Laurent adapted it into women's versions.**

DISTINGUISHING FEATURES — The trench coat made a discreet but striking appearance on its presentation in 1962, worn over an evening dress. In 1967, a new version was given a lot of coverage by *Women's Wear Daily*, no doubt because it was part of the famous unisex-look "Vestsuit" and "Pants vestsuit" collection. The trench coat was made either of gabardine or, more unusually, of navy blue jersey, and it was "short, short . . ."[6] The offbeat effects produced by these stunning day/evening trench coat combinations ran through the whole history of the Saint Laurent house. He designed several luxurious leopard-print versions of the coat.

SUCCESS — Catherine Deneuve immortalized the coat in Luis Buñuel's film *Belle de Jour* (1966), in a glossy black version with the square-buckled Roger Vivier shoes.

NOTES

6 — "St. Laurent Deals Vestsuit and Trumps the Paris Scene," *Women's Wear Daily*, January 31, 1967.

Black ciré trench coat, Saint Laurent Rive Gauche collection, *Vogue Paris,* October 1968. Photograph by Jeanloup Sieff.

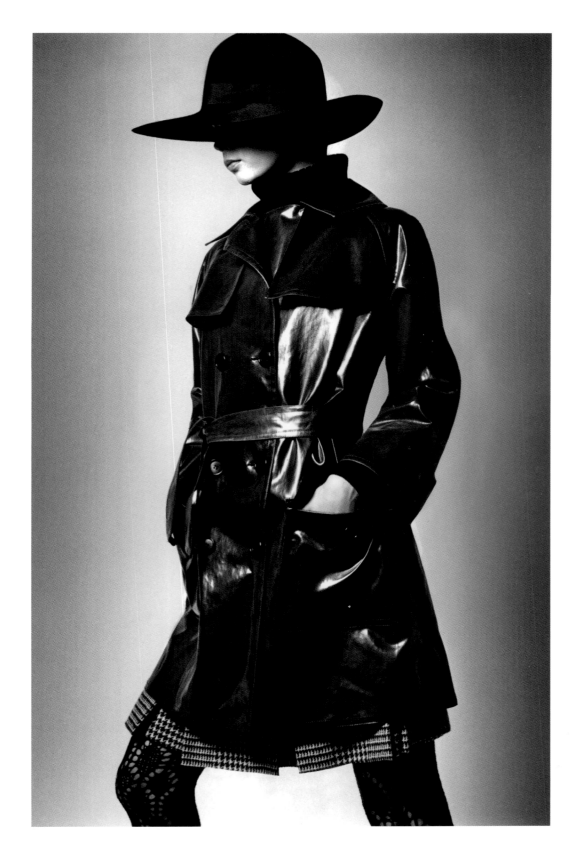

Left — Black ciré trench coat, worn by Alla, Fall–Winter 1962 haute couture collection.

Opposite — Sketch of a trench coat, Fall–Winter 1986 haute couture collection.

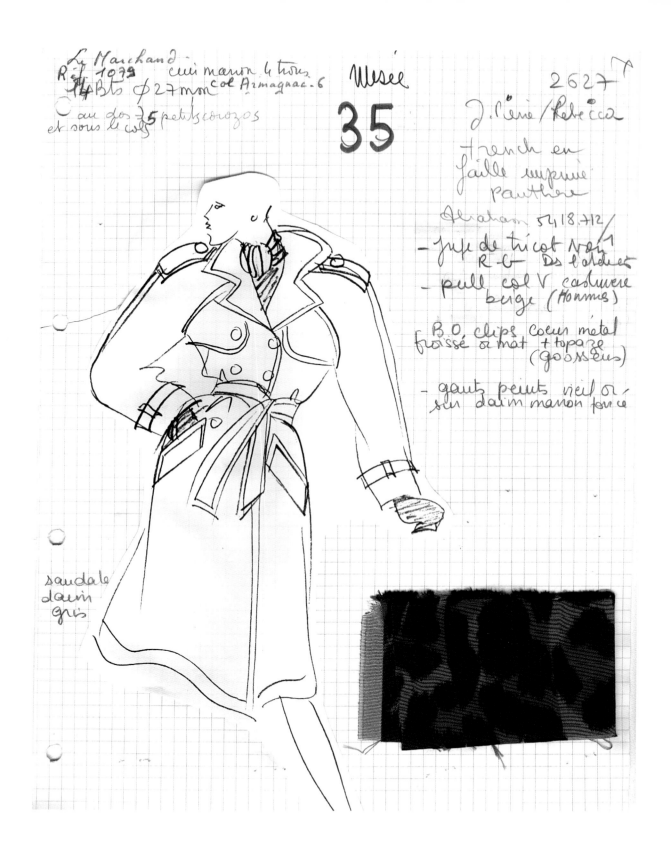

Le Marchand
Réf 1079 cuir marron 4 trous
14 Bts ⌀ 27mm col Armagnac -6
au dos 5 petits corozos
et sous le col

Musée
35

2627
J. Périe / Rebecca
trench en
faille imprimé
Panthère

Abraham 54 18.712/

- jupe de tricot Noir
 R-6 Ds l'atelier

- pull col V cashmere
 beige (Hommes)

- B.O. clips coeur métal
 froissé or mat + topaze
 (Goossens)

- gants peints vieil or
 sur daim marron foncé

saudale
daim
gris

LOOSE-FITTING BLOUSE, SMOCK

DATE OF BIRTH — **Autumn–Winter 1962**

IN BRIEF — This garment freed the upper body, waist, and chest.

DISTINGUISHING FEATURES — The first blouse design that went down in history was the "Norman" smock [*blouse normande*] of Winter 1962. It was described by the *New York Times* of August 12, 1962, as a peasant's shirt reworked as a flannel tunic that hung over the hips, creating a tubular effect. The previous collection had already featured shantung blouses with fringed hems that were worn with skirt suits. The blouse, or rather the loose-fitting, blousy style, was a constant throughout the designer's work and took varied forms: the chemise dress, which first appeared in the Winter 1963 collection in an evening dress version; the *chemise-longuette* [long shirt] of Winter 1970; the peasant's chemise-dress of Summer 1971; the painter's frock of Winter 1974; loose-fitting blouses worn with tailored jackets or pantsuits; and smock dresses. There were also the "naive chemises," thus dubbed by the American press as the great success of the Winter 1974 haute couture collection.[7] The long chemise dress with a floppy chiffon necktie was one of the diaphanous evening classics.

SUCCESS — The success of the blouse was partly due to the scandal caused by a see-through version worn over bare breasts. This completely transparent cigaline blouse shown in the Summer 1968 collection, worn with a black alpaca tuxedo with Bermuda shorts, caused a stir in the United States, where it was dubbed the "see-through blouse." In keeping with the designer's wish to achieve a progression in his work, an initial experiment with transparency had already been made in the Summer 1966 collection, in navy organdy with sequin embroidery concealing the breasts. Later, the long chiffon and ostrich feather dress (CAT. 87) of Winter 1968 entirely revealed the body, which was simply and transparently clad in a jewelry belt in the form of a gold serpent.

NOTES

7 — *Women's Wear Daily*, July 23, 1974.

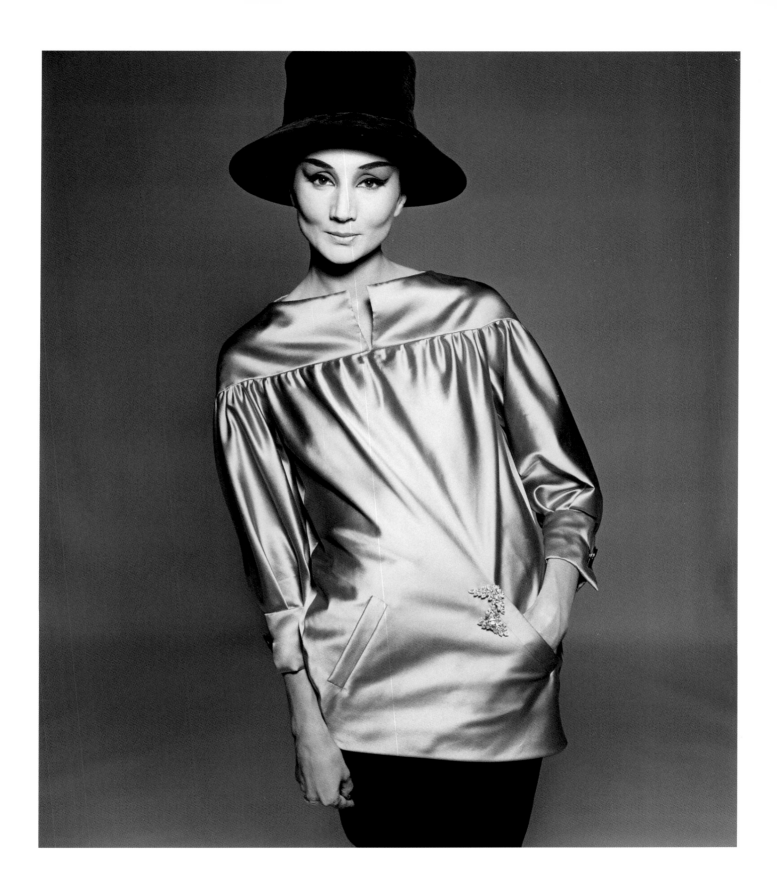

Page 139 — Viscountess Jacqueline de Ribes, Paris, July, 31, 1962. Norman smock in gray satin, Fall–Winter 1962 haute couture collection. Photograph by Richard Avedon.

Opposite — Fall–Winter 1973 haute couture collection (CAT. 73).

Right — Sketch of a suit with skirt and blouse with floppy necktie, Spring–Summer 1989 haute couture collection.

TUXEDO

IN BRIEF — A revolution, whose French name, *le smoking*, was quickly adopted by the Americans, upturned evening dress convention.

DISTINGUISHING FEATURES — For an evening event, women would wear a long dress. Men would go out in a tailcoat (a formal jacket with long pointed "tails," in French a *queue-de-pie*) or in a tuxedo, a *smoking* in French, a type of jacket invented in England in the nineteenth century. With his *smoking*, Yves Saint Laurent gave women a new way to dress, and it wasn't just a copy of the men's garment but a truly feminized version. The first *smoking* ensemble (CAT. 262), shown in the Winter 1966 collection, consisted of straight pants, a white organdy shirt with a jabot, a floppy necktie, a satin belt, and a long jacket with a feminine close-fitting cut. Magazines replayed reports of women arriving at formal evening events dressed in a tuxedo. From 1966 to 2002, it became the eternal Saint Laurent tuxedo, awaited ritualistically at each fashion show. Over the years, the designer explored all the possibilities of this new clothing concept. Sometimes he retained only one or two of the original distinctive features, such as the satin trim on the outer seam of the pants, the bow tie, the jacket's satin lining, or the satin belt, and gave free rein to his imagination in the other elements. He allowed himself every combination, every mixture or fancy, creating tuxedos with shorts, skirt, knickerbockers, dress, kimono, pea jacket, safari jacket, and jumpsuit. Starting with a great classic of the male wardrobe, Saint Laurent created a look that was infinitely renewable.

SUCCESS — The tuxedo showed that for a designer, success can be a very relative affair. Yves Saint Laurent recognized it himself: "The street gets there faster than the salons. I saw it five years ago when I made my first tuxedo. In couture: no success. In ready-to-wear: huge."[8] Helmut Newton provided proof of this, albeit involuntarily. Everyone is familiar with his famous shot of the model Vibeke posing at night on rue Aubriot, Paris, like a 1920s film noir character. It is often thought to be Newton's portrait of the Saint Laurent tuxedo. Yet published in *Vogue Paris* in September 1975, it actually shows a pinstripe pantsuit worn with a tie-neck blouse.

CELEBRITIES — In 1966, a ready-to-wear version of the tuxedo went on sale in the newly opened shop on rue de Tournon, following the haute couture version launched in July. Françoise Hardy, who came in to buy boots, saw it, bought it, and took it with her to the United States. Dressed in the Saint Laurent tuxedo, she created a sensation at Macy's Thanksgiving Day parade and later in Paris at the *Figaro*'s centennial party. Elsa Martinelli adopted the black velvet version of the tuxedo and wore it at the first night of the musical *Mouche*. Customers fought over the rare pieces that were still available at the Rive Gauche shop.

NOTES

8 — Quoted by Mariella Righini in "Casser le bon goût," *Le Nouvel Observateur*, August 16, 1971.

9 — Laurence Benaïm, "L'as de cœur," *Vogue Paris*, 1990.

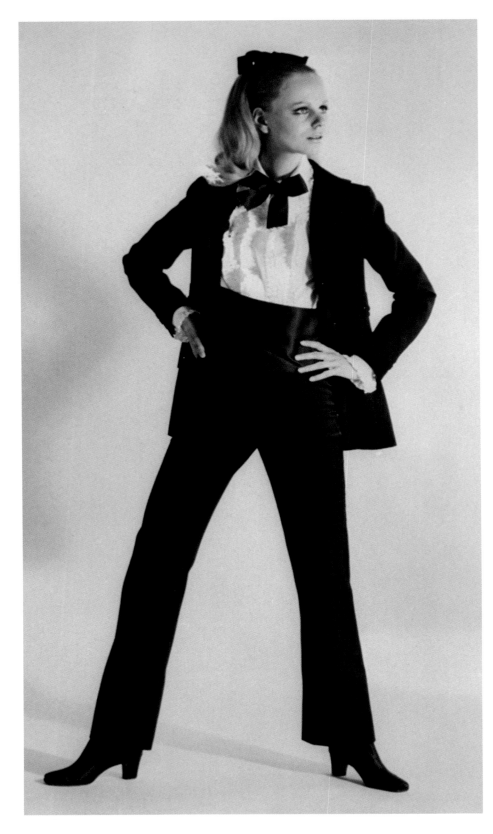

Page 143 — Barathea tuxedo, Spring–Summer 1997 haute couture collection, *Gala*, March 6, 1997. Photograph by Mario Testino.

Left — First tuxedo, worn by Ulla, Fall–Winter 1966 haute couture collection.

Opposite — Sketch of a tuxedo from the Spring–Summer 2000 haute couture collection, inspired by the first design of 1966.

Normand 403 φ22 Ibt plat à rebord 4 trous para
nacre brillante

1 Her Mercier et Nacre blanche φ11 6
85/ Normand
Manchette nacré Musée
 26

Escarpins
2 pièces
de crêpe
noir

FM le 8/12
FM le 8/12
FM le 6/07

7600 x

/Jean-Pierre

veste de
smoking de
frain de pouche
noir Gandini
2672 et 3
7600 bis JP
pantalon idem
Ceinture de satin
Dormeuil 610528
7600 ter Fredo
Blouse de coton
blanc stotz
2920 s. et or blc
et nœud de
satin noir

B.o carré de
Nacre argent
et perle blanche
c. 27

SUIT, PANTSUIT, SKIRT SUIT

NOTES

10 — Ibid.

11 — *Femme chic*, January 1, 1967.

12 — *Women's Wear Daily*, January 31, 1967.

13 — Quoted by Alice Rawsthorn, "Yves Saint Laurent in 1968," American *Harper's Bazaar*, December 1996.

DATE OF BIRTH — Spring–Summer 1967

IN BRIEF — The pantsuit [*tailleur pantalon*] was the first design to hit the runway at the Summer 1967 collection show. It introduced a new genre and became a major symbol of the power of women.

DISTINGUISHING FEATURES — The novelty of this design was not the pants that had already made their appearance in women's summer fashion as early as 1930. But Yves Saint Laurent made its use acceptable at any time of day. "I want to find a uniform for women that's equivalent to the men's jacket,"[9] he said in 1969. Maïmé Arnodin summed up the success of this project in a phrase: "Before him, it was *mauvais genre*, bad taste. After him, it became the height of fashion."[10] Another innovation was that the pantsuit harmoniously blended feminine and masculine styles—a far cry from the caricature of suffragettes and feminists. The front-pleated pants and jacket with sharply shaped shoulders gave the suit a self-assured look that belonged to the men's style. But the chiffon blouse, floppy necktie, and waist sash balanced out its feminine side. The suit perfectly expressed the contemporary identity of women who wanted to assert themselves without giving up their feminine appeal. The first design presented in 1967 was cut in a striped wool gabardine and worn with a shirt and black tie, accentuating its masculine origin. Its feminine equivalent (CAT. 34) was composed of a long jacket and a pleated skirt in striped flannel. The press noted that it had a "masculine style, and went with a vest."[11] Later, Saint Laurent explored all the possible variations of this unisex style. From the men's side, he kept the tweed fabrics, gabardines, and woolens, sharply notched collars, structured shoulders. From the women's side, he used chiffons and silk satin for the blouse, jewelry, scarves worn around the neck or as sashes around the waist, and bright feminine colors. The "Broadway Suit" collection of Summer 1978 encapsulated the quintessence of this new look: wide shoulders, short pants, a red or white straw boater, jabot blouses in satin or crepe de chine, a chiffon necktie.

SUCCESS — The American journalists and department stores showed unbridled enthusiasm for the men's-style suit when it came out. *Women's Wear Daily* proclaimed, "Saint Laurent's new Vestsuits in men's wear fabrics are the sensation of the Paris season." Mildred Custin liked the twenties touch and commented that her mother could have worn the dresses that went with them. On the opening of Rive Gauche, Lauren Bacall said of the Yves Saint Laurent pants, "Of course it's Saint Laurent. If it's pants, it's Yves."[13]

ANECDOTES— In the 1960s, Hélène Lazareff, founder and director of the magazine *Elle*, a great admirer of the Saint Laurent style, nevertheless forbade her female staff to wear pants. This prohibition was very commonplace at the time, both in schools and in many firms—and not only in France but even in the United States. One evening, Nan Kempner, dressed in a tunic and black satin pants ensemble from the Winter 1968 collection, was refused entry to the La Côte Basque restaurant in New York because she was wearing pants. But it took more than that to unnerve the young woman. She simply removed them and came back wearing only the tunic, thus transformed into a minidress, which was considered perfectly acceptable attire at the time.

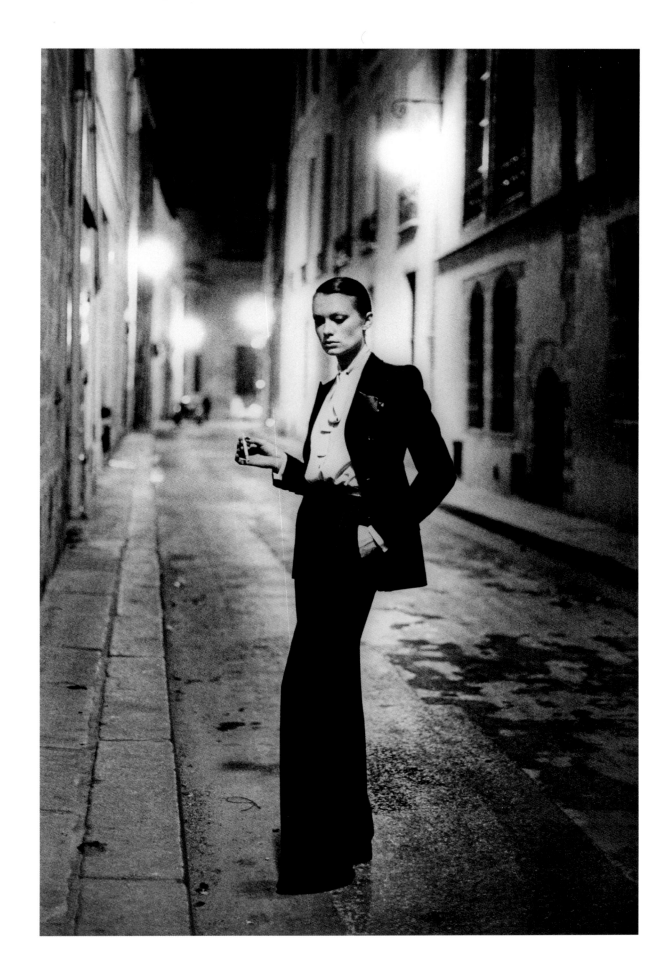

Page 147 — Rue Aubriot. Vibeke
in a gray striped wool pantsuit,
Fall–Winter 1975 haute couture
collection. Photograph by
Helmut Newton.

Below — White Ottoman
bolero, black jersey pareo, and
tuxedo. Saint Laurent Rive
Gauche collection, *Vogue Paris*,
March 1979. Photograph by
Helmut Newton.

Opposite — Charlotte Rampling
in a Prince of Wales wool
pantsuit, American *Vogue*, Spring–
Summer 1974. Photograph by
Helmut Newton.

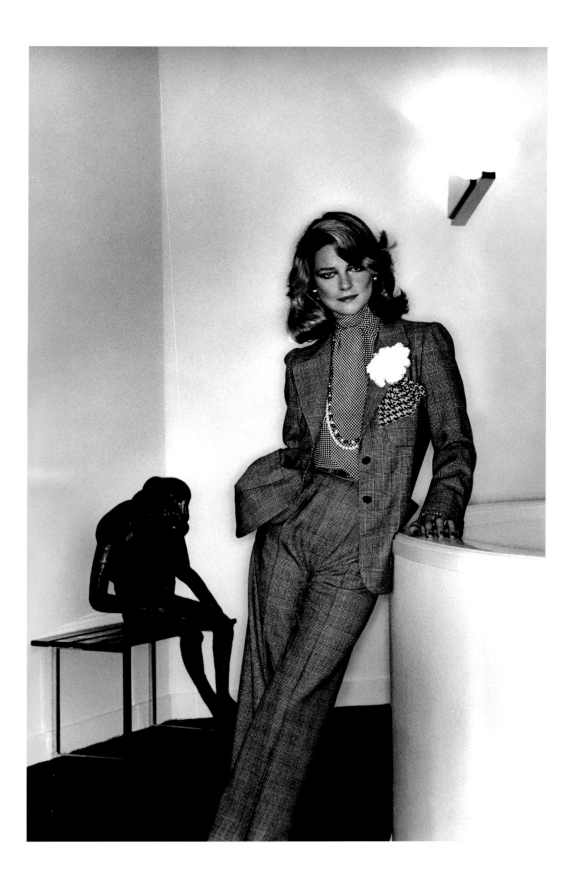

SAFARI
JACKET

DATE OF BIRTH — **Summer 1966**

IN BRIEF — This was a classic item of safari equipment redesigned for a new appeal.

DISTINGUISHING FEATURES — The Summer 1966 collection featured a "safari outfit," made up of an ocelot fur jacket, a shirt, and cotton leggings. A colonial-style pith helmet and a shirt with shoulder tabs and patch pockets characterized this safari theme. In the "Bambara" collection of Summer 1967, Yves Saint Laurent expressed the theme even more explicitly by bringing together African art and explorers' garb face-to-face. On the collection program, no. 49 was listed as a "beige cotton drill safari jacket." It had shoulder tabs and four patch packets with flaps. A trench coat with large pleated pockets was designed in the same spirit as the safari jacket, and it was worn with African-style sandals laced up the legs.

Then came May 1968. The safari jacket [*saharienne*] epitomized the spirit of this period in France and the new blurry frontiers between masculine and feminine appeal.

The design was inspired from the clothing of westerners in Africa, where the safari jacket was commonly worn. It was comfortable and kept out the heat. Its beige color masked the inconvenient effects of dust and sand. It was part of British army equipment in India and that of the German Africa Korps. The jacket had already entered the gentleman's wardrobe in the 1930s, and it characterized the writer Ernest Hemingway. In the movies of the 1950s, the safari jacket was the costume of explorers in exotic and mysterious lands. Ava Gardner wore it in her classic sensual style in the 1953 film *Mogambo*.

SUCCESS — The iconic safari suit with its deep laced-up neckline was created for *Vogue* magazine and was published in the July–August 1968 issue. It is labeled *hors collection* [off collection] in the Saint Laurent archives. The model Veruschka (Countess Vera Gottlieb von Lehndorff) immortalized the design posing as a sensual huntress in a series of photographs by Franco Rubartelli shot in the Central African Republic.

CELEBRITY— A famous photo shows Saint Laurent flanked by Betty Catroux and Loulou de la Falaise at the opening of the Rive Gauche store in London in 1969. All three are wearing safari jackets, but each has appropriated it in a completely individual way, demonstrating Saint Laurent's ability to adapt a design. The designer wears it as a tunic with a belt, Betty Catroux in a mini-dress version with thigh-high boots, and Loulou de la Falaise in a jacket and wraparound midi-skirt ensemble.

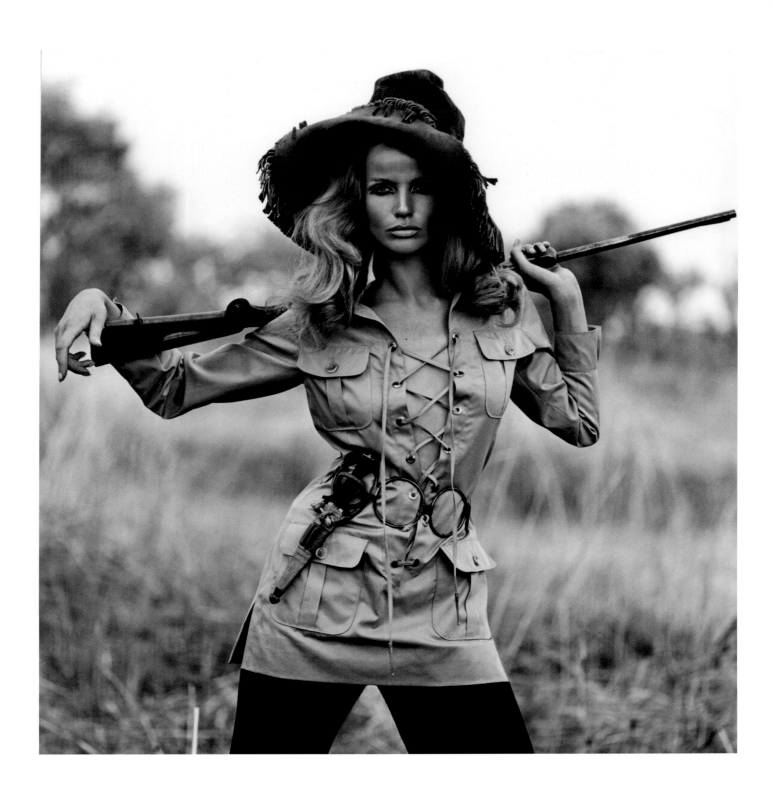

1061
Catherine
Dominique

toile
beige
Moreau
79.222

Carreau
Ceinture 24 27 exact.

sac

J. Roger.
10 Bts 491 m 16 à l'éch
Dessus.
8 Bts 37 134/22 à l'éch

écharpe sur la tête
marine/rouge/blanc/vert
Abraham 5086/3
Martèate, cuir
beige tête raphia
idôle
30 cm à terre

б

Page 151 — Veruschka in a lace-up safari jacket, *Vogue Paris*, July–August 1968. Photograph by Franco Rubartelli.

Opposite — Sketch of the first safari jacket, Spring–Summer 1967 haute couture collection.

Right — Yves Saint Laurent and his sister Brigitte, in cotton gabardine Saint Laurent Rive Gauche safari jackets, French *Elle*, May 5, 1969. Photograph by Helmut Newton.

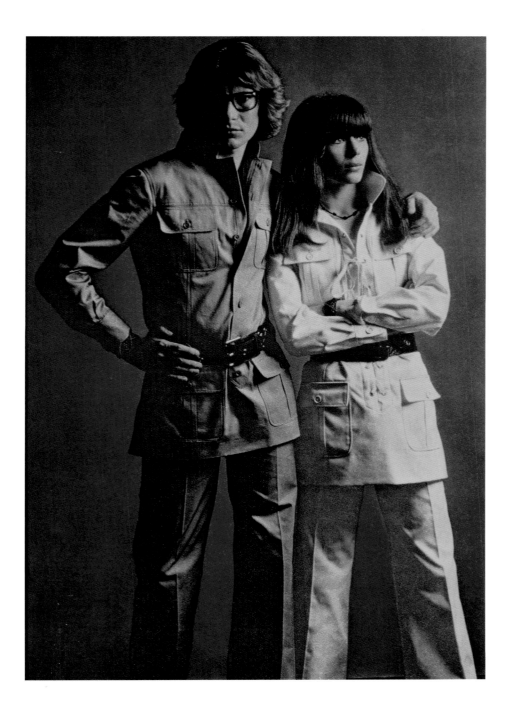

JUMPSUIT

DATE OF BIRTH — **Summer 1968**

IN BRIEF — The quintessential example of a redesigned functional garment was infused with Saint Laurent femininity.

DISTINGUISHING FEATURES — The jumpsuit was a one-piece pantsuit worn by parachuters and aviators. Its protective features put it in the same family as the overalls or boiler suits worn by workers, painters, and builders. Initial experiments in rethinking this utilitarian garment went back to the 1920s. Constructivist and futurist artists wanted to reform the modern suit, which they saw as "perverted" by the fashion system. For them, worker's overalls might constitute the universal garment. In 1923, at the Bauhaus, Laszlo Moholy-Nagy wore worker's overalls over a shirt and tie.

In 1968, the American press hailed the innovation of Yves Saint Laurent's "short jumpsuit" that gave a new dimension to this utilitarian garment.[14] Number 86 in the Summer 1968 collection was a "black silk jersey evening jumpsuit." After this first successful attempt, the following season Yves Saint Laurent developed the idea in the form of jumpsuit pants, with designs in brown jersey and in black silk jersey with sequins. For his feminine versions of this garment, Saint Laurent was inspired by men's one-piece suits by the tailor Gilbert Ferruch. He regularly returned to the jumpsuit concept, giving it different looks depending on whether it was cut in jersey, body hugging like a second skin, or, in contrast, baggy like worker's overalls. It was the great success of the Summer 1975 collection, reworked in tuxedo-with-shorts and Bermuda shorts versions and as a white zip-up suit with a drawstring belt.

CELEBRITY— Betty Catroux wore a one-piece pantsuit for a photo published in *Vogue Paris* in 1969 in an article about the nineteen Rive Gauche shops around the world.[15]

NOTES

14 — *Women's Wear Daily,* May 24, 1968.

15 — "Les boutiques de Vogue," *Vogue Paris,* February 1, 1969.

Right — Betty Catroux wearing a jersey jumpsuit, in the Saint Laurent Rive Gauche shop, rue de Tournon, Paris. *Vogue Paris*, February 1969.

Page 156 — Fall–Winter 1969 haute couture collection (CAT. 44).

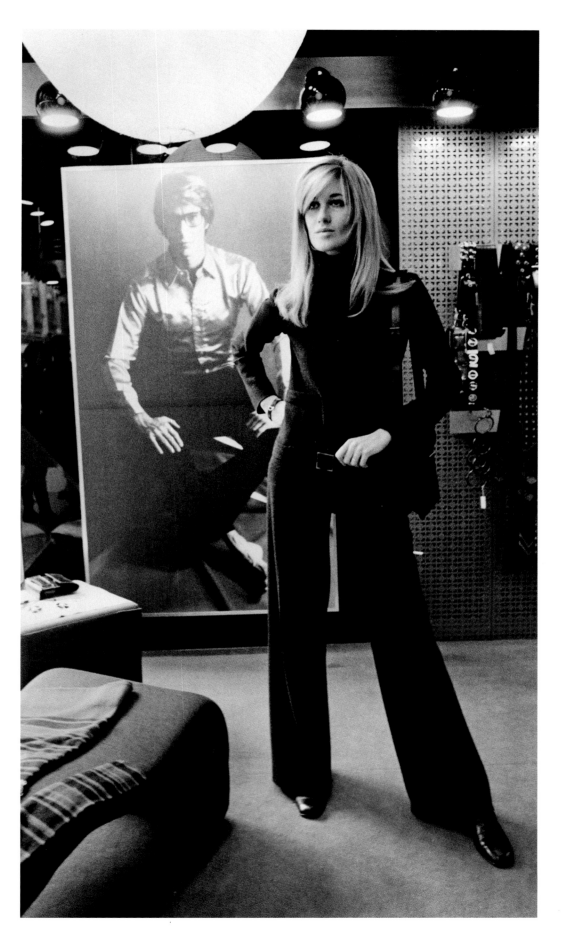

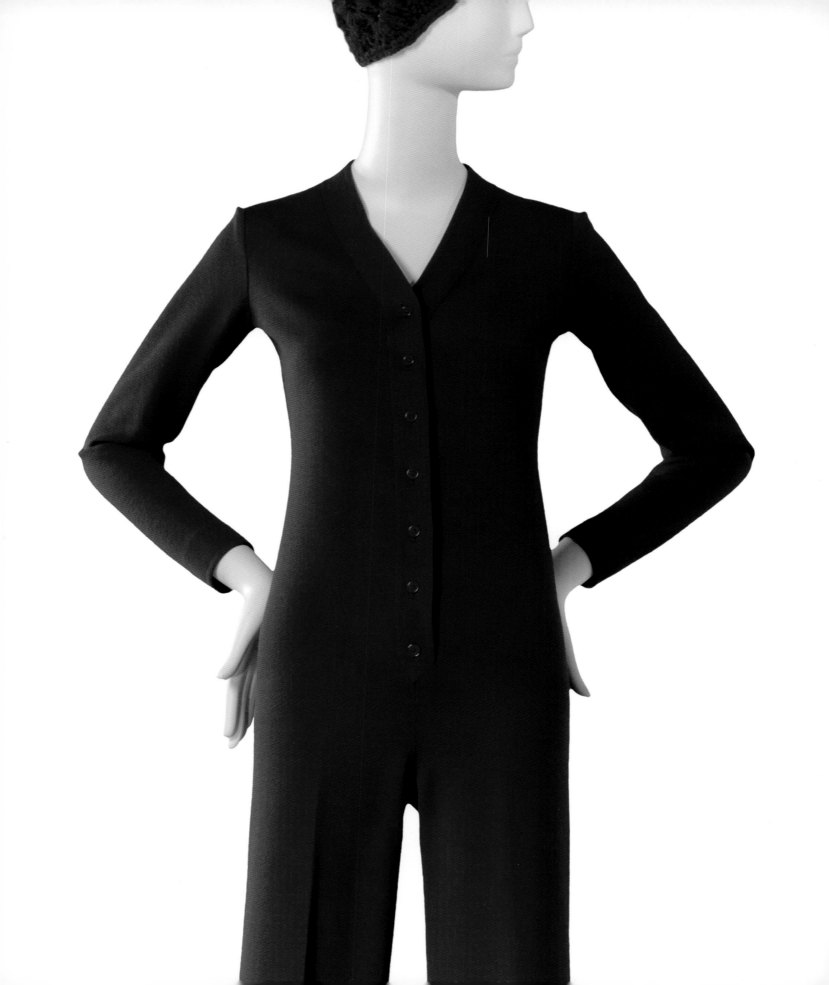

I LOVED RENOVATING
THE MAJORELLE GARDEN.
NO ONE KNOWS WITH
ANY CERTAINTY WHAT
THE EXACT COLORS
WERE ORIGINALLY.
I SCRATCHED THE WALLS,
BUT I NEVER FOUND
ANY OF THE FAMOUS
MAJORELLE BLUE.
IT WAS PROBABLY LESS
ELECTRIC. MAJORELLE
WAS A MATISSE;
THAT'S MY PASSION.

GLOBE, 1986

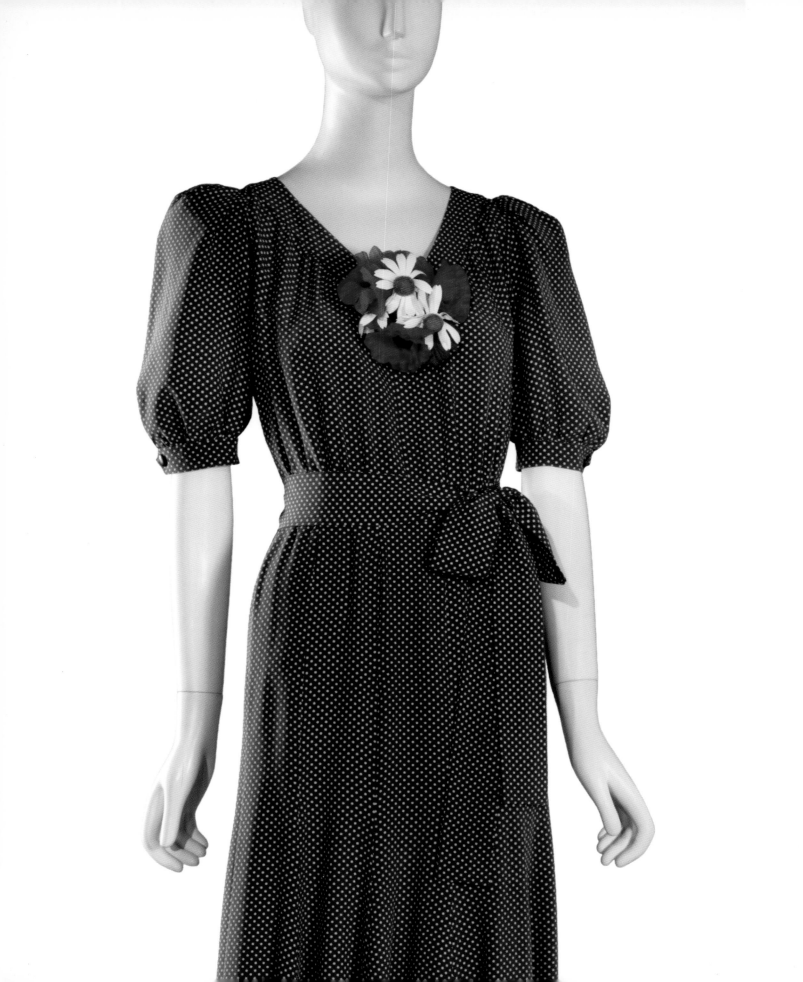

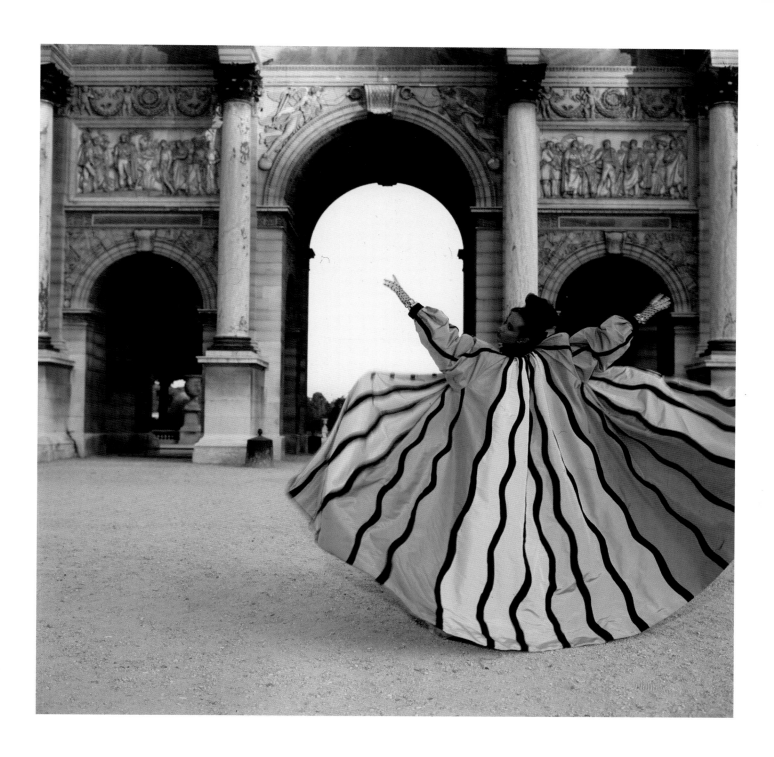

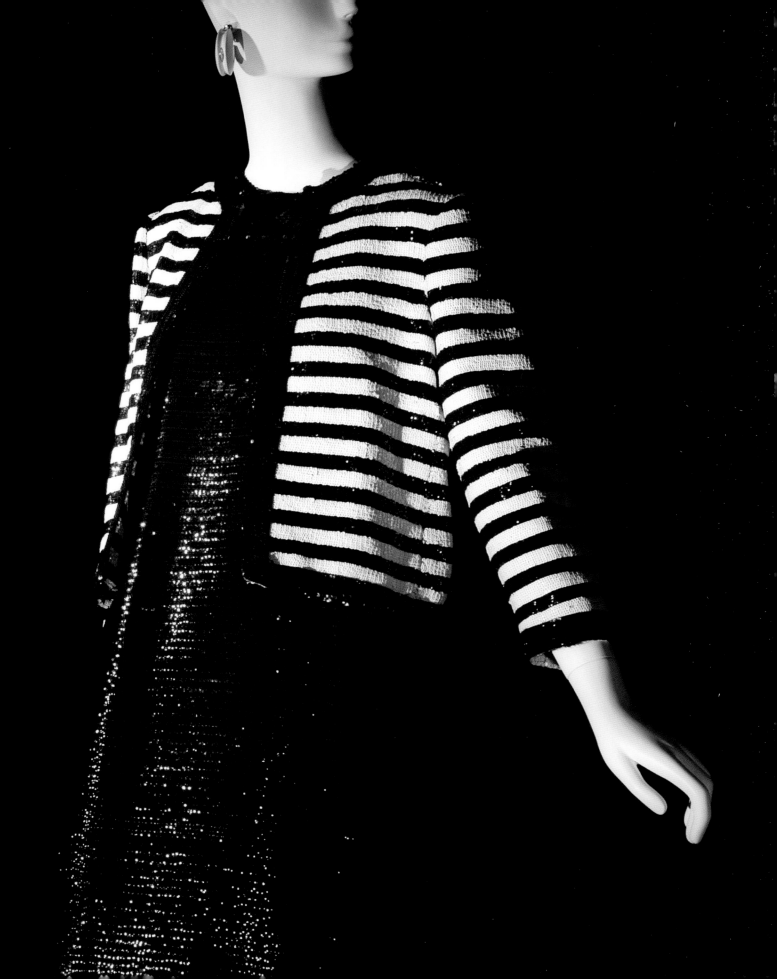

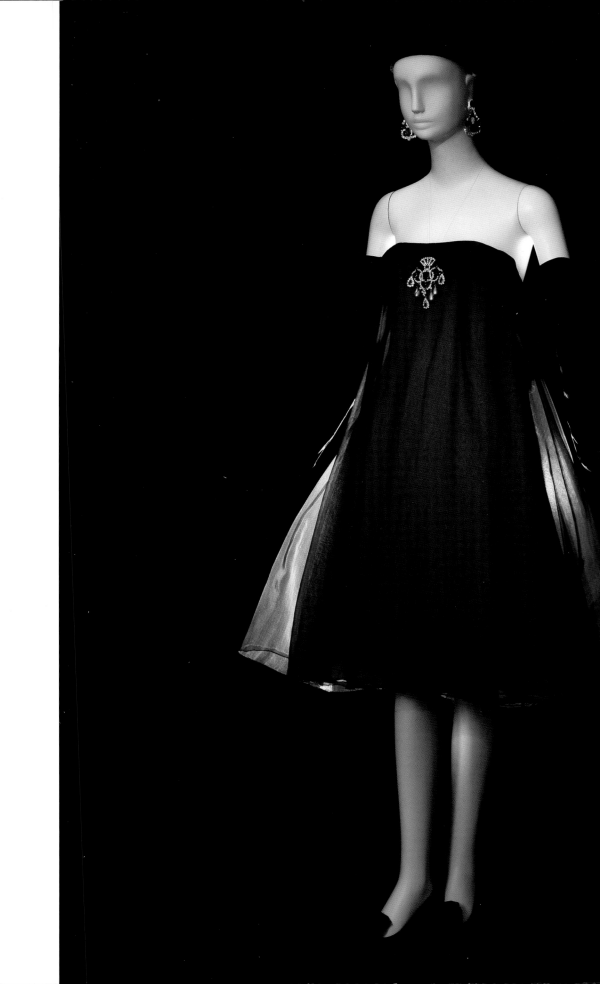

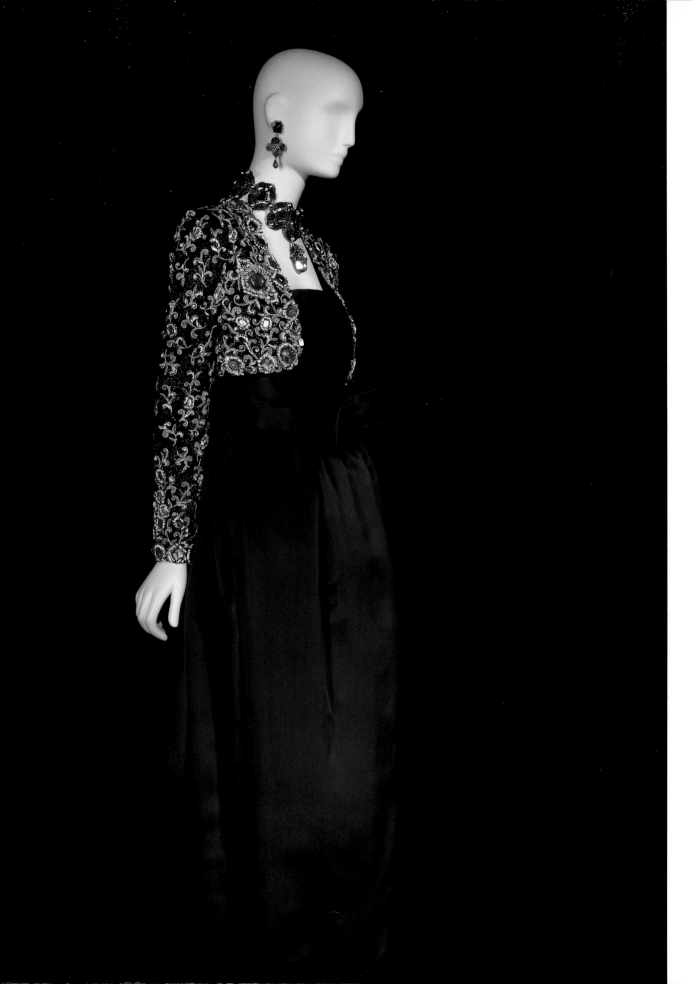

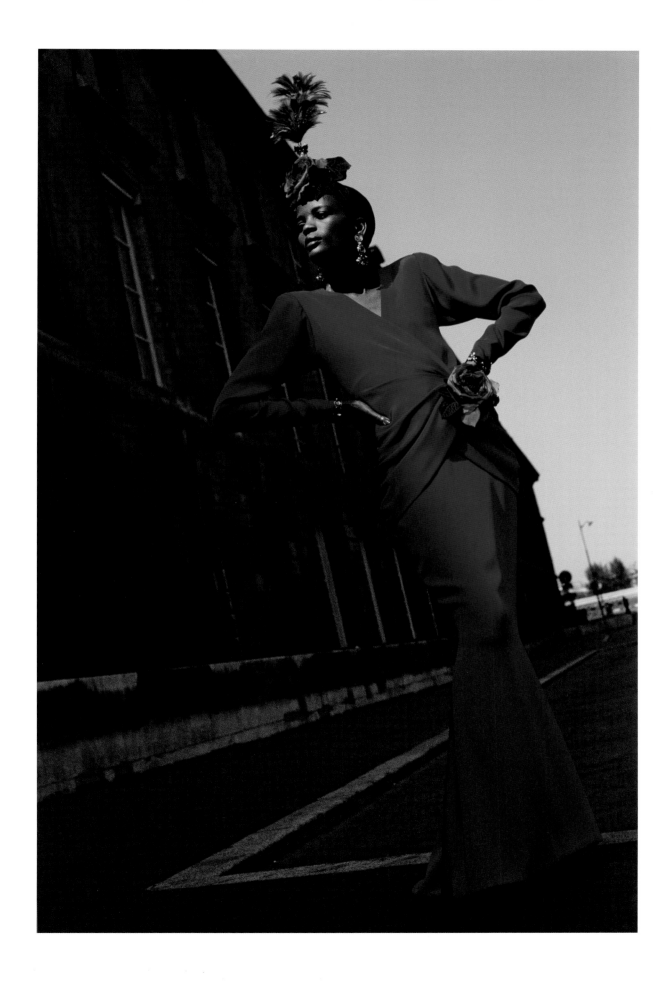

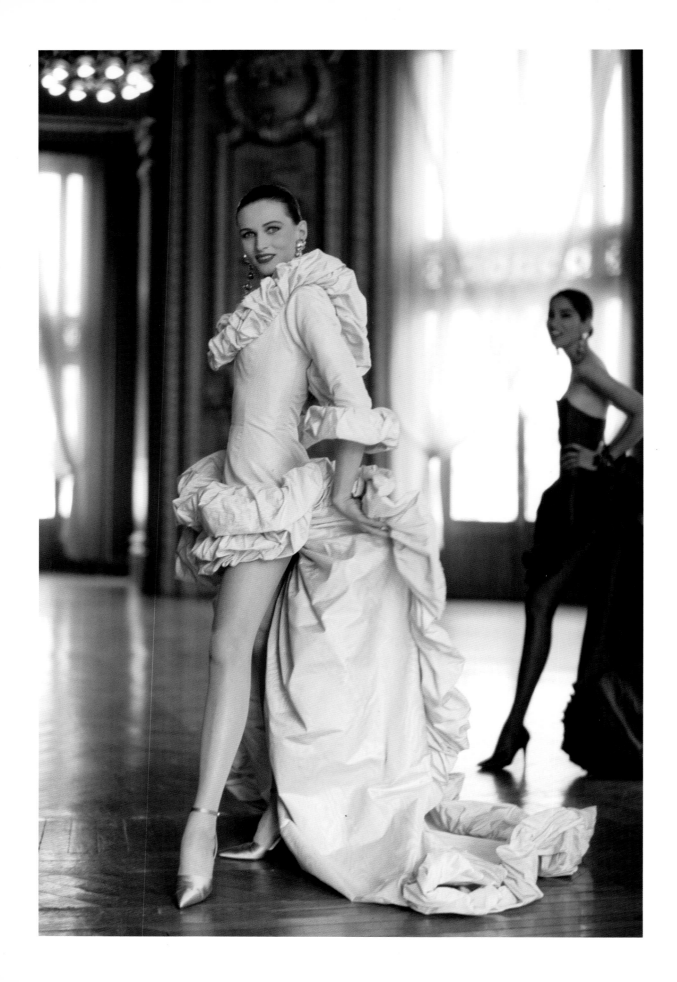

Page 159— Card with blue samples, from one of the color files assembled over the years by the Yves Saint Laurent studio.

Page 160 — Spring–Summer 1971 haute couture collection (detail of CAT. 101).

Page 161 — Domino in blue faille and black velvet, *Harper's Bazaar*, September 1984. Photograph by Norman Parkinson.

Page 162 — Spring–Summer 1966 haute couture collection (detail of CAT. 16).

Page 163 — Spring–Summer 1958 haute couture collection, Yves Saint Laurent for Christian Dior (CAT. 4).

Page 164 — Fall–Winter 1997 haute couture collection (CAT. 245).

Page 165 — Blue crepe dress, Fall–Winter 1984 haute couture collection. Photograph by Helmut Newton.

Opposite — Watteau blue moiré dress, Fall–Winter 1990 haute couture collection. Photograph by Arthur Elgort.

BODY, GESTURE, ATTITUDE, STYLE

FLORENCE MÜLLER

THE BIRTH OF THE STYLE

Chanel gave women the look. Forty years later, Yves Saint Laurent gave them the style. Over a period of forty years, in each successive collection, he explored all the possibilities of this style, a style he wanted to be eternal, unchanging. He was young and had to free himself from his master's "formula." The principle of "line" and seasonal rules that lay at the heart of Christian Dior's success were an approach that could be stifling and very limiting. Saint Laurent had experienced it himself in observing the rituals in summer 1955, with his "Trapeze" line. But his next collections escaped this straitjacket. YSL style already had the upper hand in the "Beat" collection, with its focus on youth and black jackets, imbued with the spirit of the times. After opening his fashion house in 1962, Yves Saint Laurent put away the "line" as the principal fashion indicator for good. When a journalist from the paper *L'Intransigeant* asked him a question about the summer's hem length, he refused to answer. "It depends on the woman's height and on who you're dressing. It's ridiculous to say 'the hem is 47 or 52 cm from the ground.'" Henceforth the task of journalists would be a more difficult one. How could one figure out a style when it was so easy to speak of line, skirt length, and shoulder width? Style escapes easy identification. What was outwardly visible, in this famous "YSL style"? The women on the catwalk, very beautiful but also very real, and women in real life, who seemed more beautiful simply by being "in the mood" of the times. What je ne sais quoi set them apart from other women? At first glance, their way of moving with lighthearted unconcern and self-confidence, completely free in their movements, with just a hint of affectation and carelessness. These women were not freeze-framed. They were women on the move. Their intellectual and social independence were conveyed in firm, slightly raised shoulders, which reflected the new ascendancy women had gained over their partners and over their own destinies. After the artifice of reshaping the softer areas of the body came the "truth" of the body's bone structure, which now served as the basis of each garment—the shoulders, narrow hips. In Dior, the naturally shapable waist, cinched in a wasp-waisted corset, was the core of fashion. Now it had shifted to the top of the hips and softened. The central axis of the body was freed.

What could be done with this unrestrained body? Saint Laurent's response was to develop ways to give expression to a free woman's body movements. Pockets became a necessity, an obvious need that became the rule: Most YSL clothes, daywear and evening wear alike, have pockets. The shoulder bag freed the hands. With her hands thrust deep in her pockets, her upper body mobile, just a very slight swing in the hip, shoulders set firm, her feet in boots, the Saint Laurent woman strode firmly forth toward her new destiny. In the evening, she could walk freely in a tuxedo; an evening dress with a plunging neckline and a wraparound skirt opening up to the thigh allowed for a degree of sensuality in her leg movements. The most grandiose of garments must remain comfortable, easy to wear, and endowed with its own expressive qualities. In a Dior dress, a woman was a like a splendid icon, a beautiful statue, but in her magnificent pose, the movement was stiff. Dressed in Saint Laurent, a woman moved with ease, without artifice. After the art of the pose, the mastery of attitude. The designer made this his fundamental concept: "All my dresses stem from a gesture [a movement of the body]. A dress that does not reflect or conjure up a gesture is no good. Once you have found that gesture, you can choose the color, the final form."[1]

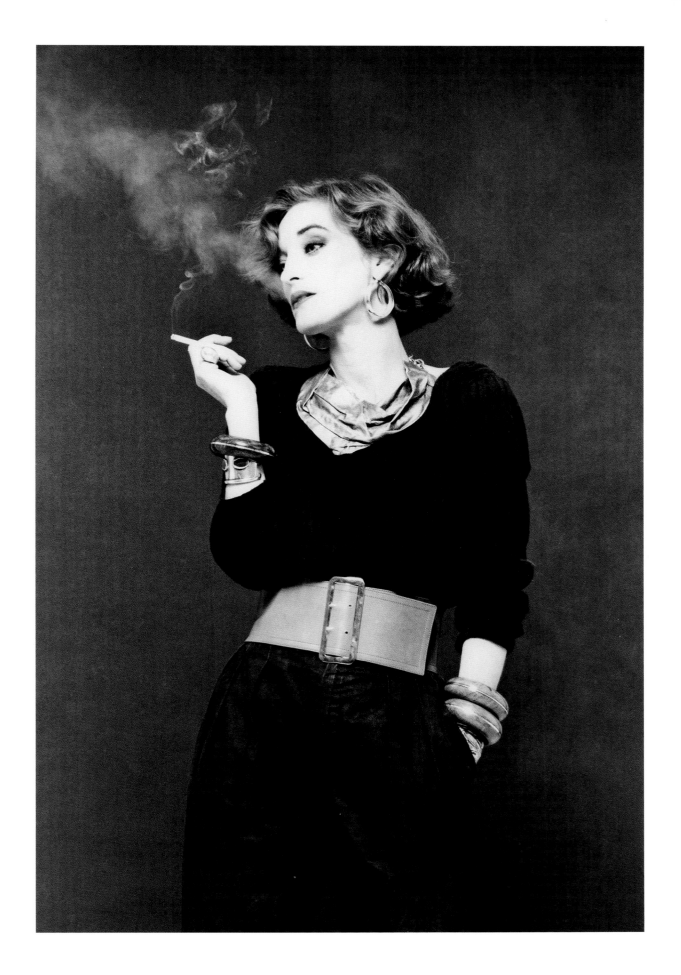

A NEW VOCABULARY FOR A NEW STYLE

Yves Saint Laurent understood early on that it was impossible to create his own couturier style without inventing his own "language." His first couture team was made up of seamstresses, *secondes d'atelier*, whom he had met at Dior.[2] The fact that they were not *premières d'atelier* [responsible for a workroom] proved an asset: A young personnel was capable of freeing itself from the techniques learned at Dior and of embracing innovative ones. Madame Esther, who was part of this first team, summed up the difference between Dior and Saint Laurent: "At Dior the dresses stood up on their own. There, the clothes weren't as stiff; they were softer."[3] Yves Saint Laurent kept Dior's rigor, his "obsession with cleanness, the cleanness of a model."[4] But to work movement and gesture into this rigor, he explored territories that had been looked at before him by Madeleine Vionnet and Balenciaga—but with a new angle of vision. He gave preference to neither the *tailleur* [tailoring] nor the *flou* [dressmaking; loose-fitting, free-flowing clothes] techniques.[5] On the contrary, he sought a kind of symbiosis between the two, by doing away with the rigidity in tailoring techniques and in strengthening free-flowing garments. Among his most principal employees were people who excelled in both techniques. Monsieur Jean Pierre, who was qualified in both *tailleur* and *flou*, had that double competence. He had worked in a *flou* workroom at Dior and started at Saint Laurent as a *second d'atelier* on January 5, 1965. After a few months Saint Laurent put him in charge of the *tailleur* workshop. In the 1990s, the man who described himself as *Saint Laurentissime dans l'âme* [totally Saint Laurent through and through] was made technical director of all the haute couture ateliers. Madame Félissa gained this double competence after a misunderstanding. Yves Saint Laurent thought she was a *"flouteuse"* [dressmaker]. According to Loulou de la Falaise, this former *première d'atelier tailleur* [tailoring supervisor] from the Balenciaga studio, not daring to disappointment him, had no choice but to excel equally in the role of *flouteuse*. Yves Saint Laurent encouraged his employees to stretch their abilities and expertise, and always challenge workroom practices. With much thought and exacting work, the Saint Laurent technique was perfected over time, developing harmoniously alongside the style it served.

EVERYTHING FROM THE SHOULDER

The garment that best represented this style was the tailored jacket. Customers who could only afford a single Yves Saint Laurent design in their entire life would unhesitatingly order a suit. The shoulder was its foundation stone, and it was what announced from afar that it was a Saint Laurent jacket. "It is from the shoulder that I unroll the material," said the designer.[6] Since Paul Poiret, Coco Chanel, Madeleine Vionnet, since the corset had been done away with, the garment's focal point on the body had moved from the waist to the shoulders. Saint Laurent created a new vision of this displacement of the center of gravity. The Saint Laurent shoulder ensured the garment's fall while leaving the neck and head free. Anne-Marie Muñoz, the Saint Laurent studio director, explained to *Vogue Italia* in 1998: "Yves has a way of pressing the shoulder of the models, as if to bring out the line of the neck, to accentuate, refine the look."[7] The shoulders had movement in them, raised at the outer edges and tracing a slightly ascending line. The YSL shoulder literally reflected the new dynamism of women active outside the family home. It had an elaborate structure that was a far cry from the traditional shoulder pad. Its various components were sculpted according to the anatomy of this part of the body and placed symmetrically on either side of the shoulder seam—for extra ease of movement. Two pieces of canvas placed edge to edge were joined with a 1.5- to 2-centimeter organza bias binding that prevented any visible thickness. The second piece of canvas, 1 or 2 centimeters shorter than the first, prevented any stiffness. Onto these canvases was placed some padding, which was shaped by hand to reduce its thickness (2 to 4 centimeters, depending on the period; it was thickest in the 1980s), tapering away at the bottom. Then a pad was placed at the edge of the shoulder, projecting beyond the sleeve by 1 centimeter. The whole structure was sewn together with a blind hem stitch and then ironed to create a natural continuity between the folds of the fabric at the join. To complete the interconnection between these parts and heighten the impression that they were quite continuous, and also avoid the appearance of a roll or fold, the shoulder seam was ironed flat with a dry cloth. The shoulder thus sculpted stylized the body in an ascending movement from a solid base: from the ground to the sky, from the lower limbs to the head.

After the shoulder, it was the sleeve that required the most attention. From 1962, Saint Laurent created specific sleeves. A daily newspaper commented at the time: "A black wool crepe dress with very thin long sleeves fitted high under the armpit surprised by its eccentric yet sober look. It is like a long tube attached under the breast, thus given prominence, while the rest of the body is but glimpsed in the movement."[8] The sleeve was soft and flexible, accompanying the movement of the arm without bringing the rest of the garment with it. It allowed a wide movement. To avoid the risk of stretching the upper body, it was fitted in the front to just overlap the body with a slightly curved seam. This cut slimmed the bust and avoided flattening the sleeve under the arm. The fitting was carried out on a model with her hand on her hip. All the rest of the jacket was designed to move with the body while the bust impeccably retained its form. According to Loulou de la Falaise, it had to "shudder in the back."[9] The jacket was never stiffened all over with canvas. The pieces of canvas placed in the front were short and light. To obtain more movement, the

stiffening canvas could be set at an angle, with reinforcements placed on the straight grain. For still more lightness, the pocket flaps were lined with material applied at an angle. The collars were clean cut, as in a man's suit. It was in the mastery of detail—from the sharply ironed turned-back cuffs to the perfect seams, well flattened—that you could recognize a Saint Laurent tailored jacket. An additional dart and a removed pocket were not whims but demands. Saint Laurent asked his workshop staff to get rid of any canvas stiffening that served no purpose. They were to avoid "thick seams and lighten the seam allowances [*ressources*]."[10] The form of the garment imperatively had to adapt to the line of the body, explained Anne-Marie Muñoz in *Vogue Italia* in 1998.[11]

Pants added the note of casualness that was essential to the composition of the whole look. To obtain a supple effect, they were never body hugging, the fullness located around the two darts at the waist. The legs narrowed toward the bottom, giving a slimmer look to the body. Skirts were assembled like pants, with ease of movement in the upper part. Their volume diminished at the bottom, lengthening the appearance of the legs. The upper body was always cut to look a little longer than it actually was. Belts enabled some cheating around the natural position of the waist. The sleeves were a little short, showing the cuffs of the blouse. A loose-flowing blouse counterbalanced any severity in the jacket. Its fullness masked the waist and wide hips. The blouse lining, narrower than the exterior, created contrasts in transparency and color. These superposed materials in varying hues produced a shimmering, fluid effect. And, everywhere, pockets invited the YSL gesture par excellence: hands planted firmly on the hips.

Flou dressmaking designs differed from the suits in that they sought a higher degree of sensuality. They were eccentric, more glamorous, using prints that were often developed with textile designers such as Gustav Zumsteg from the Abraham firm and combinations of colors that enhanced the woman's beauty. These free-flowing garments escape analysis. How can one explain that a waft of chiffon or a whiff of silk is held by just a stitch or one button? Some of the dresses in the "Braque" collection hung simply by the beak of the bird-shaped collar strap around the neck. The designs were all worked with lightness and looked unreal. Madame Félissa explains the Saint Laurent *flou* with this simple image: "You think it's a dress? Oh no, it's just a piece of material hung onto and draped around the model, its shape held together with pins, its folds precise. That's Monsieur Saint Laurent."[12] Often, like a kind of signature, the focal anchoring point of a drape was under the bust, between the breasts. This point was already emphasized in a dress designed at Dior that was captured by Richard Avedon in a photo of Dovima standing between two elephants, which had a high flowing belt tied in the form of a "dagger." A dress was designed like a second skin that was slipped over the body. The choice of material was determined by its arrangement on the body, the *fall* of the fabric, which varied according to its *weight*, its flexibility, its elasticity. The designer sought to express the *meaning* of the material, which had to "flow" over the body and be "barely touched." The journalist Barbara Griggs once quoted a television interview by Monty Modlinger on the opening of the Rive Gauche London shop. He asked the designer how he could justify the very high prices for a simple Rive Gauche jacket. Saint Laurent replied, "For ze cut"![13]

NOTES

1 — Laure de Hesselle and Julie Huon, "Le dictateur de velours," *Victor,* December 22, 2000.

2. *Second d'atelier* is a position of responsibility that consists in assisting a *premier d'atelier*, who, as the name suggests, has the highest level of responsibility. The *premier d'atelier* heads either a tailoring [*tailleur*] or a dressmaking [*flou*] workroom. At Yves Saint Laurent, the *premiers d'atelier* had between twenty and thirty people under their supervision.

3. Laurence Benaïm, "Yves," *Vogue Paris,* March 1992.

4. Claude Berthod, "Saint Laurent coupez pour nous!," *Elle,* March 7, 1968.

5. The *tailleur* workroom is where anything structured is produced, mainly jackets, suits, and coats. The technique is a complex one, combining the skills of architect and sculptor. The *flou* workroom is where all the dresses (whether evening, cocktail, or day wear) are made and all the loose-fitting designs or those cut in soft materials. In general more women work here. The draping technique in particular distinguishes *flou* from *tailleur* couture.

6. Florence de Monza, *Oh la!* France, January 17–23, 2002.

7. Javier Arroyuelo, "Yves Saint Laurent," *Vogue Italia, Alta Moda* supplement, March 1998.

8. "Le retour tant attendu," *Le Républicain Lorrain,* January 30, 1962.

9. Interview with Loulou de la Falaise, October 9, 2009.

10. The seam allowance [*ressource*] is a small length of extra fabric left inside the seam that allows for adjustments on fitting. Interview with Jean-Louis Debord, September 23, 2009.

11. Arroyuelo, "Yves Saint Laurent."

12. "Yves Saint Laurent au Metropolitan Museum of Art de New York. Portrait de l'artiste," conversation with Yvonne Baby, *Le Monde,* December 8, 1983.

13. Barbara Griggs, "All About Yves," The *Observer,* May 25, 1986.

Page 171 — Loulou de la Falaise. Photograph by Jean-Pierre Masclet.

Below — Handwritten note by Yves Saint Laurent.

Left — Pink wool jacket, blouse, and gray flannel pants, Saint Laurent Rive Gauche collection, American *Vogue*, March 1981. Photograph by Helmut Newton.

Opposite — Naomi Campbell in a tuxedo with short skirt, Fall–Winter 1988 Saint Laurent Rive Gauche collection. Photograph by Arthur Elgort.

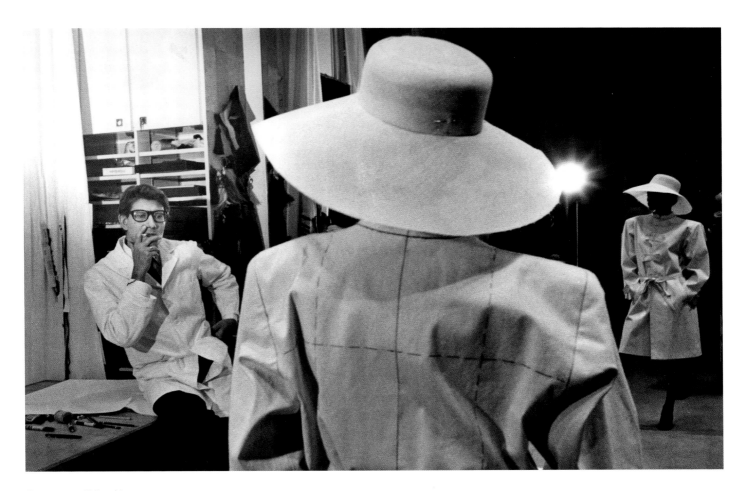

Opposite — Knitted Lurex sweater
and crepe pants, Saint Laurent
Rive Gauche collection, *Vogue
Paris*, November 1972. Photograph
by Helmut Newton.

Above — Yves Saint Laurent and
Edia Vairelli in the workshop
of 5 avenue Marceau, 1982.
Photograph by Pierre Boulat.

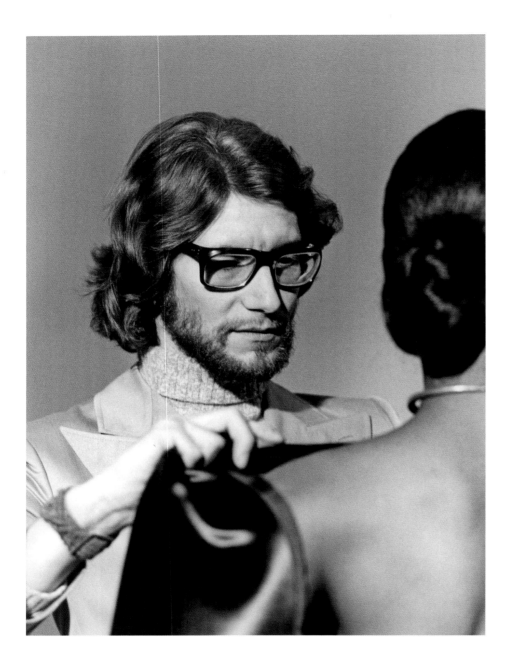

Left — Yves Saint Laurent during
the fitting for a dress from the
Fall–Winter 1970 haute couture
collection. Photograph by
Giancarlo Botti.

Opposite — Yves Saint Laurent and
Victoire Doutreleau, January 29,
1962. Photograph by Pierre Boulat.

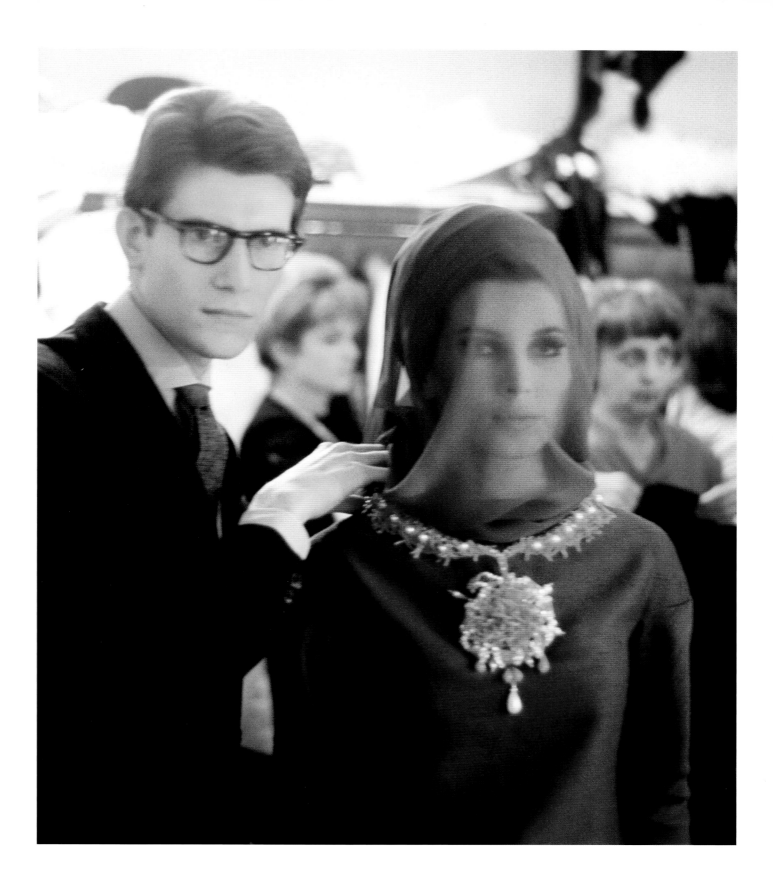

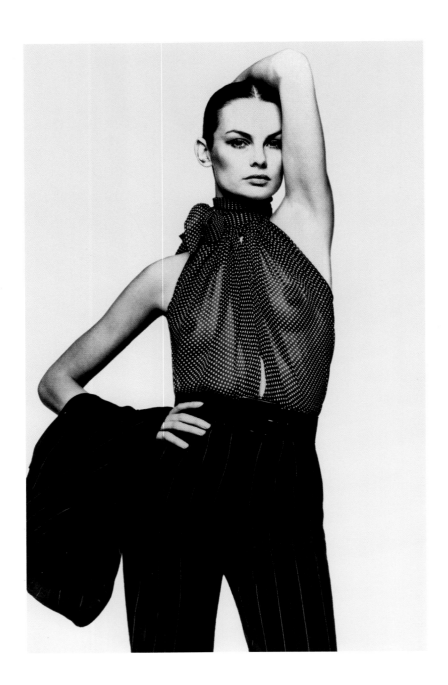

Left — Pantsuit with thin stripes
and transparent dotted blouse,
Spring–Summer 1971 haute
couture collection, American
Vogue, March 1971. Photograph
by David Bailey.

Opposite — Transparent chiffon
dress with ostrich feathers,
Fall–Winter 1968 haute couture
collection. Photograph by Bill Ray.

Page 184 — Spring–Summer 1978
haute couture collection (detail of
CAT. 272).

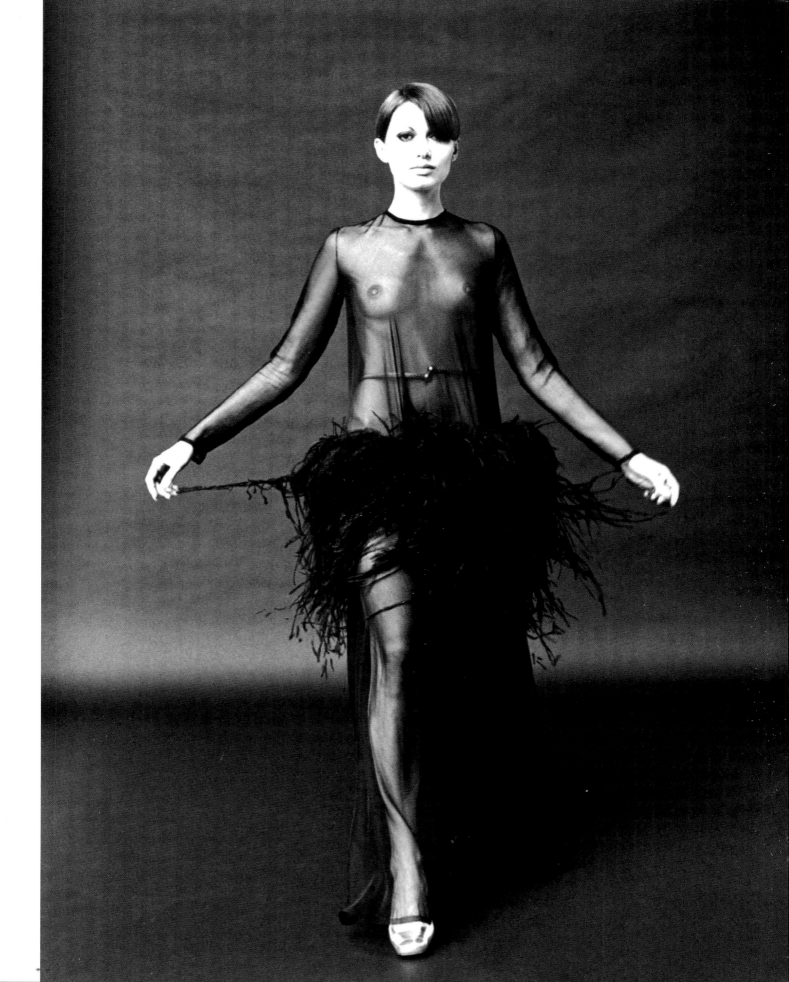

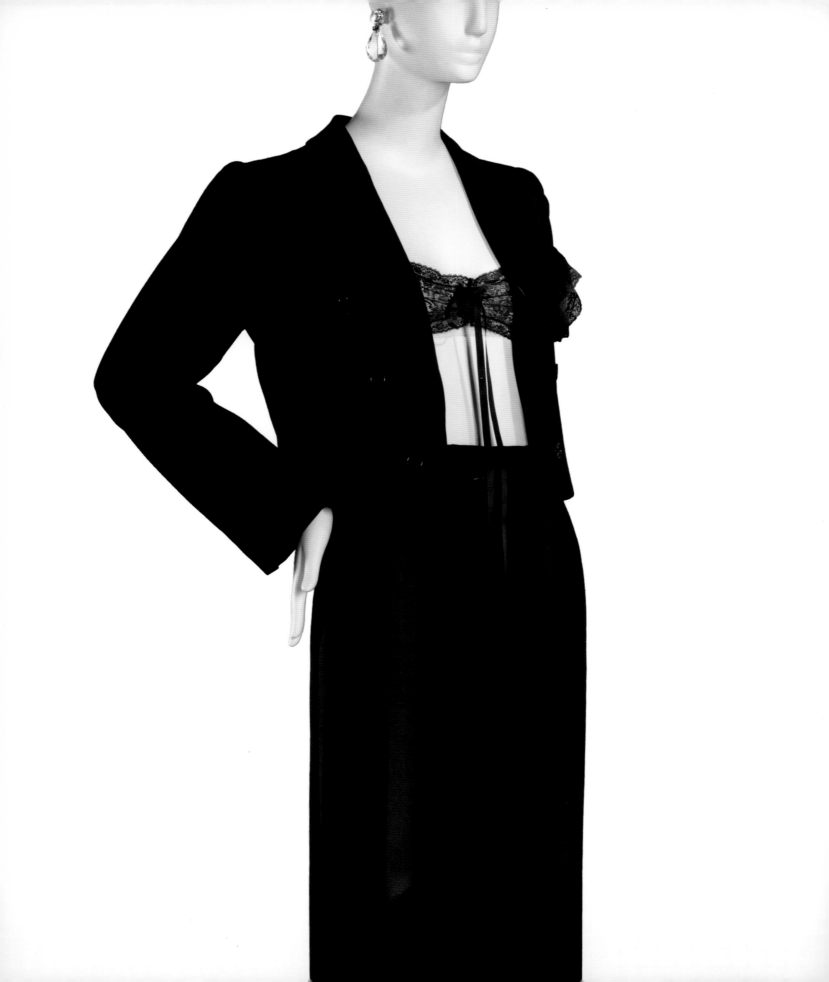

I LIKE DULL COLORS BY DAY, BECAUSE I FIND THAT THE LIGHT OF PARIS IS ILL-SUITED TO BRIGHT COLORS, BUT AT NIGHT I WANT WOMEN TO BE LIKE BIRDS OF PARADISE.

ELLE, 1977

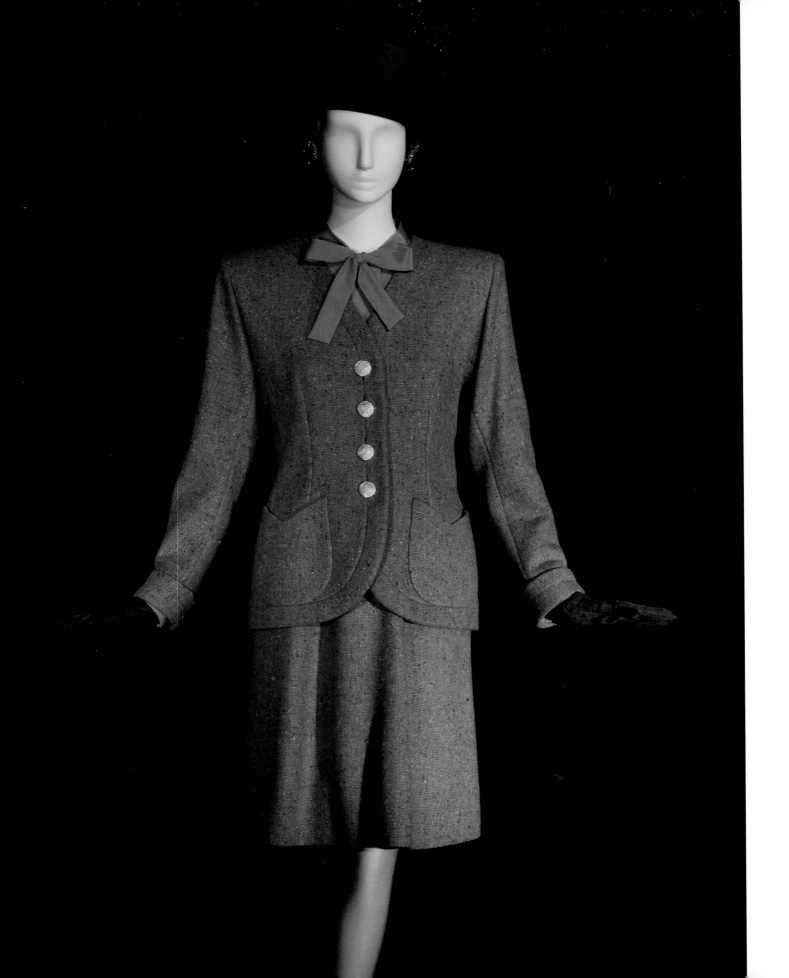

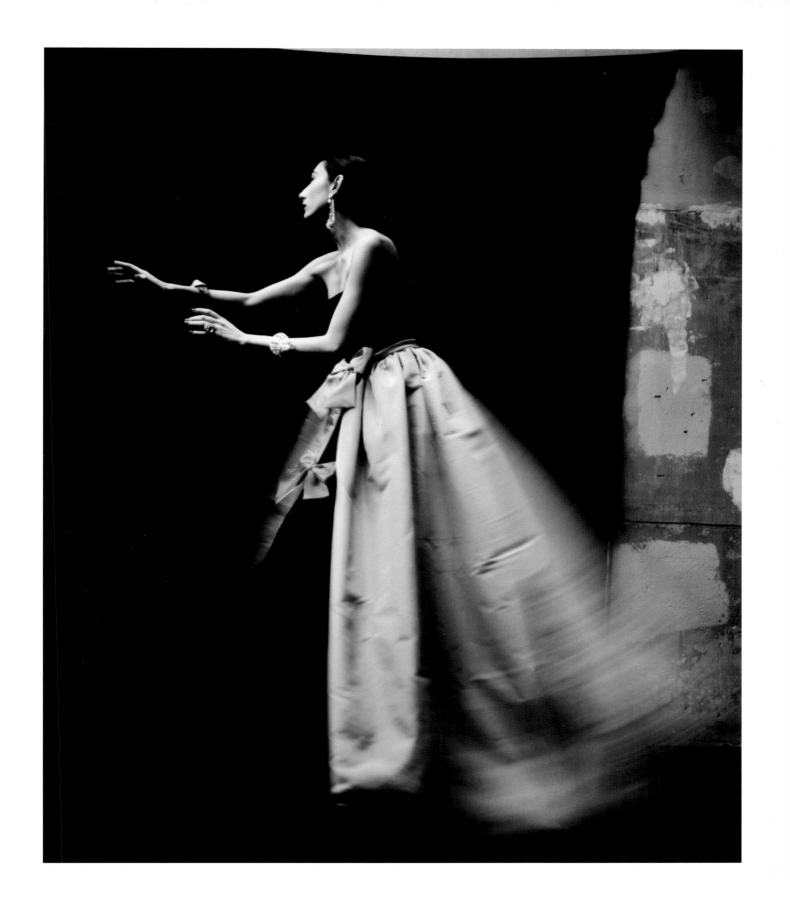

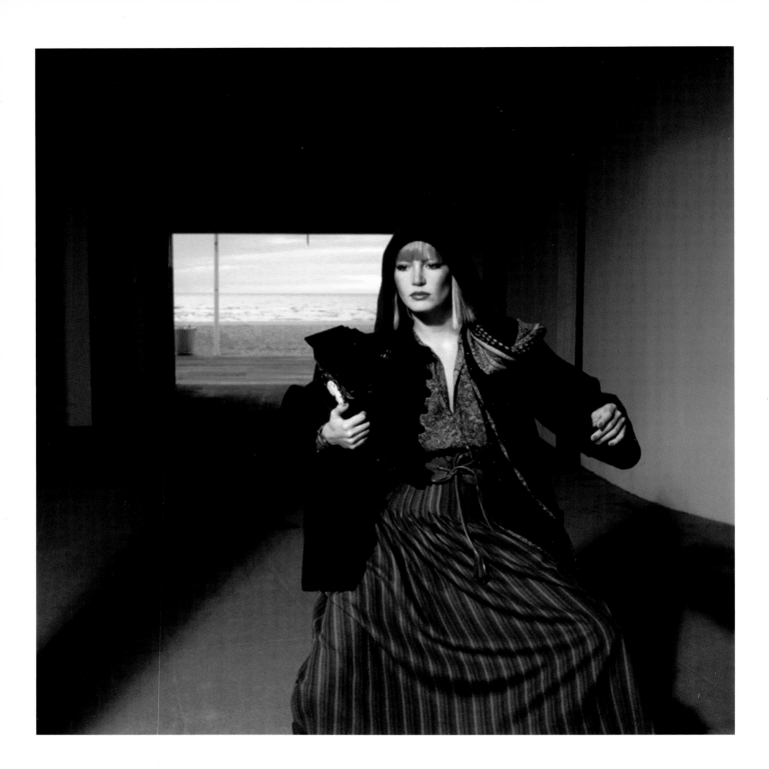

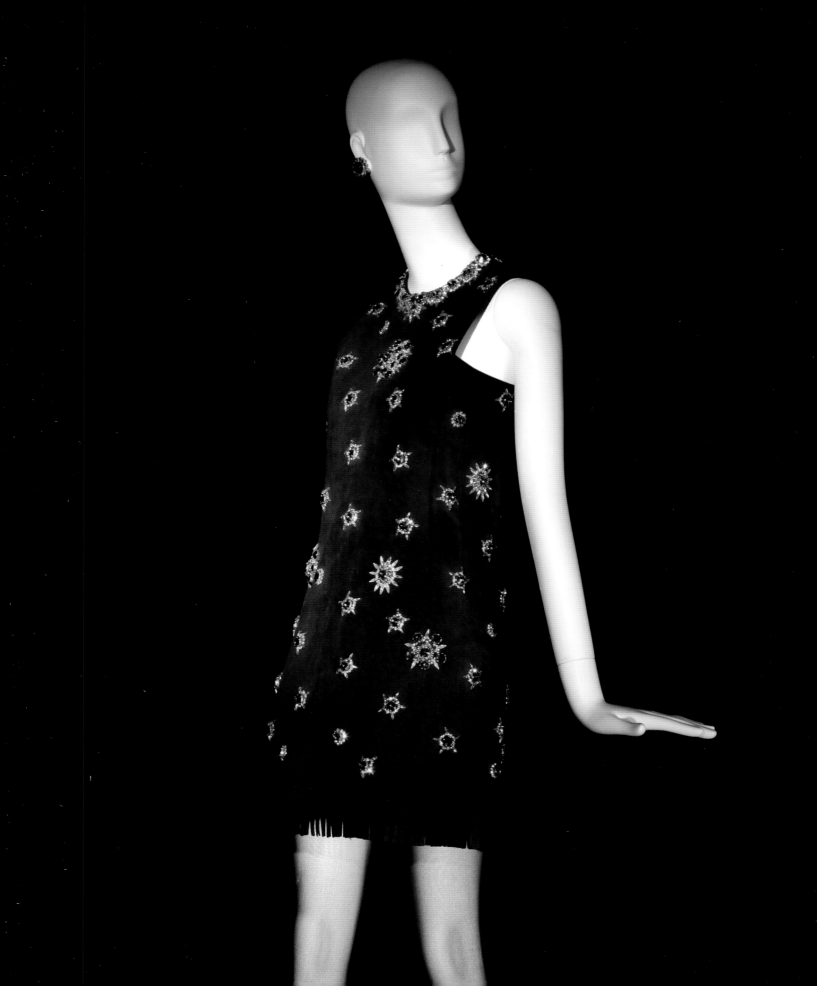

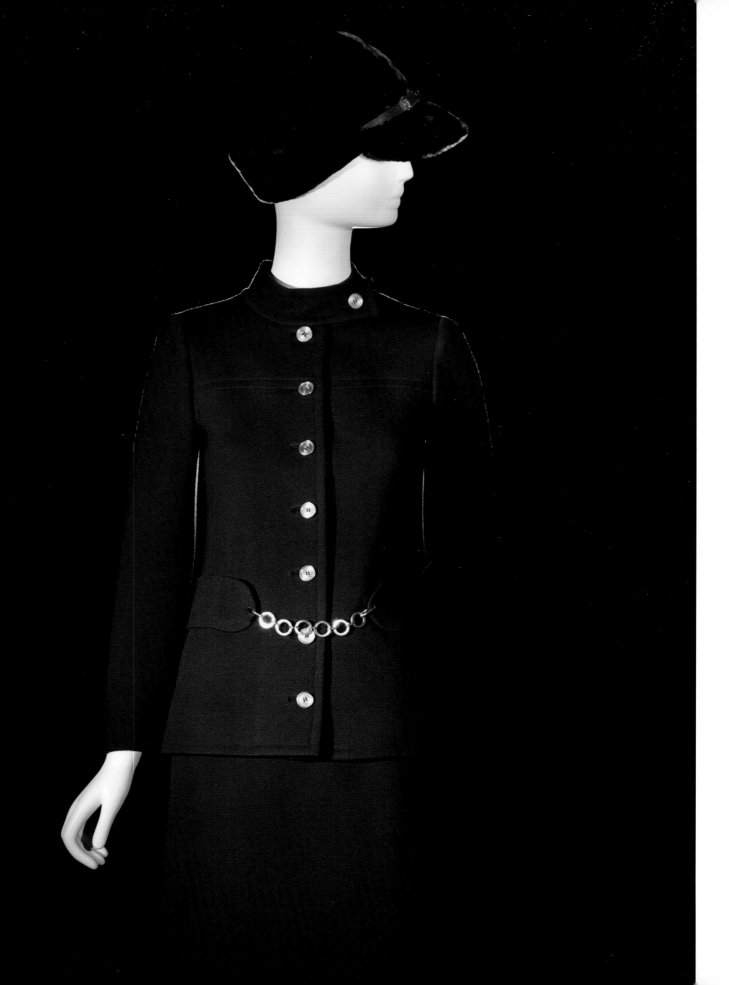

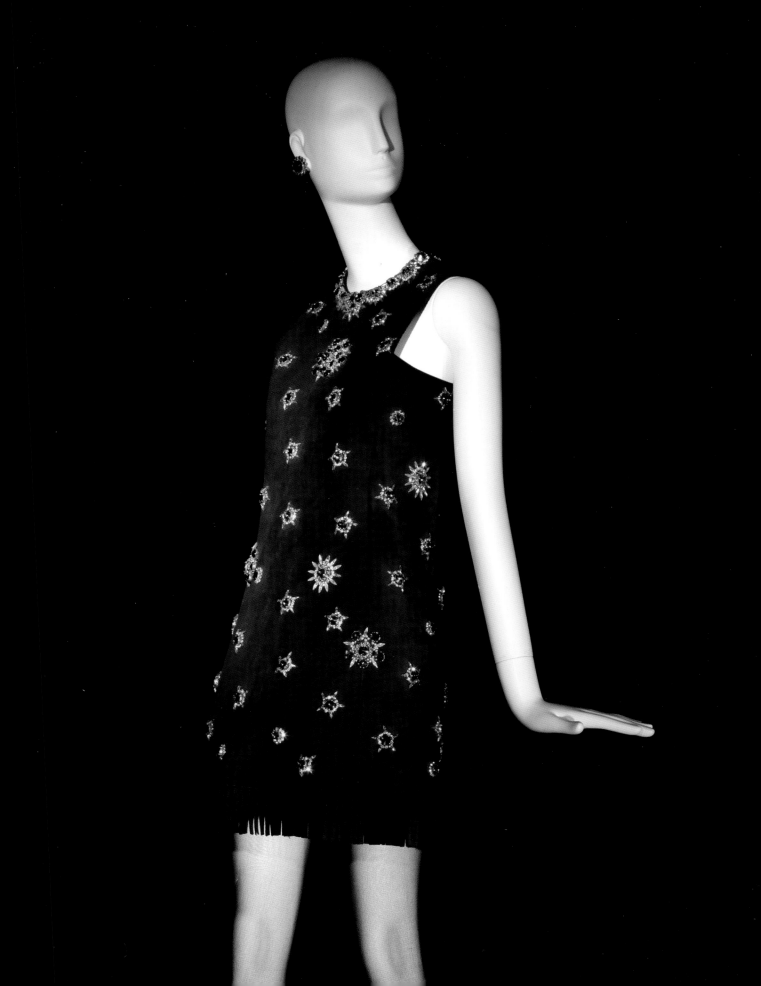

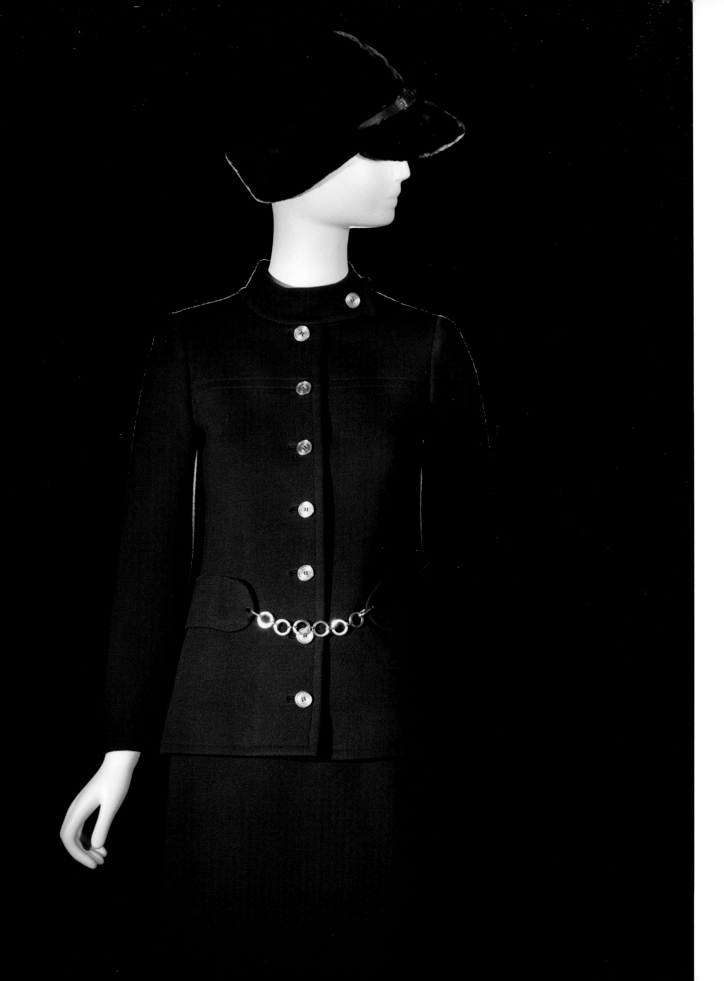

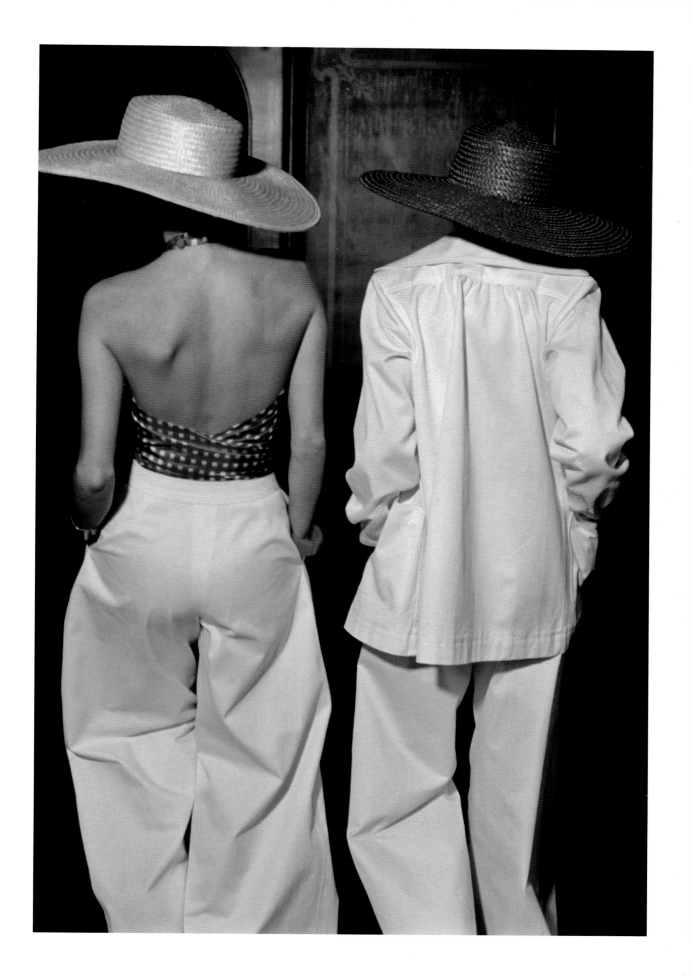

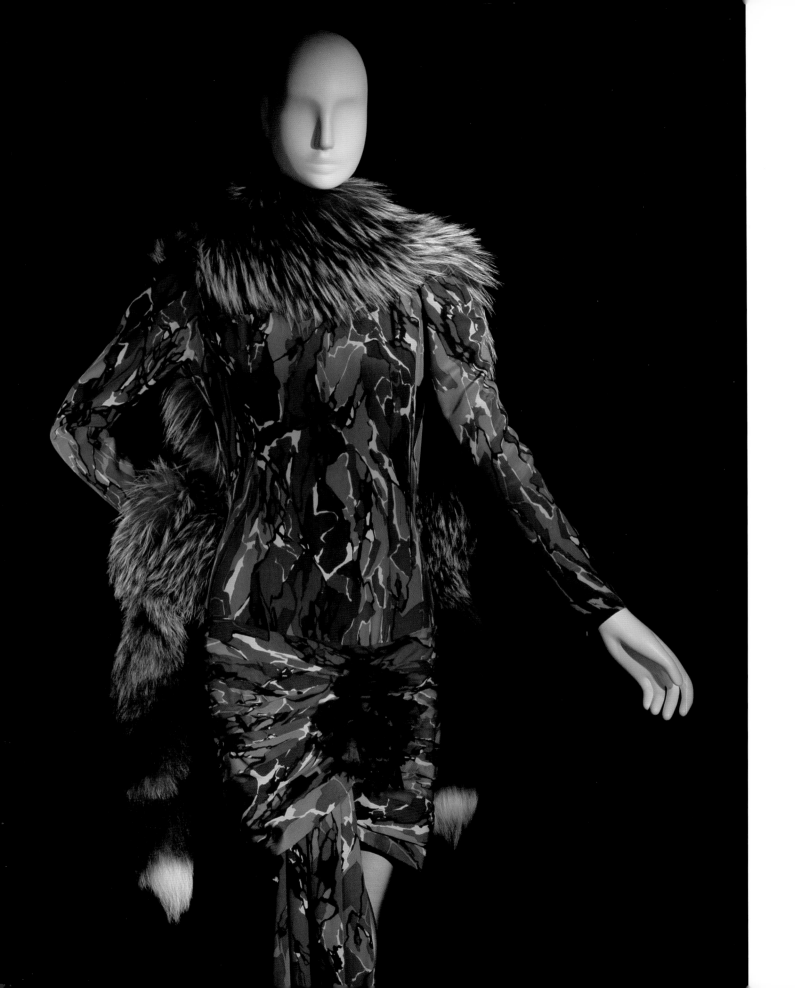

Page 187 — Card with brown and green samples, from one of the color files assembled over the years by the Yves Saint Laurent studio.

Page 188 — Fall–Winter 1990 haute couture collection (CAT. 41).

Page 189 — Ahn Duong in a black guipure lace and green faille dress, Spring–Summer 1986 haute couture collection. Photograph by David Seidner.

Page 190 — Russian-inspired Saint Laurent Rive Gauche ensemble, *Stern*, September 16, 1976. Photograph by Peter Knapp.

Page 191 — Fall–Winter 1968 haute couture collection (CAT. 70).

Page 192 — Fall–Winter 1967 haute couture collection (CAT. 51).

Page 193 — Summer dresses, taffeta and cotton, Saint Laurent Rive Gauche collection, Spring–Summer 1972, British *Vogue*, March 1972. Photograph by Peter Knapp.

Opposite — Spring–Summer 1971 haute couture collection (CAT. 102).

SPRING–SUMMER 1971: ANATOMY OF A SCANDAL

FARID CHENOUNE

A woman only truly becomes stirring once she starts cheating, when artifice comes into play.

YVES SAINT LAURENT,
MANUSCRIPT, FONDATION PIERRE BERGÉ–YVES SAINT LAURENT

On January 28, 1971, the Spring–Summer 1971 collection was shown in the salons on rue Spontini: velvet turbans spiraling skyward, enormous boleros in green fox or black monkey fur, short jackets with square shoulders and narrow braided lapels, little jersey dresses whose bias cutting, drape, and gathering clung brashly to the body, high-heel wedgies and ankle-strap shoes, bold makeup. People instantly realized they were being projected back to the 1940s. The critics slammed the collection. "Nauseating," said the *Daily Telegraph*, and the *Guardian* called it "a tour de force of bad taste."[1] "A cold shower," claimed *Paris-Jour;*[2] "women at their worst," concluded *The Daily Sketch*.[3] But it was Eugenia Sheppard who wrote the most famous putdown of all: "The Ugliest Show in Town."[4] Pierre-Yves Guillen, meanwhile, was the most vitriolic. "What arrogance to think that, like sheep penned in a concentration camp, we would applaud when we saw good taste sent to the slaughter, elegance consigned to a mass grave, glamour dispatched to the ovens."[5] The outcry reflected the level of the shock: People in the stunned audience were heard to murmur "dreadful comments."[6] Never had an Yves Saint Laurent collection attracted so much hostility, a term that is perhaps an understatement given how adored he had been.

This collection remains a strange one, known to historians and the "fashion crowd" but unfamiliar to the general public. It almost seems as though, after having exploded in scandal, the collection immediately closed down on itself, shutting up its internal tensions. Saint Laurent's "dark work" nevertheless continued to feed into fashion, social habits, and ways of seeing and being seen (if sometimes surreptitiously). It accomplished more than just the first feat of arms for which it received official recognition, namely, launching the craze for "vintage" or "retro" fashion. So let's just call it the "71" collection.

What was Saint Laurent accused of? Merely harking back to the forties, a time of war, occupation, and collaboration in France? By 1971, in fact, a "retro" mood was already in the air, although the term *rétro* was just making its appearance in French. Fashion had begun looking back nearly two years earlier as the optimistic sixties came to a close and hippie utopianism began to age. Nostalgic fashion turned its mind back to the interwar period, the thirties, followed by the forties. "Like almost everyone else in couture," wrote the *San Francisco Chronicle* on January 30, 1971, "Saint Laurent is infatuated with the 1940s." So what was the problem? Part of the Anglo-American press believed that the designer was merely catching up: "While the '40s look has been around London and the East Village for some time, most designers agree that it was Yves St. Laurent who pulled the look together and sparked it off with his spring couture collection," wrote *Women's Wear Daily* on March 12, 1971. Although Saint Laurent didn't invent the "forties" fashion, it wouldn't have developed as it did without him.

Criticism of the collection was not exclusively hostile. True, no one noticed the back-to-childhood time machine probably buried within it (Yves Saint Laurent was born in 1936). However, several journalists realized that this show reflected "the pulse beat of young fashion."[7] Such fashion was flourishing elsewhere, beyond couture, among trendy young women, and nothing could stop it. In the months that followed, this retro look—once recast by Saint Laurent in his Rive Gauche ready-to-wear line—would become so popular, notably in America, that the critics fell silent. And Eugenia Sheppard went to Paris to make amends.[8]

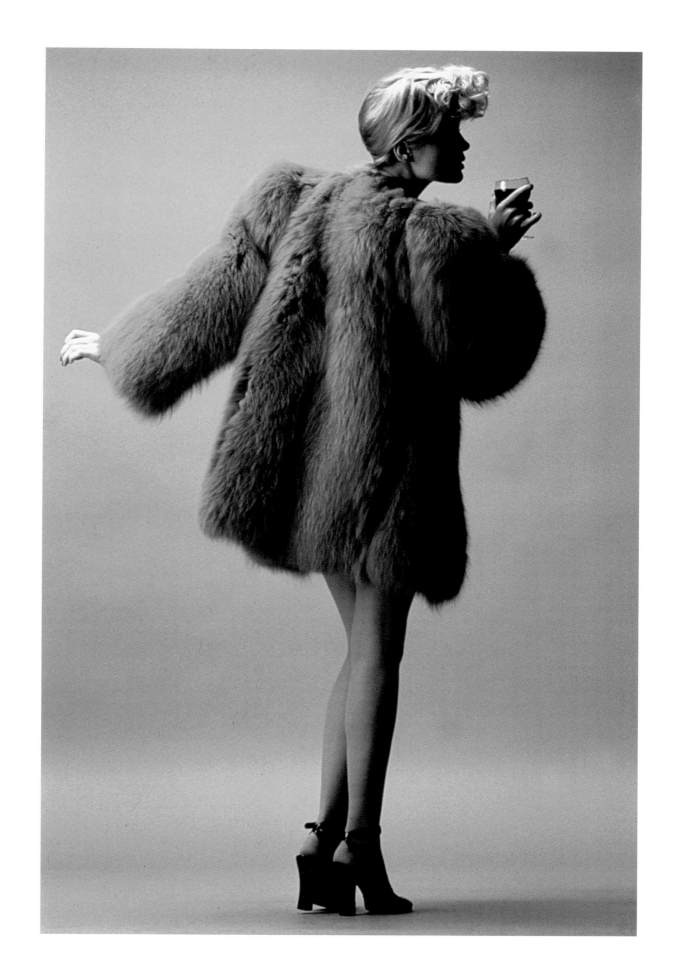

PALOMA PICASSO, TOTEMIC MUSE — So who were those trendy young women? By 1970 they were being glimpsed not only in London and New York but also in Paris: on rue de Buci, in La Coupole very late at night, and in the rare screenings of movies from the *underground*, a fetish term of the day that thrilled an entire fringe of youth culture. These women bought their clothes at flea markets, adopting a *vintage* look—a term that had not yet made its way into the French language, as it would around the year 2000—that had its own special aura, lending an anachronistic, casual chic to faded old-fashioned clothing wrapped in the memories of glamorous Hollywood movies of the 1940s. They were the forerunners of the fashion for irony, which would fuel the retro tastes of the 1970s. Born after the Second World War, these young women didn't notice the "dreadful" connotations of 1940s clothing, so obvious to the older generation, the generation that dominated fashion journalism on the day the collection was unveiled.

One young woman nevertheless made a sensation in the rue Spontini salons on January 28, 1971: Paloma Picasso, daughter of Pablo Picasso and Françoise Gilot. The budding young jewelry maker wore a red turban, a black swansdown bolero over a clinging flowered dress, and platform shoes with round tips and ankle straps.[9] Probably the only person there to be so completely "forties," Paloma Picasso was already the object of press photographers' attention. And she had a decisive influence on Saint Laurent's "forties" development. In fact, she directly inspired it. The two met at the rue Monsieur home of landscape architect Mark Rudkin, probably in the spring of 1970. The encounter gave Saint Laurent an "aesthetic jolt," according to Pierre Bergé who was present.[10] In this very young woman's getup and look, Saint Laurent saw *more* than a passing fashion; he glimpsed a totally new approach to the antiestablishment sense of freedom that he had always craved but which his status as the prince of haute couture denied him. Already back in 1965, he had admitted he was "fed up with making dresses for blasé millionaires."[11] Paloma Picasso suddenly intensified his desire to "stir things up."[12] Picasso's totemic silhouette was the source of the 71 collection.

The effect of this revelation was immediate, right from the Fall–Winter 1970 collection that contained the seeds of the 71 collection. Saint Laurent was already inspired by his recent encounter with Paloma Picasso. He slipped in five designs, including the bridal outfit, that prefigured the "gimmicks"—or stigmata—of the forties look: velvet turbans in the style of Carmen Miranda, stocky shoulders, fitted dresses that came to just above the knee, platform shoes. Incongruous in a collection that generally fell to the ankle, these dresses seemed disturbing, halfway between funny and worrying. The bride's cloak with its kitsch instructions to her betrothed stitched in velvet letters—"Love me forever" on the front, "Or never" on the back—sparked laughter, but the press was disconcerted. The *Evening Standard* of July 24, 1970, wondered whether it was "a touch of genius or schoolboy prank." Six months later, the prank assumed the scope of an entire collection while Paloma Picasso took on the status of muse.

The magazine *Elle*, which defended the heavily criticized collection, made Paloma's reputation. "Saint Laurent designs dresses with her in mind . . . [and] in recent months many young women have begun to resemble her," it

wrote in its issue dated March 1, 1971. These young women not only shopped at flea markets, but "like [Paloma], they paint their lips dark red and give themselves the air of thirty-five at the tender age of twenty. Like her, they have swapped the fun of Pop style for the delights of Kitsch." The weekly magazine then went on to ask, "What is Kitsch?" And, in a proselytizing tone, it explained that Kitsch "is everything in bad taste, provided that you look at it with 'irony.'... Examples of kitsch include a plastic brooch of a little dog, souvenirs, doll's tea sets, and artificial flowers"—like the flowers Saint Laurent added to the dresses in his collection.

Meanwhile, the British and American press used the terms *camp, high camp,* and *campy* to described the mentality of an ironic trend that cultivated frivolous femininity, deliberately outrageous bad taste, and an insolent vulgarity that undermined not only the codes of haute couture but also the dress codes of 1960s modernity and hippie utopianism. After years of flat or low heels, Saint Laurent's wedge sandals with open toes and ankle straps ("Raymondes," as some Frenchwomen ironically nicknamed them)[13] embodied a new spirit that today would be described as *décalé* [quirky], another French term that didn't come into its own until the end of the twentieth century.

There was nothing scandalous about this younger generation's irony in itself. But applied to imagery associated with the war and Occupation in France, it literally shocked the older generation. There where the former saw only stylistic posturing in the present, the latter had to face up to memories of its past. With Saint Laurent, the clash between these two sensibilities became, for a time, explosive. Whereas other designers had merely toyed with the idea of the forties, Saint Laurent fully embraced a period reputed to be the ugliest in the history of fashion. The stage was set for scandal.

COUTURE HOUSE, CATHOUSE — In 1971, just over twenty-five years after the Second World War ended, memories of the tribulations of German occupation were still vivid in France. People remembered shortages that meant food rationing, poor-quality fabrics and clothing, do-it-yourself accessories, and small-time fashion. Almost all women, living in straitened financial circumstances, were affected by it.[14] People recalled all this in 1971, and the press pointed it out again, but that wasn't the real problem with Saint Laurent's collection. It wasn't this everyday wartime wardrobe that the show on rue Spontini evoked. Rather it reincarnated *another* wardrobe, one composed of lavish, showy clothing worn by the women who had collaborated with the occupying army in the worst possible way—what was known as "horizontal collaboration." That, at least, was how Saint Laurent's designs were perceived twenty-five years later.

When France was liberated in 1945, people forcibly shaved the heads of all the despicable women who had "slept with the Germans," an irrevocable indictment that peppered French discussions of wartime for thirty years thereafter. Although clothes can make the period, the period also makes the clothes; the only problem with these clothes was that they had dressed this particular period. Hence the true problem with the 71 collection wasn't one of taste but of sexuality, morality, and politics. In the January 30, 1971, issue of the *Times*, Prudence Glynn warned, "If you are thinking of dressing like this, gather your reputation about you. Otherwise, the impression you are most likely to create is

that you belong in the world of professional horizontal collaboration." In a kind of equally "retro" re-creation of the past, in 1971 the press turned itself into judge and jury of appearances, thereby convicting Saint Laurent's collection outright. Pierre-Yves Guillen wrote in *Combat* on February 1, 1971, that "the models, their heads probably shaved by the Free French forces, wear wigs curled with Corinne Luchaire's curling iron,[15] held in place by silly turbans. When you have the talent of an Yves Saint Laurent, that's scandalous."

"Models with shaved heads," "horizontal collaboration"—the *real* word never appeared in print, even though it was on everyone's mind. The name used to designate the cursed collection was constantly pushed around under vague titles—and still is today—as the dates shifted from review to review, thereby modifying the primal scene: '38–'45 collection, forties collection, '39–'45 collection, '45 collection, postwar collection, "Liberation" collection, and so on. Some journalists even invented Saint Laurent's motives for the show out of whole cloth. In its issue of January 30–31, 1971, *Paris-Jour* wrote, "After the war, when still a child, Saint Laurent must have walked along rue Saint-Denis [known for its gaudy prostitutes] and had such a shock that, twenty years later, he can't forget the trauma caused by the sight of outrageously made-up women dressed in poorly draped but provocative furs, with a fox stole around the neck and platform shoes on the feet."

The phantasm of prostitution was unbearable for most people. In the days following the show, certain clients were too alarmed to enter the fashion house.[16] That the phantasm was spawned in the plush salon on rue Spontini made it all the more intense. And it further fueled the almost stealthy quality of the picture in Helmut Newton's photo spread on the collection, published in *Vogue Paris* on March 1. The same phantasm had haunted Dior, although it was repressed—physically repressed. In his memoirs, the designer of the "new look" recounted how, on the eve of his first collection, subsequent to a small ad placed in the papers, a cohort of prostitutes appeared on the doorstep, convinced that a cathouse was hidden behind the couture house. They were turned away. "There were some pretty girls among them, but they really weren't the right type," added Dior with a hint of regret. "A couturier can hardly forget that the grand-daddy of fashion magazines was called *Bon Genre* [The Right Style]."[17]

Something unmentionable had happened. It was as though Saint Laurent, playing "sorcerer's apprentice" (*Combat*, February 1, 1971), had opened a secret door, connecting fashion house to whorehouse. The phantasm of prostitutes and brothel was so strong that the guilty garments and damning details sparked more than just rejection: They generated disgust and phobic obsession. Wedge sandals with open toes and ankle straps were described by Simone Baron of *France-Soir* as "hideous" and by Eugenia Sheppard as "positively repellent."[18] The prize for disgust went to the little dresses with bias-cut draping, typical of the forties. Crepe and jersey dresses hugged—not to say "clung to"—the body's every curve while plunging V-necks draped the breasts. There were also corset-belted dresses that caressed the belly and "sheath dresses that wrap[ped] you in ruffles from chest to thighs."[19] Even the jersey fabrics of these dresses were demonized. There was something uncomfortable, almost unhealthy about them. These jerseys were too soft and "flabby," unlike the ones Saint Laurent previously employed, with their "very fresh, crisp handle."[20] Unhealthy—and sexy:

"The entire body, from breasts to thighs, is sheathed in cross pleats, the skirt is gathered. They wear red flowers in their hair and buskins with four-inch heels on their feet. It's more than a little sexy."[21] This "more than a little" sexiness was epitomized by one redheaded model who was alleged to be unprofessional; her sensuality stood out and shocked people. "Yves was mad about her but the audience found her sordid," recalled Loulou de la Falaise. Both opinions were based on the same explanation: because she was a redhead, "because she had breasts, because she had a suggestive way of walking—very pronounced and languorous, almost sluggish—all of which seemed a little lewd."[22]

PANDORA'S BOX — In March 1968, on the TV program *Dim Dam Dom*, Yves Saint Laurent said that he found the word *elegance* as old-fashioned as the phrase "haute couture." An appealing woman, he argued, is "a seductive one who dresses to please men." By relegating elegance to the past and by placing seductiveness at the heart of modern relationships, Saint Laurent was the first designer to assert so clearly the primacy of body over social code. The 71 collection thus comes across as an anatomical manifesto. "The bottom is Yves Saint Laurent's new erogenous zone," noted Suzy Menkes in the *Evening Standard* on January 30, 1971. Saint Laurent himself confirmed this comment. "For years the eye was used to a boyish girl without breasts, waist or hips. I never thought the appearance of a true woman would provoke a scandal."[23] The forties collection included only four pairs of pants, whereas the Fall–Winter 1968 collection had featured over twenty-five. Yves Saint Laurent enjoyed a prominent role in the grand saga of female emancipation in the latter half of the twentieth century, like a knight at the service of contemporary women. His spectacular, dramatic fashion initiatives had endowed women with male armor (the pantsuits, the tuxedo) that gave them confidence and power in the real world. But then came this collection that scrambled the message. The handsome cliché was shattered. Suddenly at the forefront of Saint Laurent's sexual theater there appeared a femininity that had been previously banned. This femininity had a provocative body built from quotations, parodies, caricatures, and travesties, flaunting its insubordination and sexual sovereignty even as it pretended to name its price. When coupled with the effect of imagination, the impact of the reality of the show—taken so seriously—sent the couture world went into a spin and unmasked its hypocrisy.

Yet this unrest was accompanied by another, more subterranean one, caused by the hemlines of Saint Laurent's dresses: They rose above the knee, being by far the shortest of the season. For months, sensitive to this traditional barometer of fashion, the industry's manufacturers, retailers, and journalists—notably influenced by Yves Saint Laurent—had been working hard to send women the message of "maximum length." But these short dresses suddenly went in the opposite direction, provoking a certain chaos concerning trends as debate raged over "mini" versus "maxi" versus "midi," just when everyone had expected Saint Laurent, the youngest and most recent of great designers, to settle the matter. From manufacturers to journalists, the profession cried bloody murder. The United States, in particular, went ballistic. But here again, Saint Laurent couldn't care less. He was basically saying that the dictatorship of the hemline was a thing of past. It was up to women to choose![24]

The 71 collection was a commercial flop. The folder containing orders from private clients still included the names of important loyal customers: Nan Kempner, Charlotte Aillaud, Baroness Rothschild, Betty Catroux, Catherine Deneuve, Zizi Jeanmaire, Elsa Schiaparelli, Liliane Bettencourt, Sao Schlumberger, Dame Margot Fonteyn, Hélène Rochas, Madeleine Renaud, and Lauren Bacall, although mainly for a few popular designs. In the section devoted to furs, only "Mrs. Mick Jagger" figured, having ordered the white fox bolero (no. 87).[25] The firm's other clientele—whom Saint Laurent referred to as "the bourgeoisie," whom he fled and sought to alienate—had indeed deserted his order books, appalled.

Catherine Deneuve claims she wasn't shocked by the 71 collection,[26] perhaps because she and Saint Laurent had a joint baptism of fire during the making of *Belle de Jour* a few years earlier. In December 1966, the year *Belle de Jour* was shot, she told *Elle*, "David [Bailey] made me change fashion designer. Now I'm dressed by Saint Laurent. I like my clothes to be modern, enticing, with a little bit of a come-on. David likes it when people look at me when we walk down the street."

This essay could hardly conclude without describing Luis Buñuel's film *Belle de Jour*, in which Deneuve played Séverine, a young bourgeois woman of frigid beauty who is sensibly married yet so haunted by sexual fantasies that she becomes an afternoon prostitute, working in a little apartment for private trysts run by Madame Anaïs. Saint Laurent designed the clothes for Séverine, a character who led a double life. Her highly elegant, severe outfits made Séverine's professional colleagues swoon with envy. In Saint Laurent's career there were always early signals of coming developments—a scandal always crept up stealthily, prior to bursting. *Belle de Jour* now looks like the stealthy approach of the 71 collection, invisible beneath Séverine's restrained outfits. It functioned as prehistory, as antechamber, as early laboratory. Later, starting with the "Ballets Russes" collection in 1976, Saint Laurent would develop another kind of bordello, open to only one man: the harem. In an undated note found in his papers, the designer listed the occupants of this harem, the ladies who populated his "Oriental" and "Mediterranean" collections of the late 1970s: "HAREM/exotic women/peasant girls/Orientals/tragediennes/Spanish senoritas." In a paean to Newton's "brothel" series of 1971, Guy Bourdin published a lavish series of fashion photos of this "harem" in the September 1967 issue of *Vogue Paris*.

Whether brothel or harem, Saint Laurent opened his fashion house to an unanticipated specter of femininity. It is often said that Saint Laurent means style. One could also say that Saint Laurent means appearances. He redesigned appearances, exploring their limits, fantasies, and fictions as few people of his day did. The 71 collection was one of his finest moments, involving disreputable appearances. In a way, it was a forerunner of punk in the archaic meaning of that word, *prostitute*. Like all fashion events, the 71 collection was more than a show. It was a condensation of fashion in which all the tensions and crises of the day were crystallized: the political aspect of the "retro" trend, the dislocation of generations, the evolution of fashion mechanisms, the trompe l'oeil play on femininity, and also, perhaps, the designer's own desire to play with fire. That is what made the 71 collection a wonderful Pandora's box. Some day we'll have to open it.

NOTES

1 — The *Daily Telegraph* and *Guardian* were quoted in "Yves St. Debacle," *Time*, February 15, 1971.

2 — "Comme en 1945," *Paris-Jour*, January 30–31, 1971.

3 — Jean Rook, "Yves Has a Touch of the Rita Hayworth and I Call It a 1940 'Weepie,'" *Daily Sketch*, January 30, 1971.

4 — Eugenia Sheppard, "The Ugliest Show in Town," *New York Post*, February 1, 1971.

5 — Pierre-Yves Guillen, "Saint-Laurent: l'apprenti sorcier," *Combat*, February 1, 1971.

6 — Interview with Loulou de la Falaise, October 9, 2009. Loulou, attended the show at Yves Saint Laurent's request, as did Paloma Picasso and Marisa Berenson (Elsa Schiaparelli's granddaughter, known at the time as a fashion model). "Yves was very worried about this collection," recalled Loulou. "He strategically 'planted' us in the audience. Marisa was among the Anglo-American crowd, I was over with the French press, and Paloma was sitting with the socialites. People were very shocked. . . . All three of us, from our respective seats, heard dreadful comments. At the end of the show we went up to Yves' office with him and we burst into laughter, but it was nervous laughter." On Loulou de la Falaise, see the essay "A Gallery of Saint Laurent Women" in this volume.

7 — Suzy Menkes, "Yves Brings Up the Rear—with Bottoms," *Evening Standard*, January 30, 1971.

8 — De la Falaise interview.

9 — Simone Baron, "Saint-Laurent priez pour elles," *France-Soir*, February 1, 1971.

10 — Interview with Pierre Bergé, October 15, 2009.

11 — *Le Journal du Dimanche*, August 15, 1965.

12 — Bergé interview.

13 — De la Falaise interview.

14 — On this period, see Dominique Veillon, *Fashion Under the Occupation*, trans. Miriam Kochan (Oxford, UK: Berg Pub., 2002).

15 — Corinne Luchaire (1921–1950) was a French actress sentenced to ten years of *dégradation nationale* (loss of civic rights) for wartime collaboration.

16 — Interview with Gabrielle Busschaert, September 15, 2009; de la Falaise interview.

17 — Christian Dior, *Christian Dior et moi* (Paris: Le Livre Contemporain-Amiot-Dumont, 1956).

18 — Baron, "Saint-Laurent"; Eugenia Sheppard, "The Ugliest Show."

19 — "La mode: Yves Saint-Laurent ressuscite l'époque 1938–1942," *Le Provençal*, January 31, 1971.

20 — De la Falaise interview.

21 — Baron, "Saint-Laurent."

22 — De la Falaise interview.

23 — Aline Mosby, "St Laurent's '40s Look: HE Likes It," *Cleveland Press*, February 20, 1971.

24 — On the hemline crisis during this period, see notably *Women's Wear Daily*, February 1,1971; Sheppard, "The Ugliest Show"; and Bernadine Morris, "Now Why Are They Throwing Brickbats at Saint Laurent?" *New York Times*, February 2, 1971.

25 — Folder titled "B1 Clientes par modèle 1971 PE," archives, Fondation Pierre Bergé–Yves Saint Laurent.

26 — Catherine Deneuve interviewed on November 5, 2009, by Jérômine Savignon, who reported the comment to this author.

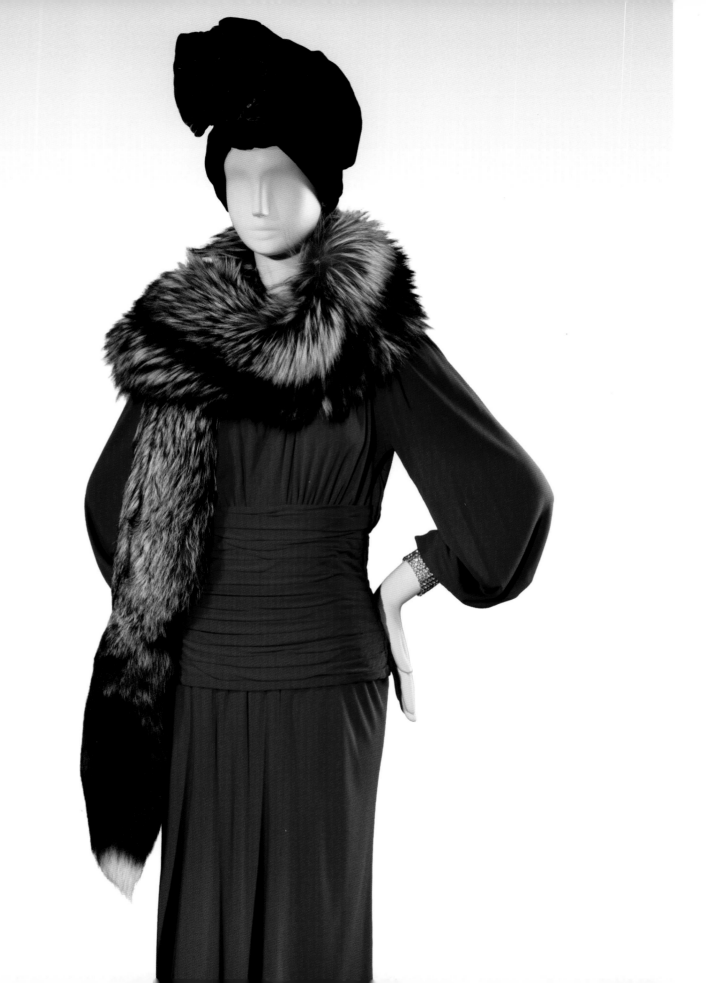

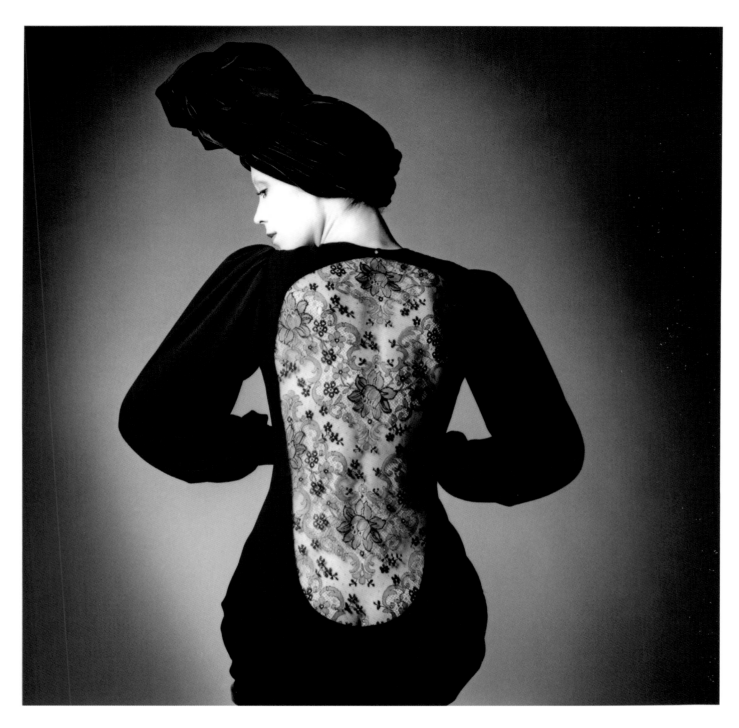

Opposite — Spring–Summer 1971
haute couture collection (CAT. 99).

Above — Marina Schiano in a lace
dress, Fall–Winter 1970 haute
couture collection. Photograph by
Jeanloup Sieff.

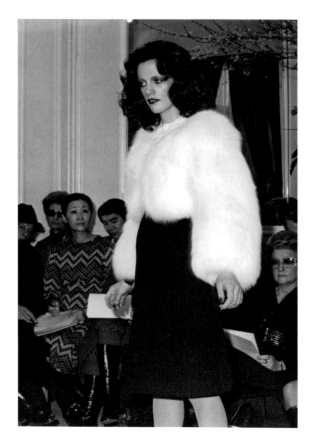

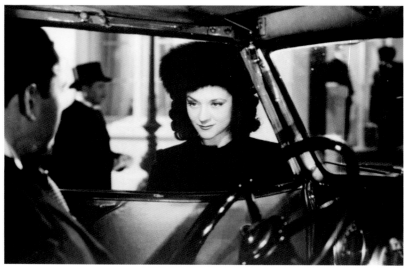

Above, left — Fur bolero, Spring–
Summer 1971 haute couture
collection.

Above, right — Maria Casarès in
Les Dames du Bois de Boulogne,
film by Robert Bresson, 1945.

Right — Crepe de chine dress
with yellow and black print,
Spring–Summer 1971 haute
couture collection, French *Elle*,
March 1971. Photograph by
Hans Feurer.

Opposite — Fox fur coat worn
over a crepe shorts tunic,
Spring–Summer 1971 haute
couture collection, *Vogue Paris*,
March 1971. Photograph by
Helmut Newton.

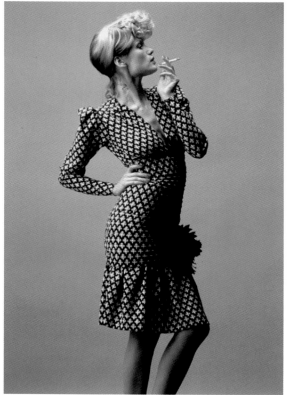

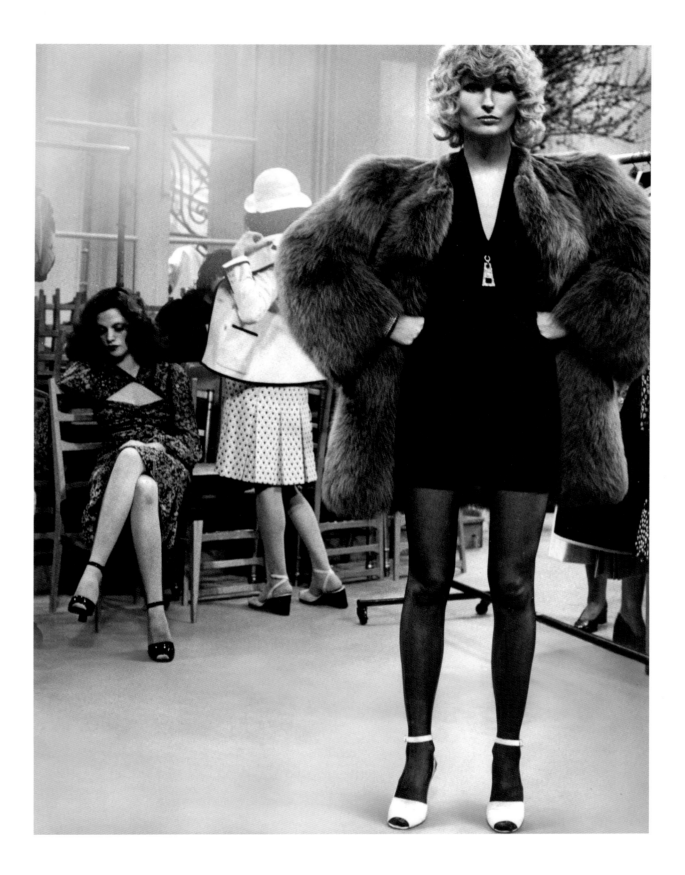

Placard E

E

Cost q
OK

Robe R.V. 41.
Jersey. Sporting 1101/735

POP

A

A

OK

Robe R.V 41
Jersey. beige.
Sporting 1101/735

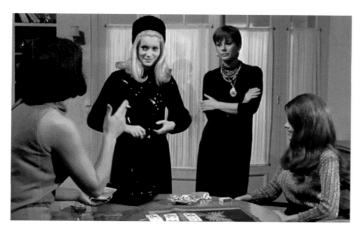

Opposite — Sketches of
ensembles designed by Yves Saint
Laurent for Catherine Deneuve in
Luis Buñuel's *Belle de Jour*, 1967.

Page 212— Patent-leather sandals,
known as "Raymondes," with
poppy clip, French *Elle*, March 1,
1971. Photograph by Hans Feurer.

Above — Stills from *Belle de
Jour* by Luis Buñuel, 1967, with
Catherine Deneuve and Jean Soret.

RED IS THE FOUNDATION OF MAKEUP, IT'S LIPS AND FINGERNAILS. RED IS A NOBLE COLOR, THE COLOR OF A PRECIOUS STONE—RUBIES— AS WELL AS THE COLOR OF DANGER, AND SOMETIMES YOU HAVE TO PLAY WITH DANGER. RED IS A RELIGIOUS COLOR, IT'S THE COLOR OF BLOOD, THE COLOR OF ROYALTY, PHAEDRA AND SO MANY OTHER HEROINES. THE RED OF FIRE AND THE RED OF BATTLE—RED IS A BATTLE BETWEEN DEATH AND LIFE.

LE MONDE, "YVES SAINT LAURENT AT THE METROPOLITAN MUSEUM, NEW YORK. PORTRAIT OF THE ARTIST," AN INTERVIEW WITH YVONNE BABY, DECEMBER 8, 1983

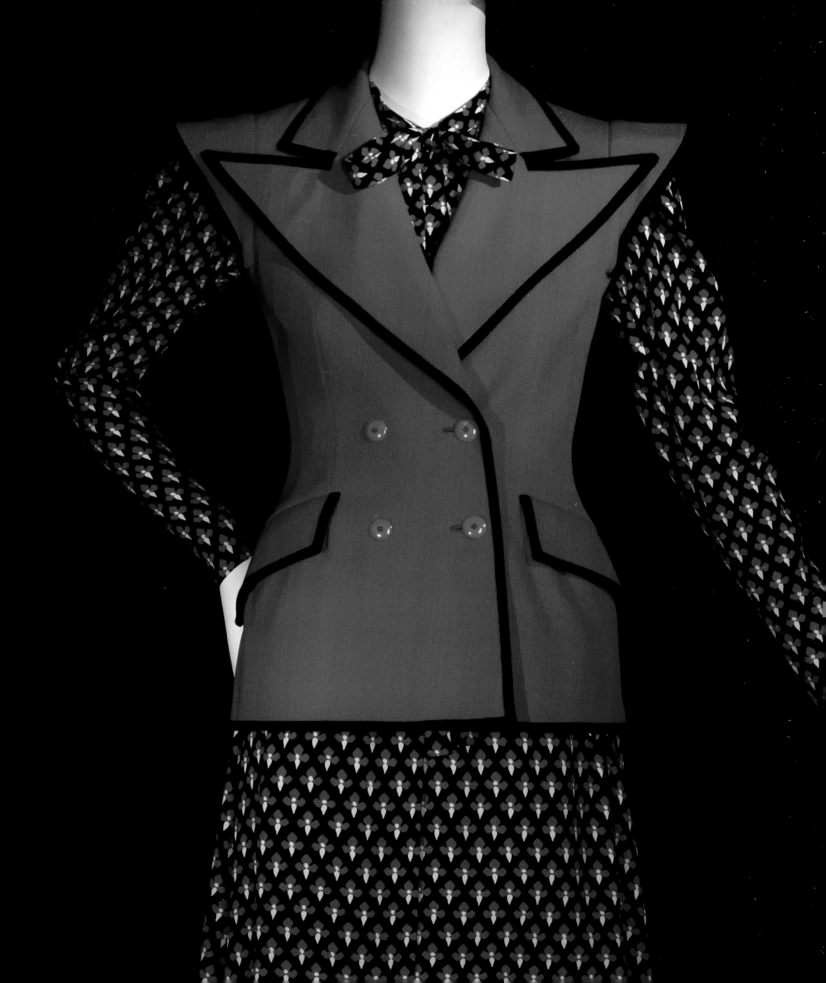

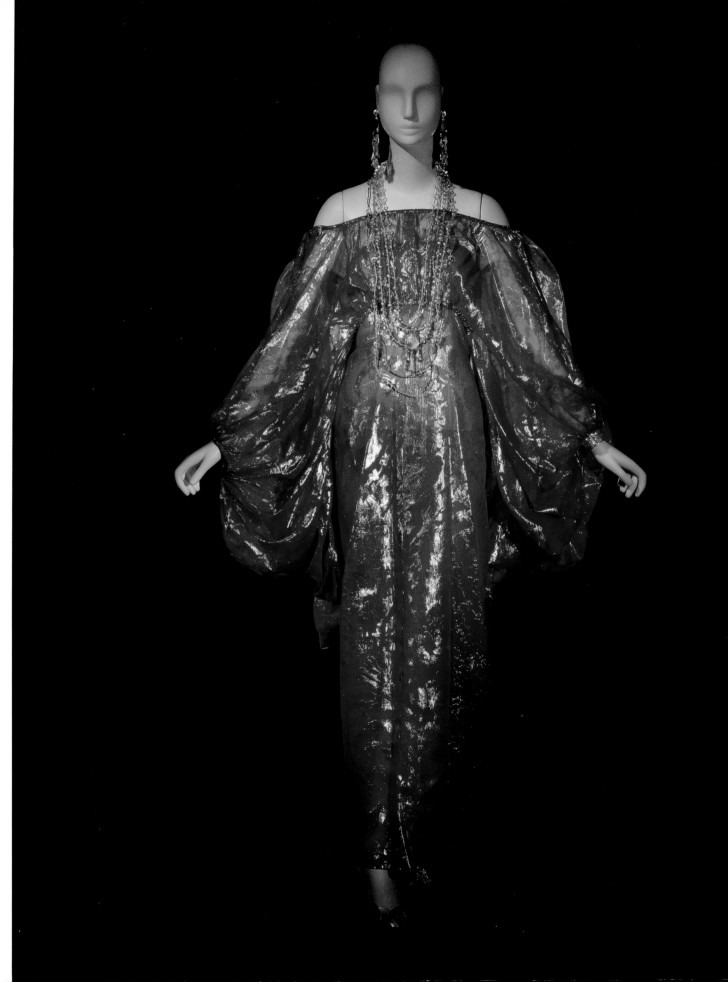

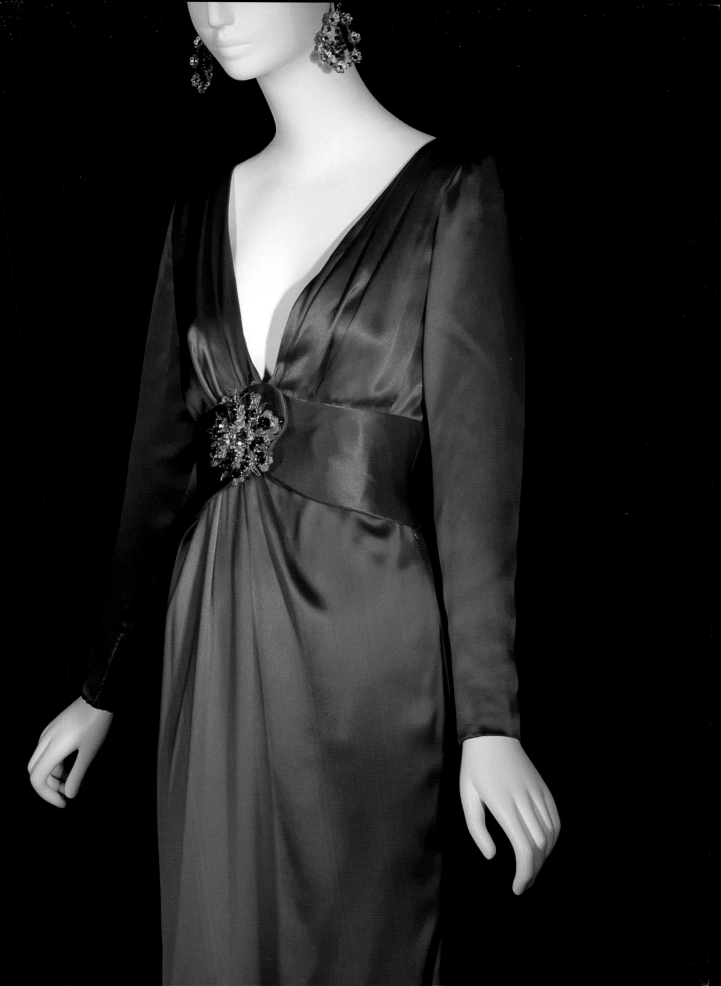

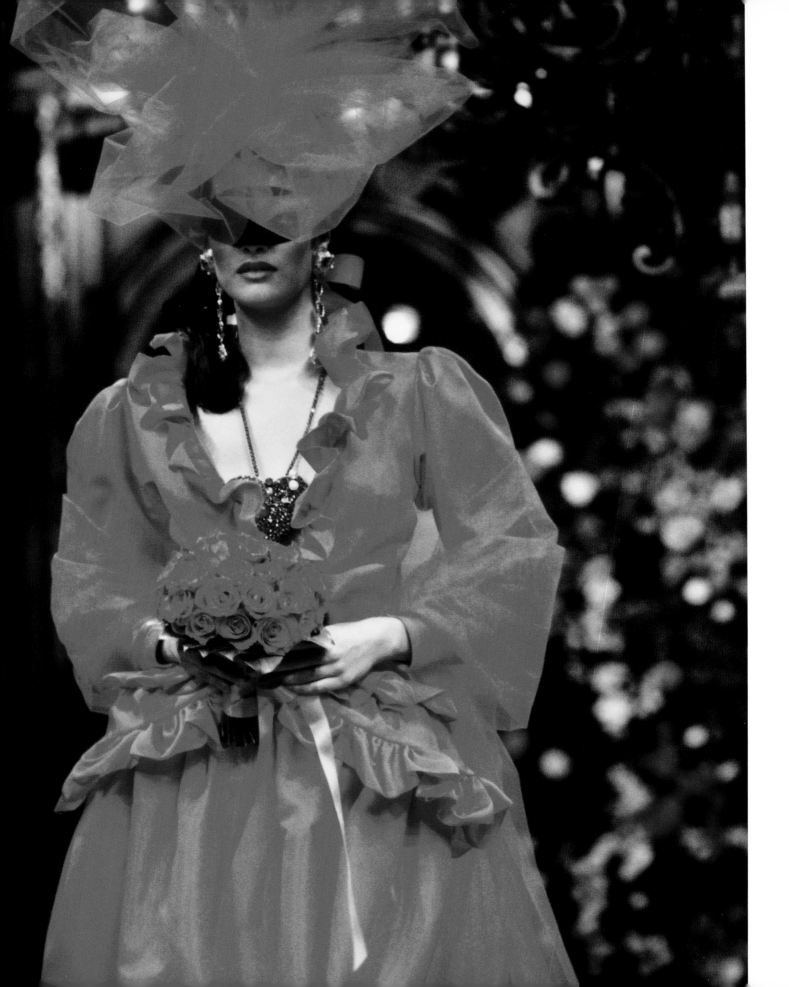

Page 215 — Card with red samples, from one of the color files assembled over the years by the Saint Laurent studio.

Page 216 — Detail of a velvet redingote (fitted coat) embroidered with sequined lips, Spring–Summer 1971 haute couture collection, French *Elle*, March 1, 1971. Photograph by Peter Knapp.

Page 217 — Ruby panne velvet dress, Fall–Winter 1975–76 haute couture collection, British *Vogue*, September 1975. Photograph by Norman Parkinson.

Page 218 — Spring–Summer 1971 haute couture collection (CAT. 97).

Page 219 — Spring–Summer 1981 haute couture collection (CAT. 220).

Page 220 — Evening jersey top and skirt, Saint Laurent Rive Gauche, American *Vogue*, February 15, 1972. Photograph by Helmut Newton.

Page 221 — Spring–Summer 1997 haute couture collection (detail of CAT. 82).

Opposite — Wedding dress, Spring–Summer 1992 haute couture collection and "heart" pendant, Yves Saint Laurent's "lucky" jewel, present in every one of his shows. Photograph by Claus Ohm.

"DOWN WITH THE RITZ, UP WITH THE STREET!" THE BIRTH OF THE "RIVE GAUCHE" STYLE

JÉROMINE SAVIGNON

"Down with the Ritz, down with the Moon, up with the street!"[1] This cri de coeur from Yves Saint Laurent, uttered during an interview in the summer of 1965, was not just a humorous remark but one tinged with provocation. It spoke volumes of Saint Laurent's intuitions and thinking about something that had begun to take root in his mind, something that appeared increasingly obvious to him and was drawing him irresistibly toward the rue de Tournon and the invention of "Saint Laurent Rive Gauche."

The times were favorable. In the air were furtive expectations, excitement, eager desires for new horizons, which was bound to strike a chord with the "Petit Prince de la couture," the "Beatle of the Rue Spontini,"[2] ever fascinated by the present. In a tidal wave of illuminations, everything suggested to him the rifts and upheavals to come, and the vision of a new world in which he fully intended to occupy the role of the "couturier who [thinks] about the women of today."[3] "Between a journey to Cythera and a trip to the Moon, there is room for another era, our own, about which no one seems to care," said the man, often torn between Proust and Warhol, who was, according to L'Express editor in chief Françoise Giroud, about to "capture" one of the most powerful trends of the 1960s: "the imperialism of youth."[4]

Since the triumph, when he was just twenty-one, of his first collection for Dior, "Trapeze," and all the deceptively classical successes of his society temple in Rue Spontini, Yves Saint Laurent had, in the course of his sketches over seven years totally dedicated to couture, discovered that fashion is first and foremost a "change of attitudes."[5] Beyond the stroke of a pen, a dress is gesture; it is not made to be contemplated but to have an attitude, that of a woman-as-a-working-drawing, conveying an appeal that has little regard for the codes of elegance: "A certain way of living rather than a certain way of dressing."[6] At the same time, the climate was changing fast, exposing an increasingly cloistered, affected, and shaky haute couture that found itself awkwardly positioned in modern times. "What's old fashioned . . . is the whole system, the shows, the clients, the orders."[7] In town, a new generation of femmes amazoniques [Amazon women][8] was asserting itself, waiting with feverish impatience for the "suggestion of something else; a fashion that fragmentarily suggested another world and some instruments to attain it."[9] And this was what passionately interested Yves Saint Laurent at the time: these women's direct manner of approaching life, their way of behavior and desire to exist, to express themselves, to have fun, gave him the irresistible urge to "not just be a great fashion designer anymore."[10] For these young, active women, who were not "blasé billionaires"[11] but working women who had neither the desire nor the means to dress in haute couture, he dreamed up the concept, the cultural originality, dubbed "Saint Laurent Rive Gauche": his ready-to-wear, "his absolute idea,"[12] his conviction.

That is not to say that others had not already made a few discreet, embryonic attempts, within the fashion houses, in the form of simplified copies of existing collections. But Yves Saint Laurent was "the first to express and to introduce into contemporary mores"[13] his ideological revolution, that of a ready-to-wear collection that was radically independent from the inner sanctums of couture, with an autonomous creative identity and prices designed to be highly affordable. "I think that the future is ready-to-wear because it

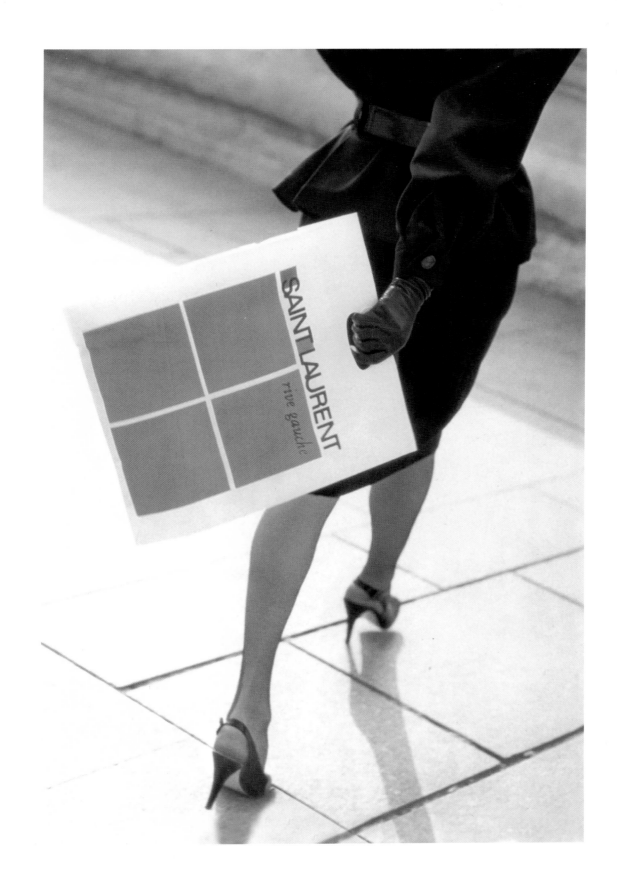

is something that's full of hope and novelty. There is a great injustice in the prices of haute couture.... What I would like is really to be Prisunic [a chain of supermarkets], make much less expensive dresses . . . for everyone to be able to come in and buy them."[14] "I am not sure that Saint Laurent himself understood how far he carried this position, but the position was a very social one," Pierre Bergé recalls today. "We were in admiration at the time of Terence Conran's 'Habitat' concept";[15] Terence Conran "just wanted the whole world to have a 'well-designed' salad bowl."[16] "For us," says Pierre Bergé, "that was contemporary creation."[17]

In those intoxicating early days, this was the beginning of Saint Laurent and Bergé's four-handed oeuvre, "Rive Gauche," which swiftly became the passport for thousands of women all over the world to the Saint Laurent style.

Yves Saint Laurent, who lived on place Vauban at the time, was a native to the Rive Gauche. He loved the area, the cafés, the antiques dealers, its somewhat bohemian atmosphere of eccentricity and freedom. Its appeal no doubt mirrored the regrets of a well-behaved child, catapulted too young by success into adulthood and the starchy world of couture, without having lived out his youth, his beatnik dreams, or had the chance to get into trouble. His big project was to open a store for the students of the Latin Quarter and Saint-Germain-des-Prés, and for all young women who dared favor appeal over elegance.

Amid the picture framers and bookshops of the quaint and tranquil rue de Tournon leading down to the Luxembourg Palace and the Sénat, there's an old antiques shop at number 21: long and narrow like a den, almost a cellar, a former bakery. This would be the first "Saint Laurent Rive Gauche" shop.

The young interior decorator Isabelle Hebey, who specialized in glass and metal, carried out the transformation designed by Yves Saint Laurent, and on September 26, 1966, an open day launched the store in a lighthearted, buzzing atmosphere of joyous improvisation. The event's guest of honor, Catherine Deneuve, was there, looking very "Belle de Jour"[18] and *so* Saint Laurent, in a little navy blue fitted coat with a high half belt and gold buttons. Everyone was in raptures. Yves Saint Laurent himself welcomed the guests in his "time capsule," which was liberally sprayed with "Y" eau de toilette and revealed, in its contrasts, Yves Saint Laurent's sharp sense of anticipation of the moment. Imagine an oxblood-colored carpet and Japanese-style perforated metal screens, exposed stone and beams, long solid aluminum rectangles for the clothes rails and accessory showcases, lots of glass, a huge mirror, deep-purple jersey poufs by Olivier Mourgue, and filtered lighting through Noguchi "lanterns." Facing the entrance, right at the back, was a giant portrait of the designer by Arroyo. In the little yard were Niki de Saint Phalle *Nanas*, renegades from a Roland Petit ballet decor. They marked, like a signature, the hosts' predilection and enlightened curiosity for art. It became a habit; shortly afterward they chose two large Dunand vases, recently purchased in rue Bonaparte, as the sole decor for the window of another of Paris shop, at 38 Faubourg Saint-Honoré.

The phenomenal success of the store filled the quiet street with lines of parked cars. "It had never been seen before!"[19] remembers Clara Saint, a young "Rive Gauche" press attaché at the time. Catherine Deneuve also has vivid

memories of the time: "It was so surprising, unexpected, to be able to access on the hangers everything that represented 'Rive Droite' luxury, haute-couture quality reinterpreted in ready-to-wear. And we had no idea yet of all the incredible consequences of the project's success."[20]

The fashion reporters, drawn initially by curiosity, astounded at the prices and quite captivated by the perfection of the models, vied for the privilege of photo ops improvised in the street or under the portrait of the designer, arms crossed. American *Vogue* cried, "Paris: Saint Laurent turns left, crosses the river and, everybody—watch out!" and "Paris: Regardez! The new Yves Saint Laurent's."

This "spontaneous small unit"[21] that had invented the highly original, noncouture Saint Laurent concept became a major attraction. People flocked, queued, to buy a "Rive Gauche" outfit, late into the evening. Small, simple things, at unbeatable prices, divinely well cut, in sizes 24 to 42, easy to live with and easy to sell. Customers carried them out right away, wrapped in tissue paper, in a "shopping bag" emblazoned with the orange-and-pink squares of the shop's logo, especially designed for "Rive Gauche" by Yves Saint Laurent himself and the perfume designer Pierre Dinand. It was rare to leave with just one item. At rue de Tournon, customers were not shown a skirt without the indispensable little matching tops or skinny-rib pullovers, and the saleswomen were trained to suggest looks, combinations, accessories to personalize an outfit according to mood, basic sets with lots of combinations, always infinitely youthful, designed to appeal and for the enjoyment of doing so. "Just suppose . . . I meet him . . ." More than a wardrobe: a style! "We were selling on the basis of instant appeal," recalls Dominique Deroche today. Yves Saint Laurent's "Rive Gauche" was a place of freedom, a freedom never hampered by the diktats of line and or the old laws of haute couture. Sometimes, in midseason, he suddenly decided, "Hey, I've an idea! We make three dresses. He made them and it amused him greatly."[22]

His marathon "Rive Gauche" fashion shows in the following years were prepared in the same spirit of spontaneous modernity. Choices were made instinctively, as if one was rummaging around in one's dressing room guided only by "elective affinities" and the dizzying possibilities of infinite combinations.

When the designer felt the urge to dress differently and to "do something to change things,"[23] he only had to move steps away to open his first shop for men, at 17 Rue de Tournon. The Saint Laurent wardrobe, not least the safari jacket, was freely available to all. "Everything except suits!"[24] He said, "I'm catering to free men, and what I'm offering them isn't a new 'line,' which means new constraints, but freedom."[25]

Saint Laurent and Bergé were there almost every day. Sales were very high. In the shop, "It's crazy, a massacre from morning to night."[26] Crowds and traffic congestion were such that Bergé himself sometimes worked at the till, and very soon a young woman had to be hired just to fold and constantly tidy everything that the buyers, in their enthusiastic frenzy, scattered to the winds. Even the traditional haute couture customers crossed the Seine to come and see; won over, they had their "Rive Gauche" selection sent to rue Spontini. *Elle* cautiously advised its readers to take a look, as did Mireille Darc and

Catherine Deneuve, usually at the quieter lunchtime period. All of them fell for the gold-metal chain belts that tinkled on the hangers. Another memorable addiction at the time was the white silk scarf with the "YSL" logo, whose story the designer cut short prematurely following a Zizi Jeanmaire premiere at the Olympia music hall, where everyone, men and women alike, was sporting the Saint Laurent colors.

Yves Saint Laurent understood very early on that women not only wanted but needed a certain stability in their wardrobe, so that, as free agents, they could look for and assert themselves with self-confidence and therefore be happy. His genius was to have sensed at precisely the right time the need to impart a young, timeless spirit to Saint Laurent clothing and create a new wardrobe that was specifically for the modern woman. The new "Rive Gauche" tune was playing through all of the "Rive Gauche" hits.

Like the designer's other basics, the *smoking,* conjuring up dark and dubious desires, "the absolute emblem of Yves Saint Laurent,"[27] made its obligatory detour via the "Rive Gauche." This was his chance. Created for the winter 1966–67 collection and hailed by the international fashion press, it met only with a succès d'estime among couture customers. Shortly after the opening of the rue de Tournon shop, Françoise Hardy came in. She saw it, tried it on, thought of her next gala . . . *le smoking* was made for her. And Clara Saint seized the opportunity to get a photograph for the front page of *France-Soir,* which caused sales to soar—and the legend to grow.

The "*smoking* case" was a good illustration of the strong and original relationship that always existed between Yves Saint Laurent haute couture and ready-to-wear, beyond their clearly stated independence. And not always in the sense one might expect. Themes and ideas often gravitated from the ready-to-wear to the couture version, rather than the other way round, as shown in the memorable "Ballets Russes" collection, another mystery of the "intermittencies of the heart."

Everything snowballed; it was a tidal wave. "Bravo à tous les 'Saint Laurent rive gauche'"! titled *Vogue Paris* in February 1969. "Nineteen in the world today. Tomorrow, twenty more in America. In the spring, it's Lausanne and Berlin that will blossom. Grab yourself the most appealing fashions around, at the best price possible." Every large European city became infatuated with Saint Laurent: Lyon, Marseille, Grenoble, Nice, Bordeaux, Rome, Madrid, Munich, Toulouse, Geneva, Saint-Tropez, Brussels, Zurich, London, Hamburg, Venice, Milan. In New York, the success was huge. Pierre Bergé still remembers a telephone call on the evening of the launch of the Madison boutique to inform him that police were on the spot to channel unheard-of crowds. It was crazy. The Americans all wanted to buy the little oilskin coat that Parisians adored, the kilt dress, the famous scarf, the black jumpsuit worn by Betty Catroux when she was photographed in front of the poster of the designer by Marie Cosindas with her Polaroid. But most of all they came to buy, much more than a brand or an image, a beautiful quality garment that was perfect for their life, and for life. And this was the very essence of the "Rive Gauche" spirit.

And then in the middle of all this euphoria came the scandalous flop of the notorious "Rétro 40" haute couture collection of summer 1971. This

spectacular failure made Yves Saint Laurent acutely aware of the doomed future of a certain kind of haute couture that was perhaps eternally sublime but had become sterile, pushed to the sidelines, and "now smacked only of nostalgia and forbidden pleasures"[28] because, at the time, haute couture was impermeable to real life and to the times. This reinforced his permanent and passionate anchoring in ready-to-wear, for it was here that he could fully explore his fashion intuitions unhindered.

The snip of the scissors was radical, and "followed on from everything he had decided when he started the 'Rive Gauche' concept."[29] Banished from rue Spontini, the press was no longer shown the haute couture collection, which was reduced to forty models and presented only to privileged customers and a few members of the closest circle. *Elle* stigmatized this very official decision as "the fashion event of the fall," illustrating it with a shocking photo of the designer between two models in twin shirtdresses, both perfect, with the following caption: "On the left, in ready-to-wear: 650 F. On the right, in haute couture: 5,500 F."[30]

In a touching television interview on October 30, 1971, Yves Saint Laurent delivered his creed with serene conviction as well as sensitivity and modesty. "I have chosen to show my fashion through my ready-to-wear rather than through my haute couture . . . I think that ready-to-wear is the expression of the fashion of today. I believe it is in this only and not in haute couture." Yet he confessed to loving haute couture like a mistress that he couldn't and wouldn't do without, and that he also intended to maintain it out of respect for the craftsmanship that went into it and for those who had built up his house. One could sense the underlying wrench. Carrying your own fashion house to victory and then deciding to turn away from it to live out your ideal is not easy to do, even if happiness comes at that price.

With the shocking failure of the 1971 collection, Yves Saint Laurent more or less put an end to his long self-quest through creativity, a kind of psychoanalysis that had begun with the tuxedo, the invention of the Saint Laurent woman and her wardrobe. "The great change came when I discovered my own style. . . . It was with the tuxedo and the transparent blouse. I became conscious of the body and began a dialogue with women, began to understand better what a modern woman was all about."[31] The Saint Laurent woman, the "Rive Gauche" girl! "Secondhand beauty. Made of borrowings. In tune with the songs, words, dances of the season. With the necessities of the moment. Arising by chance, out of accident."[32] Catherine Deneuve, "the woman he was waiting for, [the one] who is [his] style,"[33] the fragile romantic adventurer in *La Sirène du Mississippi [Mississippi Mermaid]* moving away over the snow in the velvet and ostrich feathers of her "'Rive Gauche' 'beau manteau'"?[34] Charlotte Rampling, in laced boots and a soft Liberty print? Talitha Getty, as a dazzling Amazon princess? Betty and Loulou, light and sovereign? The model Danièle Varenne, inspirer of the "Rive Gauche" "gesture"? The very *Vogue*, barebreasted *belle de nuit* in high heels and silk blouse, captured by Helmut Newton for Yvresse, wavering mischievously between secretiveness and extravagance? And all the others, all those long and lean, determined, working young women, who you saw in the streets of Paris walking briskly toward a life they'd fully embraced. "Rive Gauche is *not* a scent for unassuming women"[35] but for just

those that Saint Laurent wanted to dress, for he saw it as dressing life, the instant. This was the profound raison d'être of his "Rive Gauche." "A true happiness, like convergence of truth and prose, a rare thing."[36]

"The idea of dressing every woman, not just the Parisienne, in haute couture, of being able to adapt his fashion and offer it to the greatest number, really made him happy," recalls Catherine Deneuve today. "He had a strong desire to offer that luxury and for him it was truly a personal venture that had no limits."[37]

Playing the "Rive Gauche" card was, as Pierre Bergé says, a little like "cutting off the branch on which you're sitting that would have fallen off by itself anyway."[38] But for Yves Saint Laurent it was also a powerfully symbolic gesture to place his faith in the street, to the point of dedicating to it his imagination, his "aesthetic phantoms," and to achieve for his "Rive Gauche" fashion that combination of perfection and precision, that "marvelous silence of the garment" that had seemed to be the inexpressible privilege of made-to-measure clothing. And he pulled it off: The "Petit Prince de la couture" became "The King of Fashion."

"It goes to show Yves Saint Laurent's modernity [that he should have] proved that haute couture for ladies [who] have lost everything except wealth was completely out of fashion. That is why he changed the street with enthusiasm. Can an artist dream of anything better?"[39] Like Andy Warhol, he understood that a person's "movement, gesture, and intention were part of the creative act, they were as important as the result."[40]

As Pierre Bergé said, echoing the words of Diana Vreeland, "This timid young man, who was outside of time, was the most precise, the most perfectly accorded man I know. He followed precisely what was happening in the world and what was life, and that is a truly wonderful thing. That is why he was a man of his times."[41]

NOTES

1 — Patrick Thévenon, "Le couturier qui a pensé aux femmes d'aujourd'hui," *Candide*, August 15, 1965.

2 — Ibid.

3 — Ibid.

4 — Françoise Giroud, "Juliette et Messaline," *L'Express*, August 4–10, 1969.

5 — Claude Berthod, interview with Yves Saint Laurent, *Dim Dam Dom*, March 10, 1968.

6 — Ibid.

7 — Ibid.

8 — Expression borrowed from Helmut Newton.

9 — Jean-Jacques Schuhl, *Rose poussière* (Paris: Editions Gallimard, 1972).

10 — Berthod interview with Saint Laurent.

11 — *Le Journal du Dimanche*, August 15, 1965.

12 — Interview with Pierre Bergé, October 8, 2009.

13 — Françoise Sagan, "Saint Laurent par Françoise Sagan," *Elle*, March 3, 1980.

14 — Berthod interview with Saint Laurent.

15 — Interview with Bergé.

16 — Antonia Williams, "Habitat Man," British *Vogue*, February 1974. Retranslated from the French.

17 — Interview with Bergé.

18 — Shooting for *Belle de Jour* began October 10, 1966.

19 — Interview with Clara Saint, former "Saint Laurent Rive Gauche" press attaché, October 26, 2009.

20 — Interview with Catherine Deneuve, November 5, 2009.

21 — Interview with Dominique Deroche, former director of communication for Yves Saint Laurent, who started out as a salesgirl in the "Rive Gauche" shop at 21 rue de Tournon, September 29, 2009.

22 — Interview with Saint.

23 — Claude Berthod, "Les hommes nouveaux que nous prépare Saint Laurent," *Elle*, May 5, 1969.

24 — Interview with Saint.

25 — Berthod, "Les hommes nouveaux."

26 — Claude Berthod, "Le prêt-à-porter sort ses 'griffes,'" *Elle*, October 26, 1967.

27 — Interview with Bergé.

28 — Claude Berthod, "La libération de la femme selon Saint Laurent," *Elle*, March 1, 1971.

29 — Interview with Deneuve.

30 — Claude Berthod, "Yves Saint Laurent choisit le prêt-à-porter: cette photo explique sa décision," *Elle*, June 9, 1971.

31 — Lynn Young, "The King of Couture," *Newsweek*, November 18, 1974. Retranslated from the French.

32 — Schuhl, *Rose poussière*, 23.

33 — Thelma Sweetinburgh, "Yves' Now Girl," *Women's Wear Daily*, January 6, 1967. Retranslated from the French.

34 — Reference to one of Catherine Deneuve's lines in François Truffaut's *La Sirène du Mississippi* (1969): "Il est beau mon manteau. . . . Il s'ennuie là tout seul, il est triste. J'aurais dû le garder près de moi." ("Just look how beautiful my coat is. It gets bored all alone. It's sad. I should have kept it by me.")

35 — The "Rive Gauche" perfume was launched in France in 1971.

36 — Françoise Sagan, *Toxique*, illustrated by Bernard Buffet (Paris: Editions René Julliard, 1964). Françoise Sagan's impression on a reading of Proust.

37 — Interview with Deneuve.

38 — Interview with Bergé.

39 — "Diana Vreeland expose un quart de siècle d'YSL," *Libération*, December 27, 1983.

40 — Pierre Bergé, *Les jours s'en vont, je demeure* (Paris: Editions Gallimard, 2003).

41 — Interview with Bergé.

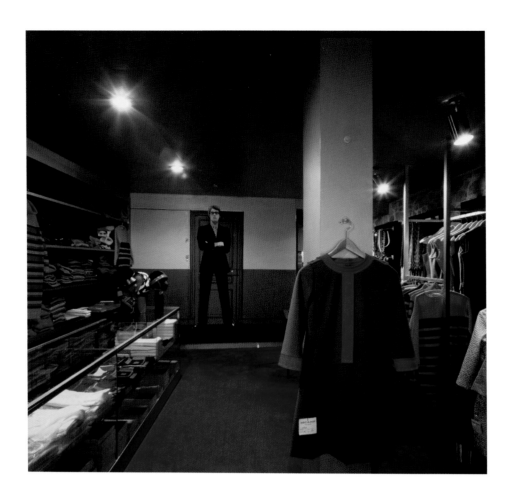

Left — Saint Laurent Rive Gauche shop, 21 rue de Tournon, Paris. In the background, a portrait of Yves Saint Laurent by Eduardo Arroyo, 1966.

Opposite — Betty Catroux, Yves Saint Laurent, and Loulou de la Falaise, at the opening of the first Saint Laurent Rive Gauche shop, New Bond Street, London, September 10, 1969.

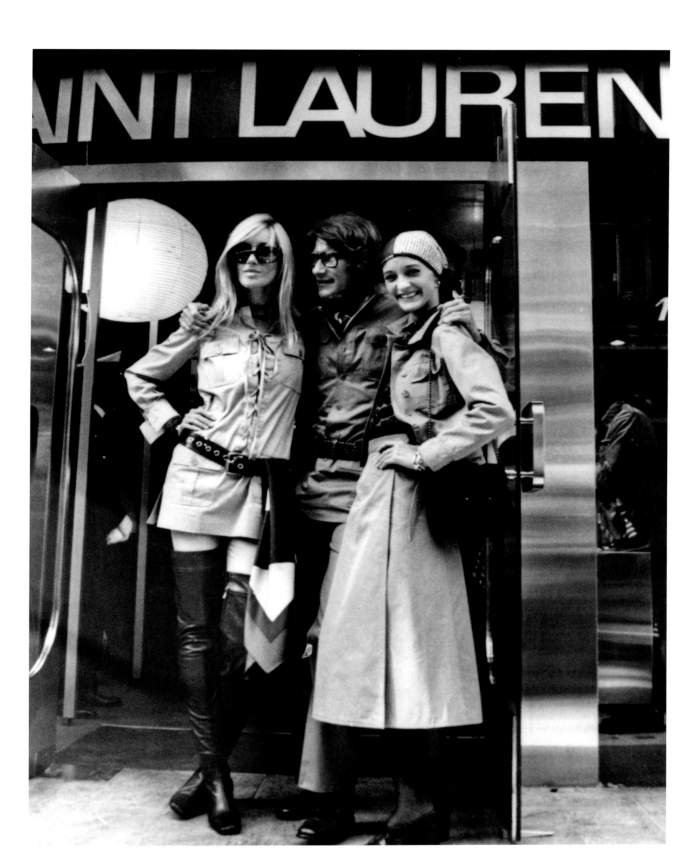

Opposite — Saint Laurent Rive
Gauche collection, Spring–Summer
1971 (CAT. 61).

Right, top — Talitha Getty in
a cotton shirt and skirt with
a red-and-yellow print, Saint
Laurent Rive Gauche, *Vogue
Paris*, May 1970. Photograph
by Jeanloup Sieff.

Right, bottom — Talitha Getty in a
long black crepe dress with a lace-
up bodice, *Vogue Paris,* May 1970.
Photograph by Jeanloup Sieff.

Il y a 4 850 F de différence entre ces deux robes-chemisiers. Celle de gauche, en prêt à porter : 650 F. Celle de droite, en haute couture : 5 500 F.

Left — Yves Saint Laurent flanked by two models wearing chemise dresses: left, a ready-to-wear version; at right: a haute couture version, French *Elle*, June 9, 1971. Photograph by Henri Elwing.

Opposite — Black devore velvet dress, Saint Laurent Rive Gauche collection, *Vogue Paris*, September 1969. Photograph by Jeanloup Sieff.

Advertising visual for Saint Laurent Rive Gauche, stairway at the Café Costes (designed by Philippe Starck), 1985. Photograph by Helmut Newton.

WHAT I LOVE ABOUT MANET IS THE SUMPTUOUS, NUANCED WHITES, LIKE THE DRESSES IN HIS BALCONY PAINTING, OR IN HIS PORTRAIT OF BERTHE MORISOT. I FIND THE PRE-RAPHAELITE WOMAN TO BE SUBLIME, QUITE MODERN, AND FULLY LIBERATED.

GLOBE, 1986

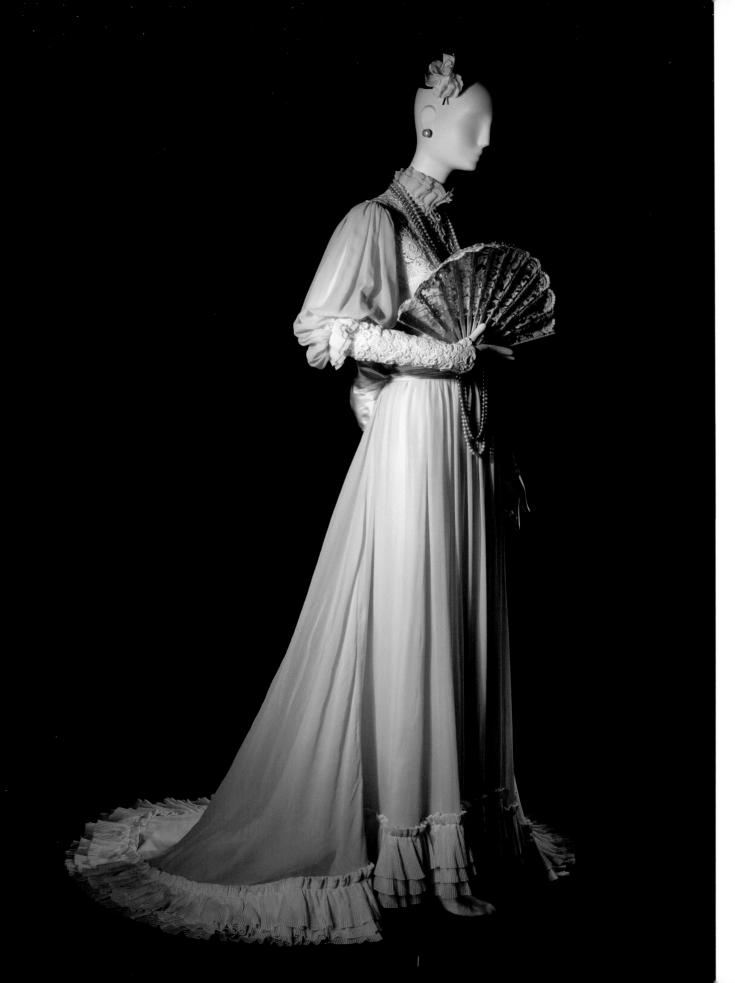

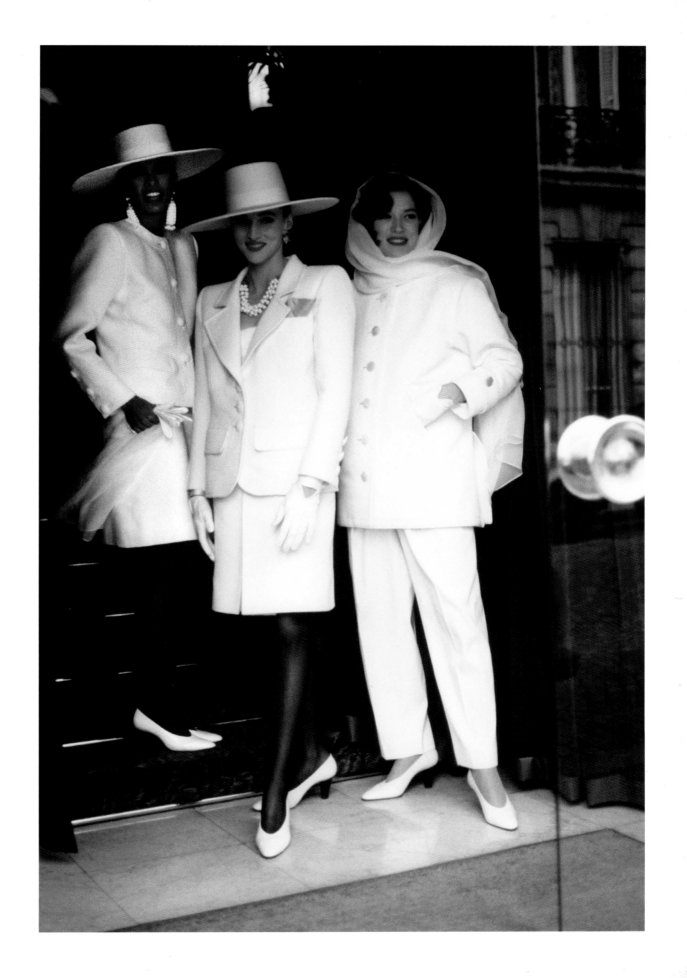

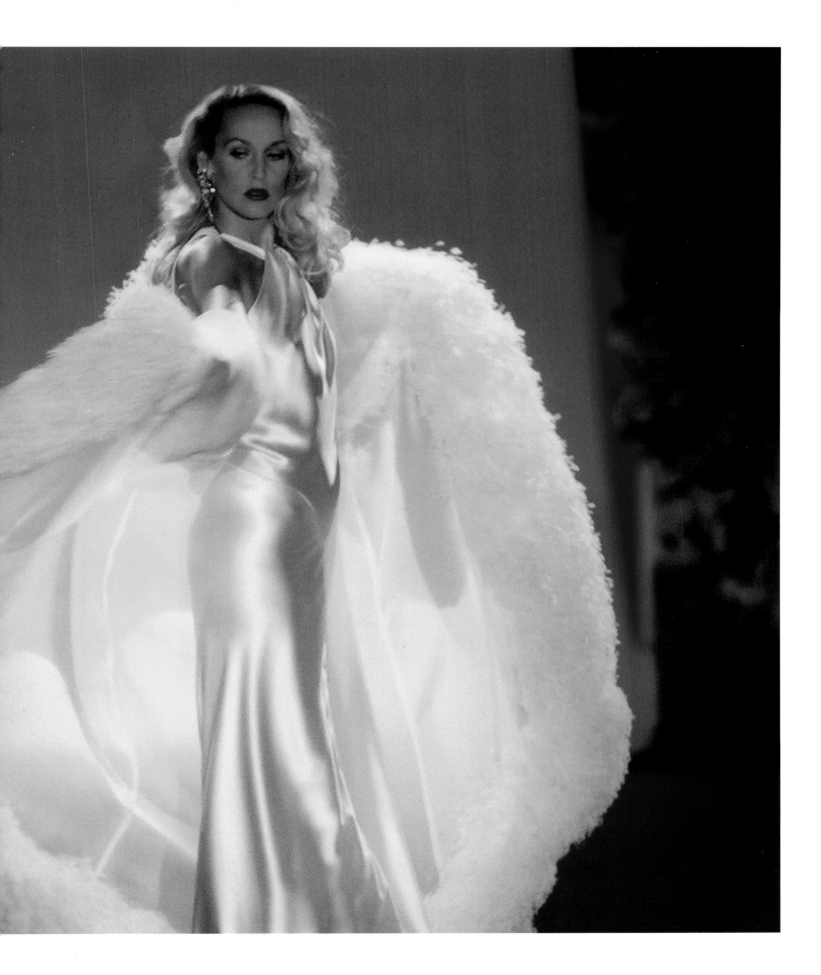

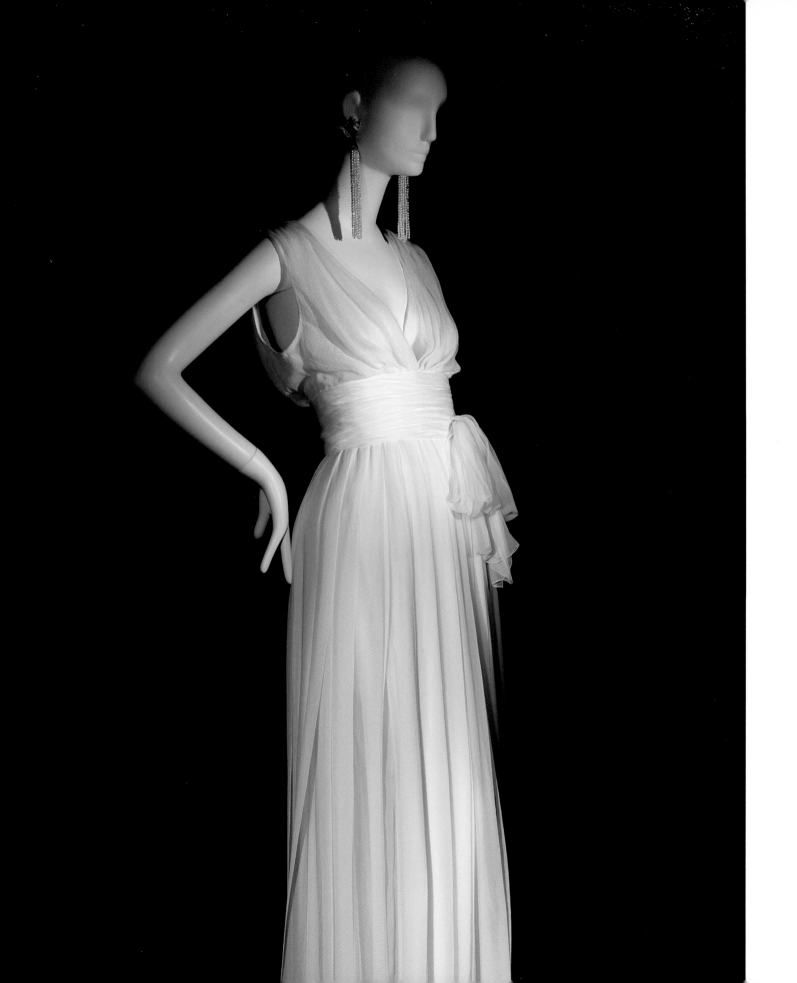

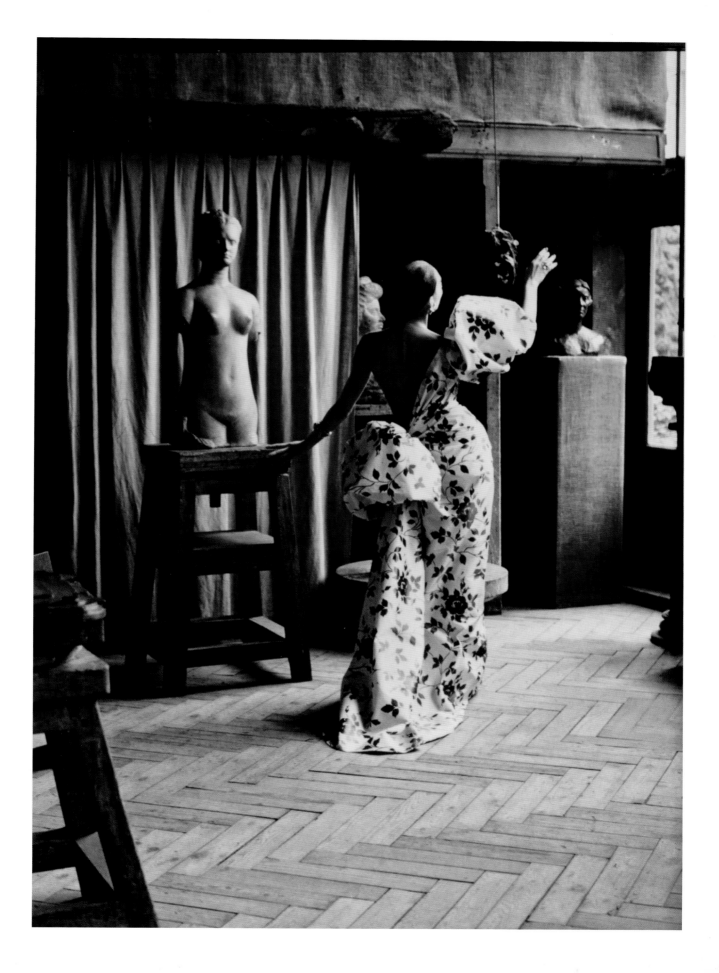

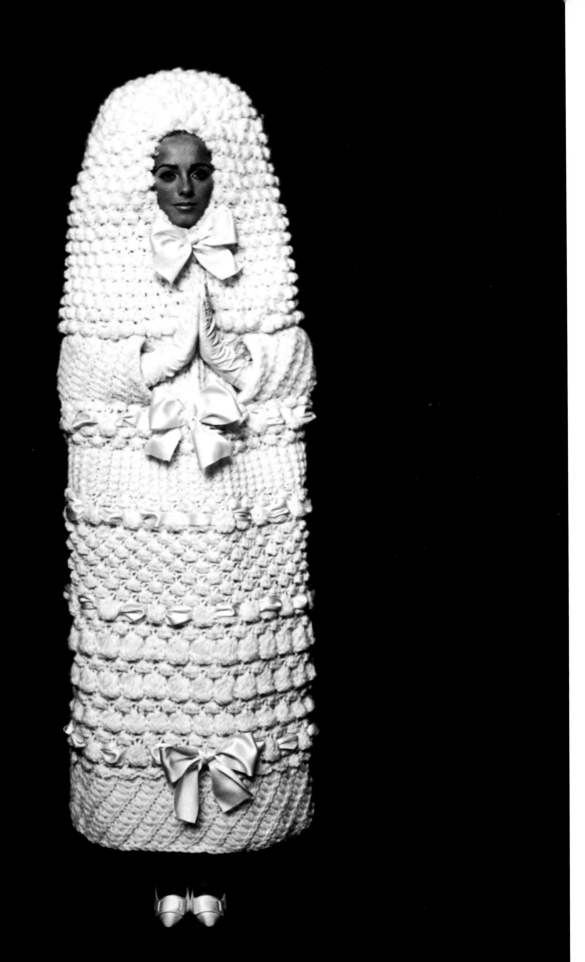

Page 243 Card with white samples, from one of the color files assembled over the years by the Yves Saint Laurent studio.

Page 244 — Dress made to order for Jane Birkin for the Proust Ball, December 1971 (CAT. 9).

Page 245 — Two white cotton suits with skirts and a white Ottoman pea jacket, Spring–Summer 1990 haute couture collection. Photograph by Arthur Elgort.

Pages 246–247 Jerry Hall in a white satin dress and gazar coat trimmed with ostrich feathers, Spring–Summer 2001 haute couture collection, retrospective show, January 22, 2002, Centre Georges Pompidou, Paris.

Page 248 — Spring–Summer 1997 haute couture collection (detail of CAT. 231).

Page 249 — Ahn Duong in a mottled taffeta dress, Spring–Summer 1986 haute couture collection. Photograph by David Seidner.

Opposite — Knitted wool wedding dress, Fall–Winter 1965 haute couture collection, French *Elle*, September 2, 1965. Photograph by Fouli Elia.

EXOTICISM IN THE DESIGNS OF YVES SAINT LAURENT: A LESSON IN FASHION

FLORENCE MÜLLER

In July 1976, the "Opera and Ballets Russes" collection was greeted with enormous enthusiasm by Saint Laurent's admirers, assembled in the great gilt ballroom of the Hôtel Intercontinental. They enjoyed a spectacular display of the exotic themes that were close to the designer's heart, and the event was a resounding success. It was also the first collection to be sumptuously staged like a dramatic performance, in which the usual constraints of fashion seemed to take a backseat. Saint Laurent himself was dazzled by the theatricality of his work: "It is perhaps not the best, but definitely the most beautiful," he said about this collection, which was inspired by the Sergei Diaghilev ballets. In putting aside his devotion to his "classics" and his quest for the "*type parfait*," a perfect type of garment, he had created a magical interlude. It was a way for this builder of an enduring, timeless couture style to take a breath. He confided as much to the magazine *Elle*: After dressing women in blazers and pants suited to the practicalities of everyday life, "Suddenly, I felt like a bit of fantasy. I was tired of fashion that was caught up in a humdrum routine and its serious approach paralyzed me. Last winter, there were Diaghilev's Ballets Russes, and women wanted to dress up like brightly colored birds of paradise. But that doesn't mean I'm giving up the classics."[1] It was Vermeer's 1665 painting *Girl with a Pearl Earring*, and, more specifically, his "exotic" arrangement of this "northern Mona Lisa" wearing a turban, that originally prompted the collection. But beyond the inherent magic of this collection, Yves Saint was countering the idea relayed by the press that haute couture was obsolete. The Russian theme in his collection was mingled with references to opera, that other symbol of a bygone cultural lifestyle. The "Russian" collection brought a taste for splendor and spectacular "entrances" back into fashion. Yves Saint Laurent transformed women into Chinese princesses, Goya duennas, and Slavic peasants. Long dresses, full layered skirts, harem pants, and tunics were ablaze with gold and velvet trimmings and embroidery. Those who, that same day, had been "wearing the pants" could, in the space of an evening, enjoy the carefree existence of an idolized woman. Yet Saint Laurent's exoticism never lapsed into costume, for, as the designer put it, "perfection is the opposite of fancy dress."[2] From the 1960s, he put this assertion into practice. In an interview given to Janine Brillet, the American fashion journalist Eugenia Sheppard cited, as an example of the success of Yves Saint Laurent's first collection, the "'Russian coat' that was copied all over America."[3] The sight of Austrians in traditional costume in the streets of Salzburg gave Saint Laurent the idea of the famous black shoes with a metal buckle made by Roger Vivier for the Winter 1965 collection and the loden of Winter 1969. The stylistic sources of the "Spanish and Romantic" collection of Summer 1977, followed by the "China and Opium" collection of Winter 1977, also escape ethnographical or folkloric analysis. Any references they contained were intermingled within graphic compositions that escape any categorization. Flowery shawls conjured up a Russian peasant look or else swathed the wearer in romantic colors, the designer imagining a Madame Bovary figure "in her garden especially, with a shawl, bored."[4] The caftan coats of Winter 1970 evoked North Africa, Turkey, or India. The Chinese models of Winter 1977 wore Cossack-style boots. According to Saint Laurent, the daywear designs of the "Russian" collection were inspired by traditional garments of Russia, Czechoslovakia, Austria, and Morocco. Loulou

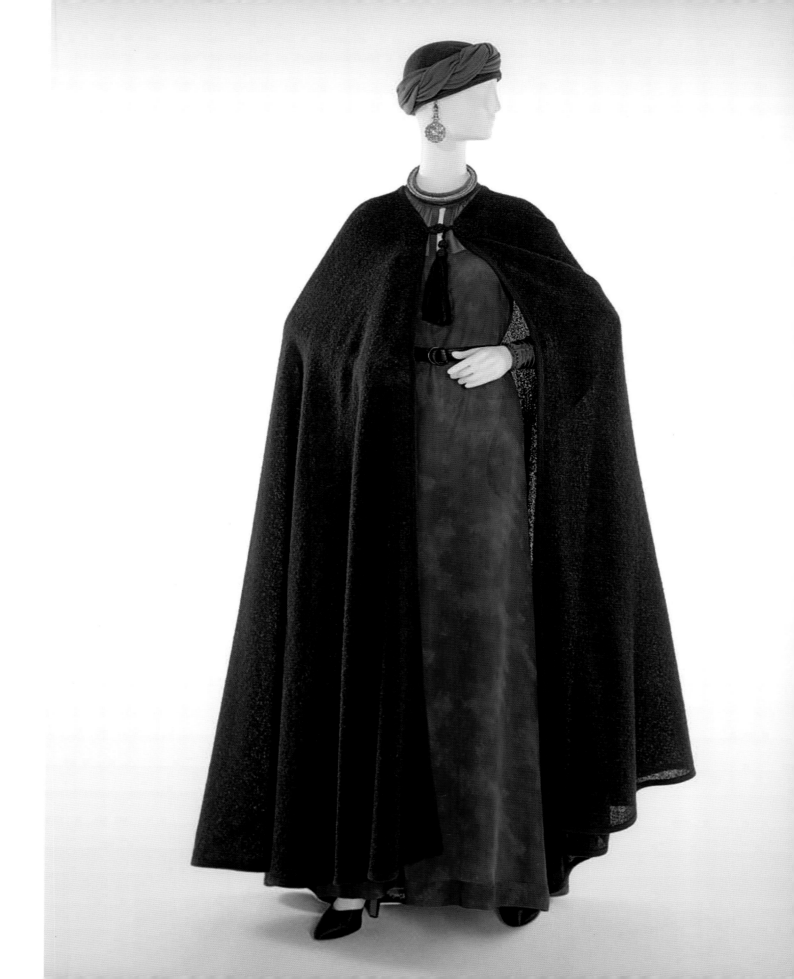

de la Falaise suggested the Silk Road as a possible bridge spanning countries that were geographically distant but mixed on the catwalk.[5] "Elsewhere" must remain mysterious if it is to exercise its full artistic appeal.

Saint Laurent's travels were essentially imaginary ones, those preferred by a resolutely stay-at-home man. But his horizons were boundless, for they followed his thoughts that were transported in his reading of illustrated books. Like Xavier de Maistre before him, Saint Laurent traveled this journey "around his room" and on his own. As he said to Catherine Deneuve in 1986, "I am very alone. I exercise my imagination in lands that I do not know. I hate to travel. For example, if I read a book about the Indies with photos, or one on Egypt, where I haven't been, my imagination takes me away. Those are my most wonderful journeys."[6] Morocco was the only foreign country for which he willingly left Paris. After 1966, in Marrakech, where he purchased a house named Dar el Hanch (the House of the Serpent) with Pierre Bergé, he discovered the beauties of North Africa that the westernized city of his youth, Oran, had concealed from him. "That is when I became more sensitive to light and colors, and when I noticed especially the light on colors. . . . [A]t every street corner, in Marrakech, you see groups of incredible intensity and relief, men and women in caftans of pink, blue, green, purple. These groups look like drawings or paintings, Delacroix sketches, but it is amazing to realize that they are in fact only an improvisation of life."[7]

The exoticism of Yves Saint Laurent made its appearance in the Dior period and in his first collection, presented in 1962. Anne-Marie Muñoz remembered a shop window design by Yves Saint Laurent at Dior: "With paper lace, red ribbons, and fake fruit, he would create a '*martiniquaise*' [a woman from Martinique] truer to life than the real thing."[8] India was Saint Laurent's principal source of inspiration. In his Winter and Summer 1962 collections the country was evoked in brocaded and embroidered tunics, rajah coats, Hindu prince turbans, and sarongs. An initial effort, perhaps, to escape the traditional long evening dresses, before he replaced these with tuxedos? For Summer 1964, a blouse, full skirt, and headscarf heralded the Slavic peasant style of 1976. The créole and gypsy dresses appeared in the Summer 1967 collection. For Summer 1968, well before the peasant woman walked down the catwalk at the Hôtel Intercontinental, a model wore a tasseled shawl wrapped around her body. Two years before the "Opera and Ballets Russes" show, the Winter 1974 ready-to-wear collection was devoted to Cossacks, babushkas, and wealthy Russian ladies clad in velvet coats. The exotic themes were sometimes tested in single models before forming the central theme of a collection. The designer focused more on everyday or working-class garb such as the Russian peasant headscarf, the Spanish cigarette girl's corselette, the Russian coach driver's jacket, the Slavic peasant's blouse, the Chinese cheongsam, and the Japanese kimono than on high-society ensembles. During a journey in Russia in the Gorbachev days, he was asked how Russian women could be as elegant as the Saint Laurent Parisiennes. He replied that it would suffice for them to borrow their husband's camel-hair coat, knit a black sweater, slip a traditional Russian blouse over the top, and add a belt.[9] The designer wove his exotic themes into his daywear models, thus adding light dashes of color to the more

NOTES

1 — Jean Dominique Baudy and Francine Vormèze, "Hommage à Yves Saint Laurent," *Elle* Québec, March 1992.

2 — "Yves Saint Laurent 10 ans dans les coulisses du grand couturier," *Point de Vue et Images du Monde*, February 4–10, 1997.

3 — Janine Brillet, "Eugenia juge la mode française," *Le Nouveau Candide*, August 1, 1962. Janine Brillet was a journalist with the magazine *Télé 7 Jours* at the time, writing articles on social affairs such as "La TV ne pense pas à ceux qui se lèvent tôt."

4 — "Pour le chic: l'éternité," recorded by Jean-François Josselin, *Le Nouvel Observateur*, December, 23, 1983.

5 — Interview with Loulou de la Falaise, October 9, 2009.

6 — On Yves Saint Laurent by Catherine Deneuve, "Je suis un homme scandaleux, finalement. Yves Saint Laurent le magnifique," *Globe* (France), May 1986.

7 — "Yves Saint Laurent au Metropolitan Museum of Art de New York. Portrait de l'artiste," conversation with Yvonne Baby, *Le Monde*, December 8, 1983.

8 — Javier Arroyuelo, "Yves Saint Laurent," *Vogue Italia, Alta Moda* supplement, March 1998.

9. Deneuve, "Je suis un homme scandaleux."

10. Saint Laurent, "Pour le chic: l'éternité."

functional look of ensembles or suits. One of the Summer 1968 *smokings* had an Hispanic air with its matador-style bolero. In so many brilliant touches, these elements of exoticism introduced a rich vocabulary into the Saint Laurent style. It was a way for the designer to capture moments of fantasy and escape the constraints of contemporary fashion. "A Romanian blouse does not belong to any period," he said. "All these peasant clothes are passed down from century to century without going out of fashion." The full skirt and gypsy blouse, Russian and Spanish dresses, dolman, and burnoose were powerful evocations of an "elsewhere." But the Chinese damask overcoat, Cossack boots, Russian coat, and North African burnoose-style cape ended up becoming basics in the Saint Laurent wardrobe and even Parisian daywear "classics." Saint Laurent's exotic style transcended fashion, for it was based on clothing that was timeless. Yves Saint Laurent saw this timelessness as something positive. He observed, "In Africa or Asia, or in Slavic countries, clothes don't change very much and, most of the time, young women wear the same dresses as old ladies. Which supports my theory that you can wear the same thing at any age."[10]

Yves Saint Laurent created his exotic designs at the same time as his famous social utilitarian garments: trouser suit, pea jacket, tuxedo. They formed a counterpoint between day and evening wear, realism and the imagination, the classical and the baroque, and contributed, in their own way, rooting the keys to the YSL style deep within the textile material. The inspiration he drew from the traditional costumes of far-off lands went beyond simply achieving a baroque effect. Folklore, by definition, is of an invariable, stable nature, escaping the cycles of fashion. These designs achieved the immutable status of "European" costumes. The Saint Laurent style was enriched with these signs of recognition, as identifiable as its masculine-feminine quality. From one year to the next, a whole new vocabulary was created, through a braid-trimmed padded jacket; a fur hat and boots; a tasseled belt; a dolman; a wraparound cape; a shawl and scarf to drape over the head, as a headscarf or turban, over the shoulders, or the chest; long full skirts in opera-style satin or gypsy-inspired muslin. And this vocabulary was Saint Laurent's own.

Catherine Deneuve and Yves Saint
Laurent, Villa Oasis, Marrakech,
French *Elle*, January 27, 1992.
Photograph by André Rau.

Below — Letter from Yves Saint Laurent to Andrée Brossin de Méré, famous supplier of haute couture fabrics, December 9, 1969.

Opposite — *Love*, 1977.

260

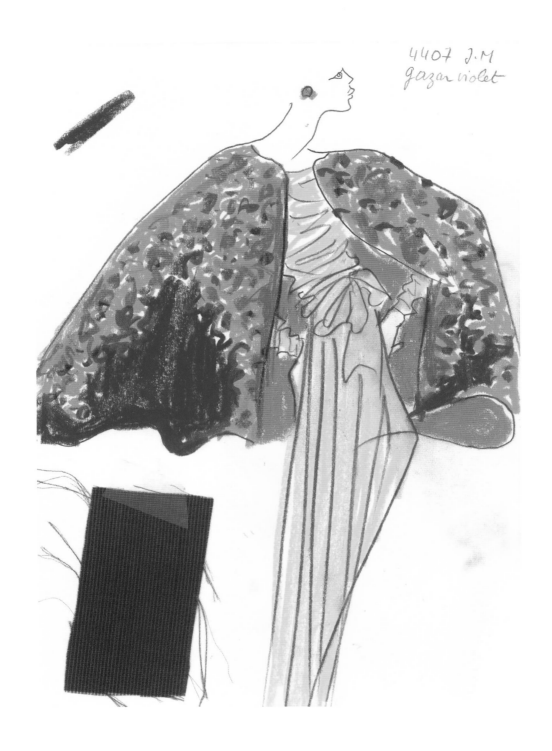

4407 J.M
gazar violet

Above — Sketch of a "bougainvillea" cape and an evening dress, Spring–Summer 1989 haute couture collection.

Opposite — Spring–Summer 1989 haute couture collection (CAT. 149).

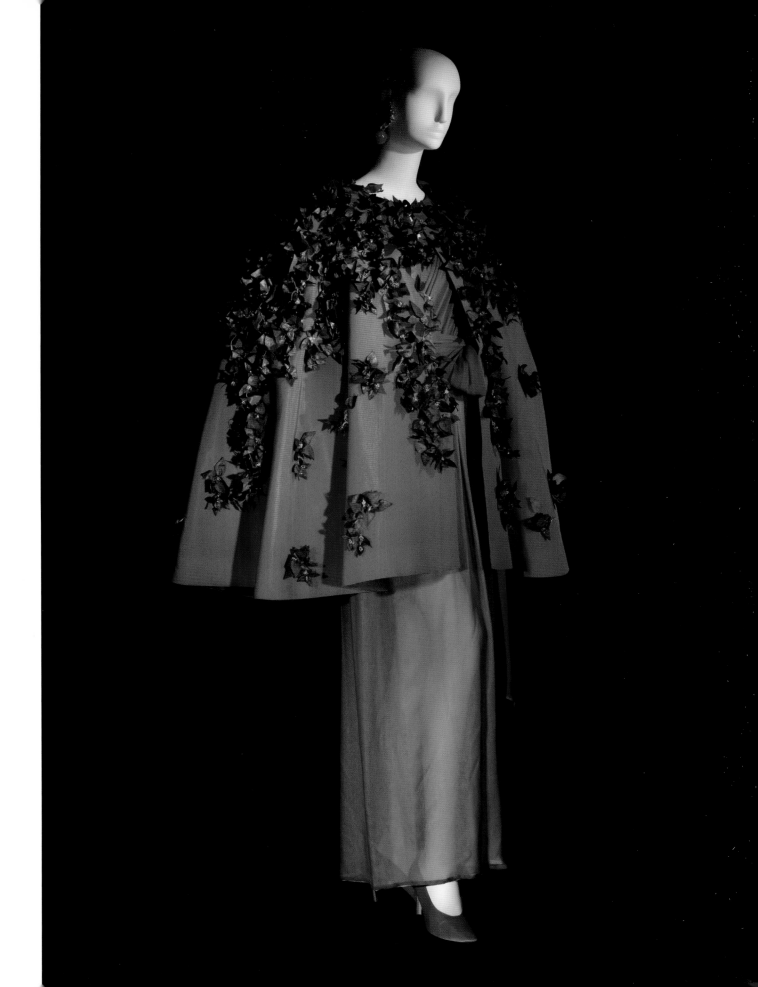

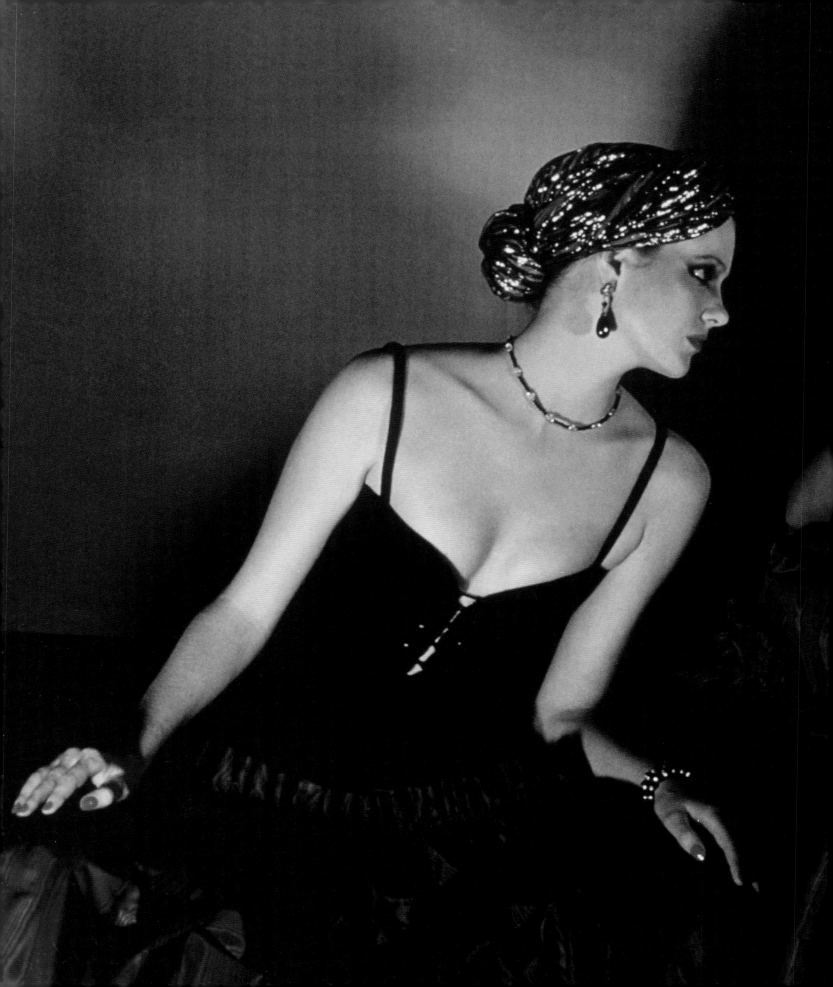

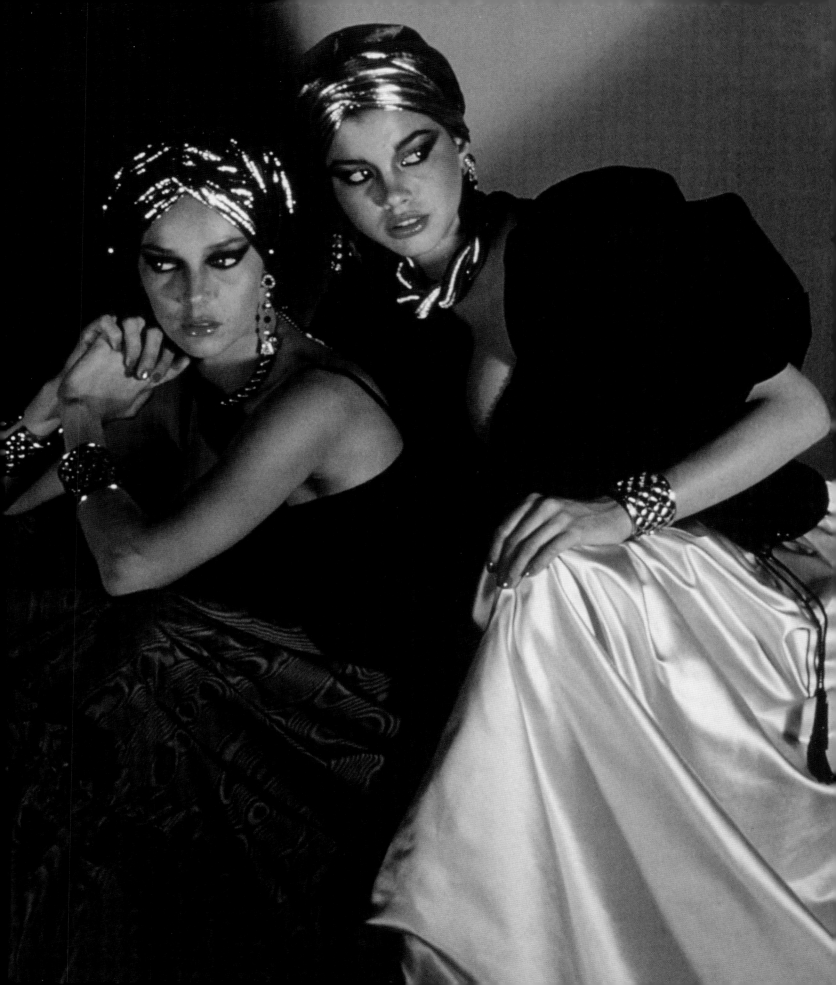

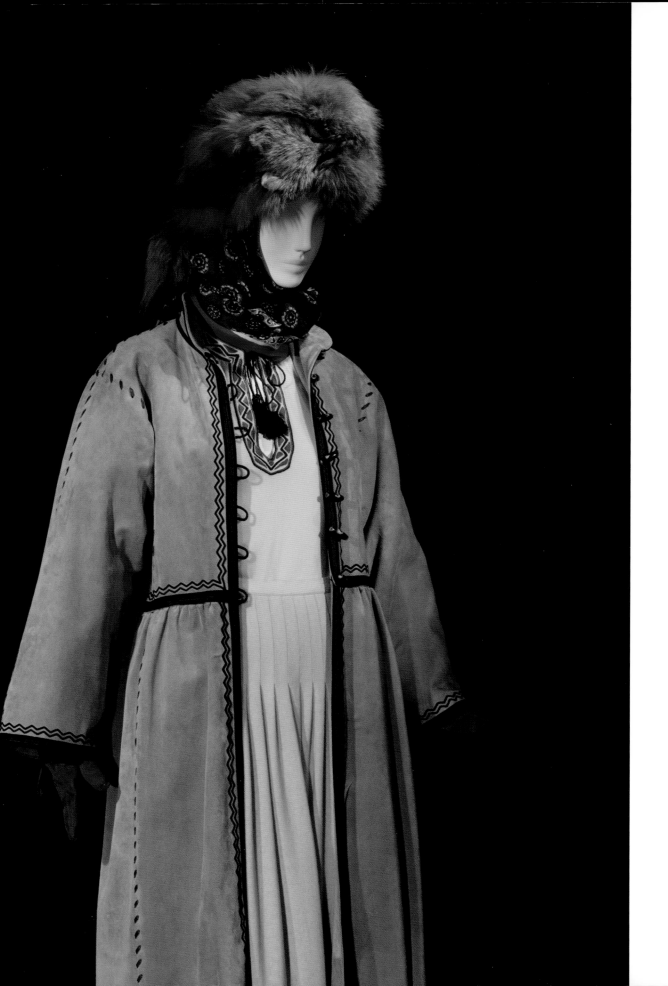

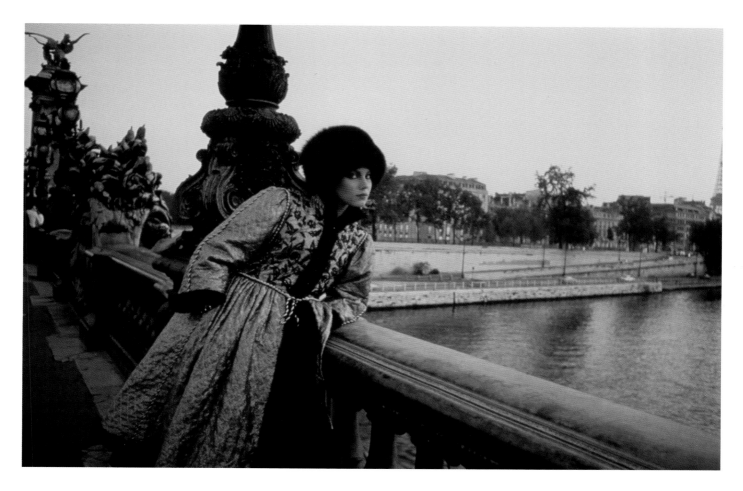

Pages 264 and 265 — Left: lace-up
corselette embroidered with jet
by Vermont and skirt in velvet by
Gandini; center: lace-up corselette
in velvet by Chatillon Mouly
Roussel and skirt in moiré by
Gandini; right: dress with bustier
in velvet by Léonard embroidered
with jet by Lesage, skirt and satin
sleeves by Taroni, at the Hôtel
Sheraton. *Vogue Paris*, September
1976. Photograph by Guy Bourdin.

Opposite — Fall–Winter 1976
haute couture collection (CAT. 123).

Above — Gold lamé coat
embroidered with jet, Pont
Alexandre III in Paris, Fall–Winter
1976 haute couture collection,
American *Vogue*, March 1976.
Photograph by Duane Michals.

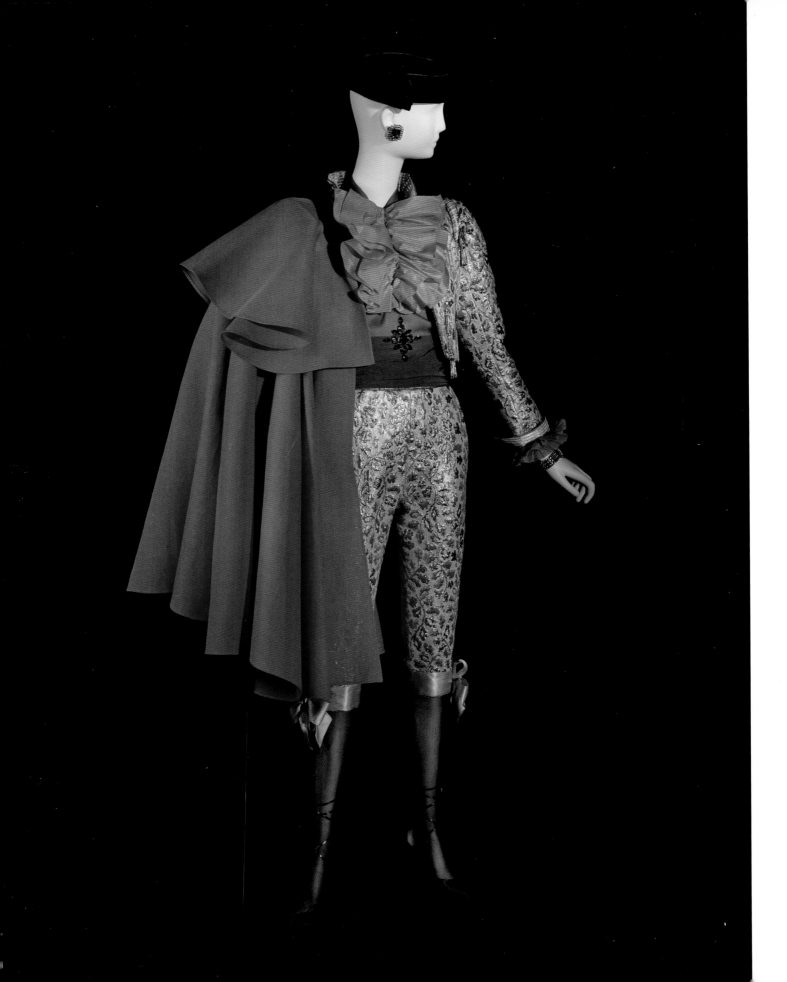

Opposite — Fall–Winter 1979
haute couture collection (CAT. 114).

Right — Black taffeta and lace
dress, Spring–Summer 1977 haute
couture collection. Photograph by
Uli Rose.

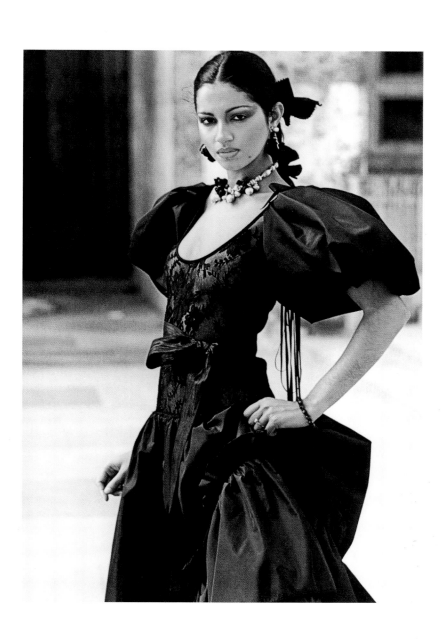

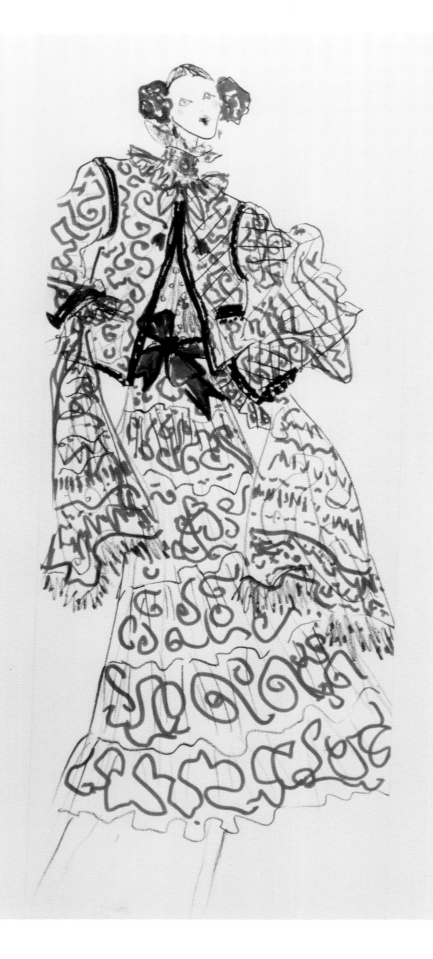

Opposite — Sketch of a dolman blouse and a skirt, Spring–Summer 1977 haute couture collection.

Right — Corselette in moiré and black faille, and white cotton Bermuda shorts, Saint Laurent Rive Gauche collection, Spring–Summer 1977.

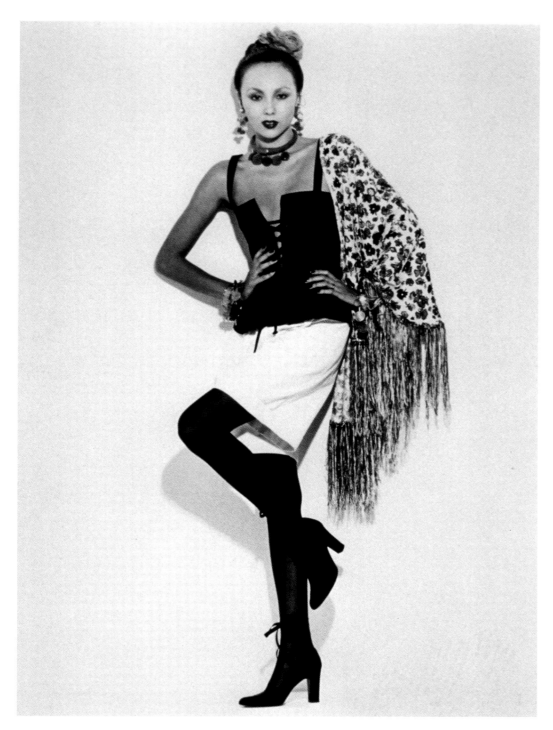

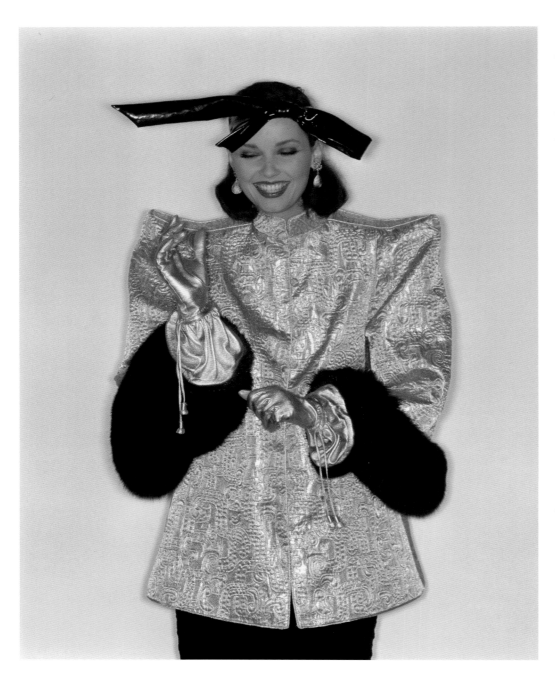

Left — Gold damask jacket and black velvet pants, Fall–Winter 1977 haute couture collection, British *Vogue*, December 1977. Photograph by Lothar Schmid.

Opposite — Yves Saint Laurent at the fitting for a design from the Fall–Winter 1970 haute couture collection. Photograph by Giancarlo Botti.

Page 274 — Fall–Winter 1977 haute couture collection (detail of CAT. 133).

Page 275 — Fall–Winter 1977 haute couture collection (CAT. 135).

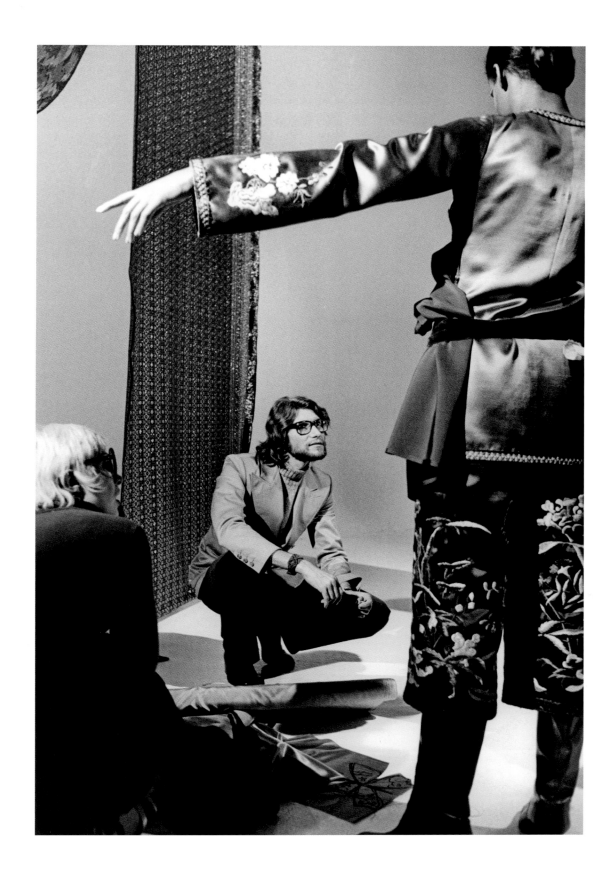

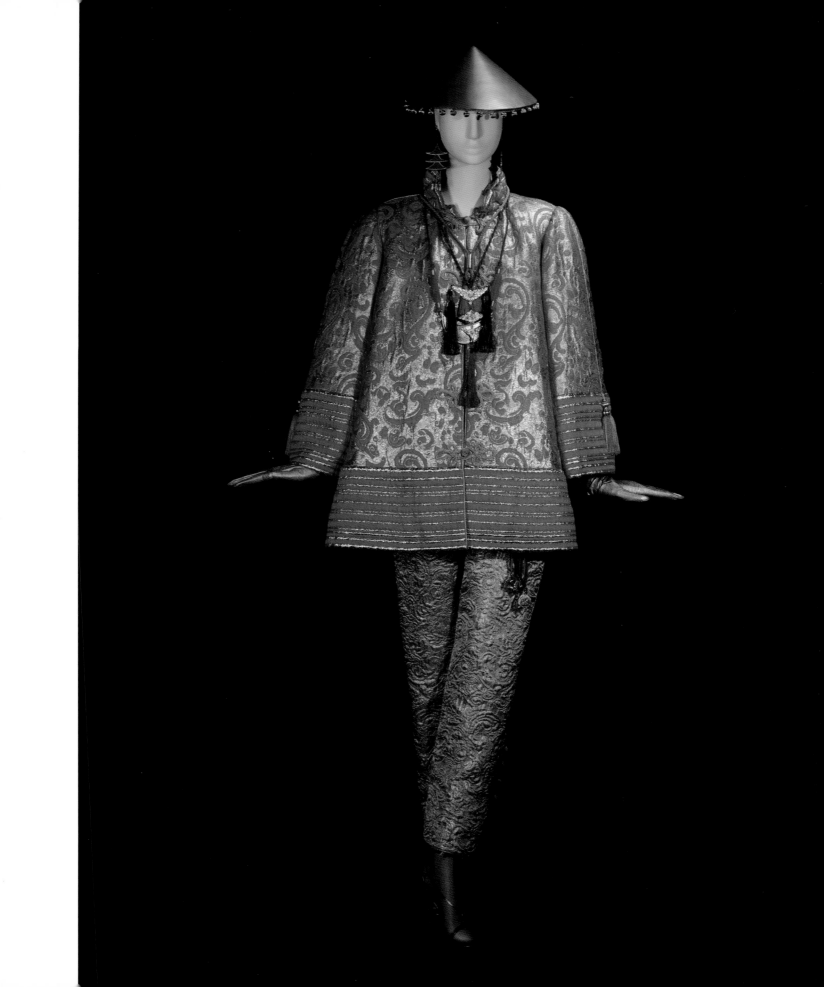

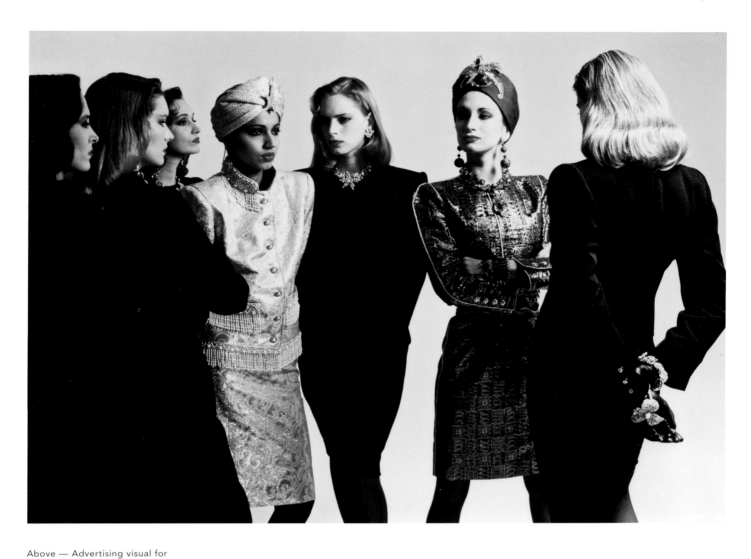

Above — Advertising visual for
Saint Laurent haute couture, *Vogue
Paris*, March 1982. Photograph by
Helmut Newton.

Opposite — Fall–Winter 1969
haute couture collection (CAT. 126).

Opposite — Fall–Winter 1984 haute couture collection (detail of CAT. 129).

Right — Indian-inspired silk jacket and turban, in the wings of the Fall–Winter 1962 haute couture show. In the background: Pierre Bergé.

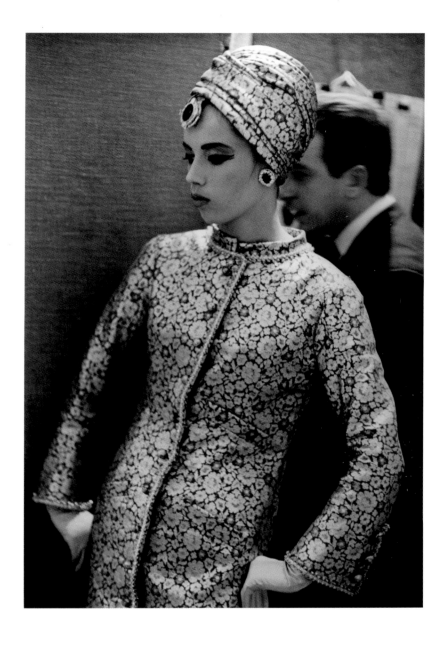

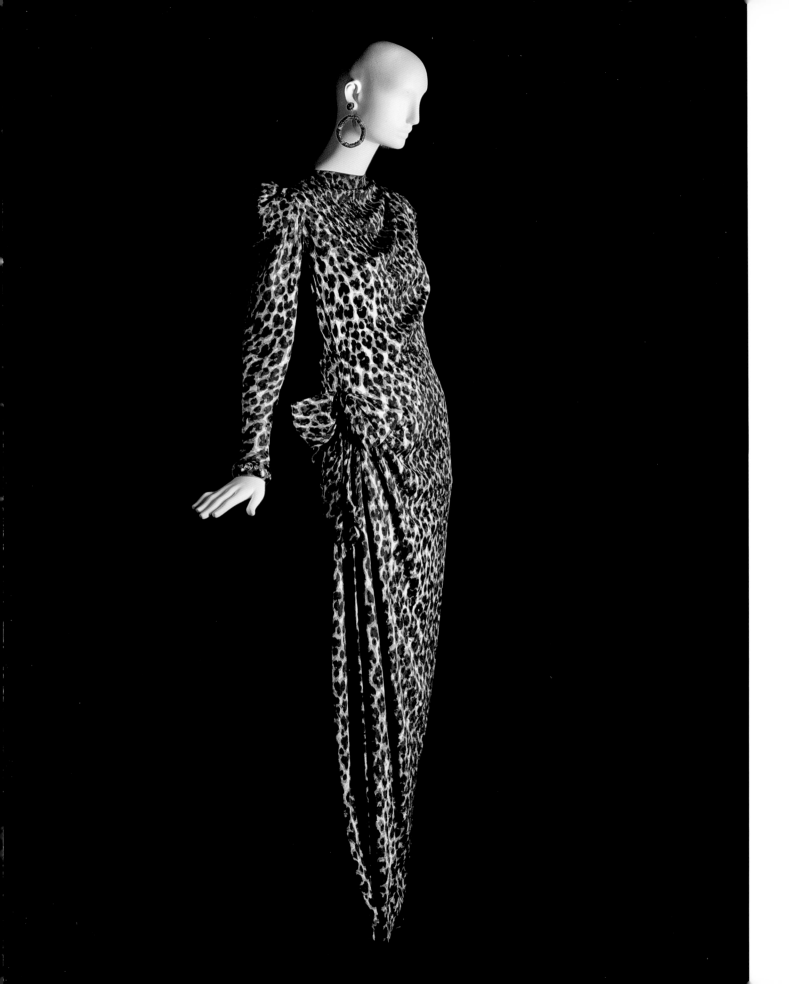

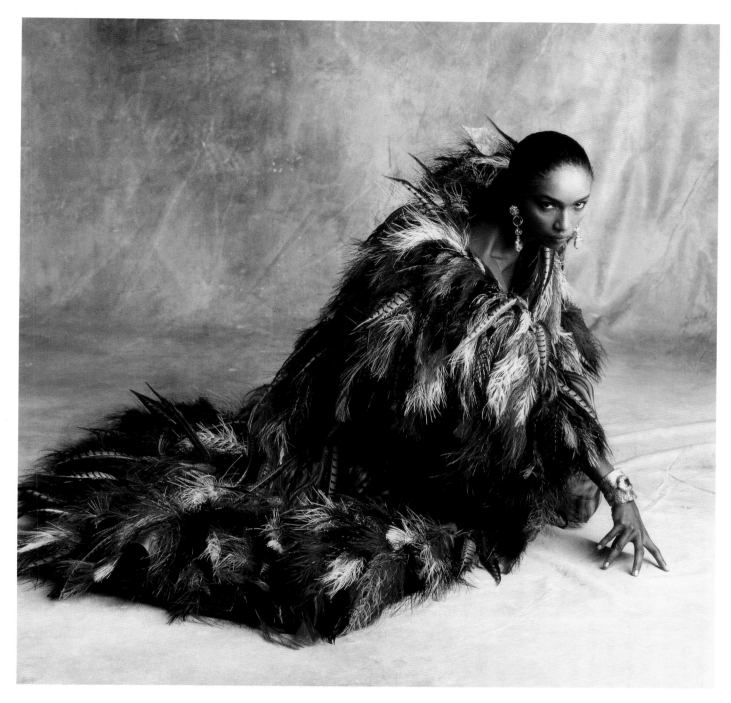

Opposite — Fall–Winter 1982
haute couture collection (CAT. 145).

Above — Katoucha in a coat of
multicolored feathers, 1990, *Paris
Match*. Photograph by Jean-
Claude Sauer.

Opposite — Fall–Winter 1987
haute couture collection (CAT. 248).

Page 284— Fall–Winter 1964
haute couture collection (detail
of CAT. 141).

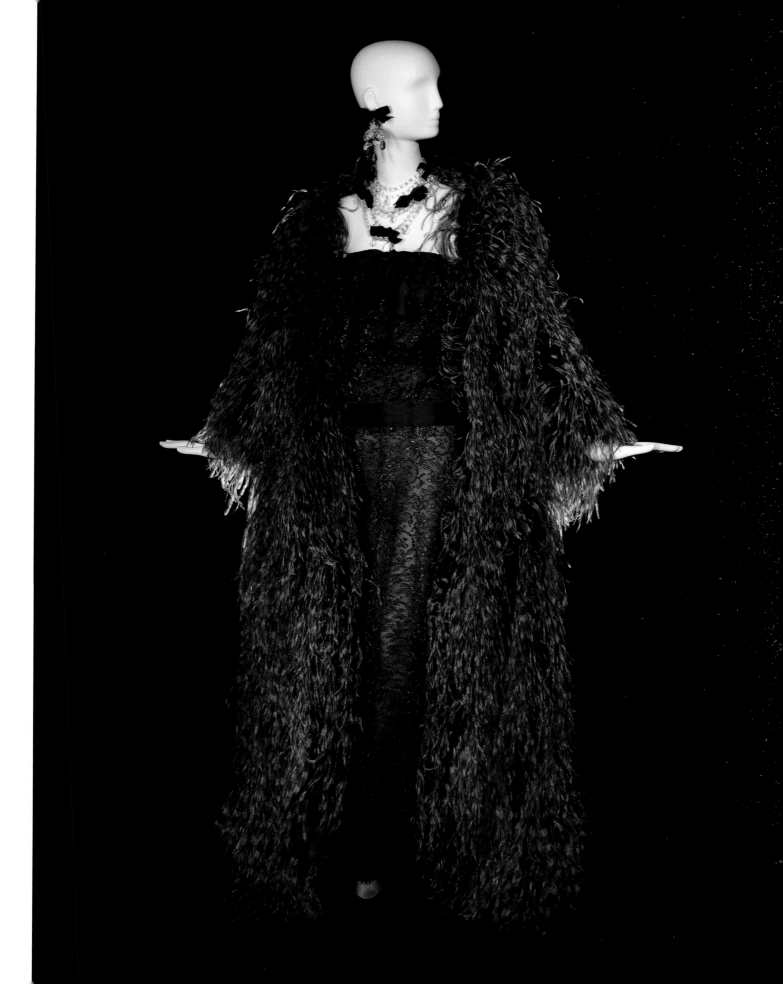

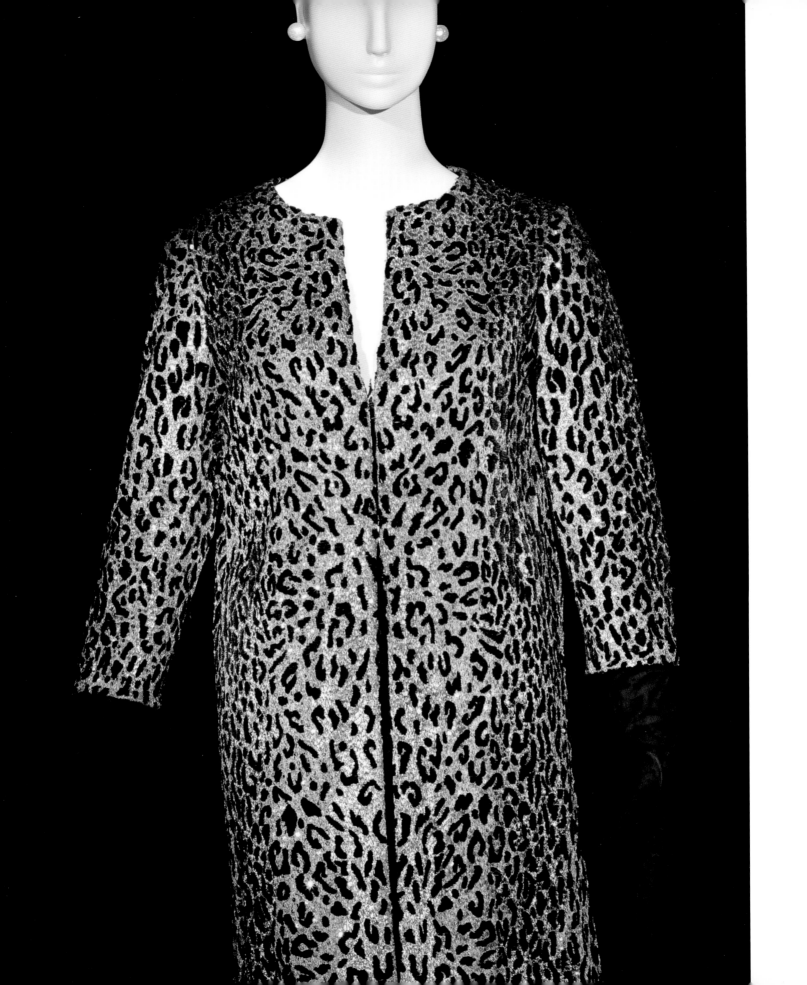

MY FAVORITE COLOR, AFTER BLACK, IS PINK.

MANUSCRIPT, ARCHIVE OF THE FONDATION PIERRE BERGÉ–YVES SAINT LAURENT

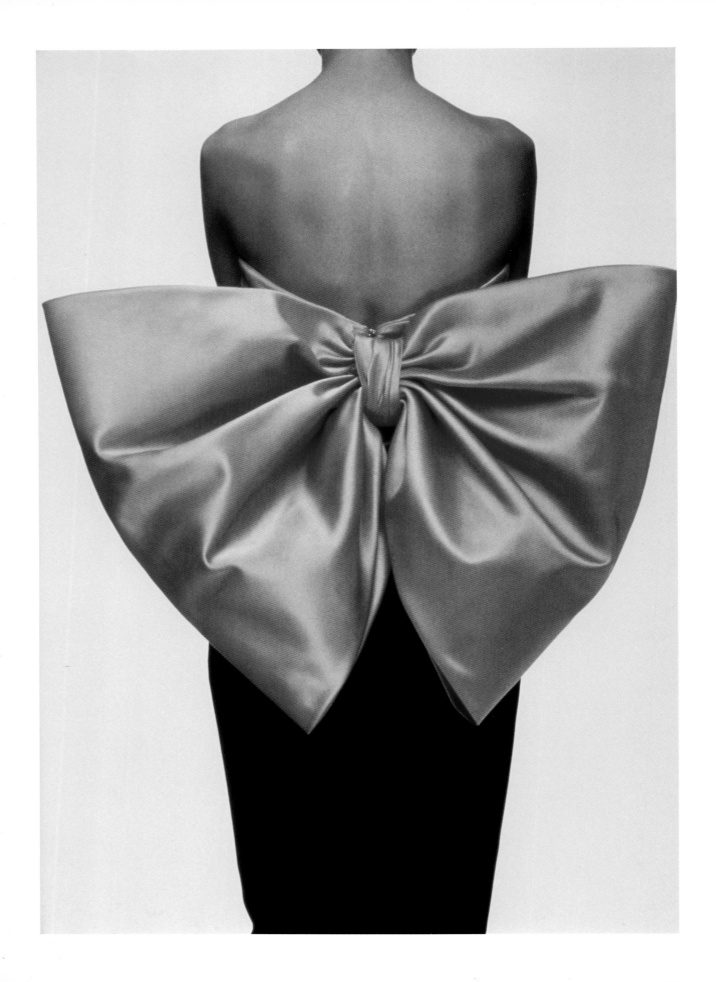

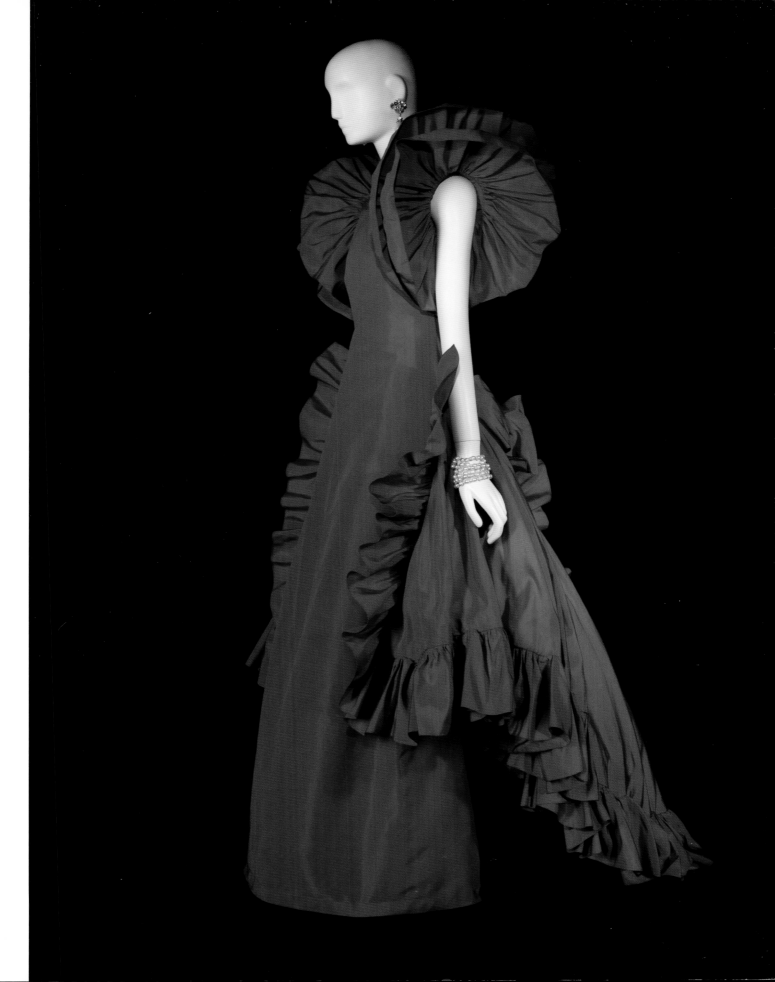

REVUE DE Roland

Palais de Cl

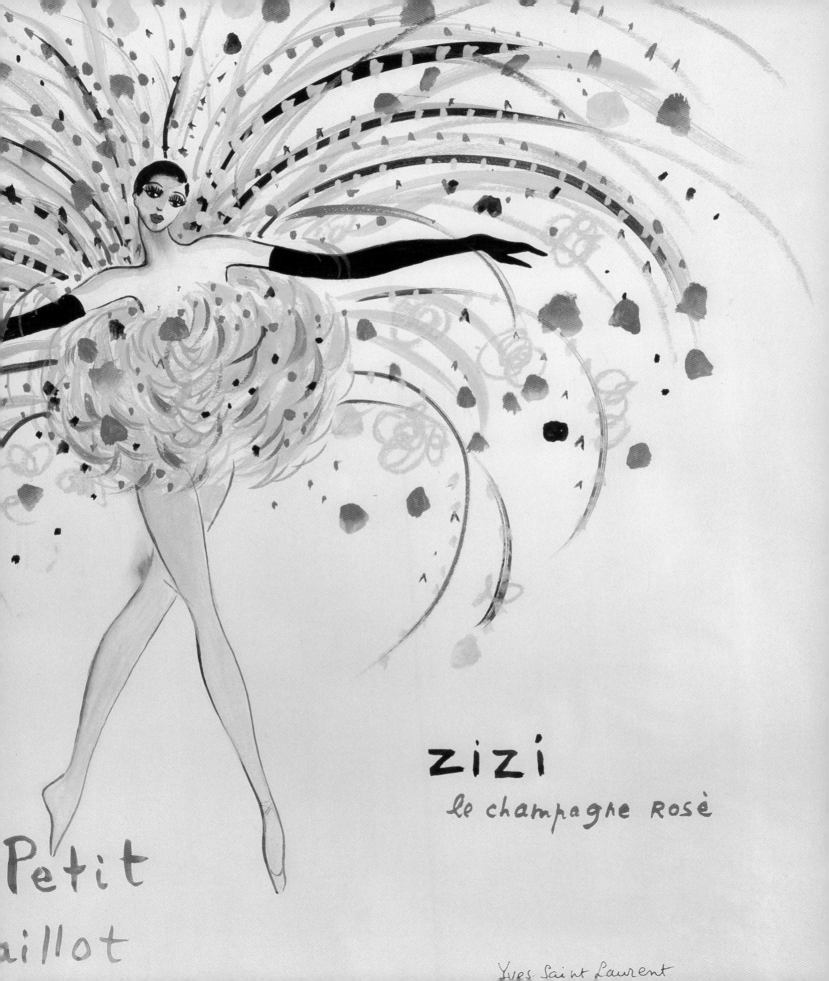

zizi

le champagne Rosè

Petit

aillot

Yves Saint Laurent

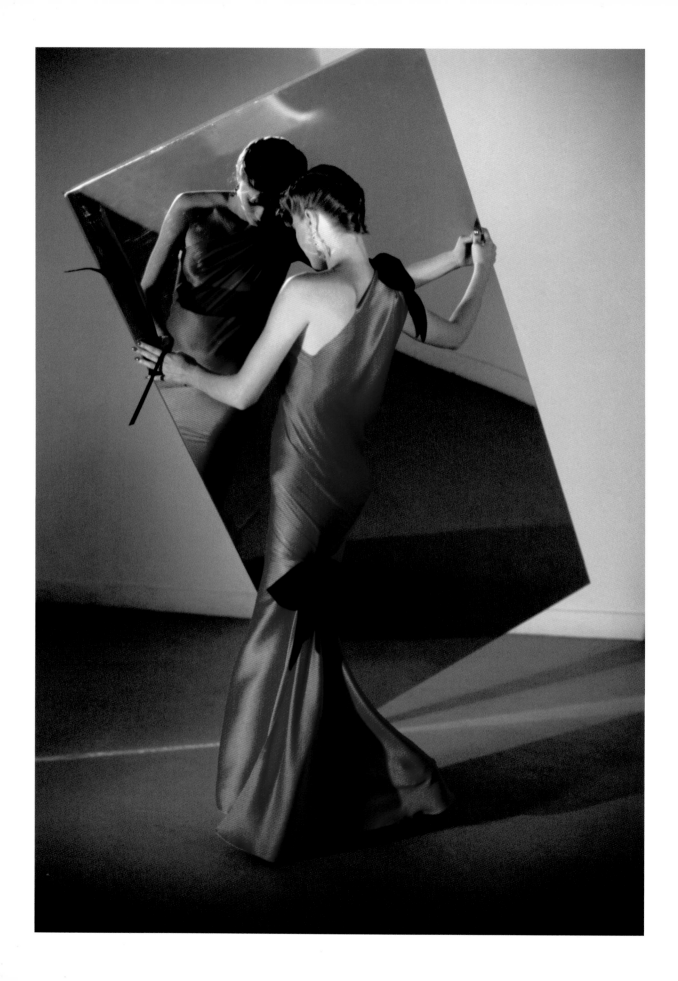

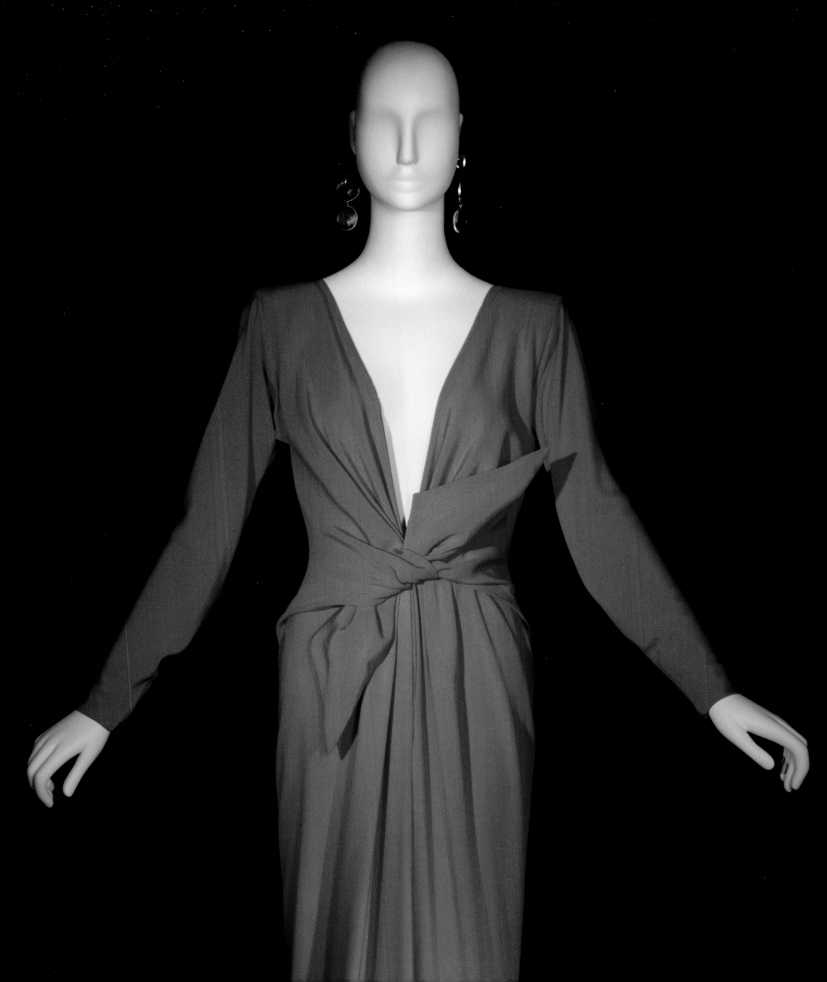

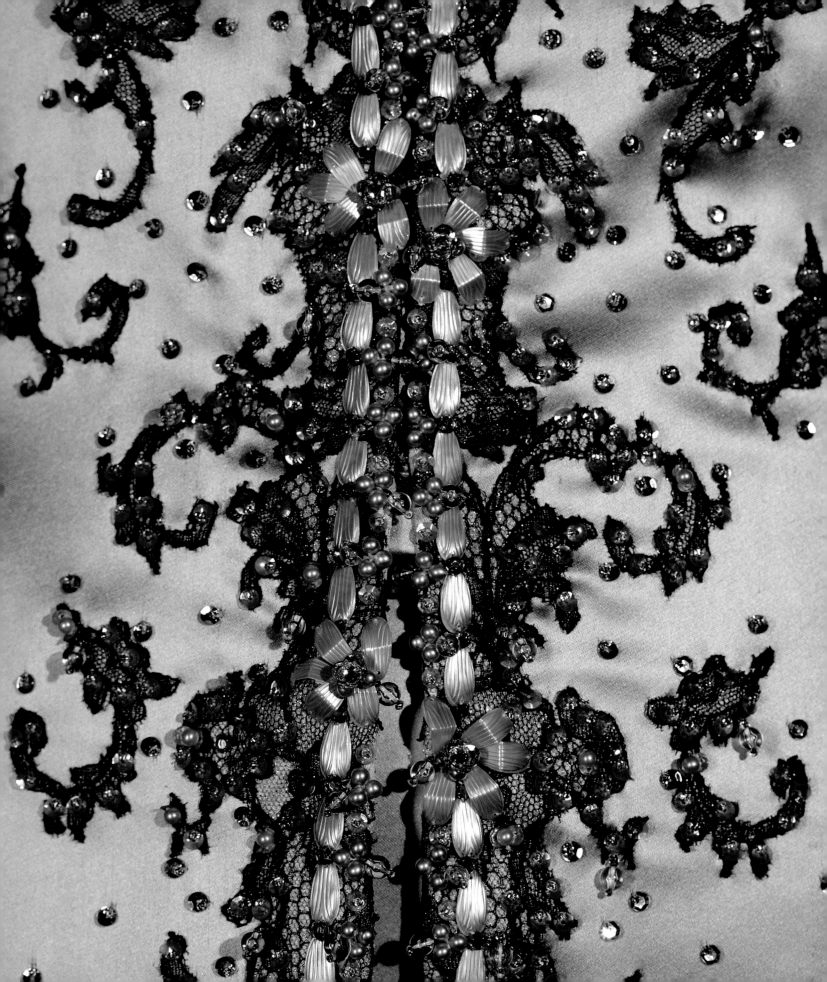

Page 287 — Card with pink samples, from one of the color files assembled over the years by the Yves Saint Laurent studio.

Page 288 — Black velvet sheath dress and pink satin bow, design created for the perfume Paris, 1983. Photograph by Gilles Tapie.

Page 289 — Spring–Summer 1980 haute couture collection (CAT. 261).

Pages 290–291 — Costume designed for Zizi Jeanmaire, for the show *Le Champagne Rosé* staged by Roland Petit, 1963.

Page 292 — Fuchsia satin dress, black velvet bow, Fall–Winter 1978 haute couture collection, American *Vogue*, October 1978. Photograph by Arthur Elgort.

Page 293 — Spring–Summer 1985 haute couture collection (detail of CAT. 84).

Opposite — Spring–Summer 1998 haute couture collection (detail of CAT. 247).

A GALLERY OF SAINT LAURENT WOMEN

FLORENCE MÜLLER

CHARLOTTE AILLAUD — Charlotte Aillaud is the sister of the singer Juliette Gréco and the wife of the architect Emile Aillaud. A figure of Parisian society, she was part of the close circle around Yves Saint Laurent, Pierre Bergé, Françoise Sagan, and the Baron de Rédé. At her house on rue du Dragon, she entertained intellectuals, writers, musicians, and painters.

MOUNA AYOUB — Mouna Ayoub, a French national of Lebanese origin, is one of the most famous French socialites from the Arab world. Since the early 1980s, she has built up one of the largest private collections of haute couture dresses, including numerous Yves Saint Laurent designs. The celebrity press of the 1980s and 1990s often published photographs of her wearing haute couture ensembles. Mouna Ayoub would choose the most spectacular creations, such as a lace dress open over the bust and legs and only held together at the waist with pink bows.

LAUREN BACALL — Lauren Bacall became a Hollywood legend in 1946 along with Humphrey Bogart when they starred in Howard Hawks's *The Big Sleep*. They formed a famous couple in crime films, including John Huston's *Key Largo* (1948). She was working as a model when Nancy Hawks spotted her in 1943 on the cover of *Harper's Bazaar*. She advised the actress on creating her own style before recommending Bacall to her husband, Howard Hawks, the film director and producer. Bacall became the perfect glamorous film noir heroine. Yves Saint Laurent's masculine-feminine style seemed made for her, as reflected in the evening ensemble, embroidered cardigan, and gray flannel pants (CAT. 73) she ordered from the designer.

BETTY CATROUX — Former Chanel model Betty Catroux met Yves Saint Laurent at the Chez Régine nightclub, and they remained very close until the designer's death. Together they formed a sensational pair because of the many things they had in common. Their physical and mental resemblances were striking: the same slim, leggy physique; a taste for partying and nocturnal temptations; the same desire to escape the banality of everyday life. Betty Saint, who became Betty Catroux on her marriage to the interior decorator François Catroux, saw herself as the female double of Saint Laurent. The designer said of her, "She's perfect in my clothes. Just what I love. Long, long, long."[1]

Above, left — Charlotte Aillaud and Eduardo Arroyo. Photograph by Guy Marineau.

Above, right — Mouna Ayoub in a lace dress with black sequins, Spring–Summer 1990 haute couture collection. Photograph by Ali Mahdavi.

Below, left — Lauren Bacall.

Below, right — Betty Catroux in a jersey tunic and pants, Saint Laurent Rive Gauche collection, *Vogue Paris*, November 1968. Photograph by Jeanloup Sieff.

Above, left — Françoise Giroud.
Photograph by Catherine Cabrol.

Above, right — Patricia Lopez-
Willshaw. *Vogue Paris*, 1956.
Photograph by Henry Clarke.

Below, left — Loulou de la
Falaise, at her wedding to Thadée
Klossowski, June 30, 1977.

Below, right — Nan Kempner
in a navy crepe de chine dress
and embroidered jacket, Spring–
Summer 1972 haute couture
collection, American *Vogue*,
January 1974. Photograph by
Francesco Scavullo.

LOULOU DE LA FALAISE — Louise "Loulou" de la Falaise made the acquaintance of Saint Laurent and Pierre Bergé in 1968, at a tea party held by Fernando Sanchez at his home on place de Fürstenberg. The young woman was living in London at the time, working as a junior editor for *Queen Magazine*. She married Thaddée Klossowski, son of the painter Balthus (in 1977), and went on to design textiles for Halston and Giorgio di Sant'Angelo in New York. Her bohemian-chic style appealed to Yves Saint Laurent, and in 1972 he hired her to work in his studio. She remained a loyal partner until the closure of the fashion house. "We lived together for thirty years. I saw him more than any other person," she recalls.[2] Yves Saint Laurent described Loulou thus: "Her haughty, aristocratic bearing in no way diminishes the aura of dark sensuality that surprises, intrigues, captivates, disturbs."[3]

FRANÇOISE GIROUD — The writer and journalist Françoise Giroud was a prominent figure in the French political arena in the 1970s. In 1953 she founded the magazine *L'Express* with Jean-Jacques Servan-Schreiber, before being appointed minister of women's affairs. The author of numerous novels, biographies, and television programs, in 1958 she coined the expression "*nouvelle vague*" to describe the new movement in French cinema. A loyal customer of Saint Laurents, Giroud wore ensembles that were adapted to the daily life of a busy working woman. For evening events, she often wore the most talked about creations in the collection, such as the embroidered fringed suede dress (CAT. 70).

NAN KEMPNER — Nan Field Schlessinger, the rich heiress of a San Francisco family and wife of Thomas L. Kempner, embodied American elegance to perfection. Diana Vreeland singled her out in the following terms: "There's no such a thing as a chic American woman. The one exception is Nan Kempner."[4] In the course of her life Nan Kempner collected 1,000 dresses, including 376 by Saint Laurent. Among them were the most iconic creations of her favorite designer. She said of him, "I don't think there's a woman in the world who hasn't been influenced by him."[5] Her choices reflect a subtle blend of European sophistication and American chic. Pierre Bergé would say of her, "Nan Kempner was loyal to Saint Laurent as a woman is faithful to her lover."[6] For all these reasons, the Fondation Pierre Bergé–Yves Saint Laurent devoted an exhibition to her in 2007, following the show "Nan Kempner: American Chic" held at the Metropolitan Museum of Art, in New York, in 2006.

PATRICIA LOPEZ-WILLSHAW — Patricia Lopez-Huici, wife of the Chilean Arturo Lopez-Willshaw, was famous for her elegance and beauty. Her husband had made a considerable fortune from guano in South America. Just after the war, the trio of Patricia, Arturo, and his protégé, Alexis von Rosenberg, Baron de Redé, sailed the Mediterranean on board the yacht *Gaviota*. At his home on rue de la Ferme, Neuilly, near Paris, Arturo Lopez collected extremely rare eighteenth-century furniture and objects made of rock crystal. He was a sponsor of the Château de Versailles. In 1962 he died, leaving half his fortune to his wife and the other to Alexis. The same year, Patricia Lopez-Willshaw had become Yves Saint Laurent's first customer; her dress bore a label with the number 00001. It was delivered to her before Saint Laurent's fashion show in January 1962.

PRINCESS GRACE OF MONACO — Grace Kelly began her brilliant cinema career in 1950. She became the iconic actress of Alfred Hitchcock, playing in three of his films: *Dial M for Murder*, *Rear Window*, and *To Catch a Thief*. In 1956 her fairy-tale wedding to Prince Rainier II of Monaco delighted the world. Princess Grace gave up her film career and turned the principality into an international hub of society life and the arts. Her elegant style was influenced by both American and European tradition and was perfectly reflected in her choice of Yves Saint Laurent designs.

PALOMA PICASSO — The daughter of Pablo Picasso and Françoise Gilot, Paloma Picasso said about her relationship with Saint Laurent, "My affinity with Yves is of an aesthetic order. Of course, I love him enormously, but the aesthetic side is, I feel, just as strong. There is a real convergence between what I tend to wear and what he tends to design."[7] From 1968 Paloma Picasso began to create costumes and jewelry with objects she found in flea markets. She went on to design jewelry for Yves Saint Laurent and for Tiffany & Co. Saint Laurent recognized her influence on his work: "Paloma Picasso is the very example of a certain elegance arising out of both rigor and audacity, of innovations and style." It was the "flea-market" look that Paloma invented, using turbans, fur boleros, and dresses from the 1930s and 1940s, that inspired his designs for the famous Spring–Summer 1971 collection.

COMTESSE JACQUELINE DE RIBES — Marcel Achard compared the countess to the queen Nefertiti. Yves Saint Laurent admired her like "the pearl in the ear of the king of Poland, the Queen of Sheba's emerald, the crescent of Diane of Poitiers, the Ring of the Nibelung."[8] From the launch of the couture house in 1962, the young wife of banker Edouard de Ribes was cited among its prestigious customers, along with Lee Radziwill, Patricia Lopez-Wilshaw, and Lady Duff Cooper. In New York she was noticed by Diana Vreeland, who published a photograph of her by Richard Avedon in American *Vogue*, leading to her entry at a young age on the International Best-Dressed List.

Above, left — Princess Grace of Monaco, c. 1956.

Above, right — Countess Jacqueline de Ribes, in a taffeta dress. Photograph by Henry Clarke.

Below, left — Paloma Picasso in an evening suit, *Vogue Paris*, December 1979–January 1980. Photograph by Horst P. Horst.

Below, right — Hélène Rochas in a black velvet dress (CAT. 10) designed for the Proust Ball, December 1971. Photograph by Cecil Beaton.

Above, left — The Duchess of Windsor, in a dress by Elsa Schiaparelli, 1937. Photograph by Cecil Beaton.

Above, right — Elsa Schiaparelli wearing one of her designs. Photograph by George Hoyningen-Huene.

Below, left — Marie-Hélène de Rothschild in an ivory satin dress made to order for the Proust Ball, December 1971. Photograph by Cecil Beaton (CAT. 11).

Below, right — Diana Vreeland. Photograph by Jack Nisberg.

HÉLÈNE ROCHAS — Hélène Rochas married the fashion designer and perfumer Marcel Rochas in 1942. After his death in 1955, she took over the management of the house whose business was refocused on perfume until it was acquired by the German group Wella in 1987. She was a prominent figure of society life in the second half of the twentieth century, her famous beauty was only enhanced by the dresses of Yves Saint Laurent. Part of a group of the designer and Pierre Bergé's close friends, she said of Saint Laurent that he was the "only one who knew how to reconcile the creative spirit of Haute Couture and that desire for simplification that is typical of the modern woman. . . . For a fashion designer, the hardest thing is not to add a bit of embroidery here, a print there. The hardest thing is to limit oneself."[9] For many, Hélène Rochas was a model of beauty, refinement, and elegance.

MARIE-HÉLÈNE DE ROTHSCHILD — The daughter of Baron Egmont Van Zuylen de Nyevelt de Haar, a Dutch diplomat, Marie-Hélène de Rothschild spent her youth in New York. She married Comte François de Nicolay but divorced in 1957 and married her distant cousin Baron Guy de Rothschild, the senior member of the French branch of the banking family. In 1959 Marie-Hélène de Rothschild gave a new lease on life to the Château de Ferrières, a family estate that had remained unoccupied since the war. In this fine setting the couple held memorable parties attended by members of the nobility, jet-set Hollywood stars, and celebrities from the worlds of art and fashion. At the Proust Ball celebrating the one hundreth anniversary of the writer's birth, Cecil Beaton took photographs of the guests in their belle époque–style dresses. After the Château de Ferrières was donated to the state in 1975, Baron de Rothschild purchased the Hôtel Lambert mansion on the Ile Saint-Louis in central Paris. The soirées and costume balls started up again, with guests including the Duchess of Windsor, Princess Grace of Monaco, Elizabeth Taylor, Rudolf Nureyev, Andy Warhol, and everyone who was anyone. Pierre Bergé and Yves Saint Laurent were regular members of this glittering circle. In the 1990s, Marie-Hélène de Rothschild retired from society life, gravely ill. Yves Saint Laurent, since 1962, had created all of her dresses for the parties and balls she hosted, including the gold-embroidered long dress (CAT. 71).

ELSA SCHIAPARELLI — History has labeled Elsa Schiaparelli a "surrealist" fashion designer. Her designs of the interwar period, inspired by her friendships and work with surrealist artists and writers, were far removed from the very neoclassical leaning of fashion at the time. She lived a flamboyant life with all the intensity of the color that is associated with her, shocking pink. Yves Saint Laurent paid tribute to her work in several designs. He shared her taste for ornament and bold colors like the famous pink. When she closed down her fashion house in 1954, "Schiap" dressed in Yves Saint Laurent, finding in the young designer a sensibility that resembled her own. The feather-trimmed panne velvet coat she ordered in 1969 shows that she remained a figure of high fashion.

NOTES

1 — Quoted in "The Saints Come," *Women's Wear Daily*, September 13, 1968.

2 — Interview with Loulou de la Falaise, October 9, 2009.

3 — Undated manuscript, Fondation Pierre Bergé–Yves Saint Laurent.

4 — Website of Metropolitan Museum of Art, New York. Text on exhibition "Nan Kempner: American Chic," 2006.

5 — Nan Kempner in "The YSL Revolution," *Harper's Bazaar*, September 1994.

6 — Nan Kempner, *An American in Paris*, catalog of the exhibition by the Fondation Pierre Bergé–Yves Saint Laurent, Paris, May 16–July 29, 2007.

7 — Javier Arroyuelo, "Tribute to Yves," *Vogue Italia*, March 1993.

8 — Undated manuscript, Fondation Pierre Bergé–Yves Saint Laurent.

9 — Danielle Bott, "Les carnets de mode d'Hélène," *Vogue* Paris, December 1995.

10 — Quoted by Diana Vreeland, in exhibition catalog *Yves Saint Laurent*, The Metropolitan Museum of Art, New York, 1983.

DIANA VREELAND — The influential fashion editor of *Harper's Bazaar* magazine from 1937 to 1962, Diana Vreeland went on to leave her stamp on *Vogue* as editor in chief from 1963 to 1971. Her elegance and knowledge of fashion were legendary. In 1937 Carmel Snow, the editor in chief of *Harper's Bazaar*, had noticed the stylish young society girl, wife of the banker Thomas Reed Vreeland, and introduced her into the world of the media. Having become fashion adviser for the Costume Institute at the Metropolitan Museum of Art, Vreeland invited Yves Saint Laurent to mount his first retrospective show in 1983. For the opening evening, she wore the gold-embroidered gazar suit with pagoda shoulders. In the catalog introduction, she wrote: "Yves Saint Laurent has a fifty-fifty deal with the street. Half of the time he is inspired by the street and half of the time the street gets its style from Yves Saint Laurent."[10]

THE DUCHESS OF WINDSOR — In 1936 the proposed marriage of Wallis Simpson, a twice-divorced American, to King Edward VIII caused a scandal and a constitutional crisis. The king finally abdicated in order to marry Wallis in 1937. The Duke and Duchess of Windsor subsequently devoted themselves to a lifestyle of refinement that fascinated their contemporaries. Their elegance was frequently covered by magazines. Besides the couture house Mainbocher, the duchess favored bold designers such as Elsa Schiaparelli in the 1930s, and in the 1960s she wore the most innovative designs by Yves Saint Laurent, such as the patchwork-inspired ensemble (CAT. 72).

MASTERPIECE THEATER: YVES SAINT LAURENT'S SHOWS OF ADMIRATION

FARID CHENOUNE INTERVIEWS
BERNARD BLISTÈNE, DIRECTOR OF CULTURAL DEVELOPMENT
AT THE POMPIDOU CENTER, PARIS

Air France Madame (AFM): What was the first painting you bought?

Yves Saint Laurent (YSL): The first "real" one was a Mondrian.

AFM: And the most recent?

YSL: A Marcel Duchamp.

[. . .]

AFM: Why did you decide to pay direct tribute to the masters you so admire, such as Matisse, Mondrian, van Gogh, Bonnard, and Picasso?

YSL: Because I've always felt a strong, if modest, connection between their art and my own work.

AFM: Could you explain *why* you like each one of them, the deep connections you feel with each?

YSL: No.

Air France Madame, August–September 1990

FARID CHENOUNE (FC) — When people talk about Yves Saint Laurent's relationship, as a fashion designer, to art, they often use the words "dialogue" and "tribute": his running "dialogue" with art and his "tributes" to various artists. Two periods in Saint Laurent's forty-year career were particularly fertile. The first went from 1965 to 1969 and was marked by Pop art, Mondrian, Poliakoff, Wesselman and the Lalannes. Plus the "African" dresses inspired by Bambara art, which featured in the Spring–Summer 1967 collection. The second period occurred much later, in 1979, and ran through the 1980s—Picasso in 1979, Cocteau, Apollinaire, and Aragon in 1980, Matisse in 1981, and Braque in 1988, to mention just those artists. But between 1969 and 1979, ten years went by without a collection that had any significant impact on this dialogue. Other things were happening: the rise of Yves Saint Laurent Rive Gauche, the "Forties" collection, the shows devoted to the Ballets Russes and exotic fashions. Which didn't mean that Saint Laurent didn't also continue, during these years, to design dresses with skillful effects that reflected paintings by artists whom he considered to be his own old masters: Vermeer and—when it came to his Spanish collection—Velázquez and Goya, and then Ingres and Delacroix when it came to Oriental inspiration. He used to say, "You'll always find an infanta or maja lurking in my collections." Still, that period didn't have the spectacular intensity of the Mondrian and Pop Art years, or of the major tributes in subsequent years.

Let's start at the beginning, with the dress that triggered this dialogue: the "Mondrian" dress featured in the Fall–Winter 1965 collection. It would become Saint Laurent's best known garment, the one most often pictured all over the world, along with *le smoking*, his ladies' tuxedo. The "Mondrian" was his best known garment, but least worn. To appreciate the significance of Saint Laurent's initiative, could we set it in context? Who was Piet Mondrian in 1965, and *why* Mondrian?

BERNARD BLISTÈNE (BB) — First of all, the crucial thing to stress, as surprising as it may have seemed twenty years after his death in 1944 (he was born in 1872), is that Piet Mondrian was completely unknown in such circles in the 1960s—at least in France. True, there had been a few shows of his work,

Right — Piet Mondrian (1872–1944), *Composition with Blue, Red, Yellow, and Black*, 1922, oil on canvas, 79.6 x 49.8 cm. © Mondrian/Holtzman Trust c/o HCR International, Virginia, USA

notably at the René Drouin gallery in 1945 and the Denise René gallery in 1957. Also true, Michel Seuphor had written a major monograph on Mondrian that was reprinted several times. But it was not until the big retrospective at the Orangerie in 1969 that Mondrian was finally recognized and acknowledged by a wider audience. In other words, in 1965 he remained completely outside any domestic debate on art in France. His work was not to be found in French public collections, which at that time favored what is called "the school of Paris." Saint Laurent's designs then included a few "kinetic" dresses, but they reflected the fashion of the day and in no way had the manifestolike impact of the first "Mondrian" dress. So there was something very bold about Saint Laurent's appropriation of an abstract painting by Mondrian back in 1965. Today, for those of us who consider Mondrian to be one of the greatest of modern painters, Saint Laurent's initiative remains absolutely unique. He was directly asserting his desire to face up to the key artists of modernism. He who always seemed like the last of the grand couturiers perceived Mondrian as the last of the grand painters, the one who refined painting to its essential elements—or maybe we should say the *first* grand painter because from that point painting could begin again from scratch.

"That tribute was more than just a polite nod—it was a thunderbolt, the sign of a total change in direction. Saint Laurent's relationship to fashion and to his own creative work would never be the same. What's more, by his own admission those Mondrian dresses are the things he remains most proud of: 'Not because of the fashion they created, which traveled all around the world, but because those dresses helped to make the general public aware of a tremendous yet forgotten artist, the twentieth-century artist who, in my opinion, came the closest to purity.'"
Olivier Séguret, *Air France Madame*, August–September 1990

FC — So how should we understand his "tribute" to Mondrian?

BB — Several things should be emphasized. First, we should remember that Mondrian's "neo-plasticism" involved reducing his paintings to a black-and-white grid plus the three primary colors—red, yellow, and blue. We should also remember that the structuring principle behind a Mondrian painting was vertical versus horizontal, even if that structure was sometimes diagonally rotated onto one corner. Finally, we should remember that going from a canvas to a dress meant going from flat plane to full volume, from a surface art to an art of the body and the envelope sheathing it. Saint Laurent wasn't copying—he didn't put a painting on a dress. He explored variations *based* on Mondrian. Variations of blues, for instance, that you won't find in Mondrian's work. Or variations on Mondrian's grids and structure. Or variation on line, notably by reintroducing curves in round necklines, sometimes underscored in black. His dresses always remained dresses, they never became paintings or pastiches of painting.

FC — The various "panels" and lines on those jersey dresses were sewn in, it wasn't just a question of printing.

BB — Therein perhaps lies the secret of his work "on" or "with" Mondrian—I'm not sure which preposition to use. Mondrian's geometry rid him, freed him, from what Adolf Loos in the early twentieth century called the problem of "ornament and crime," the crime being excessive decoration. By turning to Mondrian, Saint Laurent was able to shift his own work into the sphere of the fine arts, which, in a certain way, forced him to confront absolutes.

FC — You mentioned kinetic art and the school of Paris, but the mid-1960s were also the days of Pop art. Just a year after his "Mondrian" and "Poliakoff" dresses, Saint Laurent's Fall–Winter 1966 collection included his "Wesselman" dresses. His tributes to Pop art didn't contain any explicit "Warhol" dresses, but Andy Warhol's presence was nevertheless distinctly felt, though in a ghost-like way.

BB — Steven Koch, a Warhol exegete, dubbed him the "ghost of the media machinery." Saint Laurent always displayed an obvious interest in Warhol, for countless reasons that would require an entire book and exhibition. And the reverse was true, as I can attest. Pop art was a movement that preyed on the consumer society, which supplied it not only with the imagery for its output but the very principle behind that output, namely repetition, mass production, distribution. Warhol's works were produced using the principles of silk screening. All this background is important, I feel, for a broader understanding of Saint Laurent's consistent interest in ready-to-wear fashion and his almost utopian vision of it. Nor should we forget that Warhol's early works entailed fashion drawings and shoes, the famous *A la Recherche du Shoe Perdu*. Before he became a painter, Warhol was a decorative artist. And I'm convinced that he always remained one.

FC — Since we've mentioned the "decorative arts," at that time there was still the hard-and-fast distinction between "fine art," on the one hand, and the decorative and applied arts, on the other, which included fashion design and haute couture. Warhol overtly straddled that border and then trampled it. What about Saint Laurent?

BB — To answer that question, we have to make a small digression via another artist at the heart of this story, namely Matisse. Some of Saint Laurent's finest shows of admiration were directed at Matisse.

FC — Such as the collections in Fall–Winter 1980 and Fall–Winter 1981.

BB — Saint Laurent's fascination with Matisse was shared by Warhol. Wesselman, too, obviously. We tend to think of Pop art in terms of neo-Dada, an iconoclastic, destructive movement that attacked the consumer society. But it also had fundamental links to Matisse and painting. Despite appearances, Warhol is probably responsible for that link.

FC — What do you mean?

BB — The connection stems first of all from the amazing recognition Matisse enjoyed in the United States from the interwar period onward. I'm thinking above all of the considerable influence his "paper cutouts" had on the American avant-garde movements of the 1950s. And to be even more specific about the "decorative" side, there were the Matisse odalisques that he himself dubbed "decorative figures," for example, *Decorative Figure on an Ornamental Background*. That was back in the 1920s, in the days of the 1925 Art Deco exhibition, devoted precisely to "the decorative *and* industrial arts!" This *and* clearly raised the question of production, a question that every fashion designer faces. Matisse was the first of his day to adopt this position, to cross the line between an art that raises questions and the decorative arts that resolve them. Warhol also adopted this position. Saint Laurent, in turn, tried to go beyond the dichotomy. Don't forget that back in the 1960s he was living through another contemporary artistic breakthrough, one that sought to undermine the distinction between art and life, namely the birth of more or less spectacular "performance art" in which the body played a major role, just as it played an equally fundamental role in the design and execution of Saint Laurent's garments. For that matter, maybe the crux of Saint Laurent's work was his way of giving birth to a body just asking to exist.

FC — Saint Laurent didn't participate in performances, though.

BB — True, but more than anybody else at the time he sought to instill much-needed drama, not only through the ritual of a fashion show but also through his constant attachment to all forms of theater. He contributed to Zizi Jeanmaire's revues, he designed countless stage sets and theater costumes, and he constantly referred to his first formative artistic jolt on seeing [Molière's play] *School for Women* in Oran as a teenager. Behind all that, I feel there must have been the appeal of—an obsession with—the idea of a total artwork.

FC — In addition to Matisse, the 1980s witnessed the blossoming of a second wave of tributes: to Picasso, Léger, the cubists, Braque, Van Gogh, and so on. It even included writing, both as calligraphy and as literature. There were tributes to Aragon, Apollinaire, Cocteau—

BB — Cocteau! He was another protagonist in this story, someone who was also pilloried for having so conspicuously combined high art with the decorative arts. Saint Laurent could hardly remain indifferent to Cocteau's distinctive line, drawing, writing, and overall stance, to say the least.

"'Number 56, number 56,' announced the same soft, serious voice, without a trace of astonishment. But it was as though an electric shock riveted the audience to the back of its chairs. Short evening ensemble, sequin-embroidered jacket, lichen-colored suede skirt—followed by 57, 58, 59, 60, 61, and all the others as suit jackets edged with cubist motifs steadily invaded the runway. These paintings by Braque, Miró, and Gris, magically brought back to life,

were greeted with shouts of 'Bravo! Bravo!' The audience stood and applauded right down to the final tableau—a white bridal mini gown a-flutter with doves. The master enjoyed himself by startling us, amazing us, taking our breaths away, nailing us to our red-velvet chairs. The catwalk pranced with a clutch of white doves, with slinky décolleté, with majestic chiffons in navy, tobacco, and gray, with a sapphire blue gown held in the beak of a bird, with embroidered versions of van Gogh's sunflowers and irises, and with cubist violins that flared from both sides of impeccable, impertinent jackets. A rigorous architecture that played on imbalance, yet recovered with quiet grace."

Katerine Pancol, *Paris Match*, February 12, 1988

———————————

FC — To return to his series of tributes in the 1980s, how do you think we should interpret them?

BB — We're a long way from Mondrian. Saint Laurent's oeuvre was marked by breaks, as are all artist's oeuvres. These tributes were wonderful way stations on a quest that always haunted Saint Laurent, the quest for beauty. It was here that he returned to the idea of a unique item. Saint Laurent even went beyond the unique garment in the sense that haute couture gives it—they were no longer dresses and garments, they were, how can I put it? Maybe *costumes*. Costumes that embody the dream of the theater and the total artwork we just mentioned. They lent his fashion shows the quality of a ceremony, a procession. It had already been present in the Mondrian dresses because they, too, were unique. But it was even more marked, theatrical, and evident in the designs of the tributes of the 1980s. Those designs were votive offerings. At a time when the likes of van Gogh, Mondrian, Braque, and Picasso were known more for reproductions in books and posters than for an experience of the original, Saint Laurent pulled off an amazing turnaround. By drawing them into his pantheon, he once again emphasized the unique dimension of works endlessly popularized through reproductions.

FC — The time when Saint Laurent was elaborating this pantheon was also the period when he intensified his endless focus on what he called "the essentials," the key garments in his pantheon of clothing.

BB — Pierre Bergé's quip is well known: "I don't think fashion is an art, but it takes an artist to create it." Which makes me think of another quip, one by Marcel Duchamp, which went something like, "Can you produce a work that *isn't* art?" Bergé and Saint Laurent were fully aware of Duchamp's impact, and they even owned his famous *Eau de Voilette*. "To produce a work that isn't art" is ultimately what happened to Yves Saint Laurent.

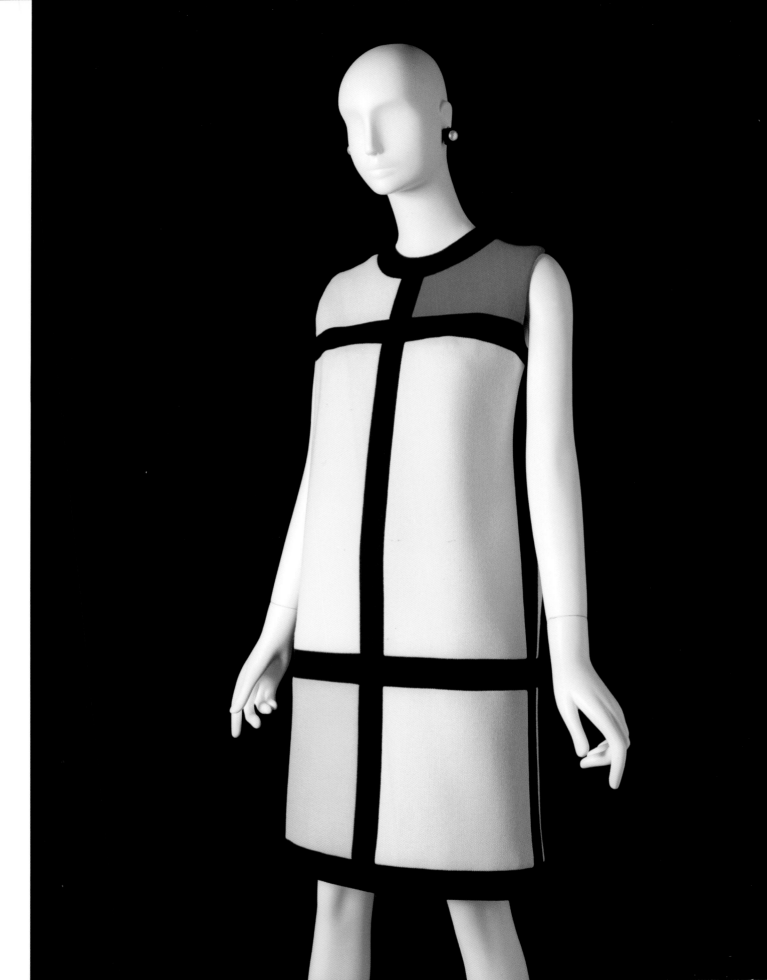

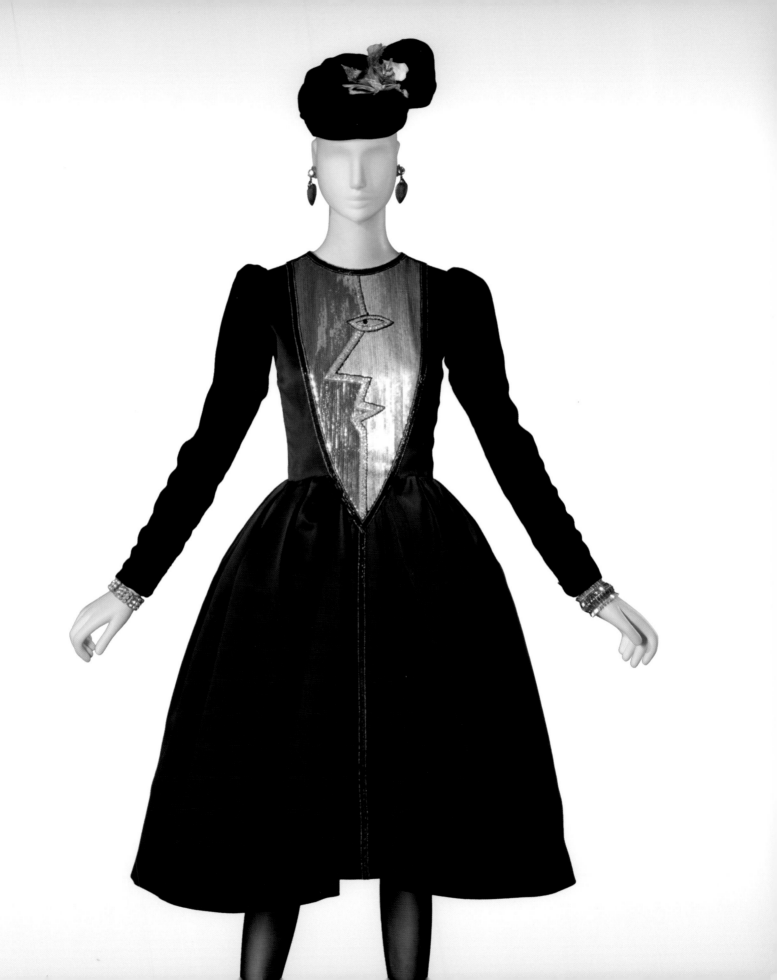

Left — Senufo bird, Ivory Coast, late nineteenth century, Yves Saint Laurent and Pierre Bergé Collection.

Opposite — Twiggy in an embroidered brown organza Bambara dress, Spring–Summer 1967 haute couture collection, American *Vogue*, March 1967. Photograph by Bert Stern.

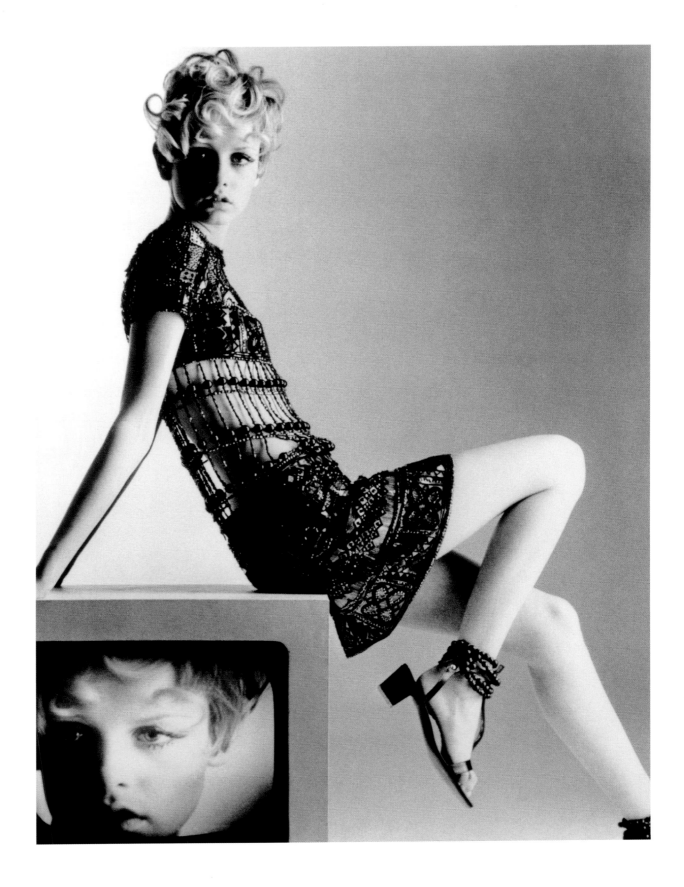

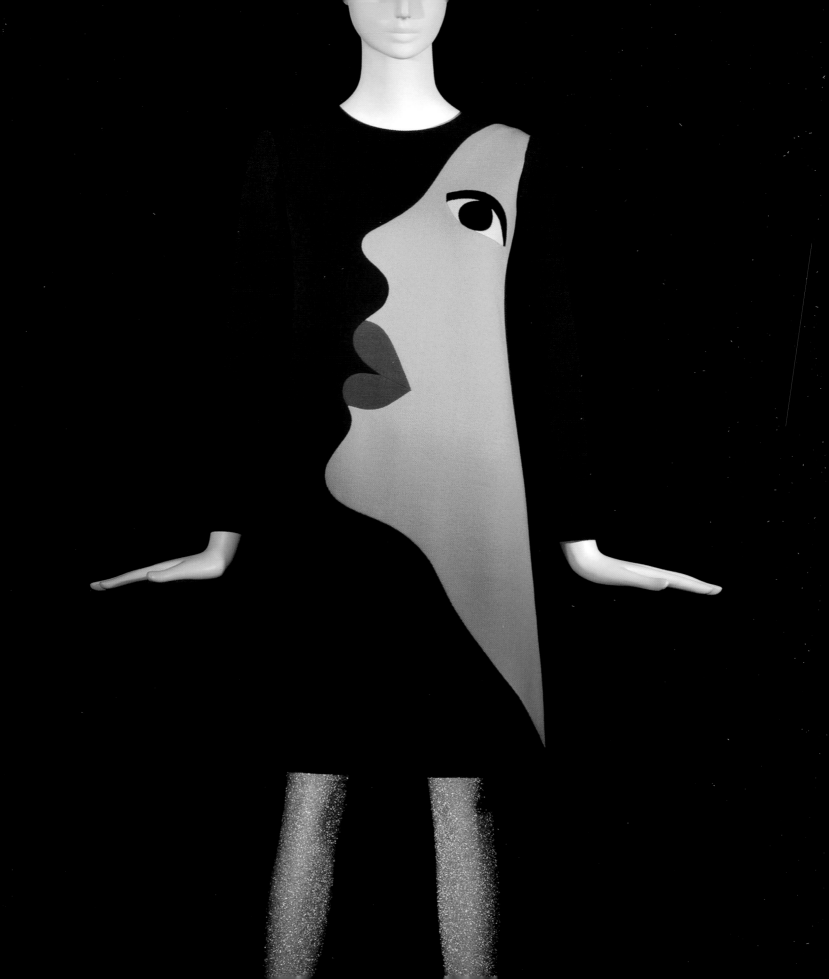

Opposite — Fall–Winter 1966 haute couture collection, tribute to Tom Wesselmann (CAT. 173).

Right — Cover of *Life*, September 2, 1966, purple-and-pink jersey dress, Fall–Winter 1966 haute couture collection. Photograph by Jean-Claude Sauer.

Pages 322–323 — Spring–Summer 1988 haute couture collection, tribute to Vincent van Gogh (CAT. 176 and 177).

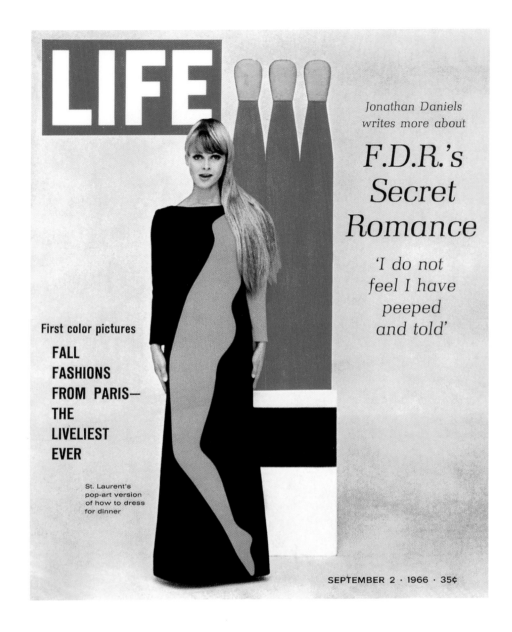

LIFE

First color pictures

FALL
FASHIONS
FROM PARIS—
THE
LIVELIEST
EVER

St. Laurent's
pop-art version
of how to dress
for dinner

Jonathan Daniels
writes more about

F.D.R.'s
Secret
Romance

'I do not
feel I have
peeped
and told'

SEPTEMBER 2 · 1966 · 35¢

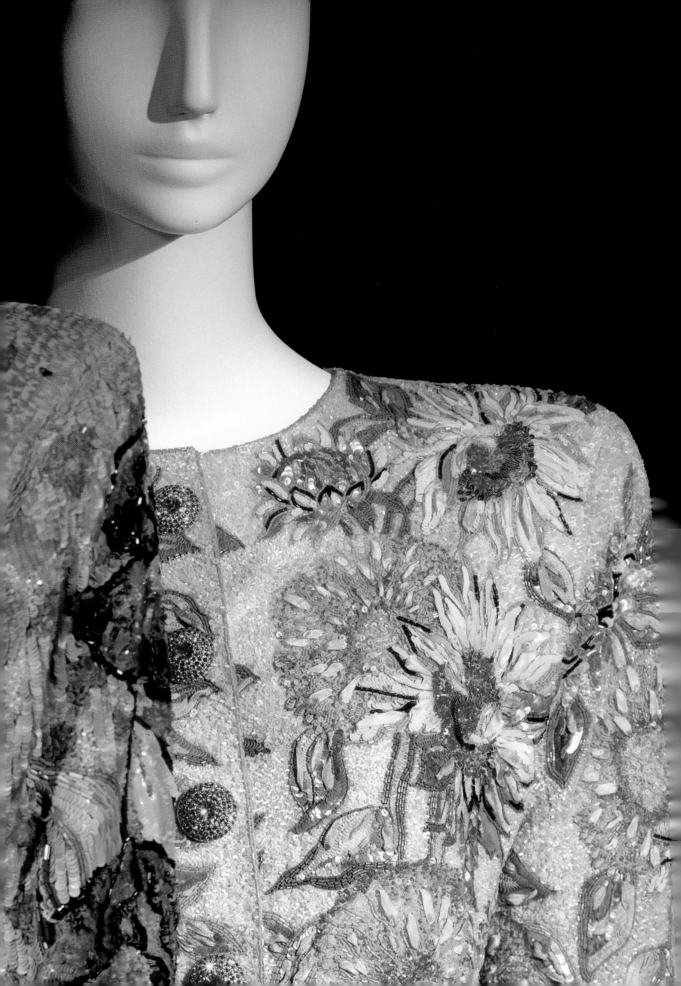

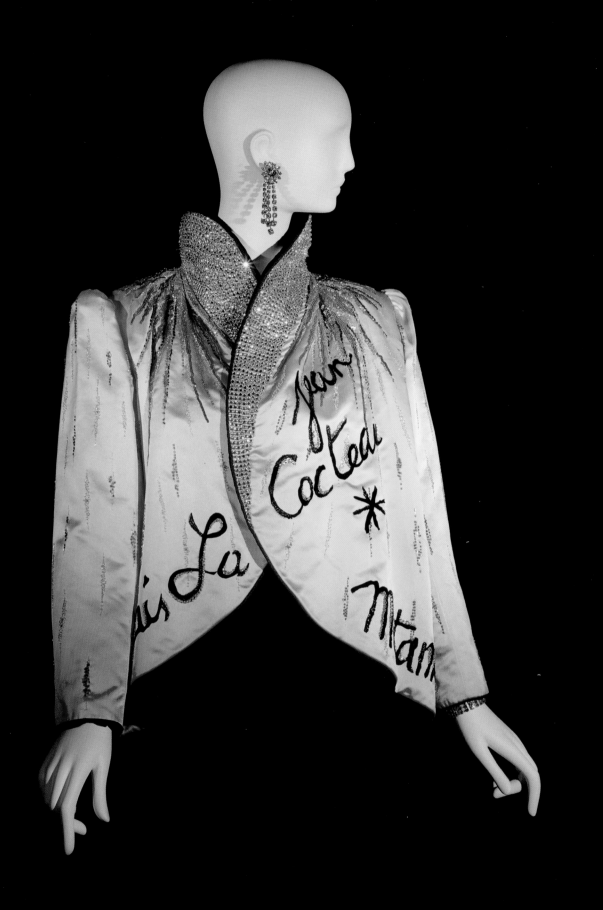

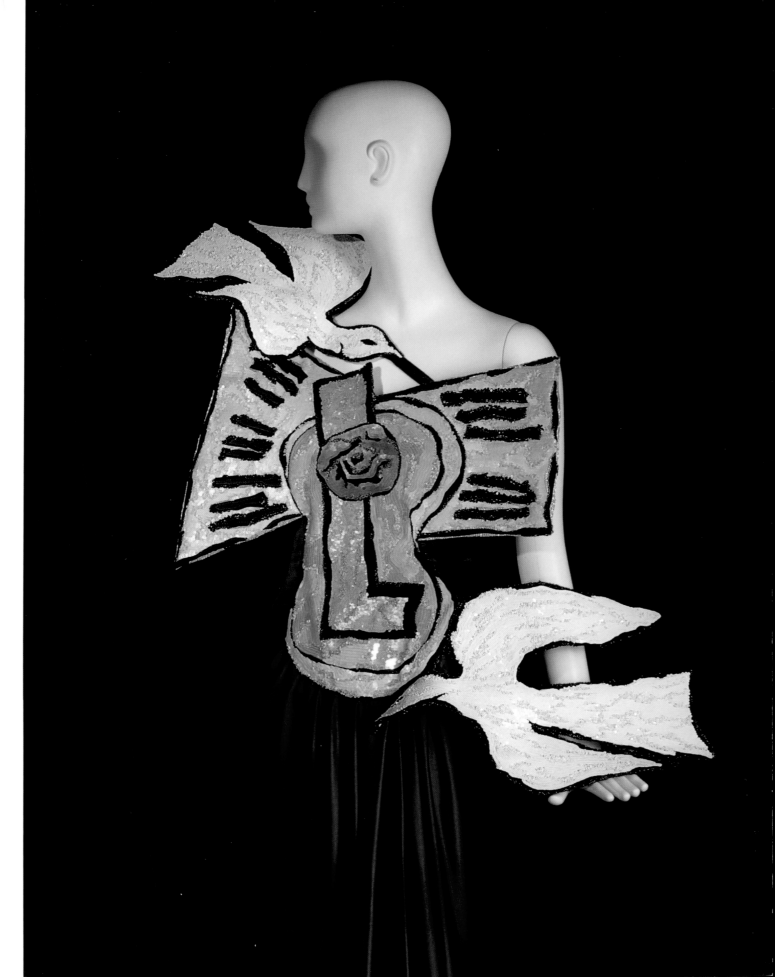

Page 324 — Fall–Winter 1980 haute couture collection, tribute to Jean Cocteau (CAT. 180).

Page 325 — Spring–Summer 1988 haute couture collection, tribute to Georges Braque (CAT. 191).

Right — Yves Saint Laurent and Carla Bruni in a wedding dress, tribute to Georges Braque, Spring–Summer 1988 haute couture collection, 5 avenue Marceau. Photograph by Jean-Marie Périer, 1998.

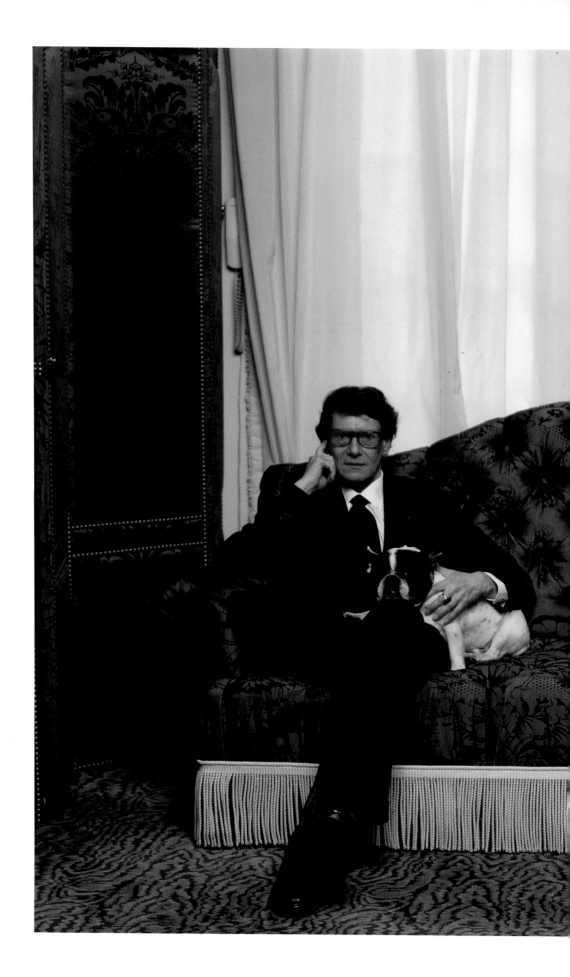

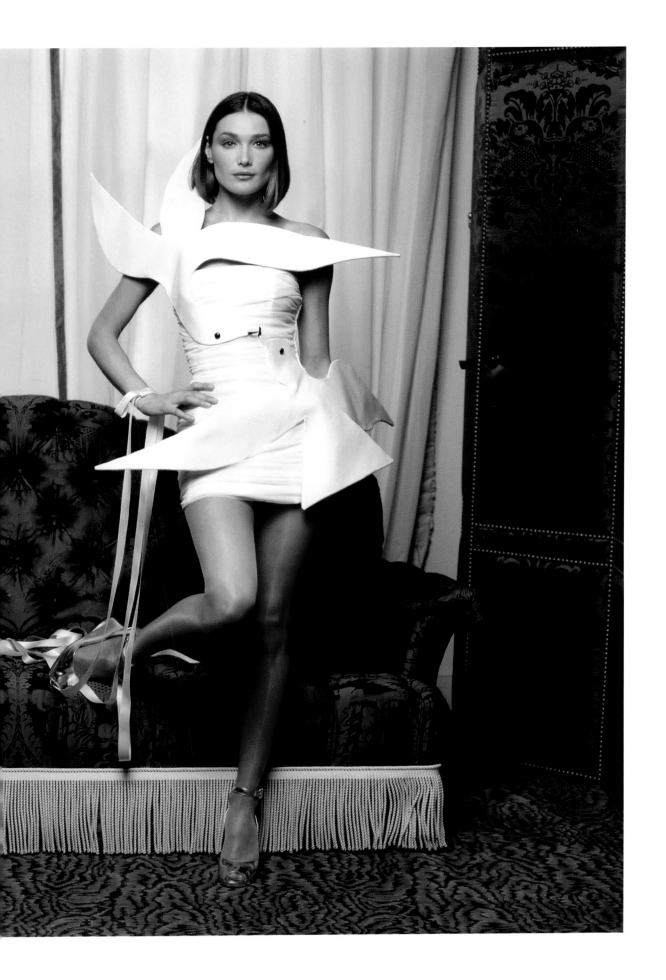

I LOVE BLACK BECAUSE
IT AFFIRMS, DESIGNS,
AND STYLES. A WOMAN
IN A BLACK DRESS IS
A PENCIL STROKE.

ELLE, SPRING–SUMMER 1968

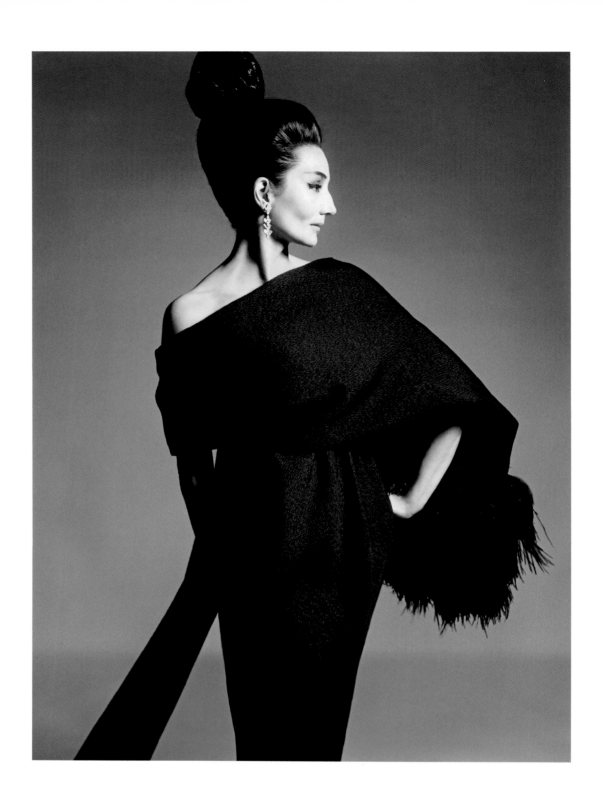

BLACK IS A COLOR.
IT'S THE STROKE OF
A PENCIL DRAWING AN
OUTLINE ON A BLACK
SHEET OF PAPER.
BLACK IS THE COLOR
OF A RENAISSANCE
PORTRAIT, THE COLOR
OF CLOUET, AGNES
SOREL, THE COURT OF
VALOIS, FRANS HALS,
AND MANET.

YVES SAINT LAURENT

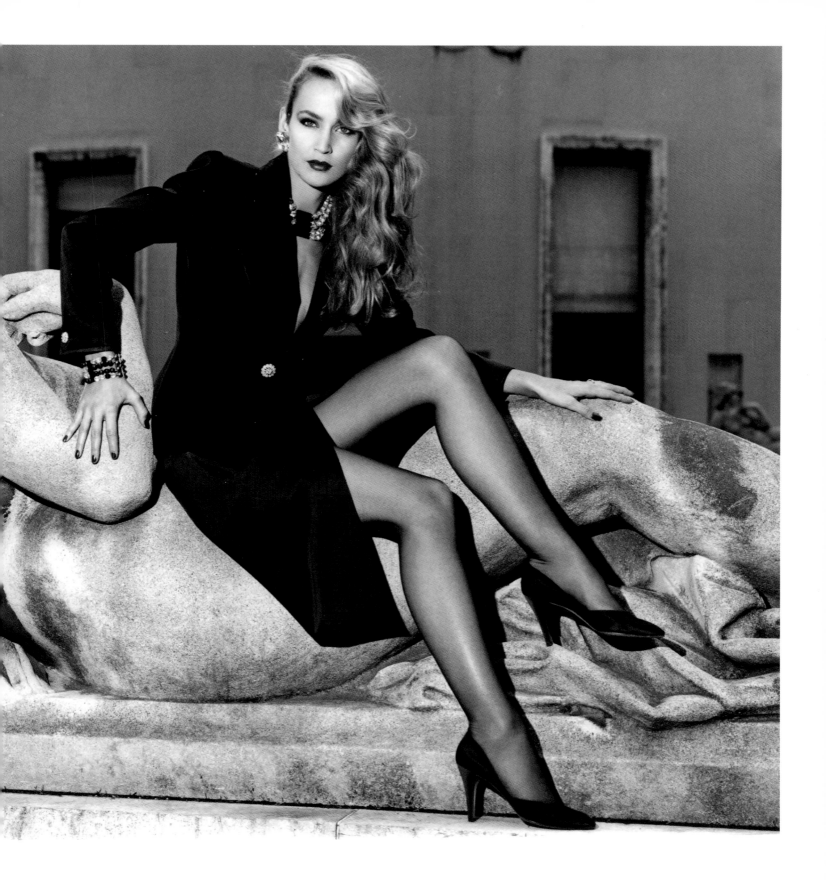

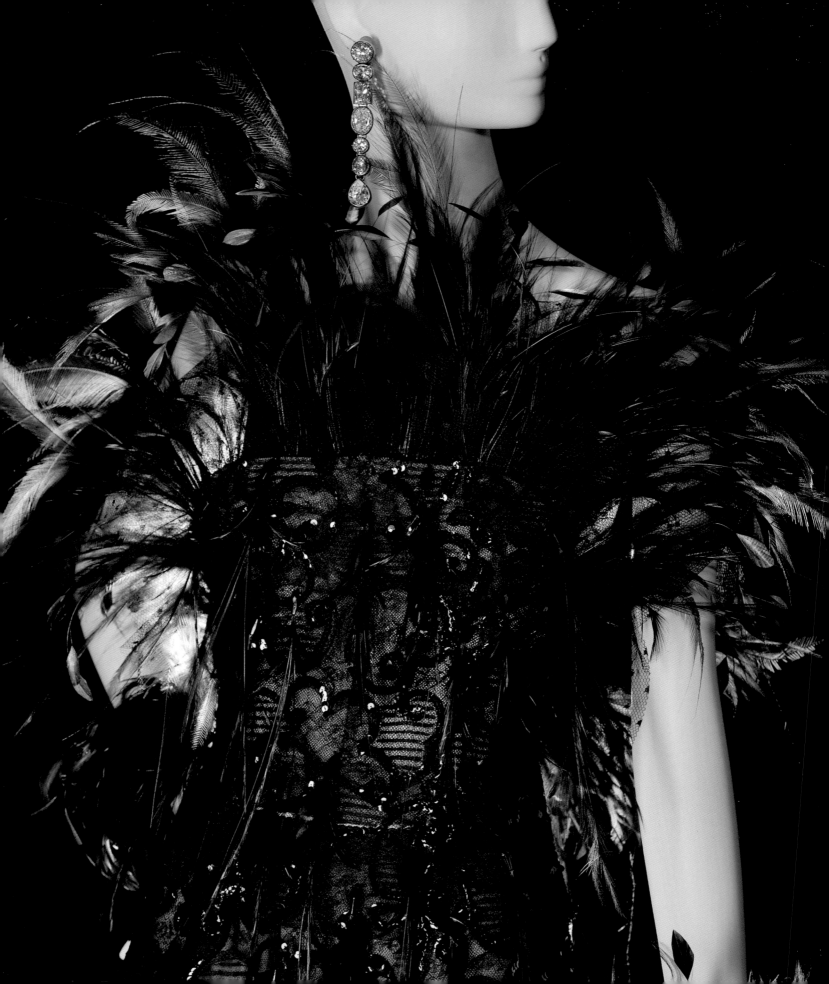

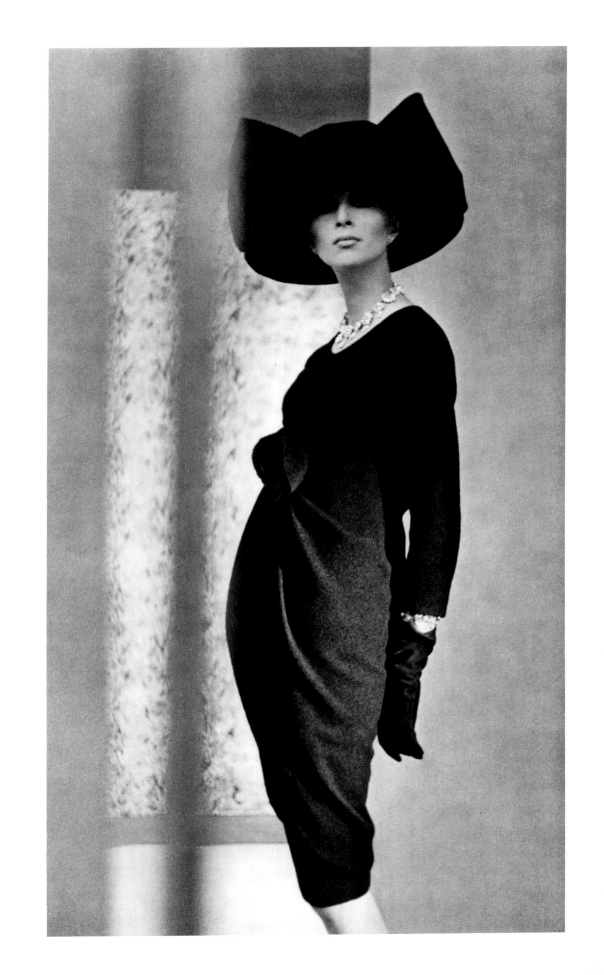

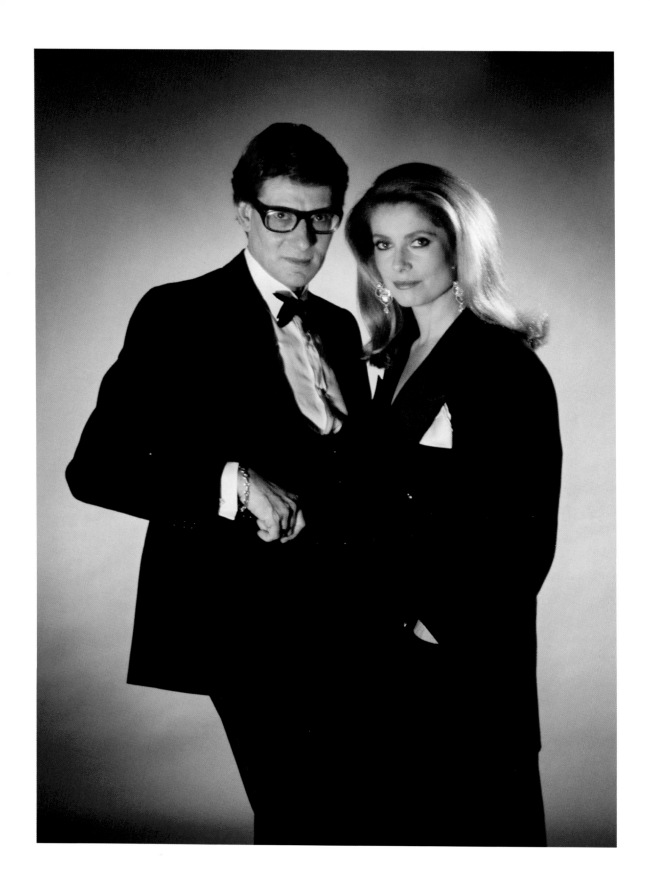

Page 331 — Card with black samples, from one of the color files assembled over the years by the Yves Saint Laurent studio.

Page 332 — Viscountess Jacqueline de Ribes, Paris, July 31, 1962. Photograph by Richard Avedon.

Page 334–335 — Jerry Hall in a black satin suit, Saint Laurent Rive Gauche collection, *Vogue Paris*, August 1983. Photograph by David Bailey.

Page 336 — Fall–Winter 2000 haute couture collection (detail of CAT. 237).

Page 337 — Draped wool dress and velvet hat, Fall–Winter 1962 haute couture collection, *L'Officiel de la Couture*, October 1962. Photograph by Pottier.

Opposite — Yves Saint Laurent and Catherine Deneuve in tuxedos, 1982. Photograph by Helmut Newton. Photograph taken on the occasion of the twentieth anniversary of the haute couture house.

ILLUSTRATED CATALOG
OF EXHIBITED WORKS

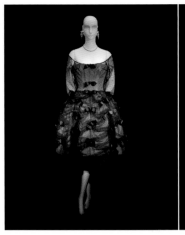
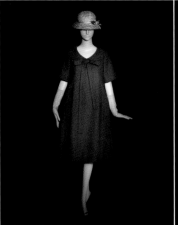
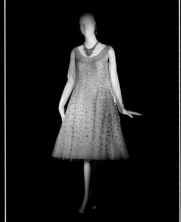
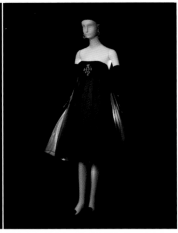

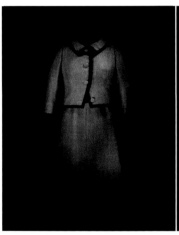
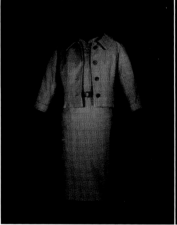
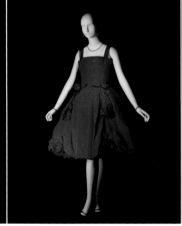

1 Short cocktail dress

"Trapeze" haute couture collection Spring–Summer 1958, *Bal masqué* [Masked Ball] design

Black point d'esprit tulle with jet sequins

HC58E001

Yves Saint Laurent for Christian Dior

2 Short daytime dress

"Trapeze" haute couture collection Spring–Summer 1958, *Bonne Conduite* [Good Behavior] design

Granite-effect gray wool

HC58E003

Yves Saint Laurent for Christian Dior

3 Short evening dress

"Trapeze" haute couture collection Spring–Summer 1958, *Valse* [Waltz] design

White silver-sequined tulle

HC58E004

Yves Saint Laurent for Christian Dior

4 Short evening dress

"Trapeze" haute couture collection Spring–Summer 1958, *Nuit* [Night] design

White organza overlaid with navy chiffon

HC58E005

Yves Saint Laurent for Christian Dior

5 Suit with short skirt

"Trapeze" haute couture collection Spring–Summer 1958, *Parc Monceau* design

Black-diamond-and-white tweed

HC58E006

Yves Saint Laurent for Christian Dior

6 Suit with short skirt

"Trapeze" haute couture collection Spring–Summer 1958, *Bobby* design

Gray-and-black-diamond Prince of Wales check

HC58E007

Yves Saint Laurent for Christian Dior

7 Short evening dress

"Trapeze" haute couture collection Spring–Summer 1958, *Danse* [Dance] design

Pink faille, appliqué roses on pink faille

HC58E008

Yves Saint Laurent for Christian Dior

8 Short daytime ensemble

"Souplesse, Légèreté, Vie" haute couture collection Fall–Winter 1960, *Chicago* design

Jacket in black-patent crocodile, trimmed with black mink; skirt in black bouclé wool

HC60H034

Yves Saint Laurent for Christian Dior

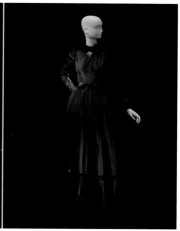

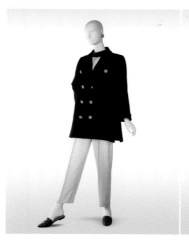
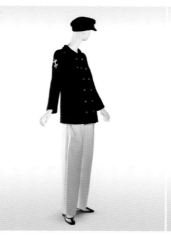
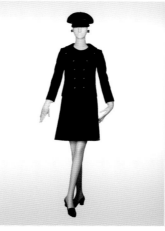
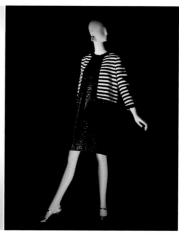

9 Dress made to order for the Proust Ball
December 1971
Ivory georgette crepe and white guipure lace, salmon pink satin belt and bow
Gift of Jane Birkin

10 Dress made to order for the Proust Ball
December 1971
Black velvet trimmed with black taffeta pleated flounce, three white silk appliqué flowers
Gift of Hélène Rochas

11 Dress made to order for the Proust Ball
December 1971
Ivory satin with three-quarter-length sleeves
Gift of Marie-Hélène de Rothschild

12 Dress made to order for the Proust Ball
December 1971
Dark green taffeta with flounces, leg-of-mutton sleeves, and belt
Gift of Nan Kempner

13 Long daytime ensemble
Haute couture collection
Spring–Summer 1962
Navy wool pea jacket; white shantung T-shirt and pants
HC62E082

14 Long daytime ensemble
Haute couture collection
Spring–Summer 1966
Navy wool jacket; white wool gabardine pants
HC66E069

15 Short daytime ensemble
Haute couture collection
Spring–Summer 1966
Navy wool jacket, top, and skirt
HC66E023

16 Short cocktail ensemble
Haute couture collection
Spring–Summer 1966
Jacket and dress with navy-and-white sequins
HC66E086

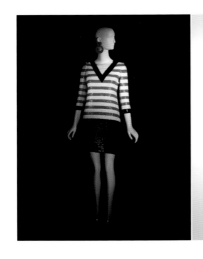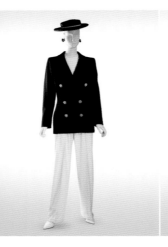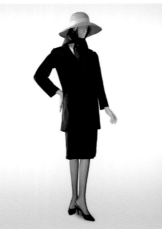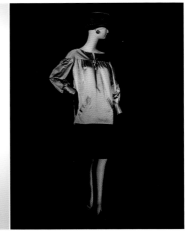

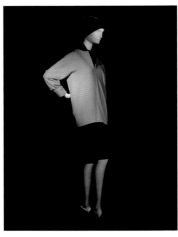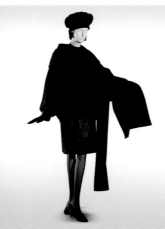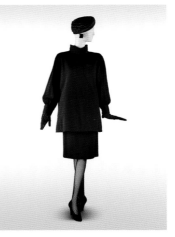

17 Short cocktail dress
Haute couture collection
Spring–Summer 1966
Tricolor sequins: red, white,
and blue
HC66E107

18 Long daytime ensemble
Haute couture collection
Spring–Summer 2001
Navy wool pea jacket;
white cotton sweater; white
canvas pants
HC01E012

19 Short daytime ensemble
Haute couture collection
Spring–Summer 1962
Black silk jersey tunic and skirt
HC62E036

20 Short evening ensemble
Haute couture collection
Fall–Winter 1962
Dressy Norman smock in pearl
gray satin; dark gray velvet skirt
HC62H106

21 Short evening ensemble
Haute couture collection
Fall–Winter 1962
Beige jersey Norman smock;
brown wool skirt
HC62H093

22 Short evening ensemble
Haute couture collection
Fall–Winter 1990
Black ribbed jersey tunic; black
embossed leather skirt
HC90H022

23 Short evening ensemble
Haute couture collection
Fall–Winter 1990
Black velvet tunic; black wool
crepe skirt
HC90H045

24 Short daytime ensemble
Haute couture collection
Fall–Winter 1985
Amaranth red tunic and skirt
HC85H025

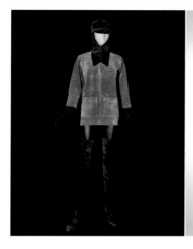
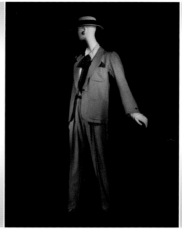
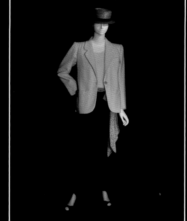
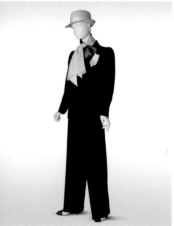

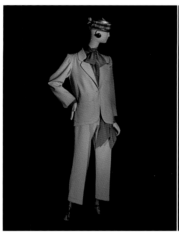

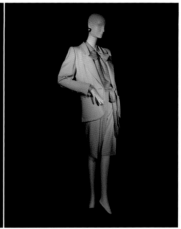

25 Short daytime piece
Haute couture collection
Fall–Winter 1963
Light brown suede tunic
HC63H116

26 Pantsuit
Haute couture collection
Spring–Summer 1967
Black wool gabardine with
white stripes; white cotton shirt;
black silk tie
HC67E001

27 Pantsuit
Haute couture collection
Spring–Summer 1978
Gray herringbone wool;
white crepe de chine blouse
HC78E002

28 Pantsuit
Haute couture collection
Spring–Summer 1979
Black gabardine with white stripes;
white crepe de chine blouse
HC79E015

29 Pantsuit
Haute couture collection
Spring–Summer 1978
Pink herringbone wool, pink crepe
de chine belt; pink crepe de chine
blouse with floppy necktie
HC78E007

30 Pantsuit
Haute couture collection
Spring–Summer 1999
Celadon gabardine; shimmering
celadon and pink chiffon blouse
HC99E020

31 Pantsuit
Haute couture collection
Spring–Summer 1978
White flannel jacket;
white wool etamine T-shirt;
navy gabardine pants
HC78E060

32 Suit with shorts
Haute couture collection
Spring–Summer 1999
Flamingo pink barathea;
ibis pink shantung blouse
HC99E025

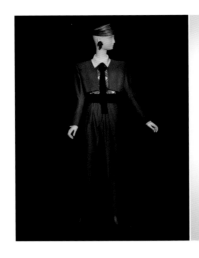
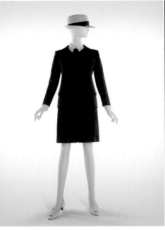
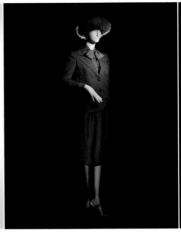

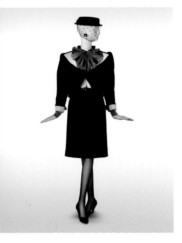

33 Pantsuit
Haute couture collection
Spring–Summer 1985
Steel gray whipcord; crepe blouse
with black-and-white tartan print
HC85E020

34 Suit with short skirt
Haute couture collection
Spring–Summer 1967
Jacket in navy flannel with white
stripes, waistcoat, and skirt;
white cotton shirt
HC67E119

35 Suit with short skirt
Haute couture collection
Fall–Winter 1975
Khaki and beige tweed;
brown crepe de chine blouse with
floppy necktie
HC75H003

36 Suit with short skirt
Haute couture collection
Fall–Winter 2001
Flame-colored wool jacket;
purple satin blouse; black wool
crepe skirt
HC01H001

37 Suit with short skirt
Haute couture collection
Spring–Summer 1962
Black shantung; Havana
shantung blouse
HC62E091

38 Suit with short skirt
Haute couture collection
Spring–Summer 1974
Black-and-white Prince of Wales
check wool; black-and-white print
crepe de chine blouse
HC74E015

39 Suit with short skirt
Haute couture collection
Fall–Winter 1980
Black-and-white Prince of Wales
check wool jacket; green damask
silk blouse; red tartan wool kilt
HC80H009

40 Suit with short skirt
Haute couture collection
Spring–Summer 1981
Black-and-white Ottoman
jacket; black-and-white check
silk organdy blouse; black
barathea skirt
HC81E055

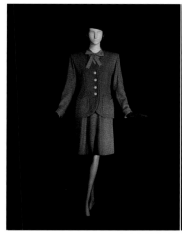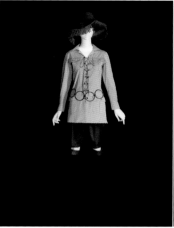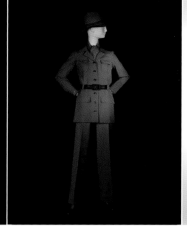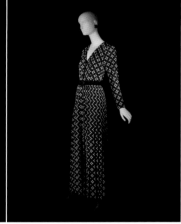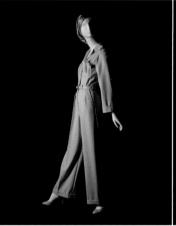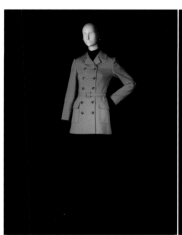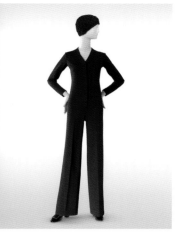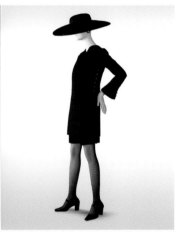

41 Suit with short skirt
Haute couture collection
Fall–Winter 1990
Green tweed; pink crepe blouse
HC90H026

42 Short daytime ensemble
Rive Gauche collection
Spring–Summer 1968
Beige cotton gabardine safari
jacket; silver metal chain
belt; black cotton gabardine
Bermuda shorts
RG68E000

43 Suit
Haute couture collection
Spring–Summer 1969
Beige gabardine safari jacket
and pants; striped beige
shantung blouse
HC69E081

44 Jumpsuit
Haute couture collection
Fall–Winter 1969
Bordeaux wool jersey
HC69H016

45 Long daytime ensemble
Haute couture collection
Fall–Winter 1968
Beige jersey three-quarter-length
coat; iron gray jersey jumpsuit
HC68H021

46 Jumpsuit
Haute couture collection
Spring–Summer 1975
Ivory gabardine
HC75E017

47 Jumpsuit
Haute couture collection
Spring–Summer 1970
Gray and Havana print
crepe de chine
HC70E054

48 Short daytime ensemble
Haute couture collection
Spring–Summer 1968
Black wool tunic and
Bermuda shorts
HC68E014

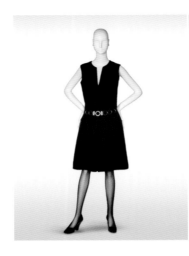
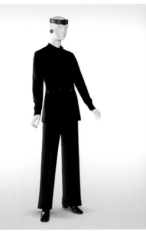
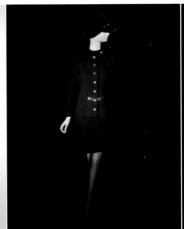
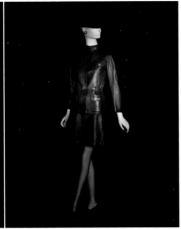

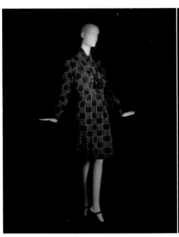
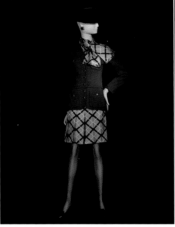
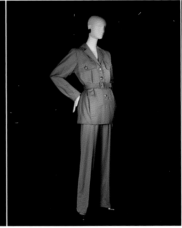
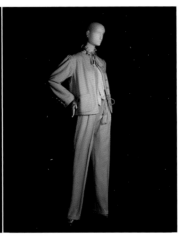

49 Bermuda dress
Haute couture collection
Fall–Winter 1968
Black wool
HC68H058

50 Long daytime ensemble
Haute couture collection
Fall–Winter 1968
Bronze green jersey tunic
and pants
HC68H047

51 Suit with short skirt
Haute couture collection
Fall–Winter 1967
Green jersey
HC67H053

52 Suit with short skirt
Haute couture collection
Fall–Winter 1967
Gray leather
HC67H066

53 Short daytime dress
Haute couture collection
Spring–Summer 1969
Brown-and-mauve
crepe de chine print
HC69E058

54 Short daytime ensemble
Haute couture collection
Spring–Summer 1968
Havana jersey jacket; beige and
Havana tartan twill dress
HC68E061

55 Pantsuit
Haute couture collection
Spring–Summer 2000
Sand-colored wool gabardine
safari jacket and pants
HC00E009

56 Pantsuit
Haute couture collection
Spring–Summer 1977
White flannel dolman
embroidered with ivory;
ivory crepe de chine blouse;
gabardine pants shot through
with beige
HC77E023

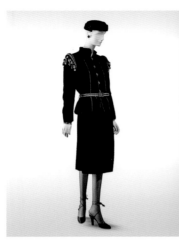

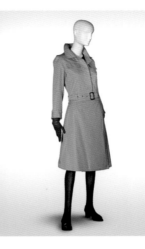
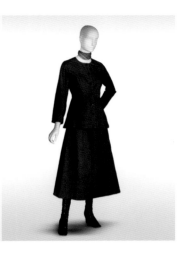

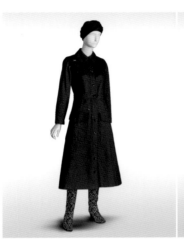
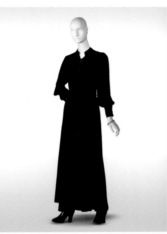
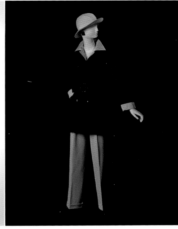
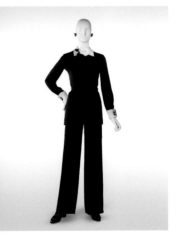

57 Torero ensemble
Haute couture collection
Fall–Winter 1979
Black velvet embroidered with
gold; gold lamé blouse
HC79H069

58 Tuxedo with pants
Haute couture collection
Fall–Winter 1996
Black barathea
HC96H053

59 Short daytime ensemble
Rive Gauche collection
Fall–Winter 1967
Beige cotton gabardine short
blouson jacket and wraparound
skirt; white wool ribbed sweater
Loan of sweater, private collection
RG67H001
Collection Michèle and Olivier
Chatenet

60 Long daytime ensemble
Rive Gauche collection
Fall–Winter 1970
Blue denim short jacket and
long skirt
RG70H001

61 Long daytime coat
Rive Gauche collection
Spring–Summer 1971
Blue jean twill
RG70E931

62 Long daytime dress
Rive Gauche collection
Fall–Winter 1969
Black crepe
RG69H001

63 Long daytime ensemble
Haute couture collection
Spring–Summer 1975
Black mercerized cotton trench coat;
ivory gabardine smock and pants
Loan of trench coat, private collection
HC75E049
Collection Michèle and Olivier
Chatenet

64 Long evening ensemble
Haute couture collection
Fall–Winter 1968
Black satin crepe tunic and pants
HC68H073
Made to order by Nan Kempner

 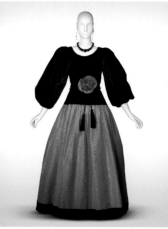 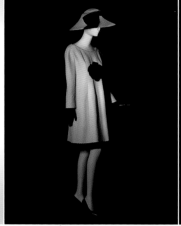 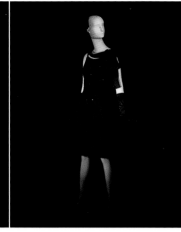

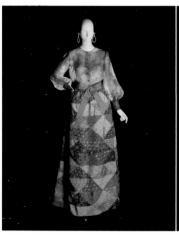 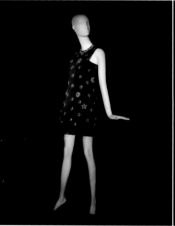 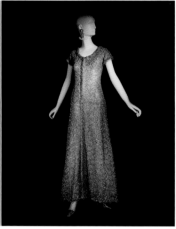 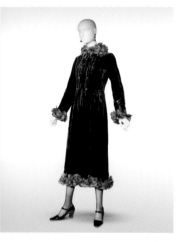

65 Long evening dress
Haute couture collection
Fall–Winter 1981
Black velvet and black
bird of paradise feathers
Loan of Comtesse Jacqueline
de Ribes

66 Long evening dress
Haute couture collection
Fall–Winter 1974
Black velvet and coral moiré
HC74H066
Made to order by Hélène Rochas

67 Short cocktail dress
Haute couture collection
Spring–Summer 1964
Natural shantung, black satin
appliqué rose
HC64E013
Gift of Her Serene Highness
Princess Grace of Monaco

68 Short evening dress
Haute couture collection
Spring–Summer 1962
Black silk seersucker and tulle,
embroidered with jet beads
HC62E100
Gift of Patricia Lopez-Willshaw

69 Long evening ensemble
Haute couture collection
Spring–Summer 1969
Multicolored patchwork print
silk organdy blouse; multicolored
patchwork print silk skirt
HC69E001
Made to order by the
Duchess of Windsor

70 Short daytime dress
Haute couture collection
Fall–Winter 1968
Fringed brown suede,
embroidered with topazes
HC68H071
Gift of Françoise Giroud

71 Long evening dress
Haute couture collection
Spring–Summer 1967
Gold brocade, embroidered with
gold beads
HC67E000
Gift of Marie Hélène de Rothschild

72 Long daytime coat
Haute couture collection
Fall–Winter 1969
Brown goffered velvet trimmed
with feathers
HC69H025
Made to order by Elsa Schiaparelli

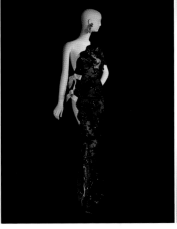
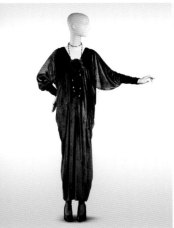
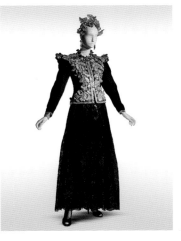

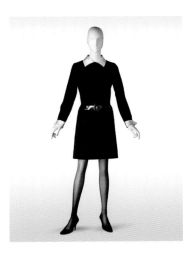
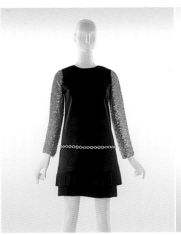
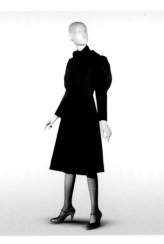
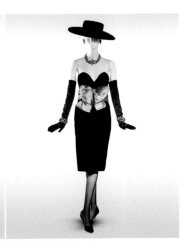

73 Long evening ensemble
Haute couture collection
Fall–Winter 1973
Cardigan embroidered with gold,
gray, and silver; sand-colored
chiffon blouse; gray flannel pants
HC73H002
Made to order by Lauren Bacall

74 Long evening dress
Haute couture collection
Fall–Winter 1990
Black sequined lace and pink
satin ribbon bows
HC90H089
Made to order by Mouna Ayoub

75 Long evening dress
Haute couture collection
Fall–Winter 1975
Ruby panne velvet
Loaned by Charlotte Aillaud

76 Long evening ensemble
Haute couture collection
Spring–Summer 1980
Gold-embroidered black gazar
jacket; black-and-gold lace dress
HC80E067
Made to order by Diana Vreeland

77 *Belle de Jour* dress
Haute couture collection
Spring–Summer 1967
Barathea, black-and-white silk
satin collar and cuffs
HC67E

78 Short evening dress
Haute couture collection
Fall–Winter 1967
Brown suede tunic dress,
gold-sequined sleeves
HC67H009

79 Short daytime coat
Rive Gauche collection
Fall–Winter 1970
Sienna velvet
RG70H020

80 Short cocktail dress
Haute couture collection
Fall–Winter 1984
Black velvet and copper satin
HC84H122

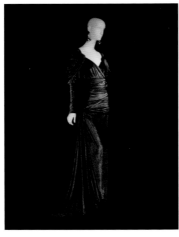
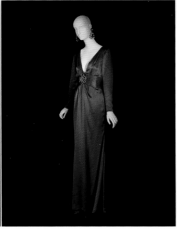
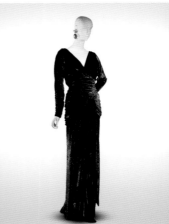
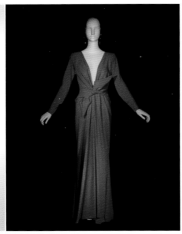

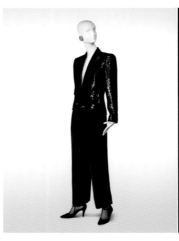
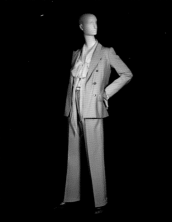
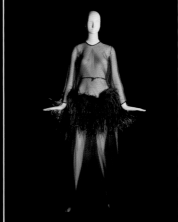
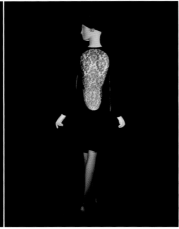

81 Long evening dress
Haute couture collection
Fall–Winter 1983
Steel gray panne lamé
HC83H139

82 Long evening dress
Haute couture collection
Spring–Summer 1997
Tango red satin crepe satin
HC97E047

83 Long evening dress
Haute couture collection
Fall–Winter 1983
Anthracite panne lamé
HC83H138

84 Long evening dress
Haute couture collection
Spring–Summer 1985
Shocking pink crepe
HC85E113

85 Tuxedo with pants
Haute couture collection
Spring–Summer 1984
Jacket embroidered with sequins;
black satin pants
HC84E078

86 Pantsuit
Haute couture collection
Spring–Summer 1976
Gray-striped beige wool; beige
crepe de chine blouse
HC76E024

87 Long evening dress
Haute couture collection
Fall–Winter 1968
Black silk chiffon and black
ostrich feathers
HC68H074

88 Short evening dress
Haute couture collection
Fall–Winter 1970
Black wool crepe and lace
HC70H117

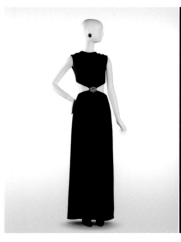
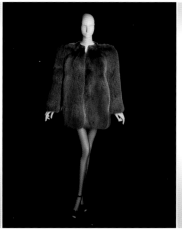
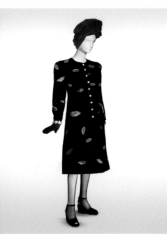
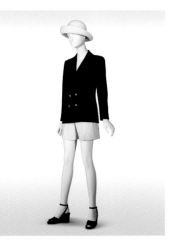

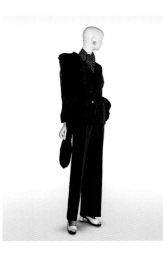
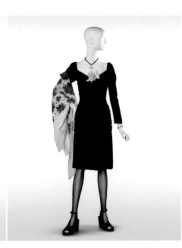
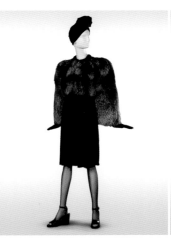

89 Long evening dress
Haute couture collection
Fall–Winter 1965
Black silk crepe
HC65H054

90 Short evening coat
Haute couture collection
Spring–Summer 1971
Green fox fur
HC71E090

91 Long evening coat
Haute couture collection
Spring–Summer 1971
Black velvet embroidered
with "lips" motif
HC71E013

92 Short daytime ensemble
Haute couture collection
Spring–Summer 1971
Navy wool gabardine blazer;
white wool gabardine shorts
HC71E068

93 Pantsuit
Haute couture collection
Spring–Summer 1971
Navy serge with bordeaux stripes;
bordeaux with white dot print
chiffon blouse
HC71E007

94 Short daytime dress
Haute couture collection
Spring–Summer 1971
Navy silk jersey, pink
silk appliqué flowers
HC71E063

95 Short evening ensemble
Haute couture collection
Spring–Summer 1971
Silver fox fur bolero;
black silk jersey dress
HC71E011

96 Short evening ensemble
Haute couture collection
Spring–Summer 1971
Black monkey-fur bolero;
black silk jersey dress
HC71E023

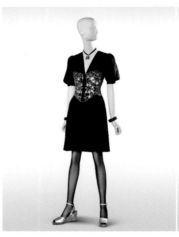
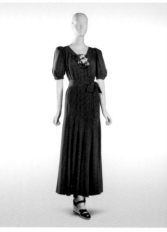

97 Short daytime ensemble
Haute couture collection
Spring–Summer 1971
Red-and-black-print crepe de
chine dress and underskirt; red
gabardine sleeveless jacket with
black braiding
HC71E022

98 Short evening dress
Haute couture collection
Spring–Summer 1971
Black silk jersey, red suede belt
HC71E062

99 Short daytime ensemble
Haute couture collection
Spring–Summer 1971
Terracotta silk jersey dress;
silver fox boa
HC71E028

100 Short daytime dress
Haute couture collection
Spring–Summer 1971
Black satin crepe, green
embroidered corselette
HC71E070

101 Long daytime dress
Haute couture collection
Spring–Summer 1971
Blue crepe de chine with
white dots, white and red
silk appliqué flowers
HC71E034

102 Short evening dress
Haute couture collection
Spring–Summer 1971
Camouflage-print crepe de chine,
black silk appliqué flower; fox boa
HC71E066

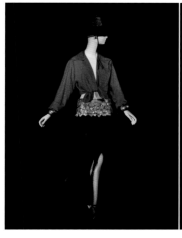
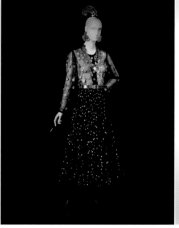
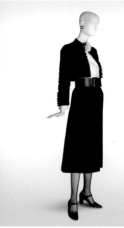
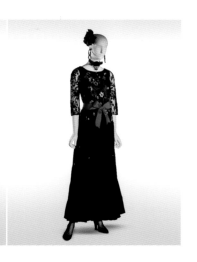

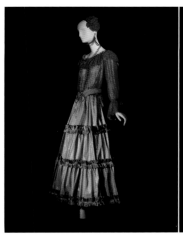
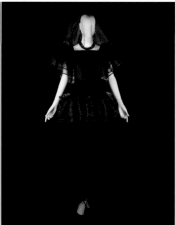
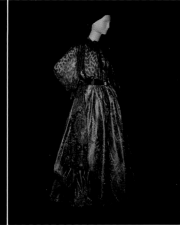
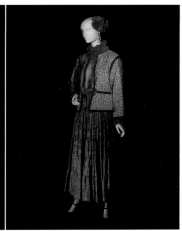

103 Long daytime ensemble
Haute couture collection
Spring–Summer 2000
Ruby shantung shirt; fringed skirt
embroidered with gold and coral
HC00E034

104 Long evening ensemble
Haute couture collection
Spring–Summer 2000
Black chiffon skirt and blouse
embroidered with gold dots
HC00E066

105 Suit with long skirt
Haute couture collection
Spring–Summer 1968
Black alpaca and wool bolero and
skirt; white cotton piqué blouse
HC68E055

106 Long evening ensemble
Haute couture collection
Spring–Summer 1977
Black lace embroidered blouse;
black georgette crepe skirt
HC77E002

107 Long evening ensemble
Haute couture collection
Spring–Summer 1977
Gold-striped fuchsia chiffon
blouse; neon green lamé
taffeta skirt
HC77E008

108 Long evening dress
Haute couture collection
Spring–Summer 1977
Black gauze and satin,
flounces on sleeves and hips
HC77E055

109 Long evening ensemble
Haute couture collection
Spring–Summer 1977
Turquoise-and-mauve Persian-print
chiffon shirt; multicolored Persian-
print faille skirt
HC77E071

110 Long evening ensemble
Haute couture collection
Spring–Summer 1977
Red shantung damask dolman
with white Persian print; red
chiffon blouse with white dots;
red-and-white Indian print
seersucker skirt
HC77E076

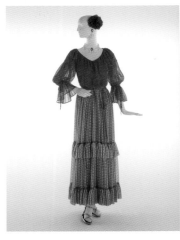
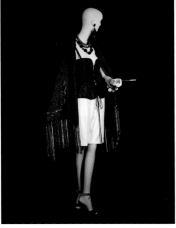
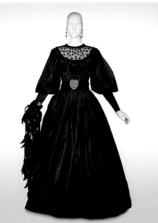
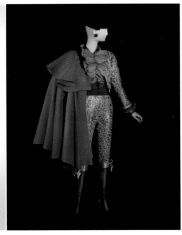

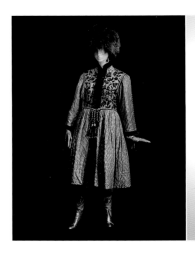
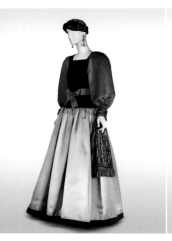
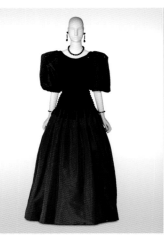
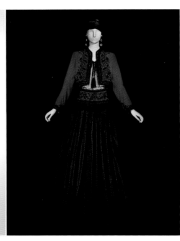

111 Long evening ensemble
Haute couture collection
Spring–Summer 1977
Chiffon blouse shot through
with red; red-and-white striped
chiffon skirt
HC77E094

112 Short cocktail ensemble
Rive Gauche collection
Spring–Summer 1977
Black moiré faille corselette;
white cotton Bermuda shorts
RG77E049

113 Long evening dress
Haute couture collection
Fall–Winter 1977
Black taffeta embroidered
with jet and gold
HC77H030

114 Torero ensemble
Haute couture collection
Fall–Winter 1979
Pink gazar cape; gold and
pink lamé bolero and
knickerbockers; bright pink
satin and taffeta blouse
HC79H091

115 Long evening ensemble
Haute couture collection
Fall–Winter 1976
Gold lamé coat embroidered
with jet and black mink; black
velvet skirt with gold braiding
HC76H014

116 Long evening dress
Haute couture collection
Fall–Winter 1976
Black velvet, orange satin puff
sleeves, and turquoise
HC76H067

117 Long evening dress
Haute couture collection
Fall–Winter 1976
Black velvet, black taffeta puff
sleeves, bordeaux faille and
black velvet
HC76H104

118 Long evening ensemble
Haute couture collection
Fall–Winter 1976
Red velvet bolero embroidered
with jet; black lamé chiffon blouse;
black moiré and red velvet skirt
HC76H088

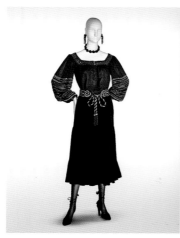
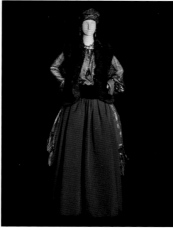
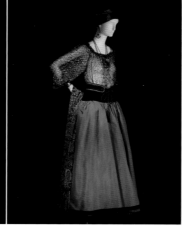

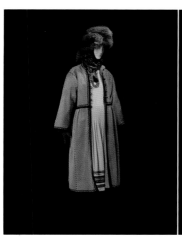

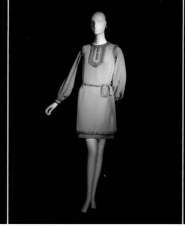
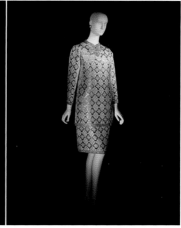

119 Long daytime ensemble
Haute couture collection
Fall–Winter 1976
Black etamine blouse
embroidered with gold;
black velvet skirt
HC76H100

120 Long evening ensemble
Haute couture collection
Fall–Winter 1976
Emerald and sable velvet bolero;
peacock blue-and-gold chiffon;
Prussian blue Ottoman skirt
HC76H093

121 Long evening ensemble
Haute couture collection
Fall–Winter 1976
Multicolored-print lamé chiffon
blouse; emerald moiré, black
velvet, and purple satin skirt
HC76H094

122 Long evening ensemble
Haute couture collection
Fall–Winter 1982
Navy wool coat and brown otter
skin; gray blue flannel pants
HC82H001

123 Long evening ensemble
Haute couture collection
Fall–Winter 1976
Embroidered beige suede coat;
green wool etamine blouse; green
and gray striped wool skirt
HC76H002

124 Long evening ensemble
Haute couture collection
Fall–Winter 1976
Bordeaux suede coat, black
passementerie; blue wool etamine
blouse with passementerie; black
wool etamine skirt
HC76H003

125 Short tunic
Haute couture collection
Spring–Summer 1968
Havana crepe embroidered
with gold
HC68E078

126 Short daytime ensemble
Haute couture collection
Fall–Winter 1969
Green lamé tunic and skirt
HC69H067

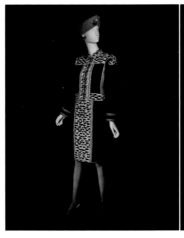
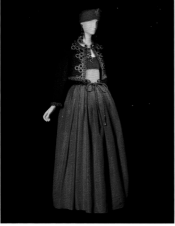
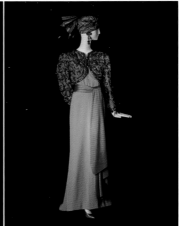
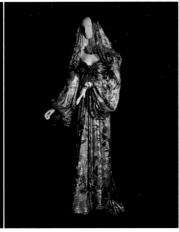

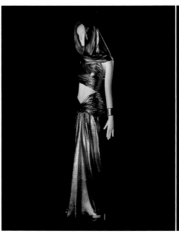
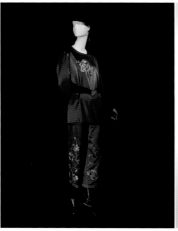
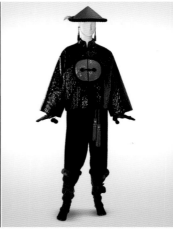
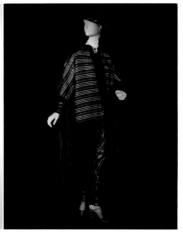

127 Short evening ensemble
Haute couture collection
Spring–Summer 1982
Grosgrain bolero and skirt
embroidered with black, red,
and yellow
HC82E075

128 Long evening ensemble
Haute couture collection
Spring–Summer 1982
Bright blue grosgrain silk
bolero embroidered in ruby;
multicolored moiré dress, yellow
silk grosgrain belt
HC82E128

129 Long evening ensemble
Haute couture collection
Fall–Winter 1984
Blue faille bolero embroidered
in gold and coral; coral satin and
yellow Moroccan crepe dress
HC84H179

130 Long evening dress
Haute couture collection
Spring–Summer 1985
Lamé chiffon printed with gold,
purple, and Parma violet
HC85E138

131 Long evening dress
Rive Gauche collection
Fall–Winter 1991
Draped gold lamé
RG91H132

132 Long evening ensemble
Haute couture collection
Fall–Winter 1970
Mauve satin tunic embroidered
with floral motifs; blue satin pants
embroidered with floral motifs
HC70H022

133 Long evening ensemble
Haute couture collection
Fall–Winter 1977
Black-and-red quilted ciré jacket;
black velvet pants
HC77H002

134 Long evening ensemble
Haute couture collection
Fall–Winter 1977
Black, gold, and purple
damask lamé jacket; black-and-
gold satin chiffon blouse;
black glossy satin pants
HC77H015

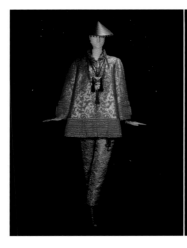 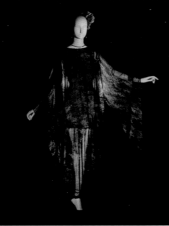

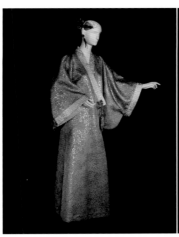 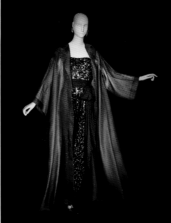 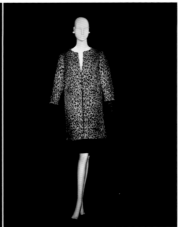 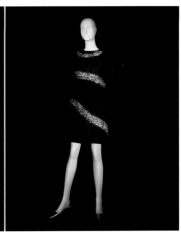

135 Long evening ensemble
Haute couture collection
Fall–Winter 1977
Flame-colored-and-gold damask
jacket; bordeaux chiffon blouse
shot through with gold; gold
damask pants
HC77H021

136 Long evening dress
Haute couture collection
Fall–Winter 1977
Smoke gray-print chiffon
HC77H085

137 Long evening ensemble
Haute couture collection
Fall–Winter 1977
Gold damask jacket, fox fur cuffs;
black velvet pants with black
overstitching
HC77H086

138 Long evening ensemble
"Opium" haute couture collection
Fall–Winter 1977
Black, purple, and gold ciré
damask jacket; purple-and-
gold lamé georgette crepe
blouse; purple damask pants
with passementerie
HC77H133

139 Long evening coat
Haute couture collection
Fall–Winter 1994
Quilted silk linden and wisteria
print
HC94H085

140 Long evening ensemble
Haute couture collection
Fall–Winter 2000
Brown orange gazar coat;
tortoiseshell-sequined jumpsuit,
brown chiffon belt
HC00H081

141 Short evening ensemble
Haute couture collection
Fall–Winter 1964
Tunic embroidered with gold
sequins; black wool crepe skirt
HC64H121

142 Short daytime dress
Haute couture collection
Fall–Winter 1966
Dark green jersey embroidered
with gold sequins, "snake" motif
HC66H053

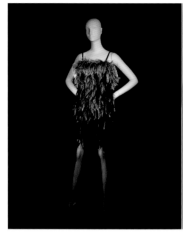
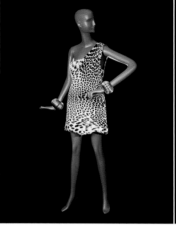
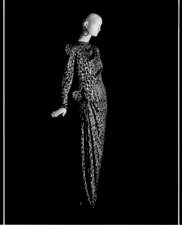
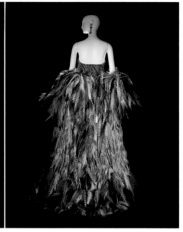

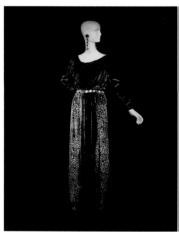
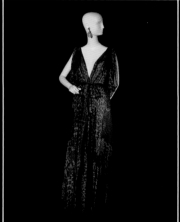
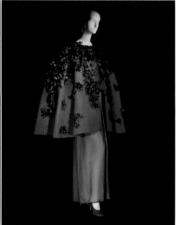
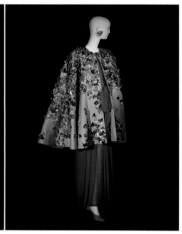

143 Short evening dress
Haute couture collection
Fall–Winter 1969
Black, dark brown, and light brown
ostrich feathers
HC69H069

144 Short evening dress
Haute couture collection
Spring–Summer 1970
Somali leopard
HC70E089

145 Long evening dress
Haute couture collection
Fall–Winter 1982
Leopard-print satin crepe
HC82H082

146 Long evening ensemble
Haute couture collection
Fall–Winter 1990
Coat of pheasant feathers and
multicolored rhea feathers;
tiger-print chiffon dress
HC90H082

147 Long evening dress
Haute couture collection
Fall–Winter 1992
Leopard-print panne velvet
HC92H046

148 Long evening dress
Haute couture collection
Spring–Summer 1994
Iridescent turquoise chiffon
with leopard print
HC94E043

149 Long evening ensemble
Haute couture collection
Spring–Summer 1989
Red faille cape with bougainvillea
embroidery; coral-and-jade chiffon
dress, orange chiffon belt
HC89E071

150 Long evening ensemble
Haute couture collection
Spring–Summer 1989
Mandarin orange gazar cape
with bougainvillea embroidery;
scarlet chiffon dress, red
chiffon belt
HC89E073

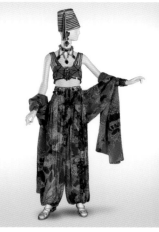
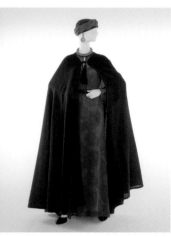

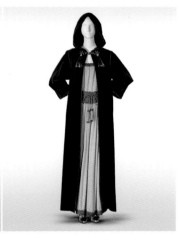
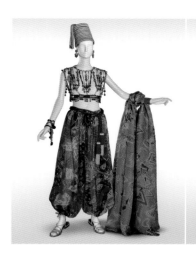

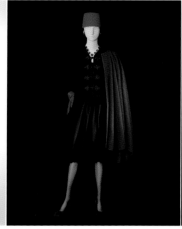
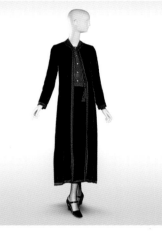

151 Long daytime ensemble
Rive Gauche collection
Spring–Summer 1991
Top with multicolored glass-paste
stones; multicolored cotton veil
harem pants
RG91E169

152 Long daytime ensemble
Rive Gauche collection
Spring–Summer 1991
Top in metal and gold-and-red
glass paste; multicolored cotton
veil harem pants
RG91E174

153 Short daytime ensemble
Haute couture collection
Fall–Winter 1979
Sapphire blue mohair cape;
black wool jacket with frogging;
black velvet top; ruby velvet
Zouave pants
HC79H131

154 Long evening dress
Haute couture collection
Fall–Winter 2000
Midnight blue crepe
HC00H064

155 Long evening dress
Haute couture collection
Fall–Winter 1977
Silver lamé
HC77H107

156 Long evening ensemble
Haute couture collection
Fall–Winter 1969
Brown cloak; brown crepe dress
HC69H101

157 Long evening ensemble
Haute couture collection
Fall–Winter 1970
Black crushed velvet coat
and skirt; black georgette
crepe blouse
HC70H093

158 Long evening ensemble
Haute couture collection
Fall–Winter 1976
Brown velvet coat with gold
braiding; ivory-and-gold
wool etamine dress, gold
passementerie
HC76H065

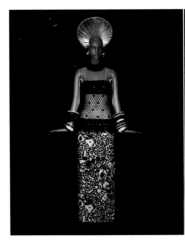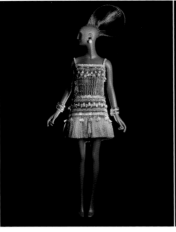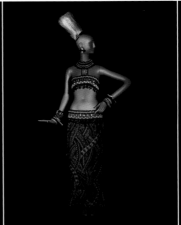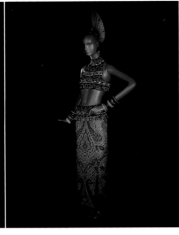

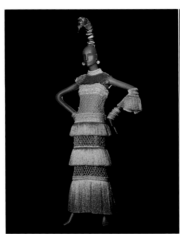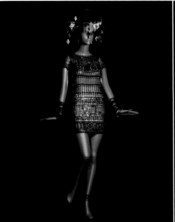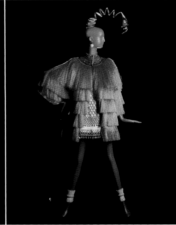

159 Long tropical dress
Haute couture collection
Spring–Summer 1967
Printed silk twill, embroidered
with wooden beads and
black raffia
HC67E007

160 Short evening dress
"Bambara" haute couture
collection
Spring–Summer 1967
Rhodoïd, wooden bead, coral,
and raffia embroidery
HC67E009

161 Long tropical ensemble
Haute couture collection
Spring–Summer 1967
Top embroidered with wooden
beads, rhodoïd, and raffia;
printed silk twill skirt, embroidered
with multicolored wooden beads
at the waist
HC67E015

162 Long tropical ensemble
Haute couture collection
Spring–Summer 1967
Top embroidered with
multicolored wooden beads;
printed silk twill wraparound skirt,
embroidered with multicolored
wooden beads at the waist
HC67E013

163 Long evening dress
"Bambara" haute couture
collection
Spring–Summer 1967
Wooden bead and natural raffia
embroidery
HC67E017

164 Short evening dress
"Bambara" haute couture
collection
Spring–Summer 1967
Brown organza embroidered in
rich brown with wooden beads
HC67E066

165 Short evening ensemble
"Bambara" haute couture
collection
Spring–Summer 1967
Russet raffia coat;
wooden bead dress
HC67E091

166 Long evening dress
"Bambara" haute couture
collection
Spring–Summer 1967
Black Rhodoïd and wooden
bead embroidery
HC67E108

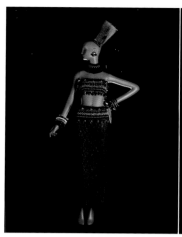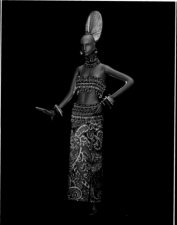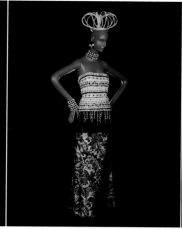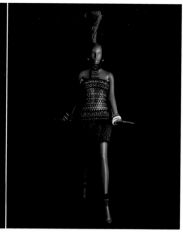

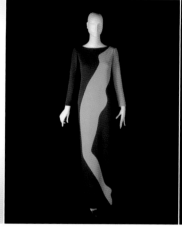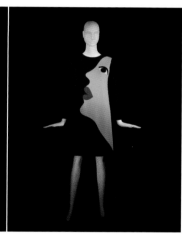

167 Long ensemble
"Bambara" haute couture
collection
Spring–Summer 1967
Top embroidered with wooden
beads and red-and-black raffia;
black crepe skirt, embroidered
with red-and-black wood beads
and black raffia
HC67E014

168 Long tropical ensemble
Haute couture collection
Spring–Summer 1967
Top embroidered with
multicolored wooden beads;
glazed cotton skirt, embroidered
with multicolored wooden beads
at the waist
HC67E019

169 Long tropical dress
Haute couture collection
Spring–Summer 1967
Printed silk, embroidered with
navy-and-green raffia
HC67E018

170 Short evening dress
"Bambara" haute couture
collection
Spring–Summer 1967
Black raffia and black-and-red
wooden beads
HC67E011

171 Short cocktail dress
Tribute to Serge Poliakoff
Haute couture collection
Fall–Winter 1965
Anthracite wool jersey, encrusted
with red and purple
HC65H070

172 Long evening dress
Tribute to Tom Wesselmann
Haute couture collection
Fall–Winter 1966
Navy blue wool jersey, encrusted
"silhouette" motif
HC66H105

173 Short cocktail dress
Tribute to Tom Wesselmann
Haute couture collection
Fall–Winter 1966
Purple-and-black wool jersey,
encrusted "face" motif
HC66H047

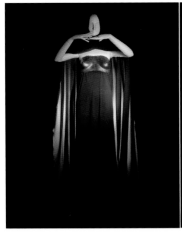
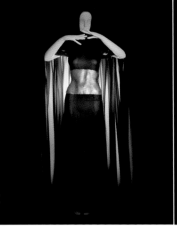
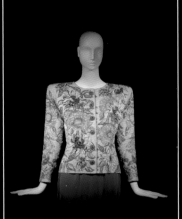
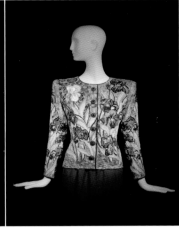

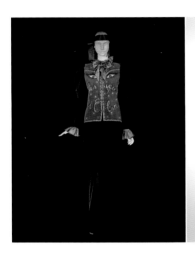
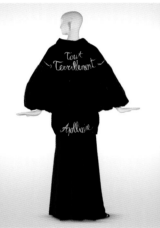
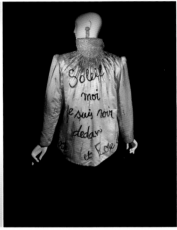
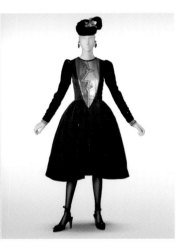

174 Long evening dress
Haute couture collection
Fall–Winter 1969
Blue crepe veil; bust sculpture
in galvanized copper by
Claude Lalanne
HC69H102

175 Long evening dress
Haute couture collection
Fall–Winter 1969
Black crepe veil, lined with
black organza; waist sculpture
in galvanized copper by
Claude Lalanne
HC69H103

176 Short evening ensemble
Tribute to Vincent van Gogh
Haute couture collection
Spring–Summer 1988
Jacket embroidered with pearls
and sequins; buttercup yellow
satin blouse; green crepe skirt
HC88E094

177 Short evening ensemble
Tribute to Vincent van Gogh
Haute couture collection
Spring–Summer 1988
Jacket embroidered with sequins
and pearls; green crepe blouse;
purple crepe skirt
HC88E093

178 Long evening ensemble
Tribute to Louis Aragon
Haute couture collection
Fall–Winter 1980
Royal blue–and–midnight blue
velvet jacket, embroidered "Les
yeux d'Elsa"; black pearly satin
blouse; sapphire blue velvet skirt
HC80H119

179 Long evening ensemble
Tribute to Guillaume Apollinaire
Haute couture collection
Fall–Winter 1980
Purple-and-black jacket,
embroidered "Tout terriblement";
amethyst-and-black velvet dress
HC80H117

180 Long evening ensemble
Tribute to Jean Cocteau
Haute couture collection
Fall–Winter 1980
Embroidered pink satin jacket;
black velvet sheath dress
HC80H118

181 Short cocktail dress
Tribute to Pablo Picasso
Haute couture collection
Fall–Winter 1979
Black satin and velvet,
embroidered with pink and
silver sequins, "face" motif
HC79H077

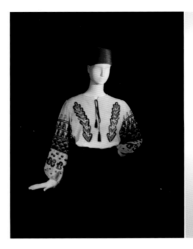
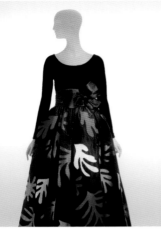
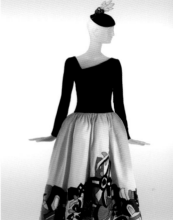
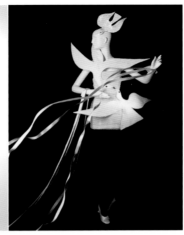

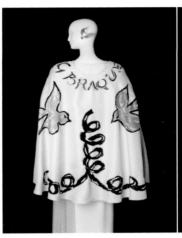
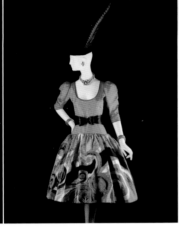
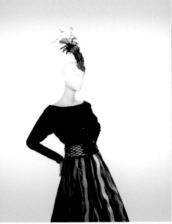
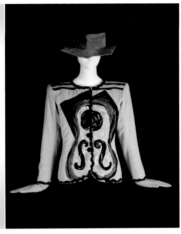

182 Short evening ensemble
Inspired by Henri Matisse
Haute couture collection
Fall–Winter 1981
Embroidered white wool crepe
Norman smock; sapphire blue
velvet skirt
HC81H072

183 Long evening dress
Inspired by Henri Matisse
Haute couture collection
Fall–Winter 1980
Black velvet and moiré faille,
multicolored satin appliqué leaves
HC80H121

184 Long evening dress
Tribute to Fernand Léger
Haute couture collection
Fall–Winter 1981
Black velvet top; white satin
skirt and multicolored appliqué
patchwork
HC81H148

185 Wedding dress
Tribute to Georges Braque
Haute couture collection
Spring–Summer 1988
White tulle, white cotton piqué
appliqué "doves"
HC88E132

186 Long evening ensemble
Tribute to Georges Braque
Haute couture collection
Spring–Summer 1988
Embroidered white gazar Cubist
cape; white crepe dress
HC88E130

187 Short evening dress
Tribute to Pablo Picasso
Haute couture collection
Fall–Winter 1979
Black velvet and orange moiré,
multicolored appliqué patchwork
HC79H133

188 Long evening ensemble
Inspired by Henri Matisse
Haute couture collection
Fall–Winter 1984
Black velvet top; black moiré
taffeta skirt, appliqué multicolored
moiré taffeta and black velvet
HC84H161

189 Short evening ensemble
Tribute to Pablo Picasso
Haute couture collection
Spring–Summer 1988
Pink-and-black satin wool jacket
with multicolored embroidery;
black barathea skirt
HC88E064

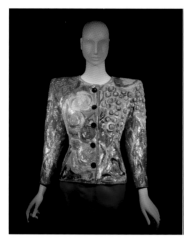 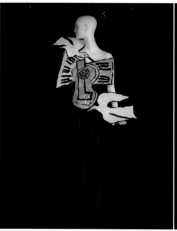 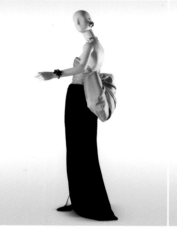

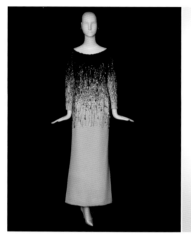 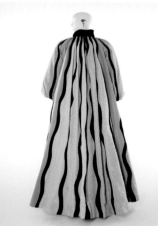 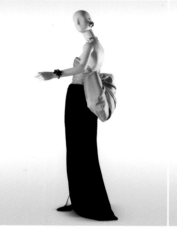 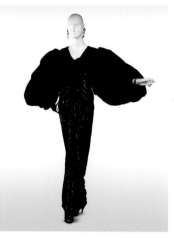

190 Short evening ensemble
Tribute to Pierre Bonnard
Haute couture collection
Fall–Winter 1988
Jacket embroidered with
multicolored and gold sequins;
satin and red leather–satin skirt
HC88H093

191 Long evening dress
Tribute to Georges Braque
Haute couture collection
Spring–Summer 1988
Navy satin embroidered
with white, pink, black, blue,
and yellow sequins, "doves
and guitar" motif
HC88E117

192 Short cocktail dress
Tribute to Piet Mondrian
Haute couture collection
Fall–Winter 1965
Ecru wool jersey, encrusted
with black, red, yellow, and blue
HC65H081.R1

193 Long wedding dress
Haute couture collection
Fall–Winter 1965
White wool knit, white satin
silk ribbons
HC65H068

194 Long evening dress
Haute couture collection
Fall–Winter 1962
White crepe embroidered with jet
HC62H110

195 Long evening ensemble
Haute couture collection
Fall–Winter 1984
Domino coat in shades of blue
faille and black velvet; black and
pearly satin embroidered guipure
lace dress
HC84H147

196 Long evening dress
"Paris" haute couture collection
Fall–Winter 1983
Black velvet sheath dress,
"Paris rose" satin bow
HC83H126

197 Long evening ensemble
Haute couture collection
Fall–Winter 1982
Black velvet bolero; black panne
velvet dress embroidered with jet
HC82H111

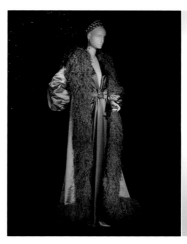
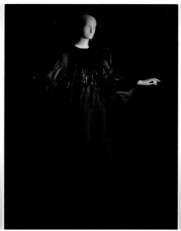
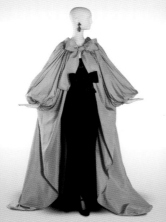
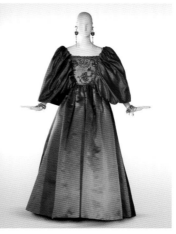
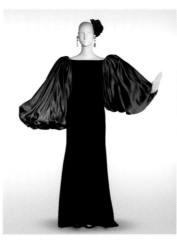
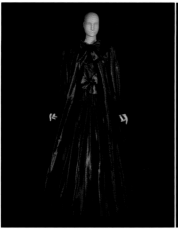
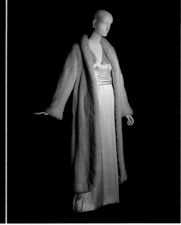
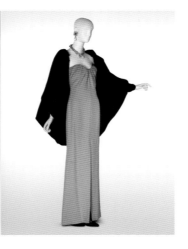

198 Long evening ensemble
Haute couture collection
Fall–Winter 1999
Pink satin coat, lime green taffeta
and multicolored ostrich feathers;
cloud blue satin dress
HC99H058

199 Long evening ensemble
Haute couture collection
Fall–Winter 1983
Domino coat in yellow faille de
chine; velvet sheath dress with
black lace
HC83H133

200 Long evening dress
Haute couture collection
Fall–Winter 1991
Organza embroidered with black
HC91H136

201 Long evening dress
Haute couture collection
Fall–Winter 1991
Amaranth red, copper, turquoise,
and emerald leather–satin;
copper-sequined lace
HC91H126

202 Long evening dress
Haute couture collection
Fall–Winter 1982
Black velvet and Persian blue satin
HC82H126

203 Long evening ensemble
Haute couture collection
Fall–Winter 2000
Domino coat in gray taffeta and
black velvet; brown taffeta dress
HC00H090

204 Long evening ensemble
Haute couture collection
Fall–Winter 1998
White mink coat; ivory satin dress
HC98H070

205 Long evening ensemble
Haute couture collection
Fall–Winter 1995
Black gazar bolero; blotter pink
crepe dress
HC95H065

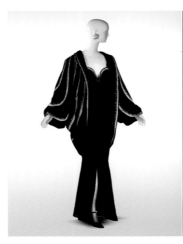 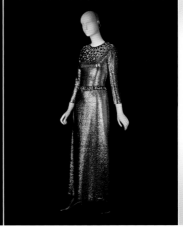 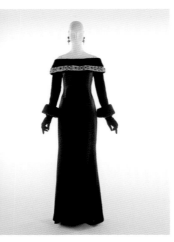

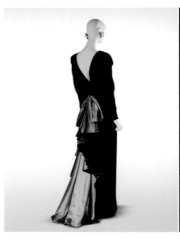 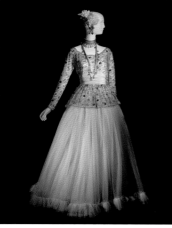 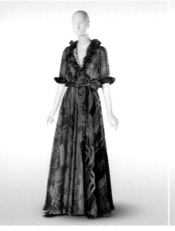 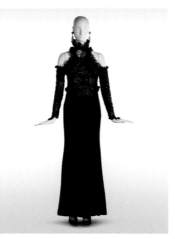

206 Long evening ensemble
Haute couture collection
Fall–Winter 1983
Black velvet jacket and sheath
dress embroidered with silver dust
HC83H140

207 Long evening ensemble
Haute couture collection
Spring–Summer 2001
Coat in gazar with white ostrich
feathers; white satin dress
HC01E089

208 Long evening dress
Haute couture collection
Fall–Winter 1966
Gold sequined, encrusted
with paste gems
HC66H060

209 Long evening dress
Haute couture collection
Fall–Winter 1997
Black velvet and satin Holbein,
embroidered with stones
HC97H060

210 Long evening dress
Haute couture collection
Fall–Winter 1983
Navy velvet and storm blue satin
HC83H120

211 Long evening ensemble
Haute couture collection
Spring–Summer 1981
Top embroidered with gold, pearls,
and flowers; white tulle skirt
HC81E117

212 Long evening dress
Haute couture collection
Spring–Summer 1974
Multicolored silk organdy
HC74E043

213 Long evening dress
Haute couture collection
Spring–Summer 1983
Black Moroccan crepe and
black sequins
HC83E092

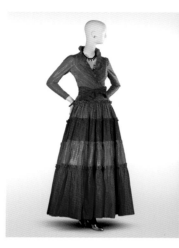 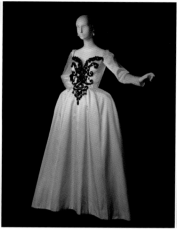 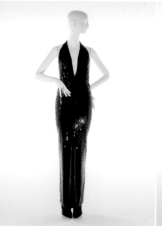 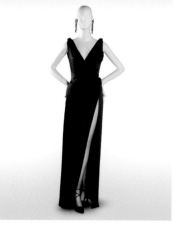

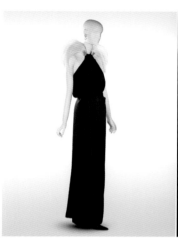 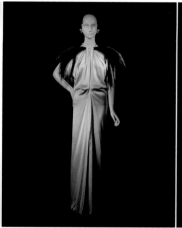 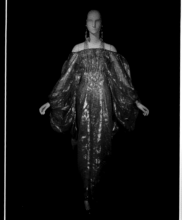 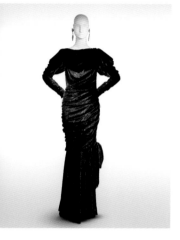

214 Long evening dress
Haute couture collection
Fall–Winter 1973
Pink, red, and dark purple taffeta
HC73H054
Gift of Francesca Sivori

215 Long evening dress
Haute couture collection
Fall–Winter 1995
White satin embroidered with jet
HC95H088

216 Long evening dress
Tribute to Marilyn Monroe
Haute couture collection
Spring–Summer 1990
Black sequined sheath dress
HC90E106

217 Long evening dress
Haute couture collection
Fall–Winter 1997
Black draped silk satin
HC97H045

218 Long evening dress
Haute couture collection
Spring–Summer 1999
Black satin and white bird of
paradise feathers
HC99E067

219 Long evening dress
Haute couture collection
Spring–Summer 1999
White satin and black bird of
paradise feathers
HC99E066

220 Long evening dress
Haute couture collection
Spring–Summer 1981
Flame-colored organdy
interwoven with gold thread
HC81E111

221 Long evening dress
Haute couture collection
Fall–Winter 1983
Black panne lamé
HC83H137

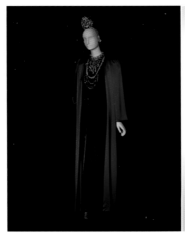 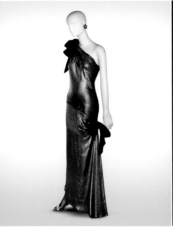 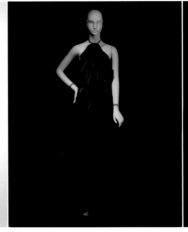 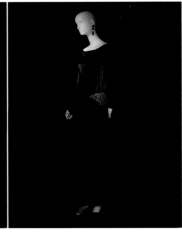

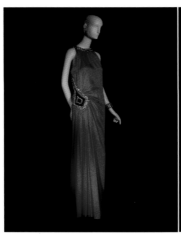 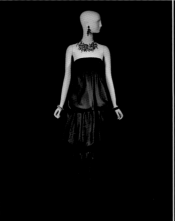 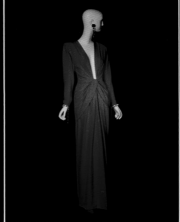 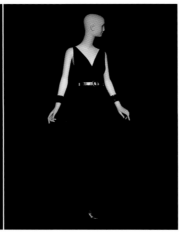

222 Long evening ensemble
Haute couture collection
Spring–Summer 1980
Lacquer red satin crepe coat; navy
satin crepe dress embroidered
with an ensemble of trompe l'oeil
appliqué necklaces
HC80E075

223 Long evening dress
Haute couture collection
Fall–Winter 1978
Gold lamé, black velvet bows
HC78H089

224 Long evening dress
Haute couture collection
Spring–Summer 1979
Navy satin crepe
HC79E109

225 Long evening dress
Haute couture collection
Spring–Summer 1982
Navy satin, embroidered in
sapphire blue
HC82E121

226 Long evening dress
Haute couture collection
Spring–Summer 1982
Fuchsia satin embroidered with jet
and diamonds
HC82E119

227 Long evening dress
Haute couture collection
Spring–Summer 2001
Navy organza and black satin
with ruffles
HC01E083

228 Long evening dress
Haute couture collection
Spring–Summer 1985
Red crepe
HC85E115

229 Long evening dress
Haute couture collection
Spring–Summer 1972
Navy crepe de chine
HC72E055

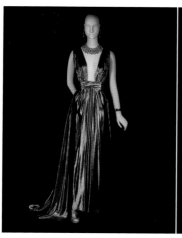 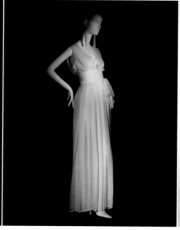 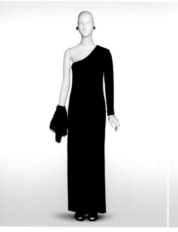 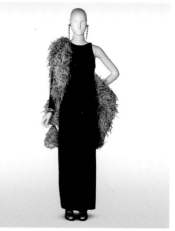

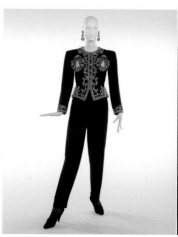 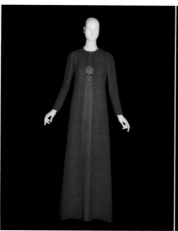 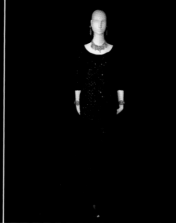 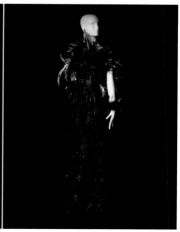

230 Long evening dress
Haute couture collection
Spring–Summer 1981
Gold-and-silver lamé gauze
HC81E133

231 Long evening dress
Haute couture collection
Spring–Summer 1997
White chiffon
HC97E055

232 Long evening dress
Haute couture collection
Spring–Summer 1979
Black silk jersey
HC79E078

233 Long evening dress
Haute couture collection
Spring–Summer 1979
Black silk jersey; white and black
ostrich feather boa
HC79E077

234 Long evening ensemble
Haute couture collection
Fall–Winter 1984
Green velvet jacket, cameo
embroidered with coral and gold;
black barathea pants
HC84H117

235 Long evening ensemble
Haute couture collection
Spring–Summer 1970
Red crepe coat; orange crepe
dress
HC70E033

236 Long evening dress
Haute couture collection
Spring–Summer 1983
Tulle embroidered with jet scales
HC83E087

237 Long evening dress
Haute couture collection
Fall–Winter 2000
Sequined lace and black bird of
paradise feathers
HC00H067

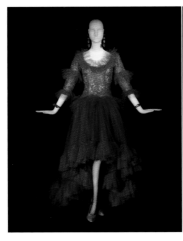
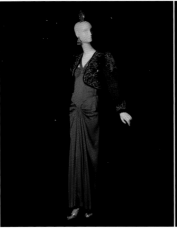
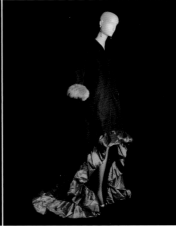
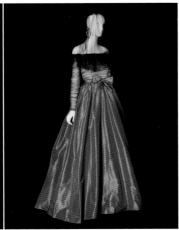

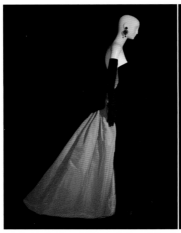
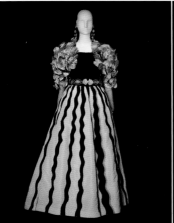
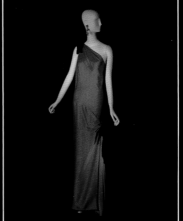
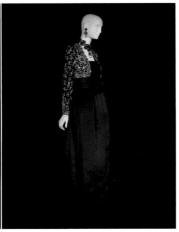

238 Long evening dress
Haute couture collection
Spring–Summer 1990
Ruby straw lace and fuchsia
point d'esprit tulle
HC90E099

239 Long evening ensemble
Haute couture collection
Spring–Summer 1980
Navy gazar bolero embroidered
with coral and jade; flame-colored
satin sheath dress
HC80E072

240 Long evening dress
Haute couture collection
Fall–Winter 2000
Black faille and pink taffeta
HC00H085

241 Long evening dress
Haute couture collection
Fall–Winter 2000
Pink [*bois de rose*] taffeta, gold
organza and lace
HC00H087

242 Long evening dress
Haute couture collection
Fall–Winter 1995
Black velvet and coral faille
HC95H066

243 Long evening ensemble
Haute couture collection
Fall–Winter 1984
Bolero embroidered with gold
leaf; black velvet top; white faille
skirt embroidered with black-and-
gold velvet
HC84H160

244 Long evening dress
Haute couture collection
Fall–Winter 1978
Fuchsia satin, black velvet bows
HC78H087

245 Long evening ensemble
Haute couture collection
Fall–Winter 1997
Embroidered bolero; Ispahan
satin dress
HC97H047

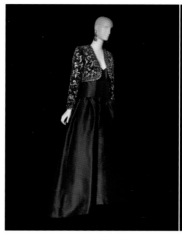
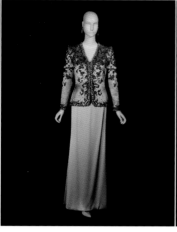

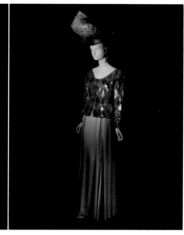

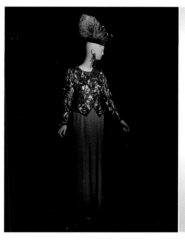
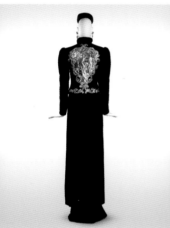
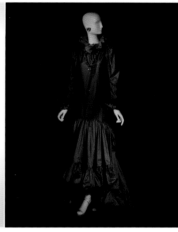
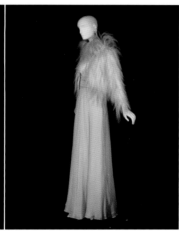

246 Long evening ensemble
Haute couture collection
Fall–Winter 1997
Embroidered ruby velvet bolero;
iris faille dress
HC97H048

247 Long evening ensemble
Haute couture collection
Spring–Summer 1998
Embroidered Bengal pink satin
jacket; Delft blue satin skirt
HC98E049

248 Long evening ensemble
Haute couture collection
Fall–Winter 1987
Speckled ostrich feather coat;
glossy black lace dress
HC87H117

249 Long evening ensemble
Haute couture collection
Fall–Winter 2001
Embroidered organza harlequin
jacket; ice blue satin skirt
HC01H054

250 Long evening ensemble
Haute couture collection
Fall–Winter 2001
Embroidered organza harlequin
jacket; Indian pink silk crepe skirt
HC01H055

251 Long evening ensemble
Haute couture collection
Fall–Winter 1978
Black velvet jacket, gold-and-silver
"broken mirror" embroidery; black
velvet skirt
HC78H097

252 Long evening dress
Haute couture collection
Spring–Summer 1979
Ocean-blue-and-jade taffeta
HC79E092

253 Long evening ensemble
Haute couture collection
Spring–Summer 1994
Bird of paradise feather cardigan;
champagne chiffon dress
HC94E033

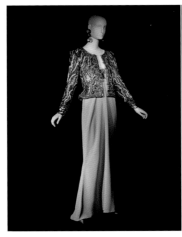
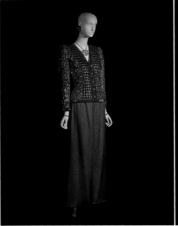
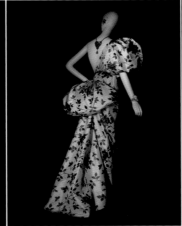
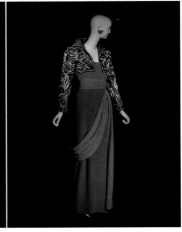

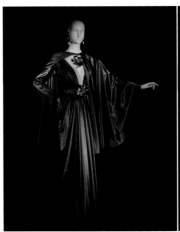
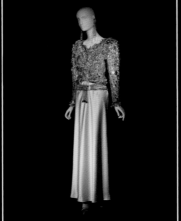

254 Long evening ensemble
Haute couture collection
Fall–Winter 1984
Bolero embroidered with white,
gray, and gold Rhodoïd and
rocaille glass beads, embroidered
cameo; pearl gray Moroccan
crepe dress
HC84H144

255 Long evening ensemble
Haute couture collection
Spring–Summer 1986
Embroidered pink cardigan;
fuchsia satin dress
HC86E079

256 Long evening dress
Haute couture collection
Spring–Summer 1986
Mottled black-and-white taffeta
HC86E097

257 Long evening ensemble
Haute couture collection
Spring–Summer 1987
Pink-and-purple sequined bolero
embroidered with flowers;
cherry, fuchsia, and Bengal pink
crepe dress
HC87E089

258 Long evening ensemble
Haute couture collection
Fall–Winter 1988
Gold satin cape; steely gray
satin dress
HC88H118

259 Long evening ensemble
Tribute to my House
Haute couture collection
Spring–Summer 1990
Jacket embroidered with gold and
rock crystal; white satin dress
HC90E113

260 Long evening dress
Haute couture collection
Fall–Winter 1994
Iridescent Orient blue satin chiffon
HC94H074

261 Long evening dress
Haute couture collection
Spring–Summer 1980
Pink taffeta
Loaned by Comtesse Jacqueline
de Ribes

262 Tuxedo with pants
Haute couture collection
Fall–Winter 1966
Black barathea and satin silk;
white organdy blouse
HC66H076

263 Tuxedo with pants
Haute couture collection
Spring–Summer 1967
Black wool; white cotton
piqué blouse
HC67E088

264 Tuxedo with pants
Haute couture collection
Spring–Summer 1967
Navy alpaca spencer and pants;
white organdy blouse with plum
satin bow tie
HC67E056

265 Tuxedo with knickerbockers
Haute couture collection
Fall–Winter 1967
Black velvet; white crepe blouse
HC67H070

266 Tuxedo with shorts
Haute couture collection
Spring–Summer 1968
Black alpaca; black cigaline and
satin blouse
HC68E031.V1

267 Tuxedo with shorts
Haute couture collection
Spring–Summer 1968
Black alpaca; black transparent
cigaline and satin blouse
HC68E031.V2

268 Long tuxedo dress
Haute couture collection
Spring–Summer 1970
Black silk crepe
HC70E056

269 Tuxedo with pants
Haute couture collection
Spring–Summer 1970
Black wool
HC70E065

270 Tuxedo with pants
Haute couture collection
Fall–Winter 1971
Black wool; black-and-red
chiffon blouse
HC71H061

271 Tuxedo jumpsuit
Haute couture collection
Spring–Summer 1975
Black gabardine
HC75E020

272 Tuxedo with pants
Haute couture collection
Spring–Summer 1978
Black barathea spencer and pants;
black lace top
HC78E005

273 Tuxedo with pants
Haute couture collection
Spring–Summer 1979
Black barathea; black silk
jersey T-shirt
HC79E045

274 Tuxedo with short skirt
Haute couture collection
Fall–Winter 1981
Black wool and satin pea jacket;
black barathea skirt; black silk
jersey sweater
HC81H079

275 Tuxedo with short skirt
Haute couture collection
Spring–Summer 1982
Black-and-white barathea spencer
and skirt
HC82E032

276 Tuxedo with pants
Haute couture collection
Spring–Summer 1982
Black barathea;
white crepe blouse
HC82E071

277 Short tuxedo dress
Haute couture collection
Fall–Winter 1983
Black barathea
HC83H082

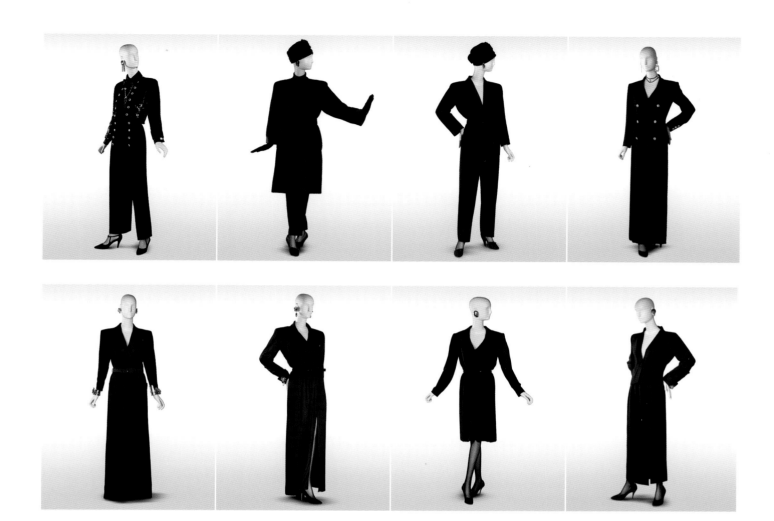

278 Tuxedo with pants
Haute couture collection
Spring–Summer 1984
Spencer embroidered with black
sequins; black chiffon and satin
blouse; black barathea pants
HC84E075

279 Long tuxedo ensemble
Haute couture collection
Fall–Winter 1984
Black wool coat; black barathea
pants; black wool turtleneck
HC84H076

280 Tuxedo jumpsuit
Haute couture collection
Fall–Winter 1984
Black barathea
HC84H096

281 Long tuxedo dress
Haute couture collection
Spring–Summer 1985
Black Moroccan crepe
HC85E123

282 Long tuxedo dress
Haute couture collection
Fall–Winter 1988
Black wool crepe and satin
HC88H081

283 Long tuxedo dress
Haute couture collection
Fall–Winter 1988
Black satin
HC88H078

284 Short tuxedo dress
Haute couture collection
Fall–Winter 1988
Navy silk crepe and black satin
HC88H066

285 Tuxedo with long skirt
Haute couture collection
Spring–Summer 1989
Navy blue barathea
HC89E044

286 Long tuxedo ensemble
Haute couture collection
Spring–Summer 1990
Black gazar duffle coat; black satin
bustier; black barathea pants
HC90E064

287 Long tuxedo dress
Haute couture collection
Fall–Winter 1992
Black barathea
HC92H044

288 Tuxedo with knickerbockers
Haute couture collection
Fall–Winter 1993
Black barathea
HC93H021

289 Short tuxedo dress
Haute couture collection
Spring–Summer 1995
Sequined lace, black barathea
and satin
HC95E047

290 Tuxedo with short skirt
Haute couture collection
Spring–Summer 1995
Black barathea spencer;
black satin skirt
HC95E046

291 Tuxedo with long dress
Haute couture collection
Spring–Summer 1995
Black silk crepe
HC95E053

292 Tuxedo with pants
Haute couture collection
Spring–Summer 1996
Black barathea safari jacket
and pants
HC96E027

293 Tuxedo with short skirt
Haute couture collection
Spring–Summer 1997
Black barathea; white silk
crepe blouse
HC97E038

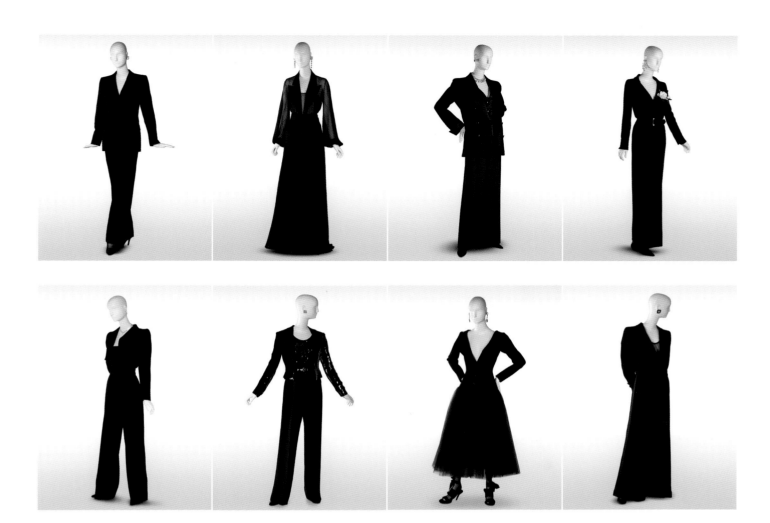

294 Tuxedo with pants
Haute couture collection
Fall–Winter 1998
Black barathea
HC98H028

295 Long tuxedo dress
Haute couture collection
Fall–Winter 1999
Black chiffon and satin
HC99H049

296 Tuxedo with long skirt
Haute couture collection
Fall–Winter 1999
Black cashmere and satin pea
jacket; black leather-satin bustier;
black wool faille skirt
HC99H048

297 Long tuxedo dress
Haute couture collection
Spring–Summer 1999
Black silk crepe
HC99E045

298 Long tuxedo ensemble
Haute couture collection
Fall–Winter 2000
Black barathea and satin bolero
and jumpsuit
HC00H040

299 Tuxedo with pants
Haute couture collection
Spring–Summer 2001
Spencer embroidered with black
sequins and satin; black sequined
top; black crepe pants
HC01E063

300 Long tuxedo dress
Haute couture collection
Fall–Winter 2001
Black barathea and tulle
HC01H035

301 Tuxedo with pants
Haute couture collection
Spring–Summer 2002
Black barathea and satin; black
chiffon and satin blouse
HC02E017

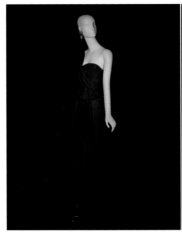 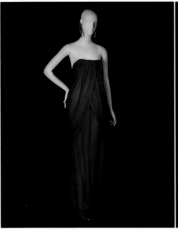 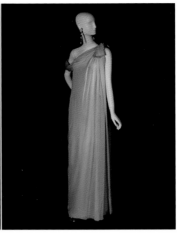

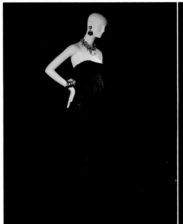 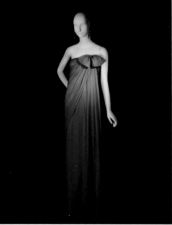 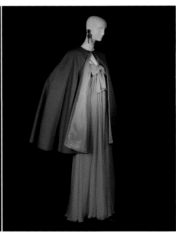

302 Long evening dress
Haute couture collection
Spring–Summer 2002
Blue draped chiffon
HC02E019

303 Long evening dress
Haute couture collection
Spring–Summer 2002
Garnet-colored draped chiffon
HC02E021

304 Long evening dress
Haute couture collection
Spring–Summer 2002
Pink draped chiffon
HC02E023

Note to the reader:
Almost all the designs shown
in the exhibition are from the
Pierre Bergé–Yves Saint Laurent
Collection. Five pieces were
generously loaned to complement
the exhibition: Two are from the
collection of Comtesse Jacqueline
de Ribes, one is from that of
Charlotte Aillaud, and two belong
to Michèle and Olivier Chatenet.

305 Long evening dress
Haute couture collection
Spring–Summer 2002
Black draped chiffon
HC02E030

306 Long evening dress
Haute couture collection
Spring–Summer 2002
Blue draped chiffon
HC02E031

307 Long evening dress
Haute couture collection
Spring–Summer 2002
Yellow draped chiffon;
blue gazar cape lined
with green silk
(*not exhibited*)
HC02E038

Hats: Yves Saint Laurent
Hairstyling: Alexandre de Paris
Jewelry: Yves Saint Laurent
Gloves: Yves Saint Laurent
Shoes: Yves Saint Laurent

SELECTED BIBLIOGRAPHY

BOOKS

Benaïm, Laurence. *Yves Saint Laurent*. Paris: Editions Grasset, 1993.

Bergé, Pierre, Françoise Sagan, Bernard-Henri Lévy, François Mitterrand, Marguerite Duras, and Yves Saint Laurent. *L'Esprit du Temps: Yves Saint Laurent*. Paris: Movida, 1989.

Bergé, Pierre. *Lettres à Yves*. Paris: Editions Gallimard, 2010.

Bergé, Pierre. *Yves Saint Laurent*. Paris: Assouline, 1996.

Boulat, Pierre (photographer). *Yves Saint Laurent: Naissance d'une légende*. Introduction by Laurence Benaïm, notes by Pierre Bergé. Paris: Éditions de La Martinière, 2002.

Deygas, Florence. *YSL Invite Hiromix*. Paris: Asia Mix Culture, 1998.

Drake, Alicia, *The Beautiful Fall: Lagerfeld, Saint Laurent, and Glorious Excess in 1970s Paris*. New York: Little, Brown, 2006.

Duras, Marguerite (foreword). *Yves Saint Laurent and Fashion Photography*. New York: Te Neues, 1999.

Levis, Fiona. *Yves Saint Laurent: l'homme couleur de temps*. Paris: Editions du Rocher, 2008.

Madsen, Axel. *Living for Design: The Yves Saint Laurent Story*. New York: Delacorte Press, 1979.

Murphy, Robert. *The Private World of Yves Saint Laurent and Pierre Bergé*. Photographs by Ivan Terestchenko. New York: Vendome Press, 2009.

Nicolay-Mazery, Christiane de, Ed. *The Yves Saint Laurent Pierre Bergé Collection: The Sale of the Century*. London: Christie's, 2009.

Rawsthorn, Alice, *Yves Saint Laurent: A Biography*. New York: Nan A. Talese, 1996.

Saint Laurent, Yves. *La vilaine Lulu*. Paris: Tchou, 1967.

Saint Laurent, Yves. *Love*. Foreword by Patrick Mauriès. New York: Abrams, 2000.

Schatzberg, Jerry (photographer). *Paris 1962: Yves Saint-Laurent and Christian Dior, The Early Collections*. Texts by Patricia Bosworth and Julia Morton. New York: Rizzoli, 2008.

Teboul, David. *Yves Saint Laurent: 5, Avenue Marceau, 75116 Paris, France*. Translated from the French by Alexandra Bonfante-Warren and Molly Stevens. New York: Abrams, 2002.

EXHIBITION CATALOGS

Le Costume populaire russe. Special issue of *Connaissance des arts* to accompany the exhibition at the Fondation Pierre Bergé–Yves Saint Laurent, Paris, March 18–August 30, 2009. Paris: Connaissance des arts, 2009.

Les Derniers Maharajas. Catalogue of the exhibition at the Fondation Pierre Bergé–Yves Saint Laurent, Paris, February 10–May 9, 2010. Paris: Éditions de La Martinière, 2010.

Nan Kempner, une Américaine à Paris. Catalog of the exhibition at the Fondation Pierre Bergé–Yves Saint Laurent, Paris, May 16–July 29, 2007. Paris: Fondation Pierre Bergé–Yves Saint Laurent, 2007.

Smoking Forever. Catalog of the exhibition at the Fondation Pierre Bergé–Yves Saint Laurent, Paris, October 5, 2005–April 23, 2006. Paris: Fondation Pierre Bergé–Yves Saint Laurent, 2005.

Une passion marocaine: Caftans broderies, bijoux. Special issue of *Connaissance des Arts* to accompany the exhibition at the Fondation Pierre Bergé–Yves Saint Laurent, Paris, March 14–August 31, 2008. Paris: Connaissance des arts, 2008.

Voyages extraordinaires. Catalog of the exhibition at the Fondation Pierre Bergé–Yves Saint Laurent, Paris, October 4, 2006–April 15, 2007. Paris: Fondation Pierre Bergé–Yves Saint Laurent, 2006.

Yves Saint Laurent. Catalog of the exhibition at the Costume Institute of the Metropolitan Museum of Art, New York, December 14, 1983–September 2, 1984, edited by Diana Vreeland. New York: Clarkson N. Potter, Inc., 1983.

Yves Saint Laurent, 1958–1985. Catalog of the exhibition at the Palace of Fine Arts, Beijing, 1985. Paris: Yves Saint Laurent SA, 1985.

Yves Saint Laurent: Diálogo con el Arte. Catalog of the exhibition at the Sede Fundación Caixa Galicia, La Coruña, February 12–April 23, 2008. La Coruña/Paris: Fundación Caixa Galicia/Fondation Pierre Bergé–Yves Saint Laurent, 2008.

Yves Saint Laurent: Dialogue avec l'art. Catalog of the exhibition at the Fondation Pierre Bergé–Yves Saint Laurent, Paris, March 10–October 31, 2004. Paris: Fondation Pierre Bergé–Yves Saint Laurent, 2004.

Yves Saint Laurent et le théâtre. With a foreword by Edmonde Charles-Roux. Catalog of the exhibition at the Musée des Arts Décoratifs, Paris, June 25–September 7, 1986. Paris: Herscher, 1986.

Yves Saint Laurent: Exotismes. Catalog of the exhibition at the Musée de la Mode, Marseille, December 10, 1993–March 27, 1994. Marseille/Paris: Musées de Marseille/Réunion des Musées Nationaux, 1993.

Yves Saint Laurent: Forty Years of Creation, 1958–1998. New York: International Festival of Fashion Photography, 1998.

Yves Saint Laurent par Yves Saint Laurent. Drawings by Yves Saint Laurent, with a foreword by Bernard-Henri Lévy. Catalog of the exhibition *Yves Saint Laurent: vingt-huit années de création*, Musée des Arts de la Mode, Paris, May 30–October 26, 1986. Paris: Herscher, 1986.

Yves Saint Laurent Retrospective. Catalog of the exhibition at the Art Gallery of New South Wales, Sydney, 1987. Sydney: Art Gallery of New South Wales, 1987.

Yves Saint Laurent Style. Catalog of the exhibition at the Musée des Beaux-Arts, Montreal, May 29–September 28, 2008, and the Fine Arts Museum, San Francisco, November 1, 2008–March 1, 2009. Paris/New York: Éditions de La Martinière/Abrams, 2008.

Yves Saint Laurent: théâtre, cinéma, music-hall, ballet. Catalog of the exhibition at the Fondation Pierre Bergé–Yves Saint Laurent, Paris, October 4, 2007–January 27, 2008. Paris: Fondation Pierre Bergé Yves Saint Laurent, 2007.

FILMS AND VIDEO RECORDINGS

Interview d'Yves Saint Laurent. Yves Saint Laurent interviewed by Micheline Sandrel, Office de Radiodiffusion-Télévision Française, November 8, 1958.

Le Temps Retrouvé. Directed by David Teboul. Movimento Production/Canal+, 2001.

Tout Terriblement. Directed by Jérôme de Missolz. Lieurac Productions, 1994.

Yves Saint Laurent Répond à Mlle. Chanel. Yves Saint Laurent interviewed by Claude Berthod, *Dim Dam Dom* (38th broadcast), Office de Radiodiffusion-Télévision Française, March 10, 1968.

Yves Saint Laurent, 5, Avenue Marceau, 75116 Paris. Directed by David Teboul. Movimento Production/Canal+/Transatlantique Vidéo, 2002.

PHOTO CREDITS

Cover: © Pierre Boulat, courtesy of the Pierre and Alexandra Boulat Association; p. 21: © The Irving Penn Foundation; p. 25: © Pierre Boulat, courtesy of the Pierre and Alexandra Boulat Association; p. 26: © The Irving Penn Foundation; p. 29: Andy Warhol © Adagp, Paris 2010; p. 33: © RDA/Hulton Archive/Getty Images; p. 35: © Alice Springs/TDR; p. 39 bottom: © François Pagès/*Paris Match*/Scoop; p. 41 top: © Studio Lipnitzki/Roger-Viollet; p. 45: © 2010 The Richard Avedon Foundation; p. 46 top: © SIPA PRESS; p. 47: © S. Weiss/Rapho/Eyedea Illustration; p. 50: © Fondation Pierre Bergé–Yves Saint Laurent; p. 52 bottom: © AFP; p. 53: © 2002 Mark Shaw/mptvimages.com; p. 55: © Maurice Hogenboom; pp. 56–57: © Pierre Boulat, courtesy of the Pierre and Alexandra Boulat Association; pp. 58–59: © Fondation Pierre Bergé–Yves Saint Laurent; p. 60: © Pierre Boulat, courtesy of the Pierre and Alexandra Boulat Association; p. 63: © G. Botti/Gamma/Eyedea Presse; pp. 64–65: © Pierre Boulat, courtesy of the Pierre and Alexandra Boulat Association; p. 69: © Hulton-Deutsch collection/Corbis; p. 70: David Bailey © Vogue Paris; p. 72 top: © Atelier Robert Doisneau; p. 72 bottom: © Fondation Pierre Bergé–Yves Saint Laurent; p. 75: © Fondation Pierre Bergé–Yves Saint Laurent; p. 77 top: © Jean-Philippe Lalanne; p. 77 bottom: © Manuel Litran/*Paris Match*/Scoop; pp. 78–79: © Fondation Pierre Bergé–Yves Saint Laurent; p. 81: © The Estate of Jeanloup Sieff; p. 85: © Pierre Boulat, courtesy of the Pierre and Alexandra Boulat Association; p. 87: © The Helmut Newton Estate/TDR; p. 89: © Pierre Boulat, courtesy of the Pierre and Alexandra Boulat Association;

pp. 90–91: © Arthur Elgort; p. 93: © Fondation Pierre Bergé–Yves Saint Laurent; p. 97: © International Center of Photography, David Seidner Archive; p. 98: © Fondation Pierre Bergé–Yves Saint Laurent; p. 102: © Bettina Rheims/*Elle*/Scoop; p. 105: © Alexandra Boulat courtesy Association Pierre and Alexandra Boulat; pp. 108–109: © Derek Hudson; p. 111: © Guy Marineau; p. 112: © Fondation Pierre Bergé–Yves Saint Laurent; p. 115: © Fondation Pierre Bergé–Yves Saint Laurent; p. 117: David Bailey/Vogue © The Condé Nast Publications Ltd; p. 118: © David Bailey; p. 121: © The Estate of Jeanloup Sieff; p. 127: © 1966 Condé Nast Publications; p. 129: William Klein/Condé Nast Archive © Condé Nast Publications; p. 131: © Estate of Guy Bourdin/Art + Commerce; p. 132: © Marc Hispard; p. 133: Henry Clarke / Condé Nast Archive © Condé Nast Publications; p. 135: © The Estate of Jeanloup Sieff; p. 137: © Fondation Pierre Bergé–Yves Saint Laurent; p. 139: © 2010 The Richard Avedon Foundation; p. 141: © Fondation Pierre Bergé–Yves Saint Laurent; p. 143: © Mario Testino; p. 145: © Fondation Pierre Bergé–Yves Saint Laurent; pp. 147–148: © The Helmut Newton Estate/TDR; p. 149: Helmut Newton/Condé Nast Archive © Condé Nast Publications; p. 151: Franco Rubartelli © Vogue Paris; p. 152: © Fondation Pierre Bergé–Yves Saint Laurent; p. 153: © The Helmut Newton Estate/TDR; p. 159: © Fondation Pierre Bergé–Yves Saint Laurent; p. 161: © Norman Parkinson Archive; p. 165: © The Helmut Newton Estate / TDR; p. 166: © Arthur Elgort; p. 171: © Jean-Pierre Masclet/Camera Press/Gamma/Eyedea Presse; p. 175: © Fondation Pierre Bergé–Yves Saint Laurent; p. 176: © The Helmut Newton Estate/TDR; p. 177: © Arthur Elgort; p. 178: © The Helmut Newton Estate/TDR; p. 179: © Pierre Boulat, courtesy of the Pierre and Alexandra Boulat Association; p. 180: © G. Botti/Gamma/Eyedea Presse; p. 181: © Pierre Boulat, courtesy of the Pierre and Alexandra

Boulat Association; p. 182: © David Bailey; p. 183: © Bill Ray/Time & Life Pictures/Getty Images; p. 187: © Fondation Pierre Bergé–Yves Saint Laurent; p. 189: © International Center of Photography, David Seidner Archive; p. 190: © Peter Knapp; p. 193: Peter Knapp/Vogue © The Condé Nast Publications Ltd; p. 199: © Hans Feurer/*Elle*/Scoop; p. 207: © The Estate of Jeanloup Sieff; p. 208 upper right: © Roger-Viollet; p. 208 lower right: © Hans Feurer/*Elle*/Scoop; p. 209: © The Helmut Newton Estate/TDR; p. 210: © Fondation Pierre Bergé–Yves Saint Laurent; p. 211 upper right: © CAT'S COLLECTION/Corbis; p. 211 upper left, lower left, and right: © 1967 STUDIOCANAL; p. 212: © Hans Feurer/*Elle*/Scoop; p. 215: © Fondation Pierre Bergé–Yves Saint Laurent; p. 216: © Peter Knapp/*Elle*/Scoop; p. 217: © Norman Parkinson Archive; p. 220: Helmut Newton / Condé Nast Archive © Condé Nast Publications; p. 222: © Claus Ohm; p. 227: © International Center of Photography, David Seidner Archive; p. 235: © Wesley/Keystone/Getty Images; p. 237: © The Estate of Jeanloup Sieff; p. 238: © Henri Elwing/*Elle*/Scoop; p. 239: © The Estate of Jeanloup Sieff; p. 240: © The Helmut Newton Estate/TDR; p. 243: © Fondation Pierre Bergé–Yves Saint Laurent; p. 245: © Arthur Elgort; pp. 246–247: © Guy Marineau; p. 249: © International Center of Photography, David Seidner Archive; p. 250: © Fouli Elia/*Elle*/Scoop; pp. 258–259: © André Rau/*Elle*/Scoop; pp. 261–262: © Fondation Pierre Bergé–Yves Saint Laurent; pp. 264–265: © Estate of Guy Bourdin/Art + Commerce; p. 267: © Duane Michals; p. 269: © Uli Rose; p. 270: © Fondation Pierre Bergé–Yves Saint Laurent; p. 272: Lothar Schmid/Vogue © The Condé Nast Publications Ltd; p. 273: © G. Botti/Gamma/Eyedea Presse; p. 277: © The Helmut Newton Estate/TDR; p. 281: © Jean-Claude Sauer; p. 287: © Fondation Pierre Bergé–Yves Saint Laurent; p. 288: © Gilles Tapie; pp. 290–291: © Fondation Pierre Bergé–Yves Saint

Laurent; p. 292: © Arthur Elgort/Condé Nast Archive © Condé Nast Publications; p. 299 upper left: © Guy Marineau; p. 299 upper right: © Ali Mahdavi; p. 299 lower left: © Sunset Boulevard/Corbis; p. 299 lower right: © The Estate of Jeanloup Sieff; p. 300 upper left: © Catherine Cabrol/Kipa/Corbis; p. 300 upper right: © Henry Clarke/Galliera/La Parisienne de photographie; p. 300 lower left: © Guy Marineau; p. 300 lower right: Francesco Scavullo/Condé Nast Archive © Condé Nast Publications; p. 303 upper left: © Pictorial Parade/Hulton Archive/Getty Images; p. 303 upper right: © Henry Clarke; p. 303 lower left: © The Horst P. Horst Estate/Art + Commerce; p. 303 lower right, 304 upper left and lower left: © The Cecil Beaton Studio Archive at Sotheby's; p. 304 upper right: © Condé Nast Archive/Corbis; p. 304 lower right: © Jack Nisberg/Roger-Viollet; p. 309: © Christie's Image; p. 316: Michael Roberts © Vogue Paris; p. 318: © Nicolas Mathéus; p. 319: © Bert Stern; p. 321: © Jean-Claude Sauer/1966 Life Inc. Reprinted with permission. All rights reserved; pp. 326–327: © Jean-Marie Périer; p. 331: © Fondation Pierre Bergé–Yves Saint Laurent; p. 332: © 2010 The Richard Avedon Foundation; pp. 334–335: © David Bailey; p. 337: © L'OFFICIEL 1962/Pottier; p. 338: © The Helmut Newton Estate/TDR.

FONDATION PIERRE BERGÉ–YVES
SAINT LAURENT
BOARD OF DIRECTORS

Mr. Yves Saint Laurent, Honorary Chairman
Mr. Pierre Bergé, Chairman
Mr. Madison Cox, Vice-Chairman
Mr. Louis Gautier, Treasurer
Mr. Jean-Francis Bretelle, Secretary
Mr. Antoine Godeau
Mr. Alain Minc
AROYSL,* represented by Ms. Patricia
Barbizet (government commissioner),
and Ms. Françoise Laplazie (Ministry of
Interior representative)

*Association pour le Rayonnement de l'Oeuvre
d'Yves Saint Laurent
Non-profit association, registration 0200278D
dated December 5, 2002, listed in the *Journal
Officiel* on December 12, 2002.

Graphic design
Philippe Apeloig,
assisted by Yannick James and Matthias
Neuer, with valuable help from Tino Grass

Editorial coordination
(Éditions de La Martinière)
Brigitte Govignon and Isabelle Dartois

Editorial coordination
(Fondation Pierre Bergé–Yves Saint Laurent)
Robin Fournier-Bergmann, assisted by
Pauline Cintrat

Documentation and picture research
Pauline Vidal

Copyediting
Marion Lacroix and Colette Malandain

FOR THE ENGLISH-LANGUAGE EDITION:

Essays and captions translated from the
French by Alexandra Keens and Deke
Dusinberre.

Project Manager
Aiah Rachel Wieder

Designer
Shawn Dahl

Production Manager
Jules Thomson

Cataloging-in-Publication Data has been
applied for and may be obtained from the
Library of Congress.

ISBN: 978-0-8109-9608-3

Printed and bound in Italy

10 9 8 7 6 5 4 3 2 1

ABRAMS
THE ART OF BOOKS SINCE 1949

115 West 18th Street
New York, NY 10011
www.abramsbooks.com

FLORENCE MÜLLER is a fashion historian,
exhibition curator, and professor at the
Institut Français de la Mode. She was senior
curator of "Yves Saint Laurent Style," hosted
by the Montreal Museum of Fine Arts in
2008 and San Francisco's De Young Museum
in 2009, and she is the author of numerous
books.

FARID CHENOUNE teaches the history of
fashion at the École Nationale Supérieure
des Arts Décoratifs and the Institut Français
de la Mode. Chenoune's publications include
*Dior, Hidden Underneath: A History of
Lingerie, Carried Away: All About Bags*, and
A History of Men's Fashion.

BERNARD BLISTÈNE is head of the
cultural development department at the
Pompidou Center in Paris. He teaches at the
École du Louvre.

JÉROMINE SAVIGNON is a fashion
historian and the author of *Jacques
Fath, Jean-Louis Scherrer*, and *Cacharel:
Le Liberty*.